Facing Black Star

IMC Books

Collections and Archives

Facing Black Star

Edited by Thierry Gervais and Vincent Lavoie

IMC Books
The Image Centre
Toronto, Canada

The MIT Press
Cambridge, Massachusetts
London, England

This book was set in Adobe Garamond Pro and Whitney by Studio Ours Inc. and was printed and
bound in France.

Library of Congress Control Number: 2022932516

ISBN: 978-0-262-04784-5

10 9 8 7 6 5 4 3 2 1

This publication has been made possible through support from Université du Québec à Montréal.

Please be advised that this book contains images that may be triggering to some readers.

Unless otherwise noted, all photographs reproduced in this book are from the Black Star Collection,
The Image Centre at Toronto Metropolitan University.

Back cover: Griffith J. Davis, *Going Through Colored Entrance at Movie, Fox Theater, Atlanta*, ca. 1948 (detail). Gelatin silver print,
25.2 x 19.7 cm. BS.2005.280822. © Griff Davis/Griffith J. Davis Photographs and Archives.

pages 64–5: Unknown photographer, *Chapter House, Zwettl Abbey, Austria*, ca. 1915 (verso detail). Gelatin silver print, 23.9 x 19.2 cm.
BS.2005.003743.

pages 140–41: Shelly Rusten, *Couple Embracing in the Street, New York City*, 1970 (verso detail). Gelatin silver print, 28.3 x 19.3 cm.
BS.2005.266374.

pages 258–59: Doris Heydn, *Gathering in Graveyard, Day of the Dead, Mexico*, ca. 1942 (verso detail). Gelatin silver print,
19.5 x 24.1 cm. BS.2005.096820.

Contents

Part 2: Generating Visibilities in the Black Star Collection

Part 3: Curating with the Black Star Collection

Foreword

Doina Popescu

The raison d'être for the Ryerson Image Centre (RIC), today known as The Image Centre at Toronto Metropolitan University, is the Black Star Collection, an anonymous donation and one of the largest gifts of cultural property to a Canadian university. In 2008 I was invited to lead the creation of a yet-to-be-defined-and-named centre of photography whose cornerstone would be this collection of 291,049 black-and-white fibre-base and resin-coated gelatin silver press prints, photographs that helped tell the story of the twentieth century in some of the most famous news publications of their day.

Expectations were high. The university's leadership, which commissioned Diamond Schmitt Architects to build a museum-standard facility for the preservation and academic study of the collection, rightly saw an opportunity to integrate new areas of multidisciplinary scholarship into the university, as well as to expand its reputation and connections with the world. The School of Image Arts saw the potential for exciting course offerings and hands-on learning for its students. The press, community members of diverse backgrounds, and an increasing number of international scholars and curators were anxious to know more about and to experience the storied legacy of the new acquisition. The challenge was to create an institution that satisfied this broad range of aspirations and did justice to the as-yet-undiscovered parameters and needs of the collection.

While our future centre of photography was under construction, the photographs were housed in a secure off-site arts storage facility at an undisclosed address, making access difficult. Inside that sprawling warehouse, the university had a compact temperature- and humidity-controlled temporary storage unit constructed. The shipping crates were unpacked and the elegant grey acid-free boxes containing the prints were stacked on makeshift metal shelving units. Each of the prints had already been newly

housed in its own protective Mylar sleeve and was to be handled exclusively with white "museum gloves." The numbering system for the boxes reflected the order of the filing cabinet drawers and folders at the Black Star agency, marking the exact location within its storage system of each photographic object on its last day as an active press photo. It was at that point that Black Star's black-and-white print archive became a collection of historic photographs, having successfully made its transition to a new life in a postsecondary institution dedicated to research and learning.

It was then possible to begin exploring the Black Star Collection with our university's team of trained photo-preservation staff and photo historians. However, we discovered that there were next to no ephemera with which to contextualize the photographs, and while some of the versos bore informative inscriptions, oftentimes there was nothing written on the backs of the prints. There were stunning stock images of the civil rights movement, the Vietnam War, the Kennedy assassination, well-known personalities from Gandhi to Marilyn Monroe, and many more historic moments of note. But there were also countless images covering topics such as farming, landscapes, architecture, science, medicine, industry, crowds, and so on that could not be readily identified. There were photographs by famous photojournalists such as Robert Capa, Andreas Feininger, Charles Moore, and W. Eugene Smith, but many more by less well-known or even unnamed photographers. We were confronted with a plethora of images that raised more questions than answers regarding their provenance and the day-to-day workings of the Black Star agency. While there was no obvious way forward, the needs of the collection were coming into focus.

That was the moment to develop a custom-designed road map for the university's photography centre, one that responded to the above questions and contextualized the Black Star Collection within its new reality. It was also important that our plans reflected the need for exchange with partner institutions and scholars around the world, and that they guaranteed a vibrant professional presence for the centre locally, nationally, and internationally. To this end I developed a detailed three-pronged vision for the RIC, addressing with equal emphasis research, acquisitions, and exhibitions. For each of those areas it was crucial to consider where we presently stood and what our first steps needed to be, but also where we were headed, and where we wanted to be in five to ten years.

To respond to our urgent questions about the Black Star Collection, it was important to establish a fully staffed professional research centre. Our focus would be on primary research, peer-reviewed publications, and public programming, including symposia, lectures, and workshops, as well as fellowship programs geared towards students, artists, photo historians, and researchers from various disciplines. One of our first moves was to acquire a digital cataloguing system, and we began scanning the rectos and versos of the photographs and entering what data we had on each one. We invited still-living Black Star photojournalists, among them Dennis Brack, Bob Fitch, Matt Herron, Larry Levin, and James Pickerell, to Toronto to revisit their images in the collection, to share with us the background stories of the photographs, and to elucidate their relationship with the agency. We offered public events on what it meant to be a photojournalist, on the complex workings of twentieth-century photo agencies, the ins and outs of magazine and newspaper publishing, photo editing, the nature of the documentary, and so on. In the summers we ran student workshops to research the use of Black Star images in magazines such as *Life*, *Look*, and *Time*. We co-published the then-bilingual journal *Études photographiques*, contributing to its ground-breaking scholarship and making it available to the English-speaking world. We connected with museum collections around the world and developed professional relationships with such institutions as the National Gallery of Canada, the Massachusetts Institute of Technology (MIT), the Société française de photographie, and many others.

On the acquisitions front, it was essential to situate the Black Star Collection and the university's teaching collection of approximately three thousand fine art and documentary photography items within a carefully structured growing collection. It would have to include elements that complemented those we already had, and that would responsibly strengthen our position as a key player in the world of the history of photography. We focused on collecting bodies of work that we could keep in scholarly and public circulation—in other words, our holdings were to be a living, breathing archive. In those early years, with the support of the remarkable group of experts on our Acquisitions Committee, we acquired archives of Berenice Abbott (shared with MIT), Wendy Snyder MacNeil, Jo Spence (shared with Birkbeck, University of London), and Black Star photographer Werner Wolff.

Last, but certainly not least, exhibitions were crucial to the fulfilment of the new vision. Given the significance of the Black Star Collection for the university, it was only logical that the RIC be launched with an exhibition curated from that collection. However, because construction of the building had been delayed, our first exhibitions were local and international collaborations with professional partner institutions outside the university.

For the September 2012 inauguration of the RIC, I asked my colleague Peggy Gale to co-curate with me an exhibition titled *Archival Dialogues: Reading the Black Star Collection*. We invited eight Canadian artists to interact with the collection from the perspective of their own artistic practice, each of which revealed unique and intimate relationships with photography and with archives, as well as with associated artistic fields such as film, video, new media, and installation art. We built the Salah J. Bachir New Media Wall in the entrance colonnade of the gallery because it was important to make a tangible statement about the fact that, in the twenty-first century, the photographic image needs to be seen in conversation with the moving image.

The commissioned artists were Stephen Andrews, Christina Battle, Marie-Hélène Cousineau, Stan Douglas, Vera Frenkel, Vid Ingelevics, David Rokeby, and Michael Snow. The accompanying exhibition catalogue included scholarly essays and contributions by the eight artists that offered further insights into their respective creative processes while navigating the complexities of the Black Star Collection. Via each of the eight installations in the exhibit, new life was breathed into the images from the collection, transporting them and their histories both conceptually and experientially into the present. The world of artist intervention was intersecting in revelatory ways with that of scholarly research.

The second curated exhibition from the Black Star Collection was of an entirely different, more documentary nature. Using the 1948 Universal Declaration of Human Rights as a point of departure, *Human Rights Human Wrongs* examined whether images of political struggle, suffering, and victims of violence work for or against humanitarian objectives, especially when considering questions of race, representation, ethics, and the cultural position of the photographer. Featuring more than three hundred original prints from the Black Star Collection, grouped as photo essays or in individual sequences, the exhibition, conceived by British curator and cultural historian Mark Sealy, covered a period primarily from the end of World War II to the

Rwandan genocide in 1994. Cards bearing images from the collection could be collected as one walked through the exhibition. On the back of each card was listed the human rights events, both positive and tragic, of a single year, offering insight into the often-overlooked simultaneities of history. The exhibition invited the visitor to take part, both intellectually and emotionally, in its enquiry into photojournalistic practice and its critical exploration of the cultural meaning of the photographs. The exhibition catalogue includes a full suite of annotated photographs from the exhibition, an essay by the curator, and a reprint of the thirty articles of the Universal Declaration of Human Rights.

While the Black Star Collection was the catalyst that made the RIC possible, it was the realization of a vision that addressed research, collecting, and a broad range of exhibition practices that allowed us to better understand and work with the collection. Once the prints had moved from their existence in a world of commerce and news production to life in a world of research and curation, they required an entirely new set of contexts. These would allow the collection to find its rightful place within the complex and interconnected disciplines of the social sciences, the arts, and, more specifically, the history of photography.

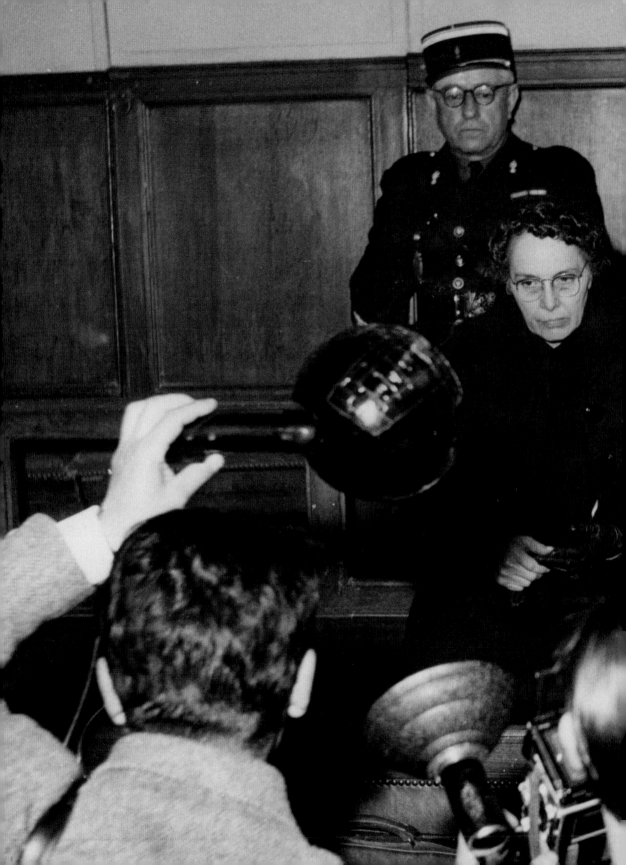

Introduction

Thierry Gervais and Vincent Lavoie

On Monday April 11, 2005, Ryerson University president Claude Lajeunesse announced to the press the university's acquisition of the New York photographic agency Black Star's black-and-white print collection. This holding was made up of 291,049 photographic prints, including "iconic images of 20th-century events and individuals."[1] A year before, the university had received the Kodak Canada archives and launched its master's program in Photography Preservation and Collection Management (PPCM). The Black Star Collection was described as a great fit that would "help Ryerson consolidate its position as an international centre for photographic studies."[2] Accompanied by $7 million in cash for the building of a gallery to preserve, exhibit, and research the collection, this donation was a coup, "unprecedented in Ryerson's history," according to Lajeunesse.[3]

The Black Star Collection joined an existing repository of photographs comprising approximately 3,126 objects. Collected for teaching purposes at the School of Image Arts since the end of the 1960s, they include albumen prints by Francis Frith and Eugène Atget; a collotype from Eadweard Muybridge's *Animal Locomotion*; *Camera Work* photogravures by Edward Steichen; gelatin silver prints by Berenice Abbott, Henri Cartier-Bresson, W. Eugene Smith, and Lee Friedlander; and more recent chromogenic prints by alumni such as Edward Burtynsky and teachers such as Robert Burley. Cartier-Bresson and Smith had also been among the 6,000-plus photographers listed in the Black Star Collection, along with Dennis Brack, Brassaï, Bill Burke,

Figure 0.1
Robert Cohen, *Marie Besnard Undergoes an Assault by Photographers at the Beginning of Her Hearing, Bordeaux,* March 16, 1954 (detail). Gelatin silver print, 13 x 18.3 cm. BS.2005.132238.

1 James Adams, "Ryerson to Receive Major Photo Archive," *Globe and Mail*, April 12, 2005, R3.
2 Tess Kalinowski, "Ryerson Welcomes Photo Library," *Toronto Star*, April 12, 2005, B2.
3 Adams, "Ryerson to Receive Major Photo Archive."

Robert Capa, Ralph Crane, László Moholy-Nagy, Charles Moore, George Rodger, and Roman Vishniac. These photojournalists and "world-famous" photographers[4] had prints in Black Star's picture library, the subsequent acquisition of which gave access to images "that define the 20th century" and also to "histories we might have not seen."[5]

As explained by Doina Popescu in her foreword, the Black Star agency's picture library turned into the Black Star Collection when acquired by the university, and it came with expectations. One of them was the creation of an institution dedicated to photography, which opened to the public in 2012 under the name Ryerson Image Centre (RIC) and is now known as The Image Centre at Toronto Metropolitan University (fig. 0.2). Another expectation was that the Black Star Collection would attract more photographic archives and collections—and it did: the Wendy Snyder MacNeil Archive, acquired in 2006; Black Star photographer Werner Wolff's archive (2009); the Jo Spence Memorial Archive (2010; shared with Birbeck, University of London); the Berenice Abbott Archive (2012; shared with MIT); the Rudolph P. Bratty Family Collection (2017); Canadian photographs from the collection of Christopher Varley (2019); the Francis Bedford Research Collection (2020); the Minna Keene and Violet Keene Perinchief Collection (2020); and the Edward Burtynsky Collection (ongoing from 2019). The Image Centre acquires and preserves photographic materials, organizes multiple exhibitions per year, and runs a research program. These expectations have certainly been fulfilled.

The Challenges of the Black Star Collection

The Black Star Collection also came with the expectation of research in the field of photojournalism. Described at the time of acquisition as "the oldest photojournalism agency in the world,"[6] one that had provided "about a third of *Life* magazine's images,"[7] the Black Star agency was also depicted

4 Adams, "Ryerson to Receive Major Photo Archive."
5 Vicki Goldberg, quoted by Vanessa Farquharson in "291,049 Photos Donated," *National Post*, April 12, 2005, AL2.
6 James Adams, "Ryerson Lands Donation of Massive Photo Archive," *Globe and Mail*, April 11, 2005, R2.
7 Farquharson, "291,049 Photos."

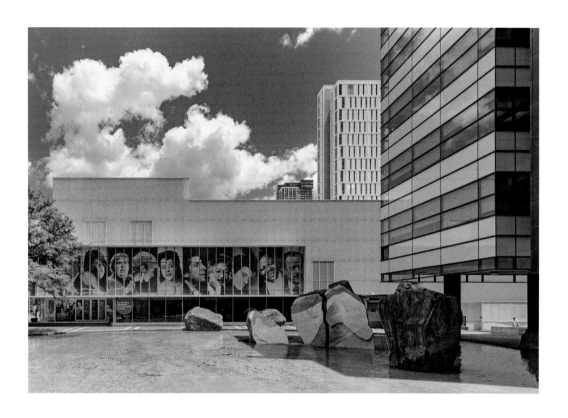

Figure 0.2
Toni Hafkenscheid, Exterior
Façade of The Image Centre,
Toronto, 2022.
© Toni Hafkenscheid.

Thierry Gervais and Vincent Lavoie 3

in literature as a driving force behind modern photojournalism in North America.[8] Black Star's founders, Kurt Kornfeld, Ernest Mayer, and Kurt Safranski, were German Jewish émigrés who fled the Nazis in 1934 and 1935.[9] Two of them, Mayer and Safranski, had been pivotal in the German illustrated press business, which expanded tremendously during the 1920s and early 1930s. Safranski worked for the Ullstein publishing company and was its managing director for periodicals. In that capacity he supervised the flow of images, oversaw their dissemination in Ullstein's illustrated periodicals, and worked closely with Kurt Korff, chief editor of the *Berliner Illustrirte Zeitung*. Through the Mauritius photography agency founded in 1929 in Berlin, Mayer was providing news photographs to the numerous magazines that appeared in Europe at the turn of the 1920s. In that context the competition was fierce, and both Safranski and Mayer, in their respective roles, developed economic and visual strategies to help them succeed.

This European economy of press photographs, with its cohort of photographers and its ever-changing landscape of magazines, has been addressed numerous times by photography historians.[10] With many other

8 C. Zoe Smith, "Émigré Photography in America: Contributions of German Photojournalism from Black Star Picture Agency to *Life* Magazine, 1933–1938" (PhD diss., University of Iowa, 1983); Howard Chapnick, *Truth Needs No Ally: Inside Photojournalism* (Columbia: University of Missouri Press, 1994); Hendrik Neubauer, *Black Star: 60 Years of Photojournalism* (Cologne: Könemann, 1997); Michael Torosian, *Black Star: The Historical Print Collection of the Black Star Publishing Company* (Toronto: Lumiere Press, 2013).

9 About the founders of the agency, see Phoebe Kornfeld, *Passionate Publishers: The Founders of the Black Star Photo Agency* (Bloomington, IN: Archway, 2021).

10 Tim Gidal, *Modern Photojournalism: Origin and Evolution, 1910–1933* (New York: Collier Books, 1973); Gisèle Freund, *Photography and Society* (Boston: David R. Godine, 1980); Hanno Hardt, "Pictures for the Masses: Photography and the Rise of Popular Magazines in Weimar Germany," *Journal of Communication Inquiry* 13, no. 1 (January 1989): 7–29; Daniel H. Magilow, *The Photography of Crisis: The Photo Essay of Weimar Germany* (University Park: Pennsylvania State University Press, 2012); Danielle Leenaerts, *Petite histoire du magazine VU, 1928–1940: Entre photographie d'information et photographie d'art* (Brussels: Peter Lang, 2010); Michel Frizot and Cédric de Veigy, *VU: Le magazine photographique, 1928–1940* (Paris: La Martinière, 2009); Estelle Blaschke, "'The Picture-Hunger of Modern Man': The Picture Market in Germany in the Weimar Republic, 1924–32," in *Banking on Images: The Bettmann Archive and Corbis* (Leipzig: Spector Books, 2016), 19–48; Malte Zierenberg, "Die Ordnung der Agenturen: Zur Verfertigung massenmedialer Sichtbarkeit im Pressewesen, 1900–1940," in *Fotografien im 20. Jahrhundert: Verbreitung und Vermittlung*, ed. Annelie Ramsbrock, Annette Vowinckel, and Malte Zierenberg (Göttingen: Wallstein, 2013), 44–65; Herbert Molderings, "Eine Schule der modernen Fotoreportage: Die

European émigrés, the founders of Black Star bridged the old continent and the new, sharing their expertise in visual news and their network of European photographers with American press barons such as William Hearst, Henry Luce, and Condé Nast, who were considering expanding the scope of their businesses.[11] The acquisition of Black Star's black-and-white print collection held the promise of access to sources that would help to understand this North American photojournalistic transition and visual turn.

The transfer of the photographs from the confidential corporate context of the agency to a university research environment generated expectations from researchers (fig. 0.3). Access to the collection was facilitated as much as possible after the donation; it became much easier when, in May 2012, the prints were deposited in a vault contiguous to the research centre housed within the new Image Centre facilities. Students, curators, and academics could make an appointment to study the black-and-white prints from the Black Star agency. But if that access fulfilled some of their expectations, it also destabilized and challenged many of the researchers, creating at times some frustration.

A first challenge encountered by researchers is the lack of ephemera associated with the collection of photographic prints. For business reasons, both the Black Star agency and the private buyer of the collection were most likely not interested in including the business's paper trail in the donation. Benjamin Chapnick, Black Star's President from 1990 to 2021, explained that they did not keep historical records of the business and, since he was still running the agency at the time of the sale, he might have deemed it inappropriate to share information regarding transactions.[12] From the buyer's perspective, the paper trail had no financial value on the art market;[13] its acquisition would thus represent no real capital gains but only extra charges.

Fotoagentur Dephot (Deutscher Photodienst), 1928 bis 1933," *Fotogeschichte* 28, no. 107 (2007): 5-21.

11 Thierry Gervais, "Making *Life* Possible" and "Three Dummies for *Life*, 1934–1935," in Life *Magazine and the Power of Photography*, ed. Katherine A. Bussard and Kristen K. Gresh (Princeton, NJ: Princeton University Press: 2020), 28–41 and 42–45.

12 Benjamin Chapnick, telephone interview with Valérie Matteau, 2011.

13 Mary Panzer, "The Meaning of the Twentieth-Century Press Archive," *Aperture* 202 (Spring 2011): 46–51; Peter Higdon, "Explanation of Outstanding Significance and National Importance," Application to the Canadian Cultural Property Export Review Board, item 6, November 10, 2004, 8–10. Acquisition files, The Image Centre, Toronto Metropolitan University.

Figures 0.3 and 0.4
Rachel Verbin, *Marianne Le Galliard, 2019 Nadir Mohamed Fellow, in the Peter Higdon Research Centre, The Image Centre, Toronto.* © Rachel Verbin.

Ephemera from the Black Star Collection, 2022. Digital photograph. The Image Centre, Toronto.

The only ephemera that accompanied the prints were the original folders from the agency's filing cabinets and any items remaining within them (fig. 0.4).[14] This corpus' organization was finalized in 2012 and PPCM student Lauren Potter created a finding aid in 2013. Potter described the ephemera as comprising "articles, captions, magazine tears (most commonly, *Illustrated*, *Stern*, and *The Picture Post*), photocopies, letters, filling slips, newspapers, and model release forms; found in three primary languages of English, French, and German with Spanish, Polish, Hebrew, and Chinese periodically present."[15] When connected with their corresponding prints, these documents reveal useful contextual information, but they provide only peripheral data about the business of the agency.

Despite the access to the prints and their associated ephemera, it remains difficult to determine the public dissemination of the images and how they circulated. In the displacement of the collection from a corporate to a public environment, the connection between the prints and their published avatars had been lost and the business aspects of the Black Star agency had been obscured. How did Black Star participate in the market for photographs? What part of its business represented sales of news photographs to magazines as compared to illustrations for textbooks and company annual reports? Was there a difference in price between photographs taken by a well-known photographer such as Robert Capa and those by Werner Wolff? What subjects sold the most? What were the fortunes of iconic photographs such as those of the civil rights movement taken by Charles Moore? In the absence of ledgers, contracts between the agency and the photographers or the agency and its clients, invoices, and correspondence, these questions remain difficult to answer despite the accessibility of the photo collection.

Another challenge encountered by researchers is the number of photographs and their organization within the Black Star Collection. To facilitate presentation of the collection, a selection of iconic photographs and images by well-known photographers was gathered in two boxes, but the entire collection

14 Jennifer Allen, "Crate 17," in *Archival Dialogues: Reading the Black Star Collection*, ed. Doina Popescu and Peggy Gale (Toronto: Ryerson Image Centre, 2012), 109–16.
15 Lauren Potter, "A Journey in Collections Management: The Creation of a Finding Aid for the Black Star Ephemera Collection at the Ryerson Image Centre" (master's thesis, Ryerson University, 2013), 25.

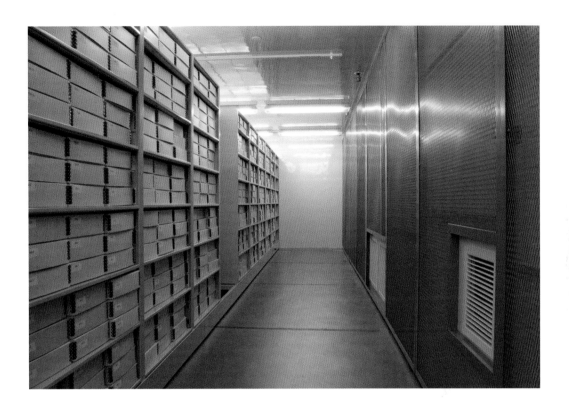

Figure 0.5
Kate Tarini, *The Black Star
Collection Housed in Boxes in
the Image Centre's Vault,* 2012.
© Kate Tarini.

is housed in more than 2,600 boxes, each of them holding approximately 100 to 130 prints (fig. 0.5). First, to view all those prints, a researcher capable of looking at 2,000 images a day would need 146 days—approximately eight months full-time—and that can happen only if The Image Centre has the human resources to accommodate such an endeavour. Second, according to the logic of *respect des fonds*, the organization of the collection as it was when used by Black Star was maintained. This organization was empirical and responded to the business needs of non-archivist staff called photo researchers.[16]

At the agency, the photographs were organized in drawers under five main types of headings: Subjects, World War II, Personalities, Presidents, and Locations. But some photographers had their own drawers, for copyright or usage reasons. The agency also decided to run a parallel classification called Prostock to gather the prints they started to digitize at the end of the 1990s and to which they added a barcode. As appraiser Penelope Dixon notes, these classifications were porous; "some photographs with barcode labels were found within the non-Prostock file drawers."[17] After deciphering these convoluted and intertwined classifications, researchers have to face the subheading architecture built up over time by the photo researchers in order to navigate the collection. In this practical approach to the collection, one finds expected subheadings such as AVIATION/SAFETY and GREECE/INDUSTRY, but also some odd associations (ACCIDENTS and ANIMALS/BEAVERS), obscure choices (MISCELLANEOUS/SILK), and outdated and/or offensive vocabulary (MENTAL RETARDATION/WOMEN WITH DOLL; MILITARY/U.S. NEGROES). Depending on their training, professional experience, and identity, many researchers may not be prepared to address the way the collection is indexed. Without the expertise of the people who created the classifications, it is difficult to browse the approximately 23,000 Black Star subject headings that are preserved in The Image Centre's database.

A final challenge for researchers accessing the Black Star Collection is the materiality of the photographs. To facilitate circulation of the images, the agency often produced multiple prints. These prints might be grouped

16 Penelope Dixon & Associates, "Description of Archive," in "An Appraisal of the Black Star Archive," August 26, 2003, 20–28. Acquisition files, The Image Centre, Toronto Metropolitan University, Toronto.

17 Dixon, "Description of Archive," 22.

under the same subject heading or dispersed under different ones to increase their chances of dissemination. The prints were produced at different times throughout the decades, and each one is a unique object. To take a well-known example, there are in the Black Star Collection five 8 x 10 prints of W. Eugene Smith's photograph of an American soldier drinking from his canteen. Three of them are very similar (figs. 0.6–8) as objects: their framing reveals that they are copy prints (we can read "W. Eugene Smith – Life" at the bottom right of the original print), their density varies only slightly, and they are printed on resin-coated (RC) paper. The fourth one (figs. 0.9 and 0.10) is printed on fibre-based paper, its framing suggests that it comes from another negative, and the image has much more contrast. The fifth print (fig. 0.11) is high-contrast and printed full bleed on RC paper, and (very interestingly) the image is laterally reversed. In this last print the soldier does not look left but towards the right, which reveals some liberty being taken by the agency with the original shot. Smith took the photograph in 1944, but the RC paper, which was widely used in the 1970s, indicates that they are later prints. The fibre-based print could have been vintage, but its verso (fig. 0.10) has a Black Star stamp and several inscriptions, including "Print by: Peter Collins 1981 / (Aperture)."

The versos of the Black Star prints bear witness to different points in their histories: stamps of different types (agency, photographer, copyright, use indications) that are sometimes superimposed; handwritten inscriptions in different languages, many of which have been crossed out, rendering them barely readable; obscure codes composed of letters and numbers. Some versos have editorial marks indicating how they should appear in an unspecified publication, others show traces of glue and Scotch tape, and some even show coffee stains, such as the one on the back of the fibre-based Smith print (fig. 0.10). The versos are undeniably tremendous sources of information, but they require background knowledge and tenacity to decipher and interpret them; then it becomes possible for researchers to determine at least part of the biography of each object. But many of the print versos in the Black Star Collection are completely blank, leaving researchers without a clue about their role and their use by the agency.

Over the past two decades, other Canadian institutions have acquired similar collections of press photographs and faced similar challenges. In Canada in 2001, the MacLaren Art Centre (Barrie, Ontario) acquired

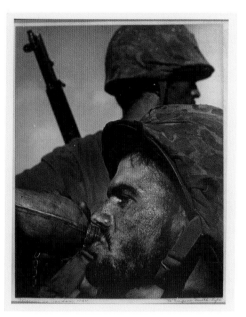

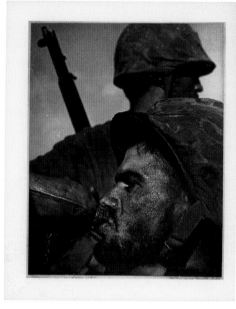

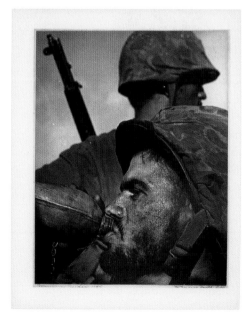

Figures 0.6 and 0.7 (above)
W. Eugene Smith, *American Soldier Drinking from His Canteen During a Battle at Saipan, Marshall Islands*, 1944. Gelatin silver prints on resin-coated paper, 25.3 x 20.4 cm. BS.2005.283282.
25.4 x 20.1 cm. BS.2005.283283.

Figure 0.8 (left)
W. Eugene Smith, *American Soldier Drinking from His Canteen During a Battle at Saipan, Marshall Islands*, 1944. Gelatin silver print on resin-coated paper, 25.4 x 20.1 cm. BS.2005.283287.

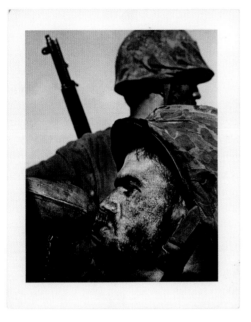

Figures 0.9 and 0.10 (above)
W. Eugene Smith, *American Soldier Drinking from His Canteen During a Battle at Saipan, Marshall Islands*, 1944 (recto and verso). Gelatin silver print on fibre-based paper, 25.2 x 20.1 cm. BS.2005.283295.

Figure 0.11 (right)
W. Eugene Smith, *World War II, 1943* [sic], 1944. Gelatin silver print resin-coated paper, 25.3 x 20.1 cm. BS.2005.283268.

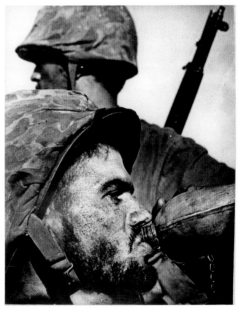

23,116 prints from the 1930s to '50s collected by the Sovfoto agency, which was the main distributor of Soviet images in North America.[18] In 2002 the Art Gallery of Ontario (Toronto) received 19,040 prints from the Klinsky Press Agency, gathered by Emil S. Klinsky, who operated the agency Recla in Amsterdam in the 1930s and '40s.[19] And in 2016 the National Gallery of Canada (Ottawa) was given a selection of 24,566 prints from the national newspaper the *Globe and Mail*.[20] These types of donations, usually made for economic reasons, have also been observed in the United States and Europe.[21] In 2003 the Archives départementales de la Seine-Saint-Denis in France started to receive the archives of the Communist newspaper *L'humanité*, encompassing more than two million images;[22] in 2013 the Harry Ransom Center in Austin, Texas, received approximately 200,000 prints from the Magnum Photos agency;[23] and in 2015 the North Holland Archives in Haarlem, Netherlands, acquired an estimated two million 35 mm photographic negatives from the De Boer Press Photo Agency.[24]

This circulation of photographic corpuses from private to public environments has raised archival questions and engaged scholarly discussions. In terms of dealing with the two million photographic objects in *L'humanité*'s fonds, archivists Joël Clesse and Maxime Courban have explained the complexity of adjusting their working methods, defining priorities in a long timeline, developing new workflows, and maintaining access to the

18 Bria Dietrich, Helen Olcott, Susan Mundy, Angela Pierre Segovia, and Cassie Spires, *Red All Over: World War II Press Photographs from the Sovfoto Archive* (Toronto: Ryerson Image Centre, 2021).

19 Lisa Yarnell, "The Klinsky Press Agency Finding Aid at the Art Gallery of Ontario" (master's thesis, Ryerson University, 2015).

20 Roger Hargreaves, Stefanie Petrilli, and Jill Offenbeck, eds., *The Canadians: Photographs from* The Globe and Mail *Archives* (Toronto: Bone Idle, 2016).

21 Mary Panzer, "The Meaning of the Twentieth-Century Press Archive," *Aperture* 202 (Spring 2011): 46–51.

22 Joël Clesse and Maxime Courban, "Organiser les masses: Le traitement des archives photographiques du journal *L'humanité*," *In Situ* 36 (2018), https://doi.org/10.4000/insitu.17878.

23 Steven Hoelscher, ed., *Reading Magnum: A Visual Archive of the Modern World* (Austin: Harry Ransom Center/University of Texas Press, 2013).

24 Melvin Wevers, Nico Vriend, and Alexander de Bruin, "What to Do with 2.000.000 Historical Press Photos? The Challenges and Opportunities of Applying a Scene Detection Algorithm to a Digitised Press Photo Collection," *TMG Journal for Media History* 25, no. 1 (2022): 1–24, http://doi.org/10.18146/tmg.815.

photographs.[25] Although the National Gallery of Canada received 24,566 prints from the *Globe and Mail*, those represent only the tip of the iceberg, a selection made by the donor.[26] Meanwhile, the City of Toronto Archives, Library and Archives Canada, and the Archives of Ontario own (respectively) 140,000, 1.7 million, and approximately 2 million photographs from the same newspaper, and they too are facing the challenges inherent in the preservation of colossal collections.[27]

When accessing these fonds and collections, researchers must face their sheer scale and the need to reconnect them, to understand and analyze the "collective oeuvres"[28] that are press picture libraries. Estelle Blaschke's work on the Bettmann Archive and Audrey Leblanc and Sébastien Dupuy's research on the French photo agency Sygma partially reveal how these organizations function and the business of news photographs.[29] Nadya Bair and Clara Bouveresse have unfolded the role of the Magnum agency in the construction and commerce of visual news,[30] and Dolores Flamiano has studied the role of women in the management of *Life* magazine's picture library.[31] This volume aims to add to these avenues of research by fruitfully highlighting the challenges experienced by researchers when facing the Black Star Collection.

25 Clesse and Courban, "Organiser les masses."

26 Anitta Martignago, "Athletes, Print Media, and Editorial Processes: Investigating Gendered Representations of Sport from the *Globe and Mail*'s Photography Collection" (master's thesis, Ryerson University, 2021), 24–25; Tanya Lynn Marshall, "The Picture Press in Archives: Facing the Institutional Challenges of Newspaper Photo Collections" (master's thesis, Ryerson University, 2021), 57–58.

27 On the archival and research challenges of colossal collections, see the very interesting book edited by Costanza Caraffa, *On Alinari: Archive in Transition* (Milan: a+mbookstore, 2021).

28 Clesse and Courban, "Organiser les masses," para. 53.

29 Estelle Blaschke, *Banking on Images: The Bettmann Archive and Corbis* (Leipzig: Spector Books, 2016); Audrey Leblanc and Sébastien Dupuy, "Le fonds Sygma exploité par Corbis: Une autre histoire du photojournalisme," *Études photographiques* 35 (Spring 2017), http://journals.openedition.org/etudesphotographiques/3698.

30 Nadya Bair, *The Decisive Network: Magnum Photos and the Postwar Image Market* (Oakland: University of California Press, 2020); Clara Bouveresse, "Le Ransom Center écrit une nouvelle page de l'histoire des archives photographiques," *Transatlantica* 1 (2013), https://doi.org/10.4000/transatlantica.6434; Clara Bouveresse, *Histoire de l'agence Magnum: L'art d'être photographes* (Paris: Flammarion, 2016).

31 Dolores Flamiano, "*Life*'s Indispensable Women," in *Life Magazine and the Power of Photography*, ed. Katherine A. Bussard and Kristen Gresh (Princeton, NJ/New Haven, CT: Princeton University Art Museum/Yale University Press, 2020), 170–79.

When soliciting authors, we asked them to highlight both their object of study and their methodology, and to address them within the context of the collection. Our personal research projects can shed light on this editorial goal and give a sense of the range of investigations we gathered.

Mapping the Black Star Images

I, Thierry, had previously worked with the collections of photojournalists such as Léon Gimpel and Jimmy Hare and had been granted access to the private archives of the French illustrated weekly *L'illustration*. In 2008 the Black Star Collection now hosted by the university represented for me an opportunity to decipher the functioning of a third part of the construction of visual news: the photo agency.[32] And which photo agency? One run by Jewish émigrés who had been key figures in the 1920s and '30s German illustrated press and were instrumental in the development of the American magazine *Life*. But I experienced all of the challenges described above and I had (and still have) difficulties navigating the collection. I knew some of the photographers, of course—those mentioned repeatedly by journalists who covered the acquisition of the collection—but their contribution appeared to be minimal compared to those of Dennis Brack and Werner Wolff, whom I did not yet know. The duplicates were confusing and their versos not always helpful.

Most disappointing was the absence of ephemera, which jeopardized my project of unpacking the role of Black Star as an intermediary between photographers and magazines. Upstream, I could not find contracts with the photographers, and downstream, there were no traces of transactions with the magazines. That information had to be found elsewhere, notably the Center for Creative Photography (CCP) in Tucson, Arizona, which preserves the W. Eugene Smith Archive, including his Black Star statements, and the Time, Inc. Archives at the New York Historical Society, which holds the business

32 Dominique de Font-Réaulx and Thierry Gervais, eds., *Léon Gimpel (1873–1948): Les audaces d'un photographe* (Paris: Musée d'Orsay/Cinq continents, 2008); Thierry Gervais, "'The Greatest of War Photographers': Jimmy Hare, A Photoreporter at the Turn of the Twentieth Century," *Études photographiques* 26 (November 2010): 35–49; Thierry Gervais, "Photographies de presse? Le journal *L'illustration* à l'ère de la similigravure," *Études photographiques* 16 (May 2005): 166–81.

records of the company and its photography suppliers. Gathering sources from different places is common research practice, and easy to accomplish when dealing with a renowned photographer such as Smith or with a corporation such as Time, Inc., that donated its archives to a public institution. But what about the rest of the more than six thousand photographers? What about the business agreements between Black Star and customers that we have not yet heard of and might not even think about? To analyze Black Star's role in the dissemination of visual news, one would have to work backwards—from the published images to the prints in the collection—and inevitably face a problem of scale that would be too difficult to address alone. The ambition of better understanding the Black Star agency required collecting data, creating new tools, and envisioning research at the institutional level.

The parallel between the launch of the Black Star agency and that of *Life* is commonplace in the literature dedicated to photojournalism, but how many Black Star photographs were actually published in *Life*? "About a third of *Life* magazine's images" were provided by Black Star, according to journalist Vanessa Farquharson.[33] From 2010 to 2013, encouraged by Doina Popescu, newly hired as the founding director of the Image Centre, and with the support of the institution, I organized summer research workshops in which students verified and learned about the extent of this collaboration. Fourteen terrific students were hired full-time for six weeks to look for Black Star credits in the magazines *Life*, *Look*, and *Time* and to transcribe the information into FileMaker databases.[34] Starting with the masthead of each issue, they identified Black Star credits, located the related images, and reported on their use on the page. The process was simple but required rigour and time—almost two years, full-time, for a single person.[35] From there we could query the databases, visualize the basic data in lists and tables, and compare the results (fig. 0.12).

The data collected confirmed that the agency had a privileged relationship with *Life*, which published six times more Black Star photographs than its main competitor, *Look*. From 1937 to 1971, *Look* published 1,361 photo-

33 Farquharson, "291,049 Photos."

34 I want to thank all the students who participated in the workshops: Mary Anderson, Ryan Buckley, Lindsay Bolanos, Hilla Cooper, Callan Field, Ross Knapper, sol Legault, Rachel Lobo, Cassie Lomore (2011 and 2012), Emily McKibbon, Jordan McInnis, Brian Piitz, Rachel Verbin, and Chantal Wilson (2010 and 2012).

35 The three databases are available at The Image Centre.

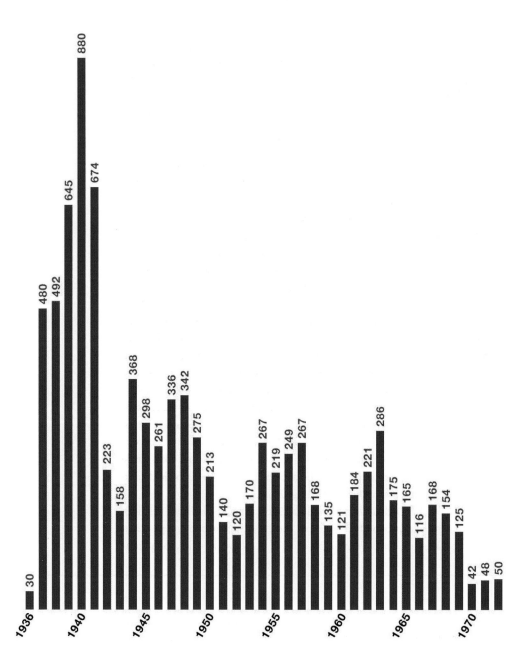

graphs credited to Black Star, while *Life* published 9,185 ones during the same period. If you add those published in 1936 and 1972, *Life* published a total of 9,265 photographs from the agency. But what does that number represent? Considering an average of 200 photographs per issue, *Life* published around 10,400 images per year, for a total of 364,000 images during its time as a weekly magazine. On that basis, 9,265 represents approximately 2.5 percent of the images published in *Life* rather than a third, as reported by Farquharson. The collaboration was strongest in the first five years (3,201 credits), with a peak of 880 photographs sold in 1940. In 1942 the number dropped to 223 and then fluctuated between 120 (1952) and 368 (1944) until 1970, when it went down to less than 50. The maximum number of Black Star photographs published in a single issue occurred in 1938, when 50 appeared in the November 14 magazine, representing 25 percent of the total number of photographs in this issue. These numbers give us a more precise indication of how *Life* relied on Black Star to construct an issue.

Cross-checking these numbers with W. Eugene Smith's Black Star statements from the CCP allowed me to change my point of view and envision what its business with *Life* represented for Black Star. For Smith, 1940 was his second-best year working for the agency, with 112 photographs sold to *Life*. Some statements for that year are missing from his archive, but the one for January offers a sense of proportion. Black Star had issued thirty-two invoices, ranging from $2 to $130, to eighteen different clients, for a total of $1,141.77.[36] Nine invoices were directed to Time, Inc., most likely for reproduction of Smith's photographs in *Life*, for a total of $490—43 percent of his Black Star income for the month. The remaining 57 percent resulted from sales to magazines such as *Collier's* and *Time* and to clients that included *Auto Digest* and Schneider Denmark. Based on these numbers, I could draw the following conclusion: at its very height, in 1940, Black Star's business from *Life* could have represented 43 percent of its income. But, as mentioned earlier, the honeymoon lasted only until 1941; from 1944 to 1969, Black Star sold *Life* an average of 213

Figure 0.12
Black Star photographs published in *Life* (1936–72). From "Total Black Star Photographs by Year," in Cassie Lomore, "The Publication of Credited Black Star Photographs in *Life*, 1936–1972" (2012), report based on research conducted by Lindsay Bolanos, Jordan McInnis, Emily McKibbon, Chantal Wilson, and Rachel Verbin in 2010.

36 "Eugene Smith — Statement of Collections Jan. 29, 1940," AG33:15/1: Black Star Publishing Co., 1938–42, Photographic Essay Project Files, ca. 1938–ca. 1976, W. Eugene Smith Archive, Center for Creative Photography, Tucson, Arizona.

images per year—a quarter of the sales from 1940. Using this logic and the numbers available, the business from *Life* would have represented about a quarter of 43 percent, or approximately 10 percent.

That leaves us with the following question: how was the remaining 90 percent of Black Star's income generated? Beyond the "famous" magazines, who were its clients? Of course, this analysis relies on a very limited sample. More of Smith's Black Star statements need to be taken into consideration, as well as other photographers' statements. Indeed, how much business for photographers was represented by the thousands of images in the Black Star Collection? To answer this question, photographers such as Dennis Brack (14,445 prints), Robert Cohen (whom Vincent discusses below, 12,895 prints), and Werner Wolff (2,309 prints) require more attention.

Henri Cartier-Bresson, Robert Capa, and W. Eugene Smith have been the focus of attention from numerous academics, curators, and journalists who have described and, in some respects, made them the pillars of twentieth-century photojournalism. These names were understandably highlighted when the collection was acquired, even though they represent small numbers of prints in the collection (10 prints by Capa and 11 by Cartier-Bresson) or did not collaborate for long with the agency like Smith, who worked for five years with Black Star (1938–43) and was recruited by *Life* in 1945. Considering the numbers cited above, it made financial sense for Smith and *Life* to cut out the agency as a middleman.

The numbers of prints by various photographers in the collection and the numbers in the FileMaker databases indicate who were the real pillars of Black Star. With almost fifteen thousand photographs, Dennis Brack is the most represented photographer in the Black Star Collection. Working in Washington and with access to the White House, Brack is known for his photographs of (and his book about photographing) American presidents.[37] But those fifteen thousand prints could not be only of American presidents (fig. 0.13). Brack was a hard worker who photographed daily ("there's always something happening every day"[38]) and who understood "the peripheral

37 Dennis Brack, *Presidential Picture Stories: Behind the Cameras at the White House* (Washington, DC: Dennis Brack, 2013).
38 Dennis Brack, interview by Valérie Matteau, May 8, 2010, Ryerson Image Centre, Toronto.

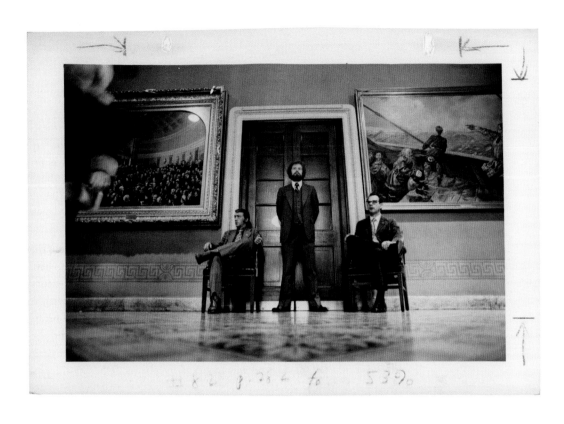

Figure 0.13
Dennis Brack, *Senator Guards Guard Door to the Senate Chambers During the Special Closed Session*, 1976. Gelatin silver print, 17.7 x 25.4 cm. BS.2005.052054.

KATNIP TREE with spring and ball attached entertains three Siamese cats. The Siamese, contrary to popular belief, were not developed for the King of Siam.

CATS CONTINUED

such as the Kennel Club for dogs and the Jockey Club for horses. Amateur cat enthusiasts are even harder to organize than the professionals. England has the Cats' Protection League, which was active in behalf of cats throughout the war and once rebuked Winston Churchill for fondling a cat during his Atlantic Charter meeting with President Roosevelt. The League took the stand that Churchill had failed to conform to cat etiquette by picking up the cat before it showed any interest in him. The U. S. has two national societies, neither of them very large or influential. The Allied Cat Lovers International Inc. is headed by Truman Pierson, a Minneapolis postal employe. This group has the support of Dr. Ida Mellen, who is probably the leading writer and scientific student of cats in this country. A much more sensational outfit is the American Feline Society, which is headed by a New York advertising man named Robert Kendell. In 1944 Kendell managed to involve the White House, U. S. State Department and British Foreign Office in an unseemly tangle over cats. It seems that two kittens had been born in the silver room of Buckingham Palace and were looking for a new home. Kendell, under the prodding of the London *Daily Mirror* and its beauteous New York corre-

CONTINUED ON PAGE 105

MOUSIE HOUSE, a patented toy, contains a mouse which runs back into the house when cat releases string. Only relatively well-to-do cats have these.

value of every picture" and its "sizable financial return."[39] Connecting his prints in the Black Star Collection with the photographer's own archives, which are preserved at the Briscoe Center for American History in Austin, Texas, is the next step in unfolding this everyday practice of photojournalism that fuelled the agency's business for years.

With 2,309 prints in the Black Star Collection, Werner Wolff is the eighth-most represented photographer. With his 361 credits in *Life*, he is also the fifth-most published in the magazine. The donation of his archive to The Image Centre inspired several students from the PPCM program to write theses about him. In her finding aid, for example, Sara Manco highlights Wolff's versatility and availability to work on many different types of assignments.[40] Reconnecting the images published in *Life* with their origin prints in the Black Star Collection and the contact sheets in the Werner Wolff Archive, Tim Ream went further, analyzing how the photographer collaborated with the magazine.[41] One of his conclusions notes the technical dexterity of the photographer, who was always capable of providing a properly lit image whether using a small or a large-format camera. Another reason for Wolff's success was his sense of composition, which he used to valorize his subjects—but always with nuance, without imposing an identifiable style that would have asserted some kind of authorship. As a result, Wolff was the perfect photographer to supply extra images for a series or to cover the ordinary (if not trivial) topics that *Life* covered each week (fig. 0.14). Technically skilled, visually proficient, versatile, humble, hard-working, and available were the qualities of the photographers who were the pillars of the Black Star agency.

For me, looking at Black Star as an entity and as part of the business of news photographs meant working at another scale in terms of content, approach, and time. The research workshops generated tools with which to measure the agency's contribution to the dissemination of visual news. When I questioned them, they highlighted photographers without ego and topics without gravitas, a counterbalance to the history of photojournalism made up

Figure 0.14
Roger Butterfield, "Cats," *Life*, April 22, 1946, 102. With two photographs by Werner Wolff from Black Star. The *Life* Magazine Collection, Gift of Peter Elendt, 2011, The Image Centre, Toronto.

39 H. Chapnick, *Truth Needs No Ally*, 149.

40 Sara Manco, "Finding Wolff: Intellectually Arranging the Werner Wolff Fonds at the Ryerson Image Centre" (master's thesis, Ryerson University, 2012).

41 Tim Ream, "The *Life* of Werner Wolff: An Analysis of Werner Wolff's Contribution to *Life* Magazine" (master's thesis, Ryerson University, 2014).

of heroes and wars. The workshop databases, which are available to the public at The Image Centre, by request, can be queried from many perspectives. The Image Centre's research fellowship program, launched in 2015, added another institutional means by which to pursue these research avenues and to further diversify approaches to the Black Star Collection.

An Ordinary Photographer under Investigation

In 2016 I, Vincent, had an opportunity to dig into the Black Star Collection for the first time. I was working on issues related to the legal uses of the photographic image and the testimonial status of press pictures.[42] I undertook my investigations in the Black Star Collection in the hope of unearthing images conducive to the analysis of interactions among the legal, photographic, and media fields. My first move was to search the database using my usual keywords: "forensics," "testimony," "veracity," "probative value," "investigation." The results were very disappointing. I decided then to abandon my usual terminology for a more general one that referred to identifiable realities. Going against my methodological tenets, I had to (at least temporarily) reduce the image to its subject matter. I had to think about words that would have been used originally to describe, classify, and, above all, market the photographs.

First lesson in humility: the subject section/subject folder terms used in the picture library were not intended for photographic historians, but rather for publishers and picture editors who wanted to please a large public. Which term in the database would be most likely to link my research interests with the commercial goals of the illustrated press industry? *Trial* was the word. It appears repeatedly in the Black Star subject headings, which are searchable in the database. I finally had some hope; I could already see a rich crop of photographs pouring into my previously empty folder. Moreover, *trial* was often linked to the names of personalities—O. J. Simpson and Adolf Eichmann,

42 See Vincent Lavoie, ed., *La preuve par l'image: Anthologie* (Montréal: Presses de l'Université du Québec, 2017); Vincent Lavoie, *L'affaire Capa: Le procès d'une icône* (Paris: Textuel, 2017); and Vincent Lavoie, "Displaying Forensic Pictures in Court: Photography as Visual Argument," in *The "Public" Life of Photographs*, ed. Thierry Gervais (Cambridge, MA/Toronto: MIT Press/Ryerson Image Centre, 2017): 74–95.

for example—who had generated an important flow of images. I was approaching my playground! If at first the list of subject headings in the database seemed odd to me, it now seemed to be filled with terms that referred to exceptional events and situations, suspenseful and emotional stories.

It was then that I came across the names Robert Cohen and Marie Besnard. The former was a photographer and the founder of the Agence d'illustration pour la presse (AGIP) in 1935, the same year that the Black Star agency was created. This historical correspondence is quite significant in terms of the rise of photographic agencies in the mid-1930s. Before creating AGIP, Cohen worked for the French agency Rol, where he distinguished himself with a report on the assassination of King Alexander I of Yugoslavia on October 9, 1934, in Marseille. Four days later, the publication in *L'illustration* of his photograph showing the sovereign lying in agony on the seat of his car established his reputation.

Although Cohen never specialized in crime photography, several French criminal cases in the 1950s and '60s gave him an opportunity to demonstrate his talent for observing human emotions, as during the trial of Marie Besnard, nicknamed "the poisoner of Loudun."[43] The case took place in a deep and suspicious postwar France. On July 21, 1949, Marie Besnard was charged with the murder of her second husband, who had died two years earlier, and of having poisoned twelve other people between 1929 and 1949. By order of the court, the investigators exhumed their bodies and the autopsies revealed high concentrations of arsenic in the remains. Money and love were the alleged main motives for the murders, and Besnard was facing the death penalty. France was fascinated by this case, which shone the spotlight on an apparently austere, discreet woman who was also potentially a serial murderer. Robert Cohen immediately understood the commercial opportunity offered by this extraordinary story.

Marie Besnard underwent three trials, the first in Poitiers in February 1952 and later trials in Bordeaux in 1954 and 1961. The "good lady of Loudun" became the focus of the illustrated press of the time. In the Black Star Collection there are more than sixty-one photographs by Cohen documenting the first

43 In addition to the Besnard case, Cohen covered the Lacaze Guillaume case (1959), which involved a wealthy heiress suspected of fraudulent art trading and child trafficking, as well as the case of the kidnapping of Eric Peugeot (1960), grandson of the auto industry magnate, who was returned to his family for ransom. Images of those trials are also in the Black Star Collection.

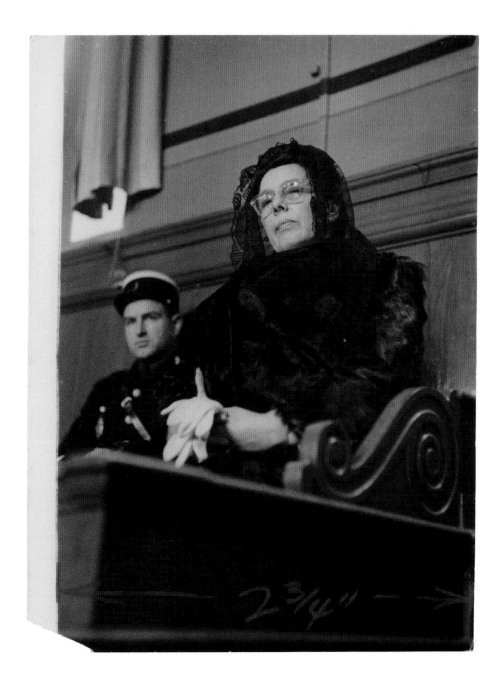

trial. To arrive at that count, a few precautions had to be taken. The first was not to rely on the captions on the versos of the prints, as they may contain date and location errors. To distinguish between the images from the 1952 trial and those taken in 1954 at Bordeaux, it was important to pay particular attention to the clothing and accessories of the accused. If she is wearing a fur coat, the image is from 1952—the hearings were held in February. In March 1954 in Bordeaux, the clothing is lighter and Besnard's glasses are different. These very prosaic details make it possible to reconstitute the sequence of trials and to rectify erroneous information attached to the prints.

The 1952 Poitiers trial is the one for which the Black Star Collection has the largest number of images. Cohen shows the judicial system in its expanded form: the actors—the accused (fig. 0.15), the police, the lawyers, the prosecutors, the witnesses, the press, the audience; the gestures—the raised hand of the oath, the pointed index finger of designation, the witnesses standing at attention; the acts of language—pleadings, reading of texts, arguments (fig. 0.16); and the facial expressions—severity, bravado, exasperation, dejection, tears. Cohen's images are representative of what Antoine Garapon calls the "judicial ritual," all the symbols, conventions, and practices governing the institution of justice.[44] If the photographs taken by Cohen respond to the press's need to provide images to a readership fond of criminal cases, if they are rooted in specific judicial news or even instruct on the functioning of the postwar French justice system, they relay a symbolism of the body (posture, attitude, gesture) that has not changed much since antiquity. Indeed, people have stood up to plead since biblical times.[45] Cohen has abundantly photographed—from low angles, as if to accentuate their verticality—the members of the "standing magistracy," namely the prosecution and the defence (figs. 0.16 and 0.17). Prosecutors and lawyers are shown in the exercise of their function, standing up in accordance with tradition. Ancient attitudes and body language survive in Cohen's images. Although their primary function was to respond to contingent editorial needs, including that of providing "portraits" of the main protagonists in the trial, Cohen's photographs take up a historical iconography. It is the researcher's task to bring to light these various temporalities of the image and to situate this type of trial photography in a long history of judicial rhetoric.

Figure 0.15
Robert Cohen, *Marie Besnard on Trial, Poitiers,* February 1952. Gelatin silver print, 24.2 x 18.3 cm. BS.2005.132309.

44 See Antoine Garapon, *Bien juger: Essai sur le rituel judiciaire* (Paris: Odile Jacob, 2001).
45 Garapon, *Bien juger,* 116.

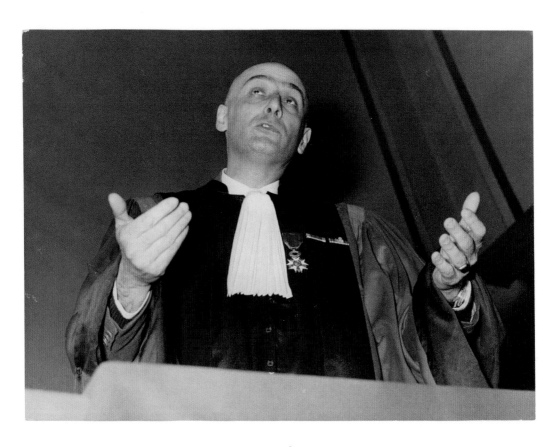

Figures 0.16 and 0.17
Robert Cohen, *The Trial of Marie Besnard at the Poitiers Assizes: General Counsel Girault, Poitiers*, February 21, 1952. Gelatin silver print, 18 x 24.3 cm. BS.2005.132307.

Robert Cohen, *The Bailiff Jamet with the Exhibits, Poitiers*, February 1952. Gelatin silver print, 24.1.x 18.3 cm. BS.2005.132281.

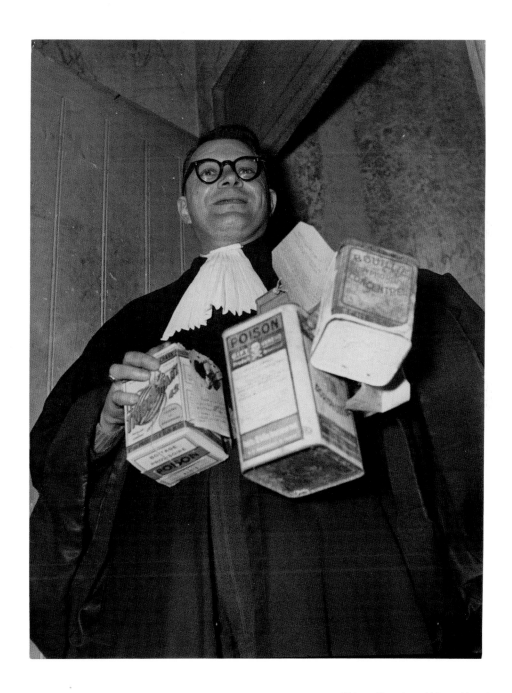

Cohen's coverage of the 1954 and 1961 trials, both held in Bordeaux, is much more modest (respectively 10 and 11 photographs compared to 55 for the trial in Poitiers in 1952), though equally revealing of the methodological challenges facing the researcher. After a first dismissal, Marie Besnard underwent a new trial in 1954 following toxicological analyses of the exhumed bodies. This time Cohen focused on the presumed poisoner, and more particularly on her facial expressions (fig. 0.18). The photographs no longer show the judicial apparatus itself but instead invite the viewer to scrutinize the physiognomy and expressions of the accused. The photograph then becomes an inquisitor, subjecting Besnard to a thorough visual interrogation. As the captions of the images indicate, Marie Besnard's expressions are the subject of a series of photographs that show her alternately pensive, distressed, and even rebellious. Taken with a flash, these close-up shots offer unprecedented access to the reactions (whether feigned or sincere) of the "good lady of Loudun" and invite the spectators to play referee. Those spectators were the readers of magazines such as *Paris Match*, *Qui?*, *Détective*, and *Point de vue: Images du monde*, who, like the jurors, were called upon to question the guilt of this woman. "Before the Bordeaux Jury, the Enigma of a Face: Marie Besnard" was the headline chosen by *Paris Match* for a report on the beginning of her second trial.[46]

The Marie Besnard case is a good example of relocation of the judicial scene to the illustrated press. For it was also in the sensational magazines that the fate of the woman was played out, at least on a reputational level. The media coverage of the "Besnard Affair" has given unprecedented visibility to this village woman, who until then had no history. Stalked by photographers like a paparazzi star, Besnard will have focused the attention of an important part of the photojournalistic field. The era was, moreover, marked by the rise of paparazzi and the celebrity press. Marie Besnard would have focused the attention of an important segment of the photojournalistic field; Cohen was not the only photographer who covered her trials. As he himself shows in one of his photographs from the 1954 trial, in which several of his colleagues are seen taking pictures of the accused (fig. 0.19), Cohen was only one agent of an industry focused on the case.

46 "Devant les jurés de Bordeaux, l'énigme d'un visage: Marie Besnard," *Paris Match* 260 (March 20–27, 1954): 27. Besnard's trial was extensively covered by French magazines such as *Paris Match*, but none of the images by Cohen in the Black Star Collection seems to have been reproduced in that magazine.

Figure 0.18
Robert Cohen, *Marie Besnard During Her First Hearing, Bordeaux*, March 14, 1954. Gelatin silver print, 18.3 x 13.2 cm. BS.2005.132257.

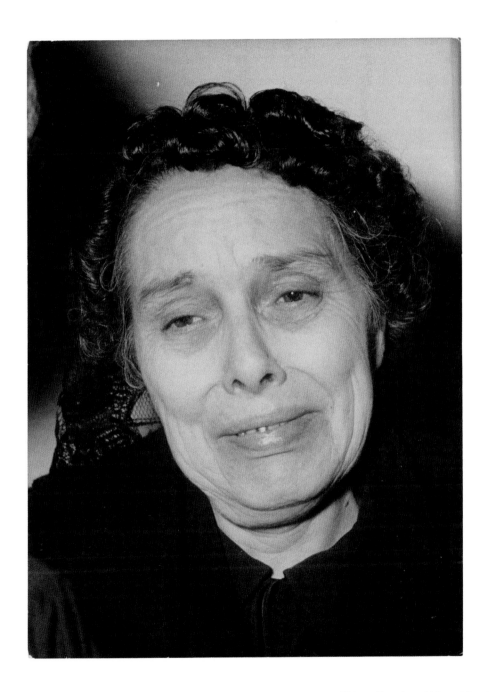

As successful as they are on an aesthetic and formal level, Cohen's images are not the result of an artistic approach but, more prosaically, that of a professional activity for profit. The fact that images by this French photographer can be found in the Black Star Collection attests to a media economy based on the multiplication of marketing platforms for press photographs. The versos of the images, where typewritten captions in French are sometimes accompanied by handwritten notes in English, attest to this transatlantic shift. Very early in his career Cohen wanted to internationalize his business operations, both by setting up a network of correspondents in various countries and by distributing his images abroad to renowned agencies such as Black Star. To reflect this ambition, the very name of his agency—Agence d'illustration pour la presse (Agency for Press Illustration)—was changed after World War II to Agence internationale pour la presse (International Press Agency).[47]

In 1961 Marie Besnard underwent a third trial, also in Bordeaux, at the end of which she was finally acquitted of the charges against her. As for the two previous trials, Robert Cohen was in the front row. However, the images he made are of a completely different nature. They highlight neither the judicial system, as in 1952, nor the expressions of the accused, as in 1954, but rather a smiling Marie Besnard leaving her home to go shopping or signing her memoirs in a Paris bookstore in May 1962 (fig. 0.20). Cohen shows nothing of the final trial, concentrating his attention on the scenes following the acquittal of the accused poisoner. What is the reason for this change of perspective? Was it simply a stylistic variation? Was it expressing a new documentary intention, now oriented towards the everyday life of this freed person? Was it because of aesthetic coquetry, concerns about inventing or renewing his figurative protocols, that Cohen took these pictures outside the courtroom?

Trying to explain his new treatment of the subject in terms of the photographer's intentions would be a methodical error. Cohen proceeded that way because he was forced to. Since December 6, 1954, a few months after the end of Marie Besnard's second trial, a French law (no. 54-1218) had forbidden visual or sound recording of public hearings. There are no photographs of the 1961 trial in the Black Star Collection, or in any other collection for that matter. Cohen

47 This is what Françoise Denoyelle suggests in an essay for the catalogue of the exhibition *La photographie humaniste, 1945-1968* (Paris: Bibliothèque nationale de France, 2006).

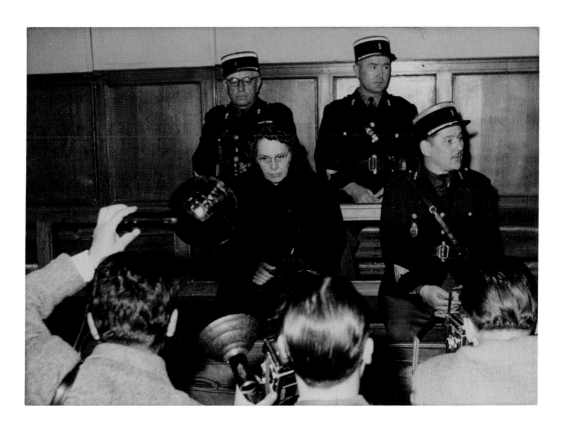

Figure 0.19
Robert Cohen, *Marie Besnard Undergoes an Assault by Photographers at the Beginning of Her Hearing, Bordeaux,* March 16, 1954. Gelatin silver print, 13 x 18.3 cm. BS.2005.132238.

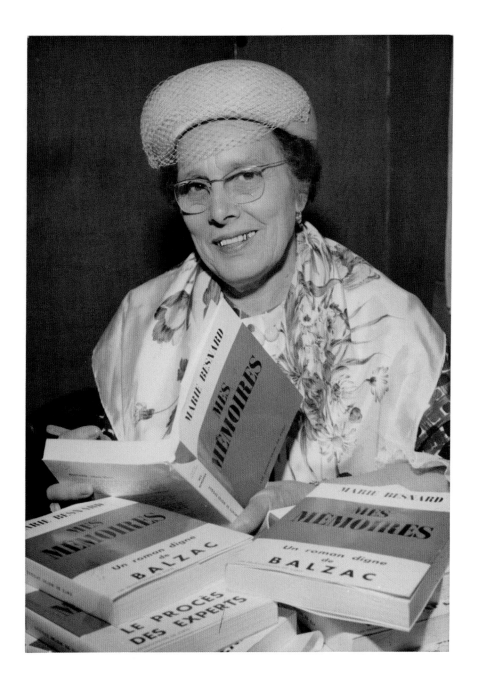

had no choice but to take his photographs on the periphery of the judicial space, namely the streets of Loudun, the vicinity of the courthouse, and a bookstore on Place de Clichy. To understand these images, one must refer to the evolution of French law, not to an aesthetic history of the press image, and even less to a psychology of the author. This was one of the lessons of the research carried out on Cohen's corpus devoted to the famous trials: analyze the images by the law.

There is another methodological lesson to be drawn from this examination of Cohen's trial photographs. It concerns the materiality of the prints preserved in the collection. So far I have commented mainly on the recto, figurative sides of the AGIP founder's images. I would be remiss if I did not say a few words about their versos. Those who have the opportunity to consult the Black Star Collection become excited when the backs of the prints to be investigated are revealed to be covered with writing, stamps, sketches, and other annotations. This diverse information is the basic material for any study that aims to reconstruct the story of the prints' commercial journey. While the information is valuable, however, it is often incomplete or inaccurate. The care with which it was produced and transcribed varies, so it must be analyzed with caution. But beyond the words and graphic elements on the backs of the images, there are material components that are potentially just as significant.

Cohen's prints are very vocal in this regard. For example, the strips of green paper on which the French captions are typed provide clues to the procedures of the people assigned to that task (fig. 0.21). First we observe that the strips are irregularly shaped, betraying sloppy cutting; some of them seem to have been simply torn rather than cut. They have not been glued to the backs of the images with the greatest care, since some extend beyond the margins of the print, at the risk of being damaged over time. Another intriguing detail is the discolouration of the ends of some strips. Obviously this yellowing is a sign of light damage to poor-quality paper, but it does not correspond to aging of the prints; rather, it occurred earlier. How else to explain how the strips, stuck to the backs of prints and thus protected from light, all show the same partial deterioration? It is obvious that already-damaged paper was used to write the captions. This observation joins others that testify to a relative carelessness in the material management of prints at the agency—which is no wonder, as the images were not produced to last; hence the indifference towards the most elementary measures of preservation. One understands, then, that what was at stake was not conservation of the images but their immediate putting into circulation. This urgency is also

Figure 0.20
Robert Cohen, *Marie Besnard Signs a Copy of Her Book*, May 9, 1962. Gelatin silver print, 18.3 x 13.2 cm. BS.2005.132229.

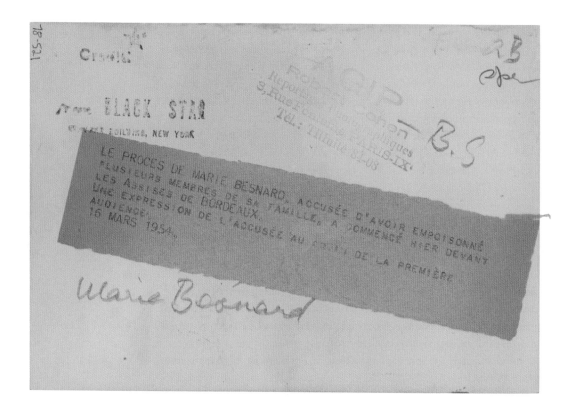

Figure 0.21
Robert Cohen, *Facial Expression
of the Accused During the First
Hearing of Marie Besnard's
Trial in Bordeaux,* March
16, 1954 (verso). Gelatin
silver print, 18.2 x 12.7 cm.
BS.2005.132256.

reflected in the way the strips were attached: with a simple squirt of glue (figs. 0.22 and 0.23). The adhesive has penetrated the greenish fibres of the caption support so that both the strip and the back of the print are marked with a shapeless pattern. This is very useful for matching the right caption to the right image if a strip comes off; the two patterns can be compared as if they were fingerprints.

Cohen's images show witnesses being called to the stand. We, however, have summoned other witnesses—yellowed paper, dried glue—the "silent witnesses" that forensics has the task of making speak.[48] We have, so to speak, followed the lead of the prosecutors and experts in the Besnard Affair, adopting investigative protocols inspired by the very subjects of the images.

Advocating for an Expanded Methodology

The idea of producing a book devoted to the research experiments conducted within the Black Star Collection was born of the following observations: whoever confronts this collection is called upon to revise their methodological preconceptions, to rethink their investigative protocols, to re-evaluate the prism of their reading, and to question the informative content and the political charge of photographic archives. This is a point common to all the contributors to this book. Whether through a visit to The Image Centre's research centre or remote access to its holdings, in the context of a university course or the preparation of an exhibition, all of them experienced some form of resistance offered by the collection. That resistance is partly attributable, as we write above, to the practical difficulty of comprehending such a large mass of visual documents, to the absence of documentary sources that allow the public life of the images to be traced, to the nomenclature

48 The "silent witness" concept refers to documents and photographs whose evidentiary value has not been validated by a human witness. "Some cases go further than advancing foundation elements for a particular category of photographic evidence unsupported by eyewitness verification and expound a general theoretical approach for the admission of all such photographic evidence. These theories sometimes refer to the evidence as a 'silent witness' because it 'speaks for itself' and not for an adopting witness." James McNeal, "Silent Witness Evidence in Relation to the Illustrative Foundation Evidence," *Oklahoma Law Review* 37, no. 2 (Summer 1984): 220–21.

used to index them, and to the structuring of the collection according to subject headings established several decades ago. But, one might rightly argue, isn't this the reality of every photographic collection? Probably, but only in part. Not all collections represent the rise of mass photojournalism in the interwar period, and not all collections have the prestige to justify creating a leading institution for the teaching, research, preservation, and exhibition of photography, as Doina Popescu writes in her foreword.

We asked the contributors to this book to talk about a specific aspect of the collection and their personal research experiences as graduate students, academics, or curators. For some, the experience goes back several years, and we are grateful that they were willing to delve into that specific episode in their research careers. Each contribution to the book highlights neglected aspects of the Black Star prints but also the fundamental role played by the collection in shaping approaches to photographs. In addition to analyzing specific sets of images, each of these contributions highlights methodological, epistemological, and political issues inherent to conducting research in photographic archives.

Three main themes run through the authors' concerns. The first questions the very origins of the Black Star agency or, more precisely, the discourses established by its main figures. Nadya Bair's perspective is historiographical and aims to revisit the myths surrounding the images that the founders of the agency brought with them to the United States while fleeing Nazi Germany. In the same vein, Christian Joschke's study of key figures from the early days of the agency, notably Max Pohly, leads to a rethinking of the authorship of certain photographers who seem inseparable from the golden legend of Black Star. The biographical paradigm is revisited and the images are subjected to the implacable verification of facts. To free oneself from discourses that have been authoritative for decades is here a genuine methodological stance. The very creation of The Image Centre in the wake of the donation of Black Star's print archive marks an important historic milestone, one that also generates celebratory discourses. Emily McKibbon and Zainub Verjee's study of the economic, institutional, and state implications of this public cultural asset is rich in insights into the symbolic capital (to use a term from sociology) now acknowledged in large press photography collections.

A second theme relates to the occultation of people, communities, sensibilities, and ideas inherent in the constitution of photographic archives, knowing that they, like all archives, are expressions of ideological and political

Figures 0.22 and 0.23
Robert Cohen, *Marie Besnard, Bordeaux,* March 1954, (verso and detached caption with erroneous date and location). Gelatin silver print, 9.2 x 13.11 cm. BS.2005.132264.

biases. More than the deficit of visibility of certain groups and social move-
ments within the Black Star Collection, it is the modalities of invisibilization,
conscious or unconscious, that concern many of the authors in this book. As
Sophie Hackett points out, for example, the representation of 2SLGBTQ+
people in the collection is either curiously discreet—some famous figures
from this community are present but without any mention of their belonging
to it—or subordinated to events and news until they are revisited by an in-
formed gaze. The same is true of the photographs of Indigenous people that
Reilley Bishop-Stall discovered indexed with the term SOCIAL ISSUES. It is the
words used to index the images, both by the agency and by subsequent parties,
that call for a critical review. Inquiring about the categorization protocols
and their impact on the interpretation of the subjects represented is an
approach that sheds light on biases that still affect marginalized and racial-
ized people. In order to highlight this dimension, contributors to this volume
have developed both a quantitative and a qualitative approach, providing a
general overview of the terminology used for categorizing the communities
involved, whether gay, Indigenous, or racialized.

Similarly, the geographical identification of images, in Alexandra
Gooding's study those documenting the Caribbean, does not do justice to
the cultural and political complexity of the territories photographed. Only
a geopolitical reading of the images in the Black Star Collection will be
able to rectify the geographical designations—often hastily written under the
pressure of tight publication deadlines—in order to finally hear the too-often
ignored voices of local populations.

The erasure of specific biographies and political commitments, such
as those of the photographer Griffith Davis[49] in Drew Thompson's essay,
in favour of generic indexing processes is one of the features of large icono-
graphic sets intended to feed an illustrated press that is not very inclined
towards non-canonical accounts. It was indeed the latter that, following
the rules of the market, dictated the choice of subjects that one finds in the
Black Star Collection. For all that, it just so happens that certain content,
such as the American postwar youth subcultures described by Vanessa

49 Griffith J. Davis was the only African-American international freelance photojournalist
for Black Star Agency (1949–52) and former student of Kurt Safranski, co-founder of Black
Star Agency, at the New School for Social Research in New York City (Spring 1949).

Fleet Lakewood, is well represented in the collection, although little published in the press of the time. In other words, the images were not necessarily shown simply because they existed.

As the research conducted in the Black Star Collection also has curatorial objectives, a third set of essays addresses the methodological challenges inherent in the selection and exhibition of images from the collection. Several approaches and strategies of visual inquiry emerge through contact with this iconographic mass and through curatorial work. As Denise Birkhofer writes, studying the internal workings of a smaller collection of photographs—in this case a collection of Canadian photographs culled from the *New York Times* photo archive—can prove to be a beneficial exercise in terms of better understanding the intricacies of the Black Star Collection. It is then that the comparative method is applied. Taous Dahmani's interview with Mark Sealy demonstrates that to excavate from the collection photographs of Black and brown bodies, scenes of bloody violence, cruelly restrained human beings, body parts, starving people, immolation, murders and executions, tortures, humiliations, and mass graves is to subject it to an investigation that is both legal and forensic. Why those images, and for what audience? The public display of such images is a major issue, as is a belief in the political efficacy of militant photographic representation. In the 1970s, Bénédicte Ramade explains, there was a market for images representing environmental issues. Does that mean Black Star wanted to play a role in the rise of environmental awareness? If the images were shared, why didn't they raise more awareness? Exhibiting the Black Star prints alongside contemporary works that consider environmental issues allowed for the intersection of distinct visual regimes, but also demonstrated the prescience of certain little-known press photographers.

For each of the contributors to *Facing Black Star*, researching in this collection meant accepting being questioned by it, in terms of both their own methods of inquiry and heuristic expectations of the visual archive. Such is the strength of the Black Star Collection: its ability to undermine certainties and shake up research habits. Although this volume results from projects begun more than a decade ago, that work is still only at its beginning. For years to come, other researchers will likewise face the collection. May this book prepare them for that challenging confrontation.

A Chronology of the Black Star Publishing Company and the Black Star Collection

Alexandra Gooding and Valérie Matteau

Introduction

This chronology presents a selection of key dates in the history of the Black Star Publishing Company, the sale and subsequent donation of the agency's black-and-white picture library to Toronto Metropolitan University (TMU; formerly Ryerson University),[1] and the development of The Image Centre (formerly the Ryerson Image Centre)[2] and its distinct collecting, research, and exhibition programs. The separate entries are denoted by the use of different colours, and are informed by primary research conducted by the authors; unpublished internal Image Centre sources, including oral histories and public archives; and published sources. A full list of sources can be found at the end of this chronology.

Black Star and the Illustrated Press: Research Workshops

In the summers of 2010–12, Dr. Thierry Gervais, head of research at the Ryerson Image Centre (RIC), led a series of workshops that sought to bridge the gap between the prints in the Black Star Collection and their dissemination in

Figure 1.1
Werner Wolff, *New York City*, 1967 (detail). Gelatin silver print, 24.4 x 16.5 cm. BS.2005.049385. © Werner Wolff, Black Star; Courtesy Steven Wolff and The Image Centre.

1 Formerly known as Ryerson University (2002–22), Ryerson Polytechnical University (1993–2002), Ryerson Polytechnical Institute (1963–93), and Ryerson Institute of Technology (1948–63).

2 Formerly known as the Ryerson Image Centre (2011–22) and the Ryerson Gallery and Research Centre (2009–11). Prior to creation of the museum, the collection was first housed and managed by the Photo-Arts Resource Centre (1971–95), later known as the Mira Godard Study Centre (1995–2009) and part of the School of Image Arts at the university.

the illustrated press. Graduate students identified and catalogued the Black Star photo credits in three popular US picture magazines: *Life* (2010), *Look* (2011), and *Time* (2012). Based on this research, the following Black Star photographers represent the ten most credited in those magazines.

Most credited Black Star photographers in *Life* Magazine (1936–72)

1.	Ralph Crane, 1,224 credits	6.	Fritz Goro, 358 credits
2.	Walter Sanders, 704 credits	7.	Kosti Ruohomaa, 356 credits
3.	W. Eugene Smith, 410 credits	8.	Gordon Tenney, 274 credits
4.	Fritz Henle, 382 credits	9.	John Launois, 218 credits
5.	Werner Wolff, 361 credits	10.	Herbert Gehr, 215 credits

Most credited Black Star photographers in *Look* Magazine (1937–71)

1.	Black Star, 662 credits	6.	Robert Malloch, 18 credits
2.	Cal Bernstein, 127 credits	7.	Shel Hershorn, 15 credits
3.	Archie Liberman, 120 credits	8.	Bob Vose, 17 credits
4.	Herbert Giles, 28 credits	9.	Bern Keating, 15 credits
5.	Lee Lockwood, 24 credits	10.	W. Eugene Smith, 15 credits

Most credited Black Star photographers in *Time* Magazine (1936–52)

1.	Black Star, 182 credits	6.	Ralph Crane, 14 credits
2.	Werner Wolff, 48 credits	7.	Paul Pietzsch, 14 credits
3.	DEVER (Deutsche Verlag), 47 credits	8.	W. Eugene Smith, 14 credits
4.	Joe Covello, 22 credits	9.	Fritz Goro, 13 credits
5.	Peggy Plummer, 16 credits	10.	Robert Cohen, 12 credits

According to Benjamin Chapnick, president of the Black Star Publishing Company from 1990 to 2021, the agency's top clients between the 1940s and 1970s included *American Weekly, Colliers, Coronet, Life, Newsweek,* the

New York Times Sunday Magazine, Pageant, Parade, Saturday Evening Post, This Week, and *Time.* Further research is necessary to better understand the full scope of Black Star's contribution to American publishing.

Photographers in the Black Star Collection

The Black Star Collection includes photographs by numerous well-known and notable photographers:

Denise Bellon, 26 prints	Dan McCoy, 643 prints
Ruth Bernhard, 24 prints	Vernon Merritt III, 537 prints
Ilse Bing, 18 prints	László Moholy-Nagy, 17 prints
Bill Brandt, 26 prints	Martin Munkácsi, 14 prints
Brassaï, 39 prints	Lennart Nilsson, 326 prints
Bill Burke, 555 prints	Hilmar Pabel, 777 prints
Robert Capa, 10 prints	James "Jim" Pickerell, 726 prints
Henri Cartier-Bresson, 11 prints	W. Eugene Smith, 358 prints
Chim (David Seymour), 2 prints	Rosalind Solomon, 39 prints
Ralph Crane, 754 prints	Gerda Taro, 18 prints
Griffith J. "Griff" Davis, 511 prints	Roman Vishniac, 62 prints
Ed Van Der Elsken, 13 prints	Sabine Weiss, 2 prints
Andreas Feininger, 39 prints	Dr. Paul Wolff, 177 prints
Fritz Goro, 149 prints	
Philippe Halsman, 64 prints	
Matt Herron, 558 prints	
Doris Heydn, 105 prints	
Emil Otto Hoppé, 155 prints	
Frank Horvat, 1 print	
George Hoyningen-Huene, 24 prints	
Germaine Krull, 90 prints	
Constance Stuart Larrabee, 686 prints	
Catherine Leroy, 17 prints	
Herbert List, 26 prints	
Lee Lockwood, 853 prints	
Ivan Massar, 987 prints	

The collection also includes significant holdings by a number of photographers and photo agents, represented by more than 1,000 prints each:

Michael L. Abramson, 1,118 prints

Charles Bonnay, 1,014 prints

Dennis Brack, 14,445 prints

Leo Choplin, 1,184 prints

Henning Christoph, 2,837 prints

Robert Cohen, 12,895 prints

Joe Covello, 1,276 prints

Gene Daniels, 1,750 prints

Victor De Palma, 1,098 prints

Bob Fitch, 1,457 prints

Edo Koenig, 4,053 prints

Herbert Lanks, 2,877 prints

John Launois, 2,740 prints

Charles May, 1,387 prints

Charles Moore, 2,005 prints

Paul Pietzsch, 1,195 prints

Max Pohly, 1,267 prints[3]

Steve Schapiro, 1,631 prints

Graeme Phillips "Flip" Schulke, 2,153 prints

Emil Schulthess, 1,373 prints

François Sully, 1,221 prints

Kosti Ruohomaa, 1,923 prints

Fred Ward, 7,343 prints

Werner Wolff, 2,309 prints

Consulting the collection holdings alongside the workshop findings reveals that the total number of prints by a photographer can seem disproportionate to the number of credits identified. This could be because photographers sometimes retained their prints after leaving the agency, and one print could be reproduced multiple times. Further information about certain photographers listed above has been included in the chronology to demonstrate the working relationships between photographers and Black Star, between Black Star and its clients, and in the broader interconnected industry of the illustrated press.

3 Pohly's authorship of the photographs is in question. See Christian Joschke, "Dismantling Photographic Authorship: The Many Voices of Max Pohly's 'German History' in the Black Star Collection," in this volume, 92–117.

Chronology of Black Star and The Image Centre

■ Black Star ■ The Image Centre

1920 Ernest (Ernst) Mayer (1893–1983) establishes the Berlin-based Mauritius Verlag publishing house.

1929: Mayer expands the business to include a photo agency.

1933 **November:** Kurt Safranski (Szafranski) (1890–1964) leaves Germany during the Aryanization of Ullstein Verlag, where he has been an illustrator, artistic director, and ultimately the head of magazine publishing, and departs for England.

July 1934: In England, Safranski meets with Richard E. Berlin, head of the Hearst Corporation's magazine division, who encourages him to move to New York to help establish a new weekly picture magazine.

September 30, 1934: Safranski immigrates to New York City to work at the Hearst Corporation. He works there until November 1936, when he leaves to focus on the new business of Black Star.

1934 **November:** Kurt Korff (Karfunkel) (1876–1938), who had been editor-in-chief at Ullstein Verlag alongside Safranski, immigrates to New York City. In summer 1935 he is hired at Time Inc. as a consultant.

December 8: Korff and Safranski meet with Henry Luce and Daniel Longwell at Time Inc. to show them a dummy of an illustrated magazine that Safranski had previously made for William Randolph Hearst.

In a letter to Kurt Korff dated November 19, 1936, accompanying an early copy of the first issue of *Life*, Daniel Longwell states that were it not for his and Luce's 1934 meeting with Korff and Safranski, "I don't believe LIFE would ever have come into being."

June 2018: Thierry Gervais locates the first dummy ("Dummy I") in the Time Inc. Archives, held at the New York Historical Society. It is accompanied by a letter from Kurt Safranski addressed to Henry Luce, dated November 18, 1956, stating that the dummy is a gift from Safranski to Time Inc. on the twentieth anniversary of *Life*'s first published issue.

May 15, 2019: Two dummies ("Dummy A" and "Dummy B"), created by Safranski circa 1935, are donated to The Image Centre, a gift of the Robert Lebeck Archives.

1935 **June:** Ernest Mayer visits New York City and meets with his friend Safranski; together they decide to establish a photo agency. The original plan for the agency includes translating and publishing European books, and for that they decide to recruit Kurt Kornfeld (1887–1967), a publisher and literary agent in Germany.

Alexandra Gooding and Valérie Matteau 47

1935
(continued)

Summer: Upon his return to Germany, Mayer meets with Kornfeld to invite him to join in establishing a photo agency in Manhattan with their mutual friend Safranski.

September: Kornfeld travels to New York City, where he meets Safranski. He returns to Germany again before immigrating to New York City in the spring of 1936.

November 27: Mayer leaves Southampton, England, to immigrate to New York City. Prior to leaving Germany, he sells Mauritius Verlag to picture agent Helmut Zwez. Mayer retains a large number of prints made by German and French photographers for which he holds the reproduction rights in North America. He takes these photographs with him to New York City, where they eventually serve as the initial inventory of the Black Star photo agency.

1972: Hans Jörg Zwez, son of Helmut Zwez, takes over as head of Mauritius Verlag.

March 2021: Hans Jörg Zwez sells the agency's picture archive to United Archives.

December 23: Ernest Mayer, Kurt Safranski, and Kurt Kornfeld formally establish the Black Star photo agency. Paperwork is filed under the name Black Star Publishing Company, Inc. to officially register the business with the New York Department of State.

According to C. Zoe Smith, "The name 'Black Star' was Safranski's idea. In Europe it was common for a company to have a logo or trademark—a symbol which stood for the company's name. All printers' boxes of type contained a star, and Safranski hoped it would become a quickly identifiable symbol. However, Americans did not pick up on the idea and few business associates ever used the simple black star." [4]

1936

Emma Gurry joins Black Star as librarian in charge of the picture library. In this role Gurry handles the photo requests from publishers: selecting the photographs, packing and sending the prints to the publishers, and refiling the photographs when they come back to the agency. She retires in the early 1970s.

Photographer Fritz Goro (1901–86) immigrates to New York City from Germany and joins Black Star. He stays with the agency until 1940, when he leaves to join *Life* as a staff photographer, remaining there until 1966. There are 149 prints attributed to Goro in the Black Star Collection; "Fritz Goro from Black Star" received 358 credits in *Life* and 13 credits in *Time*.

German émigrés Leon Daniel and Celia Kutschuk establish the photo agency PIX Publishing Inc. in New York City. The agency, a competitor of Black Star, has close ties to Europe and remains in operation until 1969. Werner Wolff, who would eventually become a Black Star photographer, works in the photo lab at PIX from January 12, 1937, to January 1, 1938.

4 C. Zoe Smith. "Émigré Photography in America: Contributions of German Photojournalism from Black Star Picture Agency to *Life* Magazine, 1933–1938" (PhD diss., University of Iowa, 1983), 113.

January: Black Star signs a lease for two rooms in the Graybar Building, adjacent to Grand Central Station, at 420 Lexington Avenue, New York City. Due to the struggling economy, there are lots of vacancies and landlords are offering special arrangements to encourage occupancy; Black Star's rent is waived for the first six months. After World War II they move to the fourth floor, where they remain until 1957.

January 1936–December 1941: Black Star has a special arrangement with Ullstein Verlag whereby the German publisher supplies the agency with daily packages of photographs of the German army. These photographs are of such great interest to *Life* that the magazine pays for right of first refusal.

> **January 1933–June 1934:** Following Adolf Hitler's appointment as Chancellor, the National Socialist German Workers' (Nazi) Party orders and carries out the "Aryanization" of several Jewish-owned companies, including Ullstein Verlag.

> **1937:** Ullstein Verlag is renamed Deutscher Verlag by the Nazi Party. Photographs in the Black Star Collection from this time forward can be found with credits to "DEVER" or "D.V." on print versos. These photographs are often credited as "D.V. from B.S." when reproduced in print.

January 6: Black Star receives its first credit in *Time* magazine, a photograph attributed to an unknown photographer.

> **April 13:** Black Star receives its first *Time* cover credit, a photograph attributed to Dr. Paul Wolff.

> **1936–1952:** 635 photographs in *Time* are credited to Black Star.

April 3: A letter sent by Daniel Longwell at Time, Inc. to Ernest Mayer outlines a contractual agreement to pay Black Star $5,000 for the next year in exchange for first-refusal rights on photographs not taken "on a direct order from other publishers." Time Inc. later negotiates first refusal on all pictures imported by Black Star, and the right to publish them in any of its magazines.

Late 1936: Black Star begins developing other European sources in order to diminish its reliance on German suppliers.

> **April 1937:** Black Star Pictures' office in London is established at 13 Orange Street; it moves less than one year later to Cliffords Inn, Fleet Street. Eventually the business is sold to Kosmos Press, which continues to supply Black Star's New York office with European photographs.

> **1938–1939:** Mayer travels to Paris repeatedly with the goal of opening a Black Star office; however, the plans are abandoned when Germany invades Poland in September 1939.

November 23: *Life* publishes its first issue, featuring a cover image and other photographs by Margaret Bourke-White.

1936
(continued)

December 7: Black Star receives its first credits in *Life* magazine in the weekly's third issue, as well as the cover credit. Eleven photographs are attributed to three photographers from Black Star—Dr. Paul Wolff, Pierre Boucher, and Feher—and the cover image is attributed to Dr. Paul Wolff.

1936–1972: 9,265 photographs in *Life* are credited to Black Star.

1937

February 1: *Look* publishes its first issue. In a disclaimer, the magazine notes that Black Star is one of several photo agencies credited for image reproductions in the issue; images are not individually credited.

April 1: Black Star receives its first credits in *Look* magazine; six images are directly attributed to Black Star; no individual photographers are specified.

December 2, 1969: Black Star receives its first *Look* cover credit, a photograph attributed to Fred Kaplan from Black Star.

1937–1971: 1,361 photographs in *Look* are credited to Black Star.

1938

July: W. Eugene Smith (1918–78) joins Black Star as a freelance photographer, staying with the agency for five years, until 1943. He leaves to become a war correspondent for *Flying Magazine* before joining *Life* as a staff photographer in 1945. There are 358 prints attributed to W. Eugene Smith in the Black Star Collection; "W. Eugene Smith from Black Star" received 410 credits in *Life*, 15 credits in *Look*, and 14 credits in *Time*.

1940

Andreas Feininger (1906–99) joins Black Star, staying with the agency until 1941. He leaves to join *Life* as a staff photographer in 1942, where he remains for two decades. There are 39 prints attributed to Feininger in the Black Star Collection; "Andreas Feininger from Black Star" received 72 credits in *Life* and 1 credit in *Time*.

2009: The Image Centre acquires 123 prints from the Estate of Gertrud E. Feininger, his widow, to complement the holdings in the Black Star Collection.

1941

Ralph Crane (1913–88) joins Black Star as a contract photographer and works with the agency until 1951, when he leaves to join *Life* as a staff photographer. There are 754 prints attributed to Crane in the Black Star Collection; "Ralph Crane from Black Star" received 1,224 credits in *Life* (the most published Black Star photographer in *Life*), 12 credits in *Look*, and 14 credits in *Time*.

Summer: Howard Chapnick (1922–96) works for the Black Star Publishing Company as a part-time assistant messenger boy and is mentored by Mayer, Safranski, and Kornfeld. His first assignment, on his first day, is to assist W. Eugene Smith on a shoot.

1944 | **February:** Kosti Ruohomaa (1913–61) signs his first contract with Black Star. In 1945 he signs a new contract as a staff photographer. In 1956 Ruohomaa renegotiates his contract to gain more independence from the agency and foregoes his guaranteed weekly payments. He continues to work with Black Star until his death. There are 1,923 prints attributed to Ruohomaa in the Black Star Collection; "Kosti Ruohomaa from Black Star" received 356 credits in *Life*, 12 credits in *Look*, and 7 credits in *Time*.

1945 | **November 14:** Werner Wolff (1911–2002) signs his first contract with Black Star. He later renegotiates his contract in 1947 and 1952, both times reducing the agency's commission on his assignments; however, the agency's commission on sales of his non-assignment photographs remains unchanged. Wolff continues to work with the agency until the 1980s. There are 2,309 prints attributed to Werner Wolff in the Black Star Collection; "Werner Wolff from Black Star" received 361 credits in *Life*, 2 credits in *Look*, and 48 credits in *Time*.

Shortly after joining Black Star, Wolff establishes the C&W Photo Lab with fellow Black Star photographer Joe Covello, as a way to monitor the quality of their prints and negatives. Following Covello's departure, Joe "Jack" Giacopelli, a master printer, joins Wolff and the business is renamed G&W Photo Lab. It eventually becomes Black Star's main processing lab.

May 27, 2009: Alice and Steven Wolff, respectively Werner Wolff's widow and son, donate the photographer's archive to The Image Centre. The archive comprises thirty-four running feet and includes photographs, negatives, contact sheets, documents, and ephemera, the majority of which contextualize the photographer's time at Black Star, including three signed contracts that detail his financial arrangements with the agency through the years.

1946 | Howard Chapnick, having returned from England after serving for three years in the US Air Force during World War II, formally joins Black Star full-time.

1947 | Magnum Photos is established in New York City by four photographers—Robert Capa, Henri Cartier-Bresson, George Rodger, and Chim (David Seymour). All except Cartier-Bresson have previously been associated with Black Star.

1951: Black Star and Magnum discuss the possibility of a merger. Ultimately the plans do not materialize.

Late 1940s–Early 1980s | A shift toward colour photography

Late 1940s: *Life* magazine begins regularly featuring colour images on its covers. Black Star contracts with photographers begin to differentiate commission rates between black-and-white and colour assignments.

June 20, 1947: Werner Wolff's revised contract with Black Star includes different rates for black-and-white and colour assignments.

Late 1959: John Launois's revised contract with Black Star includes a reduction in the agency's commission on his photographs from 50 to 15 percent, specifically for all colour assignments for Time-Life. Launois's photographs are in such high demand that even at this lower commission rate, the agency earns more money from the reproduction of his photographs than under his previous contracts.

Early 1960s: Benjamin Chapnick begins advocating strongly for the use of colour photography. The agency's photographers begin working with colour negative films from which colour prints are made.

Early 1970s: Ninety percent of photographs entering the agency's picture library are in colour.

Early 1980s: Black Star photographers shift to using colour slide film.

1953

Summer: Benjamin Chapnick (1937–2021), the younger cousin of Howard Chapnick, joins Black Star as a messenger boy during his last year of high school.

1955

John Launois (1928–2002) joins Black Star as a contract photographer based in Japan. The agency begins distributing his photographs in November 1951, and starting in 1955 he is paid a guaranteed $25 per week. There are 2,740 prints attributed to Launois in the Black Star Collection; "John Launois from Black Star" received 218 credits in *Life* and 3 credits in *Look*.

1957

Kurt Safranski suffers a stroke and retires from Black Star. Ernest Mayer and Kurt Kornfeld remain in charge of the agency.

Black Star moves to 305 East 47th Street, New York City, where it occupies the eleventh floor of the building.

G&W Photo Lab, also previously located in the Graybar Building, makes the same move.

1960

Florida-based photographer Fred Ward (1935–2016) joins Black Star, following an introduction to Howard Chapnick by Black Star photographer Graeme Phillips "Flip" Schulke. At Chapnick's request Ward relocates to Washington, DC, to help the agency meet the ever-increasing demand for photographs of John F. Kennedy and his family. Ward continues working with Black Star until the early 2000s. There are 7,343 prints attributed to Ward in the Black Star Collection; "Fred Ward from Black Star" received 81 credits in *Life* and 10 credits in *Look*.

May: Benjamin Chapnick is invited by Ernest Mayer to join the agency full-time.

1962	**April 1:** Black Star moves again, this time to 450 Park Avenue South, New York City, where it occupies an entire floor of the building, approximately 5,000 square feet.
	G&W Photo Lab also relocates there and occupies 800 square feet on Black Star's floor.

1963	**December 31:** Ernest Mayer and Kurt Kornfeld officially retire from Black Star. Employees Howard Chapnick (as majority partner), Benjamin Chapnick, and Phil Rosen buy the business from the founding partners.
	December 16: In a letter to Werner Wolff, Howard Chapnick explains that Ernest Mayer and Kurt Kornfeld have retired and that he will be taking over the agency effective January 1, 1964. Presumably similar letters are sent to all photographers under contract with the agency.

1964	**January 1:** Howard Chapnick becomes president of the Black Star Publishing Company. He remains president until December 31, 1989, when he is succeeded by Benjamin Chapnick.
	December 8: Yukiko Launois, wife of photographer John Launois, begins working three half-days a week in the picture library at Black Star, supporting the photo librarian, Emma Gurry.
	Summer 1971: Yukiko Launois becomes a full-time picture editor at Black Star.
	1973: Yukiko Launois becomes the photo librarian, with seven to eight full- and part-time researchers reporting to her.

| 1972 | **December 29:** *Life* publishes its last issue as a weekly. Eight photographs are attributed to six photographers, agencies, and publications associated with Black Star: Otteried Schmidt–Stern, Stern, AP–Stern, John Collier, Dennis Brack, and Gerald Brimacombe. |

1979	One year after the death of W. Eugene Smith, Howard Chapnick and editors John G. Morris and Jim Hughes establish the W. Eugene Smith Memorial Fund in memory of their friend and colleague, to encourage photojournalists.
	1996: Following the death of Howard Chapnick, the W. Eugene Smith Memorial Fund creates the Howard Chapnick Grant "to support leadership in fields of photojournalism and documentary photography."

| 1985 | After five years with Black Star, James Nachtwey leaves the agency. He joins Magnum in 1986, where he remains until 2001. In 2001 he becomes a founding member of the New York City photo agency VII. |

1988 | **September 3-5:** Black Star moves to 116 East 27th Street, New York City, where its offices occupy 7,000 square feet on the fourth floor.

Late 1990: The lease is expanded to include the eleventh floor, doubling Black Star's office space.

Late 1991/early 1992: Black Star terminates the lease for the eleventh floor and signs a new lease for the fourth and fifth floors. According to Benjamin Chapnick, these numerous office moves are driven by frugality.

1990 | **January 1:** Benjamin Chapnick, executive vice-president of Black Star (1963–88), becomes president of the company, a position he holds until his death on August 2, 2021.

1996 | **May 30:** Paperwork is filed with the New York Department of State to register two new business names—Black Star Photo Agency, Inc., and Black Star Picture Collection, Inc.—indicating that the agency's leadership is beginning to consider how to maximize the profitability of the historical/stock picture library while still offering editorial photography services.

1997 | Black Star begins digitizing existing prints from its picture library that are requested for reproduction. Once digitized, rather than refiling the prints in their previous location in the library, they are filed in a new section of the picture library called "Prostock" after the software used to digitize them. As with the rest of the picture library, the Prostock section is also organized by subject, persons' name, or geographical location.

2000 | Black Star commissions an evaluation of the black-and-white picture library by Penelope Dixon & Associates, an appraisal firm based in New York City. A random sampling of 6,328 photographs is reviewed.

Black Star hires an outside firm to return all colour slides to their photographers. More than eight million slides are returned over a five-year period.

2000-01 | Black Star returns all remaining black-and-white negatives and contact sheets to the photographers in preparation for sale of the picture library. The agency considers these items "originals" and is therefore not permitted to sell them. Documents found in the Werner Wolff Archive indicate that some negatives were returned as late as April 2005—likely found when Penelope Dixon & Associates packed up the black-and-white picture library.

2003 | **June 11:** Black Star's historical black-and-white picture library is sold to a private buyer. In addition to the prints, related ephemera that had been filed with the prints, such as the folders used to store and file them in the agency's picture library, are also included in the sale. The collection does not include colour slides, negatives, contact sheets, or business records.

2004 **June:** After the failure of earlier attempts to find an institutional home for Black Star in Canada, Stephen Bulger Gallery of Toronto advises the donor's lawyers to consider Ryerson University (now Toronto Metropolitan University) as a potential recipient of the collection. A formal offer is sent to the university's administration.

1968: The School of Image Arts at what was then known as Ryerson Polytechnical Institute begins acquiring original prints by historically significant photographers as a resource for students and faculty, and simultaneously develops a slide library. Both are initiated by Professor Donald Dickinson, who teaches the school's first History of Photography course.

1971: The Photo-Arts Resource Centre is created, and the Photographs Collection and slide library are given a dedicated space in the school.

1995: The Centre is renamed after Mira Godard, after the Toronto art dealer makes a substantial donation of photographs from her collection. The gift is the first acquired by the school through the Canadian cultural property review process[5] and establishes the Centre as an attractive option for Canadian donors.

1975: Professor Phil Bergerson initiates a lecture series, with W. Eugene Smith as its inaugural speaker. A wide variety of photographers, historians, and theorists are invited to speak in the annual series, establishing the university internationally as an evolving centre for the study of lens-based media.

1986: The series is sponsored by Kodak Canada Inc. and renamed the Kodak Lecture Series. In 2014 it becomes the Howard and Carole Tanenbaum Lecture Series, following a generous donation from the Toronto couple.

1976: Professor Bergerson initiates and develops a proposal for a public gallery to exhibit collection holdings and works by Lecture Series speakers. In 1978 the initiative is put on hold due to lack of financial support.

1995: Professor Bergerson revives plans for a gallery and research centre with founding Collections Curator Peter Higdon and Professors Robert Burley and Don Snyder. Their proposal incorporates a mission statement, a business plan, drawings, and an architectural model. Plans stall again because of lack of funding, but the proposal succeeds in demonstrating the need for a gallery space to the university's administration.

September 2004: The School of Image Arts' new Master of Arts in Photographic Preservation and Collections Management (PPCM) welcomes its first cohort, strengthening the department's position as a leader of education in photography.

5 According to the Government of Canada, "The certification of cultural property is a process administered by the Canadian Cultural Property Export Review Board (CCPERB), through which cultural property of outstanding significance is certified for tax purposes." See "About the Certification of Cultural Property," Government of Canada, https://ccperb-cceebc.gc.ca/en/certification-of-cultural-property/about.html.

2004 (continued)	**2013:** The program expands its scope to include film preservation and is renamed Film + Photography Preservation and Collections Management (F+PPCM).
	July 7: The Black Star Collection is inspected in a Montreal warehouse by Peter Higdon and professors Robert Burley, Don Snyder, and David Harris. The group conveys to Adam Kahan, VP of advancement at the university, the high quality of the material. They recommend that the university should proceed with acquiring the collection.
	November 10: The School of Image Arts applies to the Department of Canadian Heritage for certification of the donation as Canadian cultural property. The application, prepared by Peter Higdon, includes promises of a climate-controlled gallery space, vault, and research centre where the collection will be publicly accessible.
2005	**January 18:** The donation certification is approved by the Canadian Cultural Property Export Review Board (CCPERB). The collection is accompanied by CAD$7 million from the donor, to be used to build a museum.
	September 27, 2012: *Maclean's* magazine reports that, at the time of the donation, the Black Star Collection was "the largest gift of cultural property ever made to a Canadian university."
	February 8: The Black Star Collection is transported from Montreal to an off-site art storage facility in Toronto under the supervision of Peter Higdon.
	April 11: The university announces its acquisition of the Black Star Collection at a press conference. A selection of photographs is on view for the press.
2006-08	While the collection is in off-site storage, a small but growing staff from the School of Image Arts begins organizing summer exhibitions of surrogate photographs drawn from the Black Star Collection, to promote the acquisition and draw attention to the university's plans for a new photography museum. Exhibitions are presented in Toronto at the Contact Photography Festival in 2006, 2007, and 2008; the Luminato Festival for the performing arts in 2007; and the overnight visual arts event Nuit Blanche in 2007. Another exhibition is presented at two venues in Washington, DC in 2008, first at the Embassy of Canada to the United States, and then at FotoFest DC.
	Design and construction proceed for the forthcoming museum on campus.
	January 2007: Canadian firm Diamond Schmitt Architects is awarded the design contract.
	March 5, 2008: Diamond + Schmitt publicly unveils the design concept for the new building.
	May 2009: Construction begins.

January 2011: Unforeseen delays in construction cause the original project completion date to be changed to September 2012. Two travelling exhibitions initially intended to inaugurate the new facility are relocated to other institutions in Toronto.

April 1–August 21, 2011: *Edward Burtynsky: Oil*, curated by Paul Roth for the Corcoran Gallery of Art in Washington, DC, is presented at the Royal Ontario Museum in Toronto.

May 23–August 19, 2012: *Berenice Abbott: Photographs*, curated by Gaëlle Morel, exhibitions curator of the new institution, is presented at the Art Gallery of Ontario in Toronto and the Jeu de Paume in Paris.

May 2012: The Ryerson Image Centre staff moves into the completed building, bringing the Photographs Collection.

September 29, 2012: The RIC opens to the public on the occasion of the Nuit Blanche festival and welcomes 3,560 visitors on its first day.

2008

October 27: Doina Popescu is hired as the inaugural director of the new institution. She serves as director for five years.

2009

October–November: To mark the thirtieth anniversary of the fall of the Berlin Wall, Doina Popescu organizes an exhibition of surrogate photographs drawn from the Black Star Collection for the offices of the Consulate General of Germany in Toronto, the Embassy of Canada to Germany in Berlin, and Library and Archives Canada in Ottawa. The exhibition, titled *Images of the Berlin Wall*, is accompanied by *Freedom Rocks*, a project by Toronto artists (and School of Image Arts professors) Blake Fitzpatrick and Vid Ingelevics.

2010-11

Paul J. Ruhnke, a 1950 graduate of the School of Image Arts, bequeaths CAD$120,000 to the Centre in support of various projects. One of those projects is an oral history series in which Black Star photographers Dennis Brack, Bob Fitch, Matt Herron, and James Pickerell, along with famed picture editor John Morris, are interviewed by various university professors, museum staff, and guest curators. The interviews are recorded and produced by then-current students of the university's film program, and directed by Professor Alexandra Anderson.

2010-12

Steve Loft, a curator, writer, and media artist of Kanien'kehá: ka (Mohawk) and Jewish heritage, is awarded a National Visiting Scholar Fellowship by the Pierre Elliott Trudeau Foundation, in support of research, writing, and curatorial practice at the university. He is also named Scholar-in-Residence at the RIC. Loft's fellowship culminates in the 2013 exhibition *Ghost Dance: Activism. Resistance. Art*, which presents photographs from the Black Star Collection alongside contemporary works by Indigenous artists.

Under the guidance of Thierry Gervais, graduate students in the PPCM program complete a series of summer workshops aimed at identifying and cataloguing the Black Star photo credits in three US picture magazines, *Life* (studied in 2010), *Look* (2011), and *Time* (2012).

2010

February: The RIC commissions photojournalist Dominic Nahr, a 2008 graduate of the university's BFA program in Photography Studies, to document what is left of operations at the Black Star offices prior to the company's departure from Manhattan.

July: Without a physical picture library, and with the shift towards digital distribution, Black Star no longer needs office space in Manhattan. The agency moves to 1 Water Street, White Plains, New York, where commercial real estate is significantly more affordable.

> **Spring 2012:** Black Star moves its offices to 333 Mamaroneck Avenue, #175, White Plains, New York.

2011

June 7: Canadian filmmaker Atom Egoyan, a member of the museum's advisory board, suggests that the new institution be named the "Ryerson Image Centre." The board, chaired by Howard Tanenbaum, approves unanimously. At the next meeting, on October 11, the board votes on the institution's brand identity and a second name option; the vote is again unanimous in favour of the Ryerson Image Centre.

June 14: A complete unbound run of *Life* magazine is donated to the RIC by Toronto-based rare-book collectors Peter and June Elendt. This donation allows researchers to consult issues of the illustrated magazine alongside prints from the Black Star Collection.

2012

May–June: The RIC commissions Kate Tarini, a 2010 graduate of the university's MFA program in Documentary Media, to photograph the Black Star Collection at its temporary off-site storage, as well as its physical transfer to RIC's new facility.

May 14–28: The Black Star Collection arrives on the university campus.

June: The ephemera accompanying the Black Star Collection are reviewed and consolidated following approval by the RIC's Acquisition Committee. Empty folders, their information already transcribed into the database, are discarded. In sorting through the ephemera, RIC staff locate 297 errant photographs; they are accessioned and refiled in boxes housing the collection.

September 29: The RIC opens with its inaugural show *Archival Dialogues: Reading the Black Star Collection,* curated by Doina Popescu and Peggy Gale. The exhibition features the work of eight Canadian artists (Stephen Andrews, Christina Battle, Marie-Hélène Cousineau, Stan Douglas, Vera Frenkel, Vid Ingelevics, David Rokeby, and Michael Snow) invited to respond to the collection, shown alongside the photographs that inspired them.

Since 2012, numerous exhibition organized by RIC staff and guest curators have drawn from the Black Star Collection; these thematic exhibitions often include artworks by contemporary artists.

> **2013:** *Ghost Dance: Activism. Resistance. Art.,* guest-curated by Steve Loft.

> **2014:** *What It Means to Be Seen: Photography and Queer Visibility,* guest-curated by Sophie Hackett.

2014: *DISPATCH: War Photographs in Print, 1854–2008,* curated by Thierry Gervais.

2015: *Burn with Desire: Photography and Glamour,* curated by Gaëlle Morel.

2016: *The Edge of the Earth: Climate Change in Photography and Video,* guest-curated by Bénédicte Ramade.

2017: *Birmingham, Alabama, 1963: Dawoud Bey / Black Star,* curated by Gaëlle Morel.

2018: *TERREMOTO: Mexico City, 1985,* curated by Denise Birkhofer.

Since 2012, the RIC has also invited artists to create new artworks for exhibition in response to or in dialogue with the Black Star Collection. They include Clive Holden, Annie MacDonell, Izabella Pruska-Oldenhof, and Pierre Tremblay.

2013 **January 23:** *Human Rights Human Wrongs,* guest-curated by Mark Sealy, opens at the RIC. It is the institution's first exhibition composed fully of prints from the Black Star Collection, and includes 316 photographs.

February 8, 2015: *Human Rights Human Wrongs* opens at The Photographers' Gallery, London, UK.

May 8: Bookmaker Michael Torosian's Toronto-based Lumiere Press publishes a limited-edition letterpress book titled *Black Star: The Ryerson University Historical Print Collection of the Black Star Publishing Company: Portfolio Selection and Chronicle of a New York Photo Agency.*

2016 **December 22:** A collection of 21,362 photographs of Canadian subject matter from the *New York Times* Photo Archive is deposited at the RIC by Toronto developer Chris Bratty on behalf of the Rudolph P. Bratty Family Foundation. This archive, a promised gift, complements the holdings of the Black Star Collection, which contains only 1,838 photographs related to Canada.

2022 **July 13:** Following Ryerson University's earlier decision to change its name to Toronto Metropolitan University, RIC director Paul Roth announces that the museum will be renamed as The Image Centre.

2023 **September 13:** *Stories from the Picture Press: Black Star Publishing Co. & The Canadian Press,* curated by Paul Roth, Gaëlle Morel, and Rachel Verbin, is scheduled to open at The Image Centre.

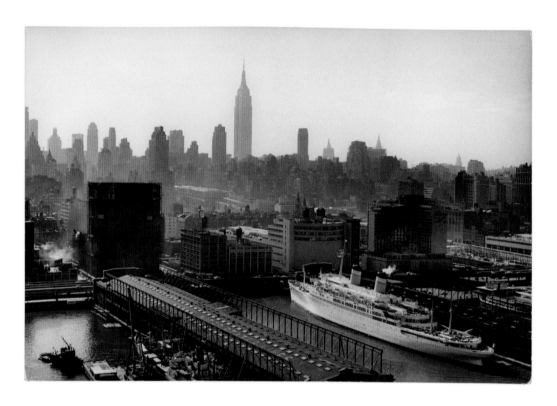

Figure 1.2
Werner Wolff, *New York City*,
1967. Gelatin silver print,
24.4 x 16.5 cm.
BS.2005.049385.
© Werner Wolff, Black Star;
Courtesy Steven Wolff and
The Image Centre.

Sources

Bair, Nadya. *The Decisive Network: Magnum Photos and the Postwar Image Market.* Oakland:
University of California Press, 2020.

Black Star Collection. The Image Centre, Toronto Metropolitan University, Toronto.

Black Star Photo Agency, Inc. Certificate of Incorporation, filed May 30, 1996. New York State
Department of State, Division of Corporations, Entity Information, DOS ID 2034520, file no.
960530000193. https://apps.dos.ny.gov/publicInquiry.

Black Star Picture Collection, Inc. Certificate of Incorporation, filed May 30, 1996. New York State
Department of State, Division of Corporations, Entity Information, DOS ID 2034522, file no.
960530000194. https://apps.dos.ny.gov/publicInquiry.

Black Star Publishing Company, Inc. Certificate of Incorporation, filed December 23, 1935. New
York State Department of State, Division of Corporations, Entity Information, DOS ID 48937,
file no. 4933-122. https://apps.dos.ny.gov/publicInquiry.

Bonner-Ganter, Deanna. *Kosti Ruohomaa: The Photographer Poet.* Camden, ME: Down East Books, 2016.

Carleton, Will. "United Archives Acquires Mauritius Verlag Photo Archive 1920–1945." *Photo
Archive News,* March 29, 2021. https://photoarchivenews.com/news/united-archives-
acquires-mauritius-verlag-photo-archive-1920-1945.

Chapnick, Benjamin. Interview by Michael Torosian, June 6, 2012. Transcript, The Image Centre,
Toronto Metropolitan University, Toronto.

———. Letter to Peter Higdon, September 27, 2004. Acquisition files, The Image Centre, Toronto
Metropolitan University, Toronto.

Chapnick, Howard. *Truth Needs No Ally: Inside Photojournalism.* Columbia: University of Missouri
Press, 1994.

Gervais, Thierry. "Making *Life* Possible." In *Life Magazine and the Power of Photography,* edited by Katherine
A. Bussard and Kristen K. Gresh, 28–41. Princeton, NJ: Princeton University Press, 2020.

———. "Three Dummies for *Life,* 1934–1935." In Bussard and Gresh, 42–45.

Heinzerling, Larry. *Covering Tyranny: The AP and Nazi Germany, 1933–1945.* Edited by John
Daniszewski, with contributions by Randy Herschaft. New York: Associated Press, 2017.
https://www.ap.org/about/history/ap-in-germany-1933-1945/.

Higdon, Peter. "Explanation of Outstanding Significance and National Importance." Application
to the Canadian Cultural Property Export Review Board, item 6, November 10, 2004.
Acquisition files, The Image Centre, Toronto Metropolitan University, Toronto.

———. "The Ryerson Image Centre Photographs Collection: Brief Timeline and Acquisitions Notes."
Memorandum to Denise Birkhofer, January 25, 2017. Acquisition files, The Image Centre,
Toronto Metropolitan University, Toronto.

Hung, Jochen. "The 'Ullstein Spirit': The Ullstein Publishing House, the End of the Weimar
 Republic and the Making of Cold War German Identity, 1925–77." *Journal of Contemporary
 History* 53, no. 1 (2018): 158–84. https://doi.org/10.1177/0022009416669419.

Kornfeld, Phoebe. *Passionate Publishers: The Founders of the Black Star Photo Agency.* Bloomington, IN:
 Archway, 2021.

"Kurt Safranski, Ex-aide with Hearst Magazines." *New York Times,* March 2, 1964, 27. https://www.
 nytimes.com/1964/03/02/archives/kurt-safranski-exaide-with-hearst-magazines.html.

Launois, John. *L'américain: A Photojournalist's Life.* New York: Easton Studio Press, 2014.

Launois, Yukiko. Interviews by Nadya Bair, October 31, and November 4, 2016. Transcripts, The
 Image Centre, Toronto Metropolitan University, Toronto.

"Leon Daniel." *New York Times,* December 31, 1974, 24. https://www.nytimes.com/1974/12/31/
 archives/leon-daniel.html.

Lomore, Cassie. *The Publication of Credited Black Star Photographs in* Life, *1936–1972: A Report of the
 2010–2012 Black Star Research Workshop.* 2012. Based on research conducted by Lindsay
 Bolanos, Jordan McInnis, Emily McKibbon, Chantal Wilson, and Rachel Verbin in 2010. The
 Image Centre, Toronto Metropolitan University, Toronto.

——. *The Publication of Credited Black Star Photographs in* Look, *1936–1971: A Report of the 2010–2012
 Black Star Research Workshop.* 2012. Based on research conducted by Ryan Buckley, Hilla
 Cooper, sol Legault, Cassie Lomore, and Chantal Wilson in 2011. The Image Centre, Toronto
 Metropolitan University, Toronto.

——. *The Publication of Credited Black Star Photographs in* Time, *1935–1952: A Report of the
 2010–2012 Black Star Research Workshop.* 2012. Based on research conducted by Ross
 Knapper, Cassie Lomore, and Brian Piitz in 2012. The Image Centre, Toronto Metropolitan
 University, Toronto.

Longwell, Daniel. Letter to Kurt Korff, November 19, 1936. Box 432, folder 9, Time Inc. Subject
 Files, MS 3009-RG 1, New York Historical Society.

Manco, Sara. "Finding Wolff: Intellectually Arranging the Werner Wolff Fonds at the Ryerson
 Image Centre." Master's thesis, Ryerson University, 2011.

Morris, John G. *Get the Picture: A Personal History of Photojournalism, 1839–1973.* Chicago: University
 of Chicago Press, 2002.

National Gallery of Canada. Andreas Feininger Fonds: Finding Aid. Library and Archives, National
 Gallery of Canada. https://www.gallery.ca/library/ngc168.htm.

Neubauer, Hendrik. *Black Star: 60 Years of Photojournalism.* Cologne: Könemann, 1997.

Penelope Dixon & Associates. "An Appraisal of the Black Star Archive." August 26, 2003.
 Acquisition files, The Image Centre, Toronto Metropolitan University, Toronto.

Pickerell, James, Steve Schapiro, and Fred Ward. "Photographing an Era: The '60s and '70s." Recording of panel discussion, Ryerson University, Toronto, May 6, 2009, 2:43:43. https://ryecast.ryerson.ca/48/Watch/468.aspx?query=fred%20ward.

Smith, C. Zoe. "Émigré Photography in America: Contributions of German Photojournalism from Black Star Picture Agency to *Life* Magazine, 1933–1938." PhD diss., University of Iowa, 1983.

Torosian, Michael. *Black Star: The Ryerson University Historical Print Collection of the Black Star Publishing Company: Portfolio Selection and Chronicle of a New York Photo Agency.* Toronto: Lumiere Press, 2013.

United Archives. "2021 March: United Archives Has Purchased the Historical Image Archive of Berlin-Based Mauritius Verlag (1920–1945), March 26, 2021." https://www.united-archives.de/news.

Werner Wolff Archive. AG02, The Image Centre, Toronto Metropolitan University, Toronto.

W. Eugene Smith Memorial Fund. "The Smith Legacy." https://www.smithfund.org/.

Berlin W.
Geisenhei
48 W

ÖSTERREICH

2

Zwett

Repst

MAX
634 W. 1.
ALL RIGH

Part 1
Questioning the Origins
of the Black Star
Collection

Suitcases, Stamps, and Paper
Piecing Together the Story of Black Star's Nazi Photographs

Nadya Bair

Suitcases

There are few objects that better represent the upheavals of the twentieth century, and the Jewish experience in particular, than the suitcase. Captured by numerous photographers as potent symbols of persecution and flight, suitcases also figure prominently in the history of photojournalism itself. Between the 1920s and 1940s, the industry was dominated by Jewish photographers, editors, and publishers who had fled fascism and for whom photographs were currency in the vibrant interwar economy of news pictures. The German-Jewish Otto Bettmann claimed to have arrived in the United States from Nazi Germany in 1935 with "two trunks filled with old pictures" that became the foundation of his historic Bettmann Archive.[1] The Hungarian-Jewish Robert Capa (né Andrei Friedmann) left Hungary for Germany and then France. He would have arrived in the United States with a suitcase of Spanish Civil War photographs, had the cache not gone missing after the Nazis occupied France. Recovered only in 2007, the "Mexican suitcase" is now the best-known visual archive of the conflict.[2]

The suitcase of photographs was likewise a recurring motif in Black Star's 1935 origin story. "They were friends," recalls Yukiko Launois, an archivist who joined Black Star in the 1960s and stayed into the 1990s. "And they brought, I heard, a suitcase full of prints."[3] That version is, however, apocryphal, since the founders fled Germany separately: Kurt Safranski

Figure 2.1
Heinz Fremke, *Der erste Kampftag der XI. Olympischen Spiele* (The first day of the 11th Olympic Games), 1936 (detail). Gelatin silver print, 23.3 x 17.0 cm. BS.2005.275043.

1 Estelle Blaschke, *Banking on Images: The Bettmann Archive and Corbis* (Leipzig: Spector Books, 2016), 56.

2 Cynthia Young, *The Mexican Suitcase: The Rediscovered Spanish Civil War Negatives of Capa, Chim, and Taro* (New York: International Center of Photography, 2010).

3 Yukiko Launois, interview by the author, October 31, 2016.

arrived in the United States in 1934, followed by Ernest Mayer in 1935. Safranski, Mayer, and Kurt Kornfeld incorporated Black Star that December, and Kornfeld immigrated to the United States the following year. Yet the image of the Black Star suitcase endured, not only because it is a potent symbol of the agency's origins, but also because it attests to the logic of picture agencies. As media anthropologist Zeynep Gürsel has shown, picture agents and editors work according to a "futurepast" logic. They must anticipate what future viewers will want to see about their world, find ways to get those scenes photographed, and file the pictures so that future staff can easily locate them.[4]

The suitcase story prompted my research in the Black Star picture collection. Were its potentially historic contents sitting at the The Image Centre? Since there were no diaries, account books, or letters in the collection to rely on, might there be photographs that contained material traces of Black Star's early operations?

Both Kurt Safranski and Ernest Mayer could have brought images with them to the United States. In charge of the magazines division of the Jewish-owned Ullstein publishing house since 1924, Safranski left Germany to work for the American Hearst Corporation's magazine division soon after the Nazis took over Ullstein in 1933.[5] Mayer had founded the Mauritius Verlag photo agency in Berlin in 1920 and sold it to the "racially pure" Helmut Zwez amid the Nazi "purification" of its press. Mayer recalled that Black Star "existed practically in the first year from the sale of the photographs I had brought from Germany and France."[6] Identifying pictures brought over by Safranski or Mayer meant asking what a publisher or editor leaving Nazi Germany might decide to take with him. What might he imagine American editors and readers wanting to see that only he could provide? What photographs from the past would be useful if a new war began?

4 Zeynep Devrim Gürsel, *Image Brokers: Visualizing World News in the Age of Digital Circulation* (Los Angeles: University of California Press, 2016), 22. By the postwar period, television was working in tandem with photography to stage the present as "instant history" and as the future's past, as happened with the media coverage of Queen Elizabeth's coronation; Daniela Bleichmar and Vanessa R. Schwartz, "Visual History: The Past in Pictures," *Representations* 145 (Winter 2019): 1–31.

5 "Nazis Swallow up Ullstein Press, Largest in Reich," New York Times, November 2, 1933, 1; Phoebe Kornfeld, *Passionate Publishers: The Founders of the Black Star Photo Agency* (Bloomington, IN: Archway, 2021), 174–82.

6 Ernest Mayer, in conversation with Zoe Smith; cited in Kornfeld, *Passionate Publishers*, 232.

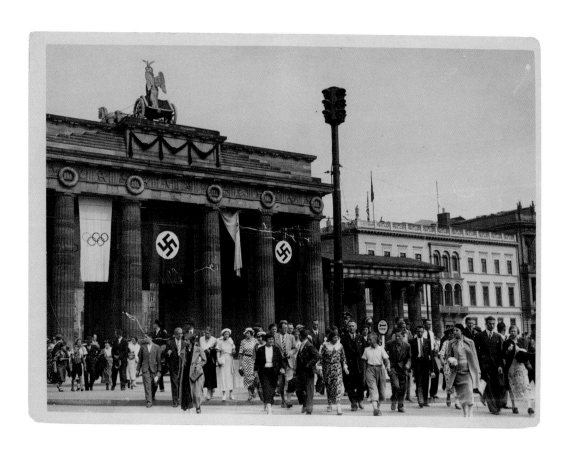

Figure 2.2
Unknown photographer/
Ullstein Bilderzentrale,
*Menschenmassen am
Brandenburger Tor in Berlin*
(Crowds at the Brandenburg
Gate in Berlin), ca. 1935.
Gelatin silver print,
18.1 x 24.0 cm.
BS.2005.019136.

My exploration of Black Star's "historic" files began with a "World War I" keyword search, which returned more than 2,000 records. While most were relatively recent reprints, a few dozen 5 x 7 photographs on yellowed, brittle paper, depicting trench warfare, fields of smoke, and soldiers in gas masks, suggesting an older provenance. But then the unexpected happened: the keywords "Ullstein" and "Mauritius" yielded hundreds upon hundreds of Nazi propaganda pictures. Nearly all of them had been made after 1935, after the founders had moved to the United States and the picture economy in Germany had been "Aryanized." These included Berlin's Brandenburg Gate decorated with Olympic and Nazi flags, provided by Ullstein Bilderzentrale (fig. 2.2). There were Adolf Hitler posing with Hermann Göring, Joseph Goebbels, Benito Mussolini, and Philippe Pétain; well-groomed and well-fed "Aryan" families receiving boxes of wartime rations with a smile; muscular shirtless Hitler youth, their outdoor games photographed from a worm's-eye view, looking simultaneously ethereal and solid; and finally, Nazi soldiers in uniform, posing in cockpits and with machine guns. Like the brittle World War I prints, these pictures were tattered. Their versos had been stamped and restamped, captioned and recaptioned and scribbled over, showing that they had passed through many hands. The quantity of these prints bespoke a serious demand for images of Nazi Germany in the lead-up to World War II that Black Star had actively filled, but neither I nor Image Centre staff at the time had known they were there.

On one level, Black Star's ties to colleagues in the "Aryanized" publishing industry throughout the mid-1930s and into the beginning of the war are not surprising in light of similar stories about the interwar media industry and the larger economic and political realities of the 1930s. The list of companies with known connections to Nazi Germany continues to grow.[7] New research into the Associated Press (AP) has revealed the concessions and alliances AP made in order to receive much-needed photographs from wartime Germany.[8] Nevertheless, Black Star's place in that history is largely unknown. The

7 See Edwin Black, *IBM and the Holocaust* (New York: Three Rivers Press, 2002) and *Nazi Nexus: America's Corporate Connections to Hitler's Holocaust* (Washington, DC: Dialog Press, 2009).
8 Harriet Scharnberg, "The A and P of Propaganda: Associated Press and Nazi Photojournalism," *Contemporary History* 13 (2016); Associated Press, *Covering Tyranny: The AP and Nazi Germany, 1933–1945* (Associated Press, 2017), https://www.ap.org/about/history/ap-in-germany-1933-1945/; Norman Domeier, "Secret Photos: The Cooperation Between Associated Press and the National Socialist Regime, 1942–1945,"

existence of its Nazi files challenges some basic tropes about the agency. For one, Black Star's founders are known for introducing American publishers to talented European, mostly German-Jewish photographers such as Martin Munkácsi and Andreas Feininger.[9] The names of Aryanized publishing houses and Nazi-sanctioned photographers stamped onto the backs of Black Star prints show that its founders dealt with a network of professionals—photographers, editors, agents, and secretaries—who met the racial and political parameters for working in Nazi Germany, and thus filled the void left by the countless Jews who had fled Germany and its publishing industry. They suggest that Black Star's American clients valued the founders' connections not only with avant-garde émigrés but especially with state-sanctioned photographers who were allowed to keep working in Germany. And the prints attest to the fact that Black Star's Jewish founders had set aside their politics and personal experiences of racialized discrimination for the sake of their economic survival in the United States.

Lacking any business records to contextualize individual transactions, I employed three methods to better understand the Nazi-era component of the agency's files. I studied the photographs as material objects, counting and comparing their stamped and scribbled-over versos to reconstruct some of the pictures' "social biographies," including where they originated, how they might have arrived at Black Star, and what the agency then did with them.[10] In conjunction with that process, I analyzed Black Star's credits in *Life, Time, Fortune,* and *Look* between 1935 and 1941 to trace where its Nazi-era pictures appeared.[11] Finally, I carried out a material analysis of a representative section of the agency's "historic" files by testing the papers on which the World War I and Nazi-era pictures had been printed. The datasets I produced are hardly complete, nor are they on the same scale as Black Star's black-and-white print collection, but they are indicative of how we can generate new information to elucidate the past, piece by piece.

Zeithistorische Forschungen/Studies in Contemporary History 14 (2017): 2–32.

9 C. Zoe Smith, "The History of Black Star Picture Agency: *Life*'s European Connection," paper presented at the Annual Meeting of the Association for Education in Journalism and Mass Communication, August 1984; Hendrik Neubauer, *Black Star: 60 Years of Photojournalism* (Cologne: Könemann Press, 1998); Michael Torosian, *Black Star* (Toronto: Lumiere Press, 2013).

10 See Elizabeth Edwards and Janice Hart, *Photographs Objects Histories: On the Materiality of Images* (London: Routledge, 2004).

11 I am grateful to Yénesis Alvarez and Ioannis Makridis for their diligent research assistance and analyses of *Life*'s coverage of Nazi Germany.

FIFTEEN CENTS

February 17, 1936

TIME

The Weekly Newsmagazine

Martin Munkácsi

HITLER'S LENI RIEFENSTAHL
At Garmisch-Partenkirchen, woman's work is never done.
(See SPORT)

Volume XXVII

Number 7

Circulation this issue more than 600,000

Figures 2.3 and 2.4
Martin Munkácsi, *Hitler's Leni Riefenstahl*, ca. 1931. *Time*, February 17, 1936, cover. The Image Centre, Toronto.

"Winter Olympics," *Time*, February 17, 1936, 38–39, with five photographs credited to Black Star. The Image Centre, Toronto.

Stamps and Scribbles

Newspapers and magazines published a steady stream of stories on Hitler's consolidation of power and the international spread of fascism in the 1930s.[12] They turned to the leading picture services of the day—including AP, Wide World, Acme, and the International News Service—for images to illustrate those stories. As a news-picture agency (that is, not solely a historical image bank such as that established by Bettmann), Black Star competed with those organizations by offering a fast, reliable flow of photographs that its clients could use. In addition to employing its own photographers and serving as the American distributor for photographers represented by agencies outside the United States, Black Star became the American clearing house and distributor for Mauritius and Ullstein. The agency paid the latter at least $3,000 per year for the rights to distribute its photos in the United States and offer them to *Life* on a first-look basis.[13]

One notable event took place before *Life*'s November 1936 launch. The Berlin Olympic Games were the first major story Black Star helped cover via its arrangement with Ullstein, and those pictures appeared mostly in *Time*.[14] The magazine's February 17, 1936, cover features "Hitler's Leni Riefenstahl" climbing a snowy peak on skis, shot from below, the sun glistening on her skin, her athletic form and exposed limbs accentuated by the camera angle and filling up the tightly cropped frame (fig. 2.3). Inside, a double-page spread of skiers, sledders, and ice skaters in action credits five photographs to Black Star (fig. 2.4). The cover, by Munkácsi, is not credited to Black Star but was almost

12 The vast literature on wartime reporting includes Deborah Lipstadt, *Beyond Belief: The American Press and the Coming of the Holocaust, 1933–1945* (New York: Free Press, 1986); Michael Zalampas, *Adolf Hitler and the Third Reich in American Magazines, 1923–1939* (Bowling Green, OH: Bowling Green State University Popular Press, 1989); and most recently, Deborah Cohen, *Last Call at the Hotel Imperial: The Reporters Who Took on a World at War* (New York: Random House, 2022).

13 Kornfeld, *Passionate Publishers*, 234–37.

14 Today Black Star's hundreds of Olympic Games pictures are dispersed throughout the Black Star Collection, an indicator of the press's established taste for pictorial reporting on sports. They are largely under the SPORTS or PERSONALITIES subject headings, such as when notable leaders arrived at the Games. The decision whether to file Hitler at the Olympics under PERSONALITIES/HITLER or SPORTS/OLYMPICS 1936 rested with the person handling pictures at Black Star at any given time; Launois, interview.

certainly sourced by the agency as well, as Safranski had worked with Munkácsi at Ullstein and remained in touch with him in New York, when both worked for Hearst.[15] The undated picture is likely a pre-1935 portrait of Riefenstahl, made before the Nuremberg racial laws went into effect.

In fact, most photographs in Black Star's "historic" files were shot by Nazi-sanctioned photographers. They included Heinz Fremke, who photographed Hitler and the war until 1944. His name ("Ullstein–Fremke," in purple) can be made out below the more legible red "Ullstein Bilderzentrale" stamp on the back of an image of Berlin's Olympic Stadium, its bleachers packed with spectators (fig. 2.5).[16] The Nazi photographer Dr. Paul Wolff is even better represented. His illustrated book on the Olympics, *Sports Shots,* appeared in the United States with Black Star's help, and his Olympic pictures now fill the print boxes corresponding to what used to be "Drawer 70" in Black Star's picture library.[17]

Wolff also took the close-up portrait of a saluting Hitler that appeared on the cover of *Time* on April 13, 1936—the first magazine cover credited to Black Star (fig. 2.6). The photo is difficult to date, given the blank background and the absence of any details suggesting the time or place where Hitler was posing. Such details corroborate the idea that Ernest Mayer, whose agency, Mauritius, had represented Wolff since the 1920s, had brought with him a Hitler personality file when he emigrated in 1935.[18] Eight months after the *Time* cover, another Hitler portrait by Wolff (from what may have been the same sitting) appeared in a *Life* pictorial survey packed with thirty historical photos tracking Hitler's rise to power. Wolff's portrait was part of a six-picture strip exploring "the faces of der Fuehrer." Its small scale and placement attest to how most Black Star photos from Nazi Germany were used in Time Inc. publications between 1936 and 1938.[19]

Figure 2.6
Dr. Paul Wolff, *Adolf Hitler,* ca. 1934. *Time,* April 13, 1936, cover. The Image Centre, Toronto.

15 Munkácsi joined Ullstein after his arrival in Berlin in 1928. Following his 1934 move to New York, he was hired by Carmel Snow to work for *Harper's Bazaar,* a Hearst publication; Peter Baki, Colin Ford, and George Szirtes, *Eyewitness: Hungarian Photography in the Twentieth Century* (London: Royal Academy of Arts, 2011), 230.

16 "Heinz Fremke," Encyclopaedia [of photographers], Fotostiftung Schweiz, Zurich, https://www.fotostiftung.ch/en/nc/encyclopaedia/.

17 Paul Wolff, *Sports Shots* (New York: William Morrow, 1937).

18 Kornfeld, *Passionate Publishers,* 188, 401.

19 "Hitler on High," *Life,* December 7, 1936, 23–28. Wolff's photo is on the bottom left of page 23. One other picture credited to Black Star is on page 24, showing the site of Hitler's 1923 Beer Hall Putsch.

April 13, 1936

TIME

The Weekly Newsmagazine

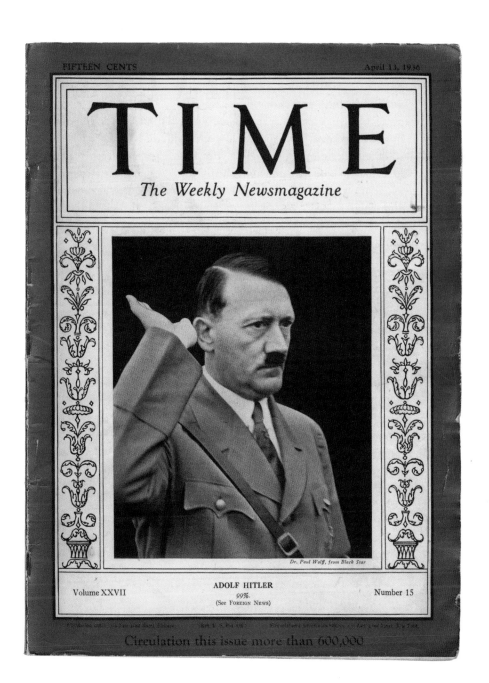

Dr. Paul Wolff, from Black Star

Volume XXVII

ADOLF HITLER
99%.
(See FOREIGN NEWS)

Number 15

Circulation this issue more than 600,000

Rather than serving as covers or constituting entire photo essays, the Black Star–sourced pictures appeared alongside images from the Associated Press, Keystone, Acme, Pictures International, and Wide World, which collectively supplied far more images than Black Star could. While multiple agencies and photographers claimed that they dominated *Life*'s early coverage, in reality no single agency could have supplied the weekly with the range of pictures it needed. The Hitler story is thus indicative of how Black Star's early Nazi images functioned as both news and stock photos. Black Star's files often helped *Life* fill in one or two visual gaps with a monument or building here, a portrait or piece of machinery there.[20] The credits for the Hitler story also demonstrate that, in the lead-up to World War II, multiple picture organizations cooperated with Nazi Germany to get photos into the American press.

Picture Credits and Magazine Coverage

The nature of Black Star's picture supply shifted in 1938 with Germany's increasing attacks on Jews and preparations for war. In 1937, as part of the effort to erase Jewish names from Germany's economy, Ullstein was renamed Deutscher Verlag. The hundreds of prints in the Black Star Collection stamped "DEVER" or hand-labelled "D.V. from Black Star" thus must have arrived at Black Star after 1937. While sending photographs to New York was one thing, getting the pictures into print was what made Black Star money, and, coincidentally, what marked the pictures as a public relations coup for Nazi Germany. As SS-Obersturmführer Helmut Laux, personal photographer to the Nazi foreign minister, Joachim von Ribbentrop, acknowledged, even pictures that seemed neutral to non-Germans, "seen from a German viewpoint, [do] not lack in propagandistic value. . . . considering existing circumstances, it is definitely an advantage to the German cause if a German picture is published in the neutral press at all."[21]

20 Circa 1936–37, photos of Nazi Germany and/or Hitler in *Life* were often published in the "Camera Overseas" feature at the back of the magazine, until the coming of the war moved news of Germany, along with an expanded version of that international feature, to the front of the magazine in 1939.

21 Quoted in Domeier, "Secret Photos," 18.

After 1938, the Nazi-related photographs sourced by Black Star and published in *Life* and *Look* were hardly neutral. They increasingly deified Hitler, securing his place as a leading celebrity. They read as propaganda pictures more so than news, not only because of what they show, but also how they were reproduced and arranged. Whereas "Ullstein from Black Star" photos appeared mostly as historical stock illustrations for larger stories sourced from multiple collections, "DEVER from Black Star" supplied entire stories about Nazis and the Führer. These illustrated features were part of a purposeful campaign, led by the German Ministry of Propaganda, to transform Hitler's image from small-town rabble-rouser and sexual deviant to cultured leader, and even desirable bachelor.

A one-page feature in the June 19, 1939, issue of *Life*, attributed to "DEVER from Black Star," consists of three large-scale photographs of a party at the home of Foreign Minister von Ribbentrop. While the captions explain that the event was held for "Italy's visiting Foreign Minister Count Ciano, who had just signed the Rome-Berlin military pact," the pictures focus exclusively on Hitler's new white military uniform, which he unveiled at the party (fig. 2.7). Escorting his hostess and watching a performance surrounded by "Nazi beauties," Hitler appears strikingly composed and refined in the feminized surroundings. The pictures invite a sumptuous survey of the tulle, satin, furs, and jewels on display. A romantic haze envelops the gathering. These photos undermine the crisp, symmetrical, militaristic aesthetic of earlier Nazi photographs published in the magazine. Hitler is no warmonger set on destroying races, but a bourgeois gentleman enjoying his leisure time.

Look's feature from the year before, also credited in full to Black Star, is striking in light of the other missing piece of The Image Centre's Black Star Collection: colour photography. Black Star returned its colour transparencies and prints to the photographers between 2000 and 2005, as the agency dismantled its picture files, reinforcing the long-standing equation of serious reporting and history with black-and-white photographs. Black Star's "Adolf Hitler's New Palace," published across two pages in *Look*'s January 17, 1938, issue, is a reminder of the early appeal of colour photographs and magazines' commitment to publishing in colour, even though the process was initially slow and expensive.[22] The feature leads viewers through the Führer's Munich

22 Vanessa Schwartz, *Jet Age Aesthetic: The Glamour of Media in Motion* (New Haven, CT: Yale University Press, 2020), 141–48.

HITLER UNIFORM

Hitler's famous uniform is a simple brown Storm Trooper jacket with Iron Cross. May 22 he appeared for the first time in something new—a white belted coat, single-breasted with patch pockets. It was slightly different from the double-breasted summer uniform coats of his Nazi subordinates. The occasion was a party for Italy's visiting Foreign Minister Count Ciano, who had just signed the Rome-Berlin military pact. The party was given in his Dahlem villa outside Berlin by Germany's Foreign Minister von Ribbentrop, onetime champagne salesman, whose wife is a champagne heiress. Present were two new Nazi beauties, Actress Olga Tschechowa and the blonde, slim wife of Labor Front Leader Robert Ley.

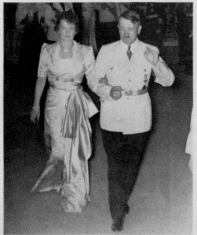

In his new uniform, Hitler leads his hostess, Frau Annelies von Ribbentrop, in to the entertainment. He wears an Iron Cross First Class over his heart and an official eagle tie-pin.

Nazi beauties are, from left, Frau Emmy Göring, onetime actress, pretty Frau Ley and the wife of Italy's Ambassador Attolico; and, at extreme right, Labor Front Leader Robert Ley.

FROM LEFT: NO. 2 NAZI GÖRING; HOSTESS FRAU VON RIBBENTROP; HITLER; ACTRESS OLGA TSCHECHOWA; AND BEYOND THE POST, FRAU GÖRING AND GUEST-OF-HONOR CIANO

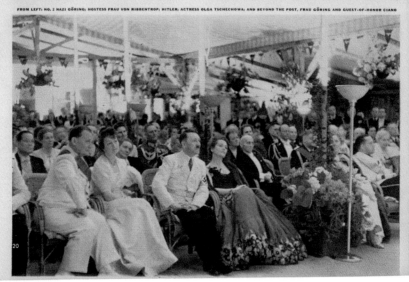

apartment, renovated and redecorated in 1935 by Atelier Troost and paid for with Hitler's royalties from the sales of *Mein Kampf* (fig. 2.8). As architectural historian Despina Stratigakos has shown, showcasing the interior design and decor of Hitler's homes was integral to transforming his image into one of a refined leader with whom global diplomats could converse and find common ground. Although the Berghof, Hitler's chalet in the Alps, is the best known, his modern Munich apartment was where he hosted international leaders in the mid-1930s, to "erase any memory of lurid rumors of moral degeneracy once associated with his private life" and convince them of his non-belligerency.[23]

Hitler agreed to have his apartment photographed for publication on the occasion of Neville Chamberlain's visit following the signing of the Munich Agreement. The job fell to Heinrich Hoffmann, Hitler's personal photographer, whose picturesque colour scenes of the Berghof were often reproduced as postcards. *Look* made special note of its exclusive publication of these colour images with a short text that satirized Hitler's megalomania and attempted to disentangle politics from the "skill of contemporary German craftsmen." The photographs allowed readers to appreciate the "exquisite furnishings and interior decorations" of the marble-and-limestone interiors and to study Adolf Ziegler's *Four Elements* (now recognized as an important example of the Nazi neoclassical nude), which evidently adorned Hitler's fireplace in the "little living room."

Although they are not credited to him in print, the apartment photographs were almost certainly taken by Hoffmann and distributed to Black Star by the German Ministry of Propaganda. Multiple black-and-white prints at The Image Centre bear Hoffmann's stamp, suggesting a longer history of Black Star's receiving and publishing his pictures. Indeed, Hoffmann was a known entity in the American press. Just a month before, *Life* had published his private snapshots of Hitler with children to explain the workings of Nazi propaganda.[24] But if *Look* had attributed the interior pictures simply to Hoffmann, the magazine could be accused of uncritically reproducing Nazi handouts. The Black Star credit thus obfuscated the Hoffmann source and allowed the feature to function more like a *House and Gardens* spread about the homes of the rich and famous—a genre that had taken off in the previous decade, and on which Hitler's publicists capitalized by staging and circulating photographs of his homes.

Figure 2.7
DEVER from Black Star, "Hitler Uniform," *Life*, June 19, 1939, 20. The *Life* Magazine Collection, Gift of Peter Elendt, 2011, The Image Centre, Toronto.

23 Despina Stratigakos, *Hitler at Home* (New Haven, CT: Yale University Press, 2015).
24 "Speaking of Pictures: This Is 'Jugend um Hitler,'" *Life*, December 6, 1937, 6–9.

THE FIREPLACE IN THE LITTLE LIVING ROOM

HITLER'S SMALL STUDY

TAPESTRIES DECORATE THE CONGRESS ROOM

Adolf Hitler

THE Fuehrer House, triumph of Nazi architecture, was the stage for the Munich conference, triumph of Nazi diplomacy. Situated
on Munich's Koeniglicher Platz, it was built
as a monument to perpetuate the fame of Dictator Adolf Hitler and his works.

A Nazi Athens

The Fuehrer House, the first of three neoclassic buildings to be completed, marks the
first step toward making Munich the Athens
of Nazidom. The House serves as a headquarters for Hitler, and is used for Nazi ceremonies and conferences.

Built of marble and limestone, the structure was designed by the late Paul Ludwig
Trost and completed by Prof. Leonhard Gall.
Mrs. Trost supervised the interior decoration.
The paintings in the "little living room" (upper left) were done by Prof. Adolf Ziegler,
Hitler's friend who conducted the recent Nazi
purge of "degenerate art."

Bomb-Proof Cellars

The ground floor is reserved for staff
quarters. The second floor contains the Fuehrer's study, Nazi living rooms and banquet
halls. The third story holds the huge drawing
room where Nazi congresses meet. As a safety
precaution there are four bomb-proof stories
underground, intended as air-raid refuges.

LOOK here publishes, for the first time in
America, colored interiors of the Fuehrer
House. The exquisite furnishings and interior
decorations are cited as proof of the taste and
skill of contemporary German craftsmen.

SECTION OF THE SMALL GALLERY

MARBLE PILLARS IN THE HALL

ew Palace

A DINING ROOM FOR 60 GUESTS

Figure 2.8
(previous page)
Black Star, "Adolf Hitler's
New Palace," *Look*,
January 17, 1939, 26–27.
Private collection, Clinton,
New York.

Taken together, the stories in *Life* and *Look* indicate the careful crafting of Hitler's celebrity. It is tempting to search the captions and story copy for signs of editorial disapproval with the Nazi leader—which do appear. But no amount of reading between the lines can undo the very clear visual evidence of the cult of the Führer, produced in Germany and exported piecemeal to the American illustrated press. Even the incomplete records that remain point to Black Star's role in producing that image and reputation. Such pictures passed through its offices frequently enough that they began to feed the rumour mill of New York City's publishing world. What exactly was the nature of Black Star's connections with Nazi Germany? At *Life*, Wilson Hicks heard that the agency was engaged in espionage. Photo agent Fred Lewis heard that it was disseminating Nazi propaganda. Some claimed the prints were free handouts. In 1939 the FBI opened an investigation into Black Star as possible agents of Nazi Germany, and even suggested that, like other Nazi spies in America, the founders were using their Jewishness as a cover to spread propaganda.[25] The investigation focused on Black Star's cable correspondence with international contacts and the possibility that the agency was sending images of military significance to Germany. The founders' connections to Deutscher Verlag—and the visually attractive Hitler coverage DEVER provided—did not escape FBI attention either.

The founders were in a tenuous position when the FBI investigation began in August 1939: not yet American citizens but already powerful figures in American publishing. They cooperated with the authorities for the three years of the investigation, which included a six-month freeze on Black Star's accounts in 1942. For a business premised on circulating both pictures and money, a bank-account freeze meant halting the entire operation. It is not surprising that Black Star reported operating at a loss in 1942. The agency told the FBI that it had also lost money in US sales between 1937 and 1940, leading Safranski to advance funds to it. It is possible that the founders reported those figures to underscore that they were not making a profit from their connection to Deutscher Verlag.

The testimonies gathered by the FBI in Black Star's defence were even more effective at clearing its name, and they attest to Black Star's connections and

25 Kornfeld, *Passionate Publishers*, 271–328. The US government, press, and public were preoccupied with fears of Nazi spy networks on the eve of World War II. Anti-Semitism, xenophobia, and anti-immigration sentiments meant that such fears were often targeted at German-Jewish refugees. Lipstadt, *Beyond Belief*, 121–131.

stature. Those who came to the agency's defence dismissed the accusations as rumours spread by jealous competitors who hoped to see Black Star eliminated to help their own position in the business.[26] Even if the firm was losing money in those years, it still had a reputation as one of the most competitive picture agencies in New York, in part because of its connection to Germany. Neither did supporters see the Black Star–DEVER connection as anything out of the ordinary. In their testimonies, editors and journalists cited not only AP but also United Press, NBC, CBS, and Wide World as dealing with Nazi Germany.[27] Distribution of Nazi photos in the United States, as well as supplying American photos to Nazi Germany, was the rule rather than the exception in wartime.

Many of the Nazi-era prints that came to Black Star are now filed in boxes corresponding to "Drawer 97," labelled WWII/GERMANY/NAZI PARTY. This subject heading does not suggest anything about the pictures' provenance or the federal investigation they sparked, but the backs of the prints do. A later print from the war, subsequently marked "Poland" and "Hitler at the East Front" in cursive handwriting, bears signs of an official German stamp identifying the scene—"*Der Führer in Warschau* 5.10.1939"—and the red Mauritius sticker, stamped over with Black Star's credit line (fig. 2.10). Part of a typed caption in English remains, taped over what is likely where the original German caption was rubber-cemented. And below, in red, a stamped statement reads: "The reproduction right of this photograph is only granted with the distinct understanding that it will be used or published in strict accordance with the laws and regulations of the U.S. government." The wording suggests that Black Star decided to add this stamp to its prints in the middle of the FBI investigation, to ensure that they would be used according to US law in wartime. The verso of the print thus contains signs of both Black Star's German connections and its struggle to be perceived as a patriotic player in the American picture economy.

Paper: The Materiality of the File

While analyzing stamp patterns and tracking magazine credits reveal the patterns in the agency's Nazi picture trade described above, my third method

26 Kornfeld, *Passionate Publishers*, 279.
27 Kornfeld, *Passionate Publishers*, 289–91.

involved studying the actual paper on which Black Star's pictures were print-ed. This approach, developed by photo conservator Paul Messier and now being refined with a team of researchers at the Yale Lens Media Lab (YLML), uses specialized tools to measure the primary factors that contribute to a print's visual impact: its texture, gloss, highlight colours, and thickness.[28] As Messier notes, "An expressive paper—rough, matte, warm-toned and thick—signals interpretative subjectivity. A functional paper—smooth, glossy, white, and thin—projects objective reality through an implied conveyance of documentary fact."[29] In other words, photographs printed on smoother, glossier paper render detail better than rougher matte papers. Moreover, the coolness of the white of smooth papers increases contrast, which creates greater detail and tonal range in the final print.

Measuring such features at scale means that a photographer's working practice can be quantified and connections made across multiple collections, despite aging and deterioration. The comparative aspect of these methods means they might help contextualize a period of photographic production when no other archives are available. I was prompted to attempt this approach after learn-ing that the estate of August Sander was implementing Messier's tools to study the career of the highly regarded German photographer, whose business papers were destroyed during World War II. Studying Black Star's photographic papers was not intended to yield conclusive answers about the agency's early history; rather, this was an experiment to see what a material-based approach might yield. Could we test the legendary suitcase story by analyzing the earliest-looking prints? Were there any themes and patterns in the agency's World War I and World War II prints, both on their own terms and in comparison with the larger universe (or "genome") of papers being studied at the YLML? And might such methods offer some insight into the interwar workings of the photo agency, thus offering alternative ways to describe the files, beyond what researchers could see on the photographs' rectos and versos?

28 Texture is measured using a microscopy-based imaging system that illuminates the surface of the print with low-angle raking light. Gloss is measured with a glossmeter, colour with a spectrophotometer, and thickness with a micrometer.

29 Paul Messier, "Image Isn't Everything: Revealing Affinities across Collections Through the Language of the Photographic Print," in *Object: Photo: Modern Photographs; The Thomas Walther Collection, 1909–1949*, ed. Mitra Abbaspour, Lee Ann Daffner, and Maria Morris Hambourg (New York: Museum of Modern Art, 2014), 332.

To prepare for measuring the texture, gloss, thickness, and colour of 110 representative prints from four subject headings—WWI, WWII/HISTORIC, GERMANY/WWII, and ULLSTEIN—each stamp appearing on the backs of the prints received a unique identification number. The forty-eight unique stamps included different variations for Mauritius, Max Pohly, Ullstein, Heinrich Hoffmann, DEVER, Paul Mai, and Ilse Collignon, attesting to the range of photographers and sub-agents involved in the Black Star circulation network. The tests showed a close correlation between the stamps and the material characteristics of the prints. From this outcome we can infer that the stamps correlate to printers: that the agents or suppliers who sold to Black Star employed their own printers, who used specific papers to print their clients' work. Although we do not know which printers Mauritius and Ullstein used in Germany, Black Star, which operated out of the Graybar Building at 420 Lexington Avenue in New York, initially relied on neighbouring midtown labs such as Leco Photo Service. Its subsequent arrangement with the lab founded and initially run by Black Star photographers Werner Wolff and Joe Covello, which essentially became its in-house photo lab, affirms the practical necessity of agency–lab partnerships.[30]

By definition, photo agency prints are functional and made to be reproduced. Thus it was not surprising to find that they are all glossy, relative to the photographic papers previously analyzed by the YLML. But there are also discernible differences between the World War I and World War II prints. The former are thicker and more matte, the latter thinner and glossier. Even though the suitcase story can never be corroborated, such material differences confirm the founders' account of starting the agency with a batch of prints brought from Europe. Older papers tend to be more expressive, though they are not by default thicker. After 1930, standard single-weight papers became thicker than their predecessors.[31] The thickness of the World War I prints thus suggests an intended use. Photographers or agents might have been inclined to use thicker, heavier-weight paper in order to make a good impression, or when they knew the print needed to last a long time, for instance, standing up to multiple mailings and frequent handling. A heavier weight of paper also

30 Torosian, *Black Star*, 45–46.

31 Jennifer Mcglinchey Sexton and Paul Messier, "Photographic Paper XYZ: De Facto Standard Sizes for Silver Gelatin Paper," *Journal of the American Institute for Conservation* 53, no. 4 (November 2014): 228.

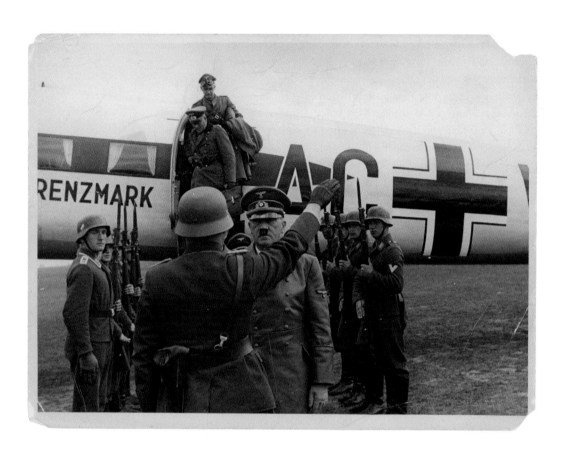

Figures 2.9 and 2.10
Friedrich Franz Bauer/
Mauritius, *Hitler Exits His
Personal Plane, Grenzmark,
in Warsaw, Poland*, 1939
(recto and verso). Gelatin
silver print, 18.0 x 23.9 cm.
BS.2005.163302.

implies a larger investment. Such patterns suggest that Safranski and Mayer were not only looking at images when choosing which prints to take with them to the United States; they were also weighing up their physical properties and considering a combination of pictorial content and material qualities that would endure over time.

By contrast, the World War II prints in the Black Star Collection are generally glossy and thin. Gloss is the most important defining feature of photojournalistic prints, because gloss increases the optical saturation of an image, making the blacks look deeper and increasing the tonal range, thus allowing the print to pack in more visual information. Because that information gets collapsed in magazines or newspapers that use the halftone process, starting with a maximally informative print is key. The glossiness of Black Star's World War II prints confirms that they were made in order to circulate rapidly in a press system of increasingly centralized agencies and clients. In fact, Black Star's prints are the glossiest in the YMLM's current genome, with one actually falling outside the sample range. The outlier was most likely ferrotyped, that is, drum-dried with the help of heat and pressure.

Because the YLML universe currently includes only naturally dried papers, the outlier will make better quantitative sense in the future, once the Yale lab processes its sample books of ferrotyped papers. To make sense of that quality today, it is instructive to look back to the instructions Kurt Safranski codified in *Selling Your Pictures*, his 1940 manual on the picture industry aimed at budding photographers. The surface of a print, he writes, should be "glossy, preferably ferrotyped. Glossy finish is still the most desirable for all kinds of reproduction because of its brilliance and ability to show up maximum detail."[32] He also warns photographers that single-weight papers bend, curl, and tear easily, and goes so far as to prescribe the correct way to flatten and secure prints before mailing them to clients. Safranski's text offers confirmation of what the paper analysis shows about the Black Star files, beginning with his observation that all the editor wants is a "good, clear, sparkling print."[33]

Safranski's emphasis on print clarity and gloss is a reminder that the materiality of press agency prints mattered then and that we need to continue taking that materiality seriously now. Getting into the material mindset can

32 Kurt S. Safranski, *Selling Your Pictures* (New York: Ziff-Davis, 1940), 57.
33 Safranski, *Selling Your Pictures*, 57.

feel unnatural for a historian used to analyzing what photographs depict or how they appear in print. Picking up a print of Mussolini's foreign minister shaking hands with his Nazi counterpart (sent to Black Star from Ullstein), but only to measure the thickness of the paper on which the visibly retouched image appears, requires an uncomfortable separation between what can be observed—signs of the picture's utility as illustration for news outlets—and what only a micrometer can detect, and what only an equation can make sense of in relation to a much larger dataset. Such work feels disorienting in its decontextualization.

The experience can be compared to one's first impression of the Black Star Collection at The Image Centre, where one finds Adolf Hitler sandwiched between Alfred Hitchcock and tennis player Lew Hoad. Such encounters are a reminder that photo agency files have their own logic, aimed at picture workers operating in the future, with their own conception of the value of photographs. In the course of our conversation, picture librarian Yukiko Launois recalled that the Black Star offices had some "very old" prints stored in "very, very old metal cabinets" in a dark corridor. For Launois, who spent decades at Black Star filling magazine and book publishers' requests for contemporary colour transparencies, "DEVER" and "Ullstein" were dormant files. They contributed little to a picture agency that made money from reproduction rights.[34] The photographs that had served as the foundation for a new agency in the 1930s had lost their utility by the 1960s, but they re-emerged in the twenty-first century as tangible traces of Black Star's connection to Nazi Germany.

To better understand Black Star's origins and its connections to the Nazi photo-distribution system, the data that scholars use—whether from stamps, picture credit patterns, or paper measurements—need to grow exponentially, quantitatively approximating the number of prints in the Black Star Collection. In other words, scholars need to work as collaboratively and on as large a scale as was necessary to run a photo agency in the 1930s, and to invest in the "futurepast" potential of our research. Only when such methods are "networked at meaningful scale" can Black Star be more fruitfully compared to other collections, so that new stories about its history can be told.[35]

34 Launois, interview.

35 Messier, "Image Isn't Everything," 337–38.

Dismantling Photographic Authorship

The Many Voices of Max Pohly's "German History" in the Black Star Collection

Christian Joschke

For more than a century, names have been, if not the only, at least the most convenient information for ordering, identifying, and dating photographs: by naming photographers, historians flag their production, ranking them in prominent or secondary groups of image producers. Even though the photo market and many museums have continued employing the notion of a single authorship in photography, photo historians such as Abigail Solomon-Godeau, Anne McCauley, and Ulrich Keller have worked towards a social and critical history of photography that helps deconstruct the notion of authorship, contextualizing the production of commercial photos.[1] More recently, historians of the illustrated press such as Michel Frizot, Olivier Lugon, Estelle Blaschke, Anton Holzer, Wolfgang Hesse, Andrés Mario Zervigón, Vanessa Schwartz, Jason Hill, Nadya Bair, Jonathan Dentler, and the editors of this volume have focused on the many professions and skills that came together in the production process of illustrated press and visual information, and they have taken into account the material conditions of the production and consumption of images.[2]

Figure 3.1
Unknown photographer, *Polizei-Hundeanstalt in Kummersdorf* (Police dog training in Kummersdorf), 1930-36 (detail). Gelatin silver print, 10.5 x 16.0 cm. BS.2005.122162.

1 Abigail Solomon-Godeau, *Photography at the Dock: Essays on Photographic History, Institutions, and Practices* (Minneapolis: University of Minnesota Press, 1991); Anne McCauley, *Industrial Madness: Commercial Photography in Paris, 1848-1871* (New Haven, CT: Yale University Press, 1994); *L'événement: Les images comme acteurs de l'histoire*, ed. Michel Poivert (Paris: Hazan/Jeu de Paume, 2007).

2 Michel Frizot and Cédric de Veigy, Vu: *Le magazine photographique, 1928-1940* (Paris: De La Martinière, 2009); Michel Frizot, *L'homme photographique: Une anthologie* (Vanves: Hazan, 2018); Olivier Lugon, *Nicolas Bouvier, iconographe* (Geneva: Infolio, 2019); Estelle Blaschke, *Banking on Images: The Bettmann Archive and Corbis* (Leipzig: Spector Books, 2016); Anton Holzer, *Die andere Front: Fotografie und Propaganda im ersten Weltkrieg* (Darmstadt: Primus, 2012); Wolfgang Hesse, ed., *Das Auge des Arbeiters: Arbeiterfotografie und Kunst um 1930* (Leipzig: Spector Books, 2014); Andrés Mario Zervigón, "Persuading

Similar to most well-known photo agencies of the post–World War I era, Black Star noted the names of the photographers on the backs of the prints and often gave credit to them in *Life* and other publications. These names refer mostly to the producers—the ones who shot the pictures—even though there is sometimes little known about them. The historian must therefore inquire deeply in other archives in order to find out biographical elements, match the original prints with the magazine reproductions, cross-reference different types of sources to identify the exact person behind a name, and sometimes examine the production chain of press photographs.

Within the Black Star Collection, one name—Max Pohly—occurs on photographs depicting subjects that were important for the interwar period: the instability of German democracy and the rise of National Socialism. These photos, which also include images depicting World War I, have drawn attention from curators and museums in the past decade because they belong to the part of the Black Star Collection that existed before the agency was founded. The founders established the agency in 1935 with pictures they brought from Europe and then added this other European collection of Max Pohly's. The photos have recently been displayed and commented on as the productions of a photo-reporter who is supposed to have been present on several battlefields in northern France, Italy, and Gallipoli, to have assisted in the German revolution of 1918 in Munich and Berlin, and to have documented the rise of the German National Socialist Party. Max Pohly has therefore been presented as a heroic photo-reporter of this time.

This case is nonetheless rather enigmatic. Given the many areas and periods covered by the images attributed to Max Pohly, we might well be skeptical about the idea of a single authorship. Therefore, while working in the Black

with the Unseen? *Die Arbeiter-Illustrierte-Zeitung*: Photography and German Communism's Iconophobia," *Visual Resources* 26, no. 2 (2010): 147–64; Vanessa R. Schwartz, *Jet Age Aesthetic: The Glamour of Media in Motion* (London: Yale University Press, 2020); Jason E. Hill and Vanessa R. Schwartz, eds., *Getting the Picture: The Visual Culture of the News* (London: Bloomsbury, 2015); Jason E. Hill, *Artist as Reporter: Weegee, Ad Reinhardt, and the* PM *News Picture* (Oakland: University of California Press, 2018); Nadya Bair, *The Decisive Network: Magnum Photos and the Postwar Image Market* (Oakland: University of California Press, 2020); Jonathan Dentler, "Images câblées: La téléphotographie à l'ère de la mondialisation de la presse illustrée," *Transbordeur* 3 (2019): 14–25; Thierry Gervais, with Gaëlle Morel, *La fabrique de l'information visuelle: Photographies et magazines d'actualité* (Paris: Textuel, 2015); Vincent Lavoie, *L'affaire Capa: Le procès d'une icône* (Paris: Textuel, 2017).

Star Collection, I conducted an inquiry on this portion of the collection, using material in German archives and publications and US federal and local archive about German immigrants. I was able to unravel the case and undermine the lure of authorship regarding this confusing situation, which tells us much about the transatlantic fate of image dealers and picture editors. It also helps us understand how the circulation of photographic material has been transforming even the information provided by the images themselves.

Who Was Max Pohly?

The name Max Pohly appears on 1,265 photos in the Black Star Collection, which statistically makes him one of the most important providers of images—but that's still less than one percent of the whole collection. Some research on him had already been conducted. An exhibition in Ottawa about World War I displayed some photos of the war from the Black Star Collection, and he is mentioned as the author. The short biography provided in the exhibition's catalogue claims that he was born in 1888 in Göttingen, lived in Wolfenbüttel, and worked for Ernst Mayer's Berlin-based agency, Mauritius, before being deported to Warsaw in 1942.[3]

The website Stolpersteine Wolfenbüttel, which gathers biographical information about victims of the Nazi regime, has published an extended biographical note about a person named Max Pohly.[4] Born in 1878 in Seesen, fifty kilometres from Göttingen, this man worked as a gardener in Wolfenbüttel; he was eventually deported to the Warsaw ghetto in 1942 and died, probably in one of the Nazi concentration camps. No information is provided about his working as a photographer for Mauritius. Should that have been the case, he wouldn't have lived in Wolfenbüttel, given the subjects of the photographs attributed to Max

3 Anthony Petiteau and Ann Thomas, *The Great War: The Persuasive Power of Photography/La Grande Guerre: Le pouvoir d'influence de la photographie* (Ottawa: National Gallery of Canada, 2014), illus. 42. See also its review by Nathalie Neumann, "Fotografie im Krieg: Eine Perspektive aus Kanada," *Fotogeschichte* 137 (Spring 2015), https://www.fotogeschichte.info/en/back-issues/issues-126-149/137/rezension-neumann-fotografie-im-ersten-weltkrieg/.

4 "Max Pohly," Stolpersteine Wolfenbuettel, https://www.stolpersteine-wolfenbuettel.de/biografien.

Pohly: World War I, the Spartacist revolution, the rise of the Fascist move-ment, and so forth. So the clue leading to the gardener from Wolfenbüttel is obviously misleading. There must have been more than one Max Pohly at that time, and the gardener was surely not the photographer.

The pictures provide us with some elements of his professional curricu-lum. On the backs of the prints can be seen different stamps mentioning the name Pohly. The first series of stamps goes back to when he was active in Berlin (fig. 3.2). They give several street addresses in the German capital: Berlin Wilmersdorf, Geisbergstrasse 25–26, Fernruf [phone] 24 34 32; Berlin W 50, Geisbergstrasse 25–26, Fernruf 24 34 32; and Berlin Wilmersdorf, Hamburger-strasse. These addresses match Berlin's city directories from 1935 and 1936, which include a Max Pohly on Hamburgerstrasse in Wilmersdorf. They also match those dated 1937 and 1938, which give another address for the same name: Geisbergstrasse 25–26 in Wilmersdorf. Prior to these dates, the addresses of Max Pohly found in Berlin city directories are Kaufmann Schöneberg, Rubensstrasse 45 (in 1926) and Kaufmann, N 65, Togostrasse 18 (in 1929 and 1930). Neither of these latter addresses is mentioned on any of the Black Star photographs. Since the stamps include only addresses found in city directories dated 1935 to 1938, and no stamp uses Max Pohly's home address prior to that date, the deduction can be made that he began selling pictures around 1935.

On most of the prints the marks mentioning his German address have been scratched out or erased and replaced with a residence in New York City (fig. 3.3). The new stamp says "RETURN TO / MAX POHLY / 634 W. 135TH ST., N.Y.C. / ALL RIGHTS RESERVED"—which leads us to the United States. Further research I conducted on the website Ancestry.com provided more results. Someone named Max Pohly, born in Göttingen on September 14, 1884, emigrated to New York on the ship *Statenham* from Southampton, England; he arrived on December 23, 1938, with his wife, Johanna, whom he had married on September 9, 1922.[5] He enlisted in the army in 1942 and applied for US citizenship on March 14, 1945, giving as his address 634 West 135th Street, New York (which matches the address

5 "Passenger and Crew Lists of Vessels Arriving at New York, New York, 1897-1957," microfilm publication T715, NAI 300346, Records of the Immigration and Naturalization Service, National Archives at Washington, DC.

Figure 3.2
Unknown photographer,
Chapter House, Zwettl Abbey,
Austria, ca. 1915 (verso). Gelatin
silver print, 23.9 x 19.2 cm.
BS.2005.003743.

Figure 3.3
Unknown photographer, *View of Karlovy Vary, Czech Republic*, ca. 1915 (verso). Gelatin silver print, 9.7 x 14.4 cm. BS.2005.006681.

stamped on the back of the prints) and his profession as night watchman.[6] He married Marta Lehmann on July 15, 1944, in Manhattan and died a year later, on September 3, 1945.[7]

This Max Pohly is thus not to be confused with his namesake in Wolfenbüttel. He clearly emigrated from Berlin to New York via Southampton and carried in his luggage more than 1,000 press photos from his collection. Pohly's contact with Black Star might have gone through Ernest Mayer, the former owner of Mauritius, who was then an associate of Kurt Safranski and Kurt Kornfeld. Pohly's story is much closer to that of the founders of Black Star than to a photographer's biography. Those three German Jews who fled the Nazi regime and took shelter in New York City are supposed to have emigrated with approximately 5,000 photos before launching the agency in New York.[8] Pohly's photos fuelled Black Star's picture library, where they were given a new (third) stamp while still crediting Max Pohly in New York City.

Nonetheless, a more fundamental question arises that says a lot about how we deal with photo history: Did Max Pohly actually take these photographs? And how is it that we infer his authorship of the images? In order to answer this question, we must look at the photographs themselves and make a critical appraisal of the marks on the backs.

Failed Attributions

The photos credited with the name Max Pohly all refer to German history from World War I to World War II. They can be separated into two different groups. The first and most important group is related to German monuments and sightseeing: castles from Kulm to Potsdam; churches; beautiful small

6 National Archives and Records Administration, registration card 3850; "Declarations of Intention for Citizenship, 1/19/1842–10/29/1959," NAI 4713410, Records of District Courts of the United States, 1685–2009, no. 21, National Archives at Philadelphia, PA.

7 Licence no. 18669, "Index of Marriages in New York, 1907–2018"; certificate number 19066, "Index to New York City Deaths, 1862–1948," prepared by the Italian Genealogical Group and the German Genealogy Group, used with permission of the New York City Department of Records/Municipal Archives.

8 This unverified figure has been passed down through oral tradition within the agency, and then by Benjamin Chapnick to Peter Higdon in a telephone conversation in 2005.

Figures 3.4–7
Unknown photographer,
City Tower, Innsbruck, Austria,
ca. 1915. Gelatin silver
print, 24.3 x 15.3 cm.
BS.2005.004017.

Unknown photographer,
*Saint Florian Abbey, Upper
Austria,* ca. 1915. Gelatin
silver print, 17.1 x 11.5 cm.
BS.2005.004079.

Unknown photographer,
Teplitz-Schönau, [Teplice, Czech
Republic], ca. 1915. Gelatin
silver print, 16.7 x 23.9 cm.
BS.2005.006688.

Unknown photographer,
Neues Schloss, Chiemsee
(Herrenchiemsee New Palace),
Bavaria, ca. 1915. Gelatin
silver print, 11.8 x 17.1 cm.
BS.2005.012825.

Austrian towns such as Innsbruck and Braunau, a pretty little town on the German-Austrian border that happens to be the birthplace of Adolf Hitler (figs. 3.4 and 3.5). In addition, the Pohly collection includes pictures of castles and medieval towns in Czechoslovakia—in the German-speaking region of Bohemia—and Romania, in what was then called Siebenbürgen, where a German community had settled during the time of the Austro-Hungarian Empire (figs. 3.6 and 3.7). The backs of these prints reveal that these photos are mostly collected postcards or photographs of scenic places made by local photographers, such as the castle Plassenburg in Kulmbach, Bavaria, photographed by a man named Joachim Bär (fig. 3.8).

The second group is dedicated to contemporary German history, including World War I. The collection contains photos of military war games from before the war, in 1912 (fig. 3.9), and pictures taken in different arenas of the conflict, including Italy, the German-Russian front in Galicia (eastern Poland), Flanders, the siege of Péronne (Chemin des Dames), and the Battle of Argonne.[9] In the section dedicated to war and political events in Germany, one can identify two thematic subgroups: the first documents the Spartacist riots in Berlin and Munich, and the second the rise of the National Socialist movement and Third Reich military manoeuvres.

An example is a photograph of the occupation of the press quarter in Berlin on January 11, 1919 (fig. 3.10).[10] This photo depicts a Spartacist revolutionary squad that took over the building of the German Social Democratic daily newspaper *Vorwärts*. The snipers dragged the press's huge rolls and bundles of paper out of the building in order to strengthen their

9 In the Black Star Collection, see: BS.2005.110987 (BUFA/Max Pohly/Black Star, *On a Road in the Northern Piave Vallee, End of November 17*, ca. 1918); BS.2005.110737 (Max Pohly/Black Star, *Austrian Artillery in Galicia, German-Russian War 1914/16*, ca. 1930s); BS.2005.110717 (Reichsbildarchiv/Max Pohly/Black Star, *Kemmel. Beobachtungswagen in Stellung* [Kemmel. Observation car in position], *1st World War in Flanders (Kemmel)*, ca. 1930s); and BS.2005.110831 (Reichsbildarchiv/Max Pohly/Black Star, *Am Chemin des Dames* [At the Chemin des Dames], *I World War*, ca. 1930s). See also Bodo von Dewitz, *So wird bei uns der Krieg geführt! Amateurfotografie im Ersten Weltkrieg* [This is how we wage war! Amateur photography in World War I] (Munich: Tuduv, 1989), and *Vu du front: Représenter la Grande Guerre* [Seen from the front: Representing the Great War], eds. John Horne and Sylvie Le Ray-Burini (Paris: Somogy, 2014).
10 Chris Harman, *The Lost Revolution: Germany 1918 to 1923* (London: Bookmarks, 1982); Pierre Broué, *The German Revolution, 1917-1923* (Chicago: Haymarket Books, 2007).

Figure 3.8
Joachim Bär, *Plassenburg Castle*, ca. 1915. Gelatin silver print, 21.8 x 16.6 cm. BS.2005.012878.2.

Figure 3.9
Unknown photographer,
Das Feld-Telefon beim Manöver
(Field telephone during
war games), 1912. Gelatin
silver print, 11.5 x 15.5 cm.
BS.2005.014246.

barricade against bullets. This image is probably one of Robert Sennecke's shots of the event, as evidenced by the stamp on the back of the print: "Robert Sennecke Internationaler Illustrations-Verlag." We know that he, as a photojournalist and agency owner, was present along with Willi Römer, another well-known photographer, to depict the fighters outside the *Vorwärts* building.[11] The photo was reproduced in many publications, including the Communist magazine *Arbeiter Illustrierte Zeitung* (*AIZ*) in 1928, where it was presented as part of a double-page spread with a text written by Kurt Tucholsky (fig. 3.11). Tucholsky also used it in his 1929 book *Deutschland, Deutschland über Alles!*, laid out by John Heartfield.

Other pictures in the Black Star Collection stamped with Pohly's name document government troops entering Munich on May 1, 1919; a school strike in Neukölln, one of the worker neighbourhoods of Berlin; and street scenes in Berlin during the riots of 1918. Photos depicting World War I come from various sources: some originate from BUFA (Bild- und Filmamt), the photo and film agency of the German army, created in 1915 as an official propaganda photo office; others are later prints stamped with other names or offices, such as the Reichsarchiv in Potsdam. The images depicting the riots in Berlin in 1918–19 and other demonstrations during the Weimar period were also collected rather than taken by Pohly; they were shot by photographers working for several agencies in Berlin. One of them was Willi Ruge (1892–1961), founder and owner of the agency Fotoaktuell, who was well-known for his photographs of revolutionary movements and, later on, Nazi demonstrations.[12]

Another name that shows up on the back of Pohly's pictures is that of Alfred Gross (1880–1935). He first ran a portrait studio and then worked for the Berliner Illustrations-Gesellschaft (Berlin Illustration Society) before

11 Diethart Kerbs, *Revolution und Fotografie: Berlin 1918/19* (Berlin: Dirk Nischen/Neue Gesellschaft für Bildende Künste, 1990); *Der Fotograf Willy Römer, 1887–1979: Auf den Strassen von Berlin*, Diethart Kerbs, ed., (Bönen: Kettler, 2004). See also Georges Didi-Huberman, *Imaginer, recommencer: Ce qui nous soulève*, vol. 2 (Paris: Minuit, 2021).
12 Diethart Kerbs, Walter Uka, and Brigitte Walz-Richter, eds., *Die Gleichschaltung der Bilder: Zur Geschichte der Pressefotografie 1930–36* (Berlin: Fröhlich und Kaufmann, 1983). See also Kerbs, *Revolution und Fotografie Berlin 1918/19*, and Ludger Derenthal, Evelin Förster, and Enno Kaufhold, eds., *Berlin in der Revolution 1918/1919: Fotografie, Film, Unterhaltungskultur* (Berlin: Kettler/Staatliche Museen zu Berlin, 2018); Diethart Kerbs and Walter Uka, eds., *Fotografie und Bildpublizistik in der Weimarer Republik* (Bönen: Kettler, 2004).

turning independent in 1908. During World War I he was an independent press photographer who probably followed the marines. During the German revolution, in December 1918 he was captured by Spartacists and then released on Karl Liebknecht's order. His "illustration and publishing house" was a family business; after his death in 1935, his widow sold its 80,000 plates to the Reichsbildarchiv, an agency that depended on Goebbels's Ministry of Propaganda (Reichsministerium für Propaganda und Volksaufklärung). The archive was destroyed by the bombings of 1945.

One can also see on Pohly's prints stamps of the Berliner Illustrations-Gesellschaft. This agency was founded in 1900 by three schoolfriends, Karl Delius, Martin Gordan, and Heinrich Sanden. During World War I, Delius and Gordan went to the front as war photographers while Sanden kept the agency running in Berlin. After the war they split up and Delius moved to France, where he had already been active before the war. Sanden took over the business under a new name, Atlantic, with many employees (about a hundred in 1919–20). In 1929–30, a businessman named Dr. Friedrich Karl Hermann bought Atlantic, and he handed it over to the Ministry of Propaganda after 1933. This archive was also destroyed in the bombings of the press quarter in 1945. Given the low quality of the prints and the markings on their backs, the photos collected by Max Pohly seem to be late reprints (from the early 1930s) of photos taken by Delius or Gordan at the German Front.

The last large agency Max Pohly used to add to his collection (again identified by stamps on the backs of the prints) was Robert Sennecke's agency. Born in 1885, Sennecke founded Internationaler Illustrations-Verlag (International Illustrations Publisher). The agency not only sold photos taken by its own operators but also imported material from Great Britain and the United States. During World War I Sennecke was embedded with German military forces in Turkey. After years of operating a successful business, he became mentally ill in 1931 and was confined to a mental institution. His daughter Edith took over the agency but sold it in 1936 to a woman who tried to run the firm but went bankrupt a short time later. The marks on the backs of the images reveal the "social life" of these photographs,[13] which were handed from one agency to another, reprinted, and eventually ended up in Max Pohly's possession.

Figure 3.10
Robert Sennecke, *Spartacus Fights in Zimmer Street, Berlin*, 1919. Gelatin silver print, 16.5 x 12.0 cm. BS.2005.014239.

13 Thierry Gervais, ed., *The "Public" Life of Photographs* (Toronto/Cambridge, MA: Ryerson Image Centre/MIT Press, 2016).

Figure 3.11
Theobald Tiger [Kurt Tucholsky],
"Zehn Jahre deutsche Republik"
(Ten years of the German republic),
Arbeiter Illustrierte Zeitung 4 (1928):
8–9. Collection of R. Hartmann,
Bremen, Germany.

The Visual Making of a German History

Max Pohly did not take his pictures himself but brought together the photos long after they were shot. When he acquired them, they were no longer topical, already belonging to the recent past. Pohly was developing a historical archive to form a bigger picture. He was collecting documents of history, acting as both historian and collector, to paraphrase Walter Benjamin's comment on Eduard Fuchs.[14] The photos he amassed must be considered as a more or less coherent collection that provided a narrative of the German catastrophe from World War I to the rise of the Nazi movement. They do not document many aspects of cultural and social life during the Weimar period—nothing about the democratic spirit, the artistic and architectural modernism, the ground-breaking achievements of the social state, the progressive development of sexual life and gender identity in the capital. The collection focused instead on the efforts of the German army during World War I, the rise of the Nazi movement, the training camps and the war games. Germany was presented as a military state that went "from one apocalypse to another."[15]

We know very little about the conditions of Pohly's emigration to the United States via Great Britain. Like all Jews in Nazi Germany, he must have suffered terribly from stress and humiliations.[16] He may have lost his job and been banned from employment before deciding to leave his country at the onset of the deportation threat. Hoping the photos would be a useful asset, he took this collection of images with him on the transatlantic journey. After Pohly arrived in New York in 1938, he handed over the collection to Black Star. Thence another process began: employees at Black Star gave new captions to the documents, captions written in English, translated from the original German text, which was then frequently erased or scratched out. In doing so, Black Star staff intended to give them a significance that would be relevant in the new context. They referred to them as "German history," which one can see written on the backs of several of the prints.

14 Walter Benjamin, "Eduard Fuchs, collectionneur et historien," *Macula* 3/4 (1978): 38–59.
15 Lionel Richard, *D'une apocalypse à l'autre: Sur l'Allemagne et ses productions intellectuelles de Guillaume II aux années vingt* (Paris: Union générale, 1976).
16 On these terrible conditions, see also Georges Didi-Huberman, *Le témoin jusqu'au bout: Une lecture de Victor Klemperer* (Paris: Minuit, 2022).

Figure 3.12
Unknown photographer,
Strassenbilder in Berlin (Street
scenes in Berlin), 1919. Gelatin
silver print, 10.8 x 15.6 cm.
BS.2005.119427.

The events lent themselves to general captions such as "WWI," "Spartacist terror," and "inflation in Germany." We can notice the semantic displacement from particular events to a general interpretation of history. One photo shows Spartacists on a truck in 1919 (fig. 3.12). The different captions are

- On the front of the picture: *"Die Freiheitsbewegung in Berlin"* (Liberation movement in Berlin)
- On the back: *"Strassenbilder von 1919 in Berlin"* (Street pictures of 1919 in Berlin)
- On the back, in English: "Street scenes in Berlin"
- On the back, in English: "Inflation in Germany"

Given that the episodes of hyperinflation in Germany took place *after* the Spartacist movement, the relationship between the riots and economic insecurity is rather hard to follow. In compressing two different events— the Spartacist uprising and inflation—the captions produce an emblematic image of the Weimar Republic, one marked by both the Communist threat and economic instability. Used on other prints, the term "Spartacist terror" refers to the darkest period of French Revolution, "the Terror," when so many heads were cut off. In another picture using this same caption, government troops are received in Munich with enthusiasm, acting as a kind of liberation army.

We can assume therefore that the staff of Black Star chose a slightly different historical narrative for these images. The captions are simplified and provide a more general interpretation of the events depicted. They fit into a historical imagination based on what Germany stood for at that time in the American illustrated press. As circulating media, the photos were bounded by the process of alteration and transformation that characterizes every cultural transfer. Even though Pohly didn't make the images and therefore should not be credited as their author, the collection gives us a coherent narrative of Germany's recent history. Both economic instability and the revolutionary movement are presented as one of the causes of the rise of National Socialism. The only counterpoint to these pictures of social unrest is the images of reconstruction of the German army in the early thirties.

Historical Narrative and Nazi Propaganda

Max Pohly was collecting these documents as a historical archive and as testimony of the recent past in Germany.[17] He may have been working on some editorial project, but he chose to take the collection into exile in New York, hoping that the photos would have a market value. But wasn't he betrayed in a way by his sources? Didn't the documents he collected embody a discourse that he and the founders of Black Star, as Jewish immigrants, were trying to avoid—the discourse of Nazi propaganda? The majority of the photographs had been produced during the Third Reich by agencies that were already making Nazi propaganda. The greater part of the prints captioned "World War I" is actually reprints from after 1933, for example, a picture of German soldiers in Champagne that bears an Atlantic stamp. More recent scenes of military training are also included in this group of images.

Another photo shows two soldiers at the Kummersdorf training camp, a military facility in the south of Berlin dedicated partly to training dogs (fig. 3.13). Looking at these soldiers wearing gas masks, one might think it was taken during World War I, perhaps during the Battle of Ypres, where chemical weapons were first used by the German army. But if we look at the details, such as the uniforms and the stripes on their collars, we can doubt such an interpretation. The image is one of a couple of photos dedicated to military training. Its sister photograph shows training in Frankfurt on the Oder in 1932, the year of the controversial international Geneva agreement, which gave Germany the right to rebuild its army. The stamp on the photo is for the Atlantic agency, and it was probably produced after 1933, like the other.

The stamps include the mark of a professional organization of press photographers founded in July 1933, the Reichsverband Deutscher Bildberichterstatter (RDB), or Reich Association of German Photo-Reporters. The

17 Ernst Jünger, *Antlitz des Weltkrieges: Fronterlebnisse deutscher Soldaten* (Berlin: Neufeld & Henius, 1930); George Soldan, *Der Weltkrieg im Bild: Originalaufnahmen des Krieg-Bild- und Filmamtes aus der modernen Materialschlacht*, vol. 1 (Berlin: Oldenbourg, 1927). On Ernst Jünger and World War I, see Julia Encke, *Augenblicke der Gefahr: Der Krieg und die Sinne, 1914-1934* (Munich: Fink, 2006). See also Sandra Oster, "Das Gesicht des Krieges: Der erste Weltkrieg im Foto-Text-Buch der Weimarer Republik," *Fotogeschichte* 116 (2010): 23-32.

Figure 3.13
Unknown photographer,
*Polizei-Hundeanstalt in
Kummersdorf* (Police dog
training in Kummersdorf),
1930–36. Gelatin silver
print, 10.5 x 16.0 cm.
BS.2005.122162.

Figures 3.14 and 3.15
Kurt Wegener, *So war es! Ein Bildbericht vom wehrhaften Deutschland, 1914–1918* (Berlin: H. A. Braun, 1933), cover and 8–9. The Image Centre, Toronto.

image shows a photographer with a professional camera, and behind him we see an outsized eagle. The caption says "*Fördert Deutsche Arbeit*" (encourage German work)—an expression that was meant to exclude Jewish photographers from the German market.[18] The marks also include "*Mitglied im RDB*" (member of the RDB). Both the Atlantic and Sennecke's agencies included that phrase in their stamps after 1933, showing their proximity to the Nazi regime and its propaganda organizations. Most of the World War I photographs in Pohly's collection were actually produced after 1933, in order to inspire heroic memories of battles fought by the German army.

Another photo shows a German officer with a Belgian policeman during the occupation of Brussels in World War I. It bears the stamp of the Atlantic agency plus the RDB mark, indicating that the picture was produced after 1933. On the upper back of the photo can be seen a handwritten note: "*So war es! Seite* [page] *58.*" This refers to Kurt Wegener's book *So war es! Ein Bildbericht vom wehrhaften Deutschland, 1914–1918*, published in 1933 (fig. 3.14).[19] The book commemorates World War I and tries to craft a heroic image for a defeated army. The most striking thing is that this book was published along with another one, *So kam es! Ein Bildbericht vom Kampf um Deutschland, 1918–1934*. Both photo books are pure Nazi propaganda.[20]

Of course, there is no reason to think that Pohly, whatever he might have been, was working for the Nazi propaganda machine. He obviously brought with him a series of images documenting recent German history as testimony

18 Kerbs et al., *Gleichschaltung der Bilder*.

19 Kurt Wegener, *So war es! Ein Bildbericht vom wehrhaften Deutschland, 1914-1918* [The way it was! An illustrated report about defensive Germany, 1914-1918] (Berlin: H. A. Braun, 1933). Max Pohly isn't mentioned in the credit lines. Some of the images are similar to those in the Black Star Collection: on pages 58 (French and Belgian policemen), 72 (battlefield), and 9 (train).

20 Kurt Wegener and Wilhelm Keller, *So kam es! Ein Bildbericht vom Kampf um Deutschland, 1918-1934* [The way it became! An illustrated report of the fight for Germany, 1918-1934] (Berlin: H.A. Braun, 1935). The note "Gegen die Herausgabe dieser Schrift werden seitens der NSDAP keine Bedenken erhoben. Berlin, den 13. Dezember 1934" (The NSADP will not oppose the publication of this document. No concerns raised. Berlin, December 13, 1934) makes it an officially authorized publication. Some photos are similar to those in the Black Star Collection: on pages 40 (*Spartakus besetzt* [Spartacus occupied]), 42, 50-51 (*M.-G.-Posten am Spittelmarkt*), 102 (against Marxism), and 105 (*Papierflut in den Straßen* [Paper flood in the streets]).

of the National Socialist catastrophe. But in doing that he focused on pictures provided by the Nazis themselves. His collection contains no depictions of the terrible anti-Semitic crimes, the deportations, the book burnings. The image of German history provided insists on the rise of military power as a natural response to the Spartacist movement and economic instability. Accounting for the images as merely testimony of German history, users of the Black Star agency would be encouraged to mix the official Nazi narrative with denunciations of the militarization of German culture, overlapping arguments that at some point worked together hand in glove. A similar negative association was used in the American illustrated press both to delegitimate the Nazi regime and to depict the catastrophic instability of Weimar Germany. These same sets of propaganda images were reused to point to the Spartacists and the economy as the reasons for the rise of National Socialism.

There is a paradoxical, almost absurd, encounter between, on the one hand, the idea of a Jewish immigrant disseminating pictures of both the German Republic and the Nazi regime and, on the other hand, the historical narrative provided by these images, following as it does a nationalist and militarist agenda. Whether we like it or not, and whether the pictures were used individually rather than printed as series, they still belong to a selective vision of German history that was shaped by Nazi discourse. The idea of a single authorship must be dismantled to include the several agencies that were the sources of the visual material Pohly carried with him. No one could infer from his archive that Max Pohly had homogeneous, straightforward intentions as a picture editor. Many voices here play their parts against one another, confusing the issues of both attribution and signification: the photojournalists and those who selected the images more than fifteen years after the events, the captions that were translated and simplified. Max Pohly eventually tried to erase these layers of the pictures' histories and put his own name to the prints, but his stamp on their backs isn't enough to lure us into accepting a feigned authorship. To paraphrase Roland Barthes', the birth of material history is the death of the author.

The Making of the Black Star Collection at The Image Centre
Framing the Move from a Commercial Entity to a
Cultural Institution and the Conundrum of Outstanding
Significance/National Importance
Zainub Verjee and Emily McKibbon

In the past twenty years, as photographic press archives have entered the North American secondary art market, there have been a few high-profile donations of such materials as cultural property to public Canadian institutions. This includes the Sovfoto gift to the MacLaren Art Centre in 2001, the archives of the Klinsky Press Agency from the Archive of Modern Conflict to the Art Gallery of Ontario in 2002, and the Black Star Collection to Ryerson University (now Toronto Metropolitan University) in 2005. Such donations are not isolated acts of altruism; they affect both the political economy of a cultural sector and also impact the political discourse of the nation and its affiliative position in international relations on culture. In the eyes of the state, through its procedures, they are designated "cultural property." Through such donations, cultural property is brought into a normative frame—as an archive and/or a collection—that continues to produce new meaning while it functions and exists in public discourse, albeit hegemonically. Photo archives function as "complex structures, processes and epistemologies situated at the critical point of intersection between scholarship, cultural practices, politics and technologies," Blouin and Rosenberg remind us.[1] We too place our inquiry within the photography collection itself, focusing on "archive/collection as a subject."

When the Black Star Collection (BSC) came to the university in 2005, it was at the time the largest gift of cultural property ever donated to a Canadian university. With it came $7 million, planting the seed for The Image Centre and the $71-million expansion of the university's School of Image Arts. Visitors to

Figure 4.1
Ralph Crane, *Student Trip, California*, 1949 (detail).
Gelatin silver print,
20.0 x 25.4 cm.
BS.2005.280290.

1 Francis X. Blouin and William G. Rosenberg, *Archives, Documentation, and Institutions of Social Memory: Essays from the Sawyer Seminar* (Ann Arbor: University of Michigan Press, 2007), vii.

The Image Centre today might not realize that the creation of the institution was catalyzed by the gift of the collection—without Black Star, The Image Centre would not exist. Situating the political economy of collections, this chapter uses the BSC as a case study to examine, through an art historical and policy lens, the lingering impacts of Cold War cultural policies and how they have shaped Canadian collecting institutions—with a particular focus on how large photographic archives benefit from these practices—and delineate its epistemic limitations.

Taking cognizance of the BSC as cultural property, and specifically its movement from a corporate photo agency to a public cultural institution, it is vital to unpack how the production, meaning, and use of the collection are affected by its collusion with the state and its apparatus, investments, and the public. Nizan Shaked has rigorously argued about the state of the field of contemporary art collections and the value form, spotlighting the ambivalent nature of non-profit museums, as they are neither private nor entirely public.[2] Yet their trustees are empowered to collect on behalf of the state and in the "public trust." However, in this chapter we will examine the BSC within the purview of the Canadian *Cultural Property Export and Import Act* (1977).[3] The Act is an inheritor of the ideals put forward in the Massey Commission's report of 1951,[4] as both were concerned with the state's role in fostering a singular national culture as a keystone project of post–World War II and Cold War internationalism.

As argued by Althusser, ideological state apparatuses (ISAs) such as cultural institutions produce the subject that is submissive to the power.[5] With a view to establishing some provisional points of explanation about how the state, through its policy architecture and institutional mechanisms, perpetuates an ideologically rooted worldview, in the following sections we delineate this

2 Nizan Shaked, *Museums and Wealth: The Politics of Contemporary Art Collections* (London: Bloomsbury, 2022).

3 Cultural Property Export and Import Act, R.S.C., 1985, c. C-51 (Can.), https://laws-lois.justice.gc.ca/eng/acts/c-51/index.html.

4 Library and Archives Canada, Report - Royal Commission on National Development in the Arts, Letters and Sciences, 1949-1951, https://www.collectionscanada.gc.ca/massey/index-e.html.

5 Louis Althusser, "Ideology and Ideological State Apparatuses (Notes Towards an Investigation)," in *On the Reproduction of Capitalism*, trans. G. M. Goshgarian (London: Verso, 2014).

perspective by demonstrating how the Canadian Cultural Property Export Review Board (CCPERB) facilitates the institutionalization processes of cultural capital,[6] as well as how those processes are deeply embedded in the metanarratives of cultural policies both national and international.

In 1979, at the Hayward Gallery in London, England, John Tagg co-curated *Three Perspectives on Photography*, wherein he juxtaposed Althusser's concept of the ISA and Michel Foucault's theories of discourse and power, thus "relocating the debate on realism and challenging the notion of a progressive 'documentary tradition' by connecting an array of nineteenth-century modes of photographic documentation to the emergence of disciplinary techniques and to a new form of the State."[7] The importance of the documentarian paradigm lies in constituting the role of the photographic archive and the socially regulatory uses of photography in the making of the modern liberal state and its subjects. Tracing such an argument, we see that in the twentieth century, constitution of documentary discourse in photography in the United States rested on the 1930s and New Deal cultural strategies. It was in this period that the "array of techniques and technologies converged . . . around the drive to secure the necessary conditions for the politics and public culture of the social security State: the liberal, corporatist response to the crisis of the 1930s," thus tracing the "first and only true art form produced by social democracy"—the documentary photograph.[8] Concomitantly, the Black Star Collection foregrounds a certain documentarian paradigm embedded within an ideological condition of the liberal public sphere, as Tagg has aptly demonstrated. How can we unpack the hegemonic nature of this documentarian paradigm that thrusts the political ontology of the image right into the centre of the argument?

US Farm Security Administration (FSA) images of the 1930s—as a performative practice of documentary photography and as an archive—"evolved into a complex and varied visual record of the United States

6 See Shaked, *Museums and Wealth*, where it is argued that "public" is used as a default cover to establish the value of art and sustain art's monetary value and its markets. See also Dave Beech, *Art and Value: Art's Economic Exceptionalism in Classical, Neoclassical and Marxist Economics* (Boston: Brill, 2015).

7 John Tagg, *The Disciplinary Frame: Photographic Truths and the Capture of Meaning* (Minneapolis: University of Minnesota Press, 2008), 11.

8 Tagg, *The Disciplinary Frame*, 60, 61.

from 1935 to 1943."[9] Tagg draws parallels with the FSA by foregrounding the reformist work of John Grierson in the documentary movement.[10] Grierson's influential oeuvre and his roles during World War II and as the first commissioner of the National Film Board of Canada are critical. "Documentary was born and nurtured on the bandwagon of uprising social democracy everywhere."[11] Tagg argues that the Grierson/FSA mode enacts the structure of documentary itself. It offers a compact between the paternalistic state and its subject, the citizen: "To be captured by this machinery was to be captured in the imaginary of the benevolent, impartial, paternal State, but to be captured in the act of compassionate looking: an act of decency and the act of a citizen, a civic subject called duty."[12] Borrowing from Tagg's argument, based on FSA documentary photography combined with the work of John Grierson, it is imperative to understand how, through such collections, the Grierson/FSA mode's hegemony is perpetuated along with its ideological assumptions of concepts such as progress, modernity, and development.

The Black Star Gift: Cultural Property and the Canadian Context

By the close of the twentieth century, shifts in the publishing world and the growing availability of convincing digital facsimiles had resulted in approximately 292,000 Black Star photographic prints by more than 6,000 photographers entering the secondary market. In recognition of the Black Star Collection's unique value, Stephen Bulger, who appraised the collection on behalf of its anonymous donor in 2003, stated: "the collection includes pictures of every internationally newsworthy moment from the 1930s to the 1980s."[13] It represented, in Image Centre founding director Doina Popescu's

9 Michael L. Carlebach, "Documentary and Propaganda: The Photographs of the Farm Security Administration," *Journal of Decorative and Propaganda Arts* 8 (1988): 6, https://doi.org/10.2307/1503967.

10 Ian Aitken, *Film and Reform: John Grierson and the Documentary Film Movement* (New York: Routledge, 1990).

11 Tagg, *Disciplinary Frame*, 61.

12 Tagg, *The Disciplinary Frame*, 93.

13 Sara Angel, "Ryerson University Wishes upon a Shooting Black Star," *Maclean's*, September 27, 2012, https://www.macleans.ca/economy/business/the-world-as-it-was/.

Figure 4.2
Ralph Crane, *Student Trip, California*, 1949. Gelatin silver print, 20.0 x 25.4 cm. BS.2005.280290.

summation, "one of the most valuable repositories of collective global memory captured in visual form."[14] With the signing of the deed of gift, the Black Star picture library became the Black Star Collection, entering a new and permanent mode of being at what is now Toronto Metropolitan University. The BSC and its accompanying gift of $7 million transformed what was once a remarkable but concise study collection, used as a pedagogical aid for students studying photography, into what is now The Image Centre—an institution that bridges the gap between university and museum, two institutions of fundamental importance as modern ideological state apparatuses (as defined by Althusser).

To understand how a New York City–based photo agency's inventory ended up as a gift that catalyzed creation of a Canadian university gallery dedicated to the medium of photography, one must first understand the tax benefits that incentivize such major gifts. To trace the origins of the tax laws, one must first examine Canada's relationship to the United Nations Educational, Scientific and Cultural Organization (UNESCO) in the years immediately following World War II. The tax benefits designated by CCPERB and ratified by the *Cultural Property Export and Import Act* (CPEIA) have their origins in the 1970 UNESCO Convention on the Means of Prohibiting and Preventing the Illicit Import, Export and Transfer of Ownership of Cultural Property.[15] The Convention was originally intended to stop the illicit international trade in antiquities. Canada's adoption of the 1970 UNESCO Convention balanced potential infringement of the rights of cultural property owners with the need to prevent important cultural artifacts—such as archaeological finds, major works of art, and other items of "outstanding significance and national importance"— from leaving the country to be sold in more lucrative international markets.

Crucially for Canada, this approach includes a set of tax incentives designed to encourage the donation of designated cultural property to Canadian museums, archives, and libraries. The benefits include the elimination of capital gains taxes on donated works of cultural property, as well as a tax credit for the fair-market value of the item that can be used against up to 100 percent

14 Doina Popescu, "Introducing Archival Dialogues," in *Archival Dialogues: Reading the Black Star Collection*, ed. Peggy Gale (Toronto: Ryerson Image Centre, 2012), 8.
15 UNESCO, Convention on the Means of Prohibiting and Preventing the Illicit Import, Export and Transfer of Ownership of Cultural Property, (November 14, 1970), https://en.unesco.org/about-us/legal-affairs/convention-means-prohibiting-and-preventing-illicit-import-export-and.

of the donor's income.[16] The CPEIA established the role of CCPERB as the administrative body overseeing these activities, in essence directing government funds towards the purchase of works on behalf of the Canadian public.[17] Such fiduciary programs implemented through the tax code are rarely scrutinized as intensely as direct spending initiatives; however, they represent significant revenue lost to the Canadian government in support of specific policies, impacting the federal budget no less than more straightforward expenditures.

CCPERB's decisions are governed by a set of standard criteria. A qualifying recipient institution puts forward an application and a statement of "outstanding significance"[18] upon which the Board bases its determination of whether a work is indeed "Canadian cultural property." Given that CCPERB's decisions deal with tax information about individual Canadian citizens, its discussions and decision-making are strictly confidential; consequently, there is no public registry of works designated as cultural property and deposited in Canadian institutions as part of the tax regime. It is known that CCPERB's investments are significant; generally speaking, revenue lost to the Canadian government averages around $20 million per year, with a noteworthy peak of $77 million in 2003.[19] Nancy Armstrong has noted that, in Althusser's analysis, "political societies govern best when they appear not to be governing at all," and that political authority is "especially powerful when it appear[s] to be neither political nor authoritative."[20] When

16 Ian Christie Clark, "The Cultural Property Export and Import Act of Canada: A Progress Report," *International Journal of Museum Management and Curatorship* 1, no. 1, (March 1982): 13.

17 Steven L. Nemetz, "Gifting Cultural Property in Canada: Testing a Tax Expenditure," *Canadian Bar Review* 85, no. 3 (2006): 464.

18 The separation of national importance from outstanding significance reflects an amendment in the federal budget of 2019, following a challenge to the law in *Heffel Gallery Limited v. Canada (Attorney General)* in 2018. See CCPERB, "Changes to the *Cultural Property Export and Import Act*," https://ccperb-cceebc.gc.ca/en/resources/annual-reports/2019-2020/ar-2019-2020.html#a2.4.

19 It should be noted as well that calculating revenue lost through the capital gains exemption is extraordinarily difficult, making such projections inexact at best. The Government of Canada publishes an annual report on tax expenditures, providing only the numbers for the tax expenditure and more general estimates for the losses from the elimination of capital gains taxes. See, for example, Government of Canada, *Tax Expenditures and Evaluations* (Ottawa: Department of Finance Canada, 2005). https://www.canada.ca/content/dam/fin/migration/taxexp-depfisc/2005/taxexp2005_e.pdf.

20 Nancy Armstrong, "What Use Is Althusser?" *Cultural Critique* 103 (Spring 2019): 13, https://doi.org/10.1353/cul.2019.0013.

contrasted with the intense scrutiny applied to direct spending for arts, culture, and heritage, it becomes clear that CCPERB allows the state, in collusion with high-net-worth individuals, to set cultural policy without significant public oversight—in this case through spending directed towards large photographic archives. The donation of Black Star's black-and-white print archive was one such example of this spending program.

Postwar Cultural Internationalism

In the twentieth century during the interwar period, ideas about a new global order sparked multiple debates and clashing visions. Traditional understandings sought to uphold the conventional armature embedded in the Western alliance's articulation of shaping the norms. One such turning point was Harry Truman's 1949 inaugural address in which he described his "fair deal" for the entire world. Truman's Fair Deal manifested in the form of a template for a pervasive ideological construct in the name of "development," which then became a Trojan horse for broader American-led forces. Thus the idea of development became connected with that of progress as primary evidence of modernity.

The United Nations' primary organ for education and culture, UNESCO, emerged as a key site of this delivery of modernity as the face of humanism, a kind of ideological state apparatus akin to the humanist university, but in the broader realm of international relations. It was this international political language that became a touchstone in the cultural policy articulations of various Western nations. Druick argues that in Canada the Massey Commission (1949–51) embraced the ethos of this new international political language for cultural relations and exchanges, and that there was broad national and international consensus that "it is in the minds of men that the defences of peace must be constructed."[21]

Figure 4.3
Kosti Ruohomaa, *Edward Rogers Castner and His Wife. Lillian, on a Swing, Damariscotta, Maine,* 1947. Gelatin silver print, 25.2 x 20.3 cm. BS.2005.279167.

21 UNESCO, Preamble to the Constitution, 1945, cited in Zoë Druick, "International Cultural Relations as a Factor in Postwar Canadian Cultural Policy: The Relevance of UNESCO for the Massey Commission," *Canadian Journal of Communication* 31 (2006): 181-82. Druick is a professor of communication at Simon Fraser University, Burnaby, BC, and co-editor (with Deane Williams) of *The Grierson Effect: Tracing Documentary's International Movement* (London: British Film Institute, 2014).

Figure 4.4
David Moore, *Royal Arcade*,
[Sydney, Australia],
ca. 1950. Gelatin silver
print, 23.9 x 25.5 cm.
BS.2005.293313.

The central tension in the Massey Report hinges upon two impetuses. On the one hand is the role of Eurocentric "high" cultural production in creating an identity for Canadian culture for both domestic and foreign purposes. On the other hand, the mass media represented an existential cultural threat coming from the United States. The clash between high and mass culture in articulating postwar cultural policy was a conundrum not unique to Canada. The Museum of Modern Art (MoMA) initiated two touring exhibitions in the 1950s, the CIA-sponsored *The New American Painting* (1958–59), featuring Philip Guston, Grace Hartigan, Willem de Kooning, Mark Rothko, and others, and the more populist *The Family of Man* (1956–65), curated by Edward Steichen.[22] Rarely considered in tandem, the two exhibitions nonetheless show the parallel importance of high and mass culture in a Cold War context.

At face value, *The Family of Man* (figs. 4.2–7) was a travelling exhibition that depicted, in 503 black-and-white photographs from sixty-eight countries, the quotidian life of people from diverse backgrounds, offering a message of solidarity: one humanity.[23] Ariella Azoulay calls the exhibition "a series of prescriptive statements through which universal rights are claimed,"[24] while Allan Sekula terms it "'the epitome of American cold war liberalism' that 'universalizes the bourgeois nuclear family' and therefore serves as an instrument of cultural colonialism."[25] Some of the images in the show are represented in the Black Star Collection, and the exhibition has been enshrined in the UNESCO Memory of the World registry since 2003.[26] Thus we see, as Azoulay has argued, not just a mode of production but also how photography politically constructs subjects. ISAs are the material forms through which the ideology of a subject is produced, locating

22 The images shown in this chapter were all exhibited in *The Family of Man*.

23 Eric J. Sandeen, *Picturing an Exhibition:* The Family of Man *and 1950s America* (Albuquerque: University of New Mexico Press, 1995), 44.

24 Ariella Azoulay, "*The Family of Man*: A Visual Universal Declaration of Human Rights," in *The Human Snapshot*, ed. Thomas Keenan and Tirdad Zolghadr (Berlin: Sternbeg Press, 2013), 36–37.

25 Allan Sekula, "The Traffic in Photographs," *Art Journal* 41, no. 1 (1981): 19. See also Alise Tifentale, "*The Family of Man*: The Photographic Exhibition That Everybody Loves to Hate," *Foto Kvartals*, July 2, 2018, https://fkmagazine.lv/2018/07/02/the-family-of-man-the-photography-exhibition-that-everybody-loves-to-hate/.

26 UNESCO Memory of the World, "The Family of Man," https://unesco.public.lu/en/patrimoines/documentaire-memoire-monde.html.

that production within the institutional mechanisms and practices that re-produce the social and political order.[27]

In Canada, the Massey Report offered a whole new armature for the idea of modernism. It created a Eurocentric idea of culture as its central plank, around which the institutions developed. Antoncic has argued that understanding of the Canadian experience of the Cold War period is dom-inated by scholarship from the fields of communication and literature, while there has been little substantial investigation of the period through the lens of art history and the visual arts generally.[28] Nevertheless, she continues,

> Art historians and curators who have investigated the post-war period in Canada have focused primarily on formal aesthetics, conflict between proponents of abstraction and representation, and expressions of Canadian national identity in work by Canadian artists. The narrative of Canadian cultural maturity that has developed since WWII is typically framed around charismatic, dedicated and newly-professionalized curators who persuaded a reluctant wealthy class to support the arts in the name of civic and/or national public service.[29]

This is even though cultural infrastructure and institutionalization of state support became the central premises of the nationalist modernist nar-rative. The Massey Report provided impetus for an attempt to "catch up" culturally and to create an identity comparable to Canada's status in the international political arena, as Sandra Paikowsky has articulated in dis-cussing the curatorial politics of Canada's first independent participation in the Venice Biennale, in 1952.[30] Discursively speaking, Jody Berland argues,

> The relationship between nationalism and modernism that was constructed through this process combined a commitment to a particular understanding

27 Ariella Azoulay, *Civil Imagination: A Political Ontology of Photography* (London: Verso, 2012).

28 Debra Anne Antoncic, "'Oddballs and Eccentrics' (*'Les hirsutes et les excentriques'*): Visual Arts and Artists in the Popular Press in Post-War Canada" (PhD diss., Queen's University, 2011).

29 Antoncic, "Oddballs and Eccentrics," 22.

30 Sandra Paikowsky, "Constructing an Identity: The 1952 XXVI Biennale di Venezia and 'The Projection of Canada Abroad,'" *Journal of Canadian Art History/Annales d'histoire de l'art Canadien* 20 (1999): 130–81.

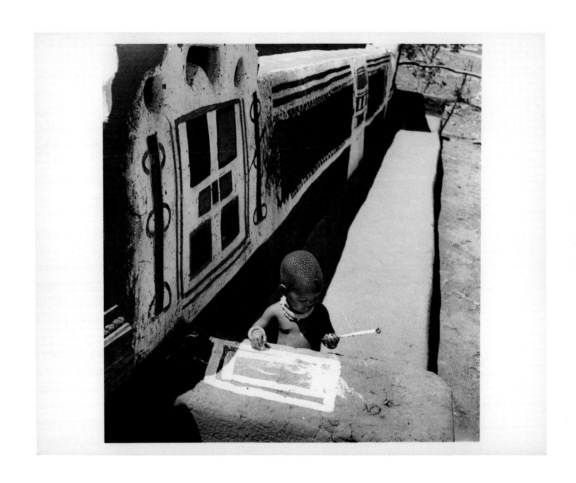

Figure 4.5
Constance Stuart, *A Child in South Africa*, 1936–49. Gelatin silver print, 20.3 x 25.2 cm. BS.2005.061485.

of nationhood blended with an essentially International modern aesthetics. An important legacy of the Massey Commission was its focus on the fine arts as the foundation for a legitimated and legitimating national culture.[31]

Berland sums it up as "Make Canadian culture, call it Canadian culture, prove that Canada has a culture, and ensure that it functions well in the world market."[32]

UNESCO-aided postwar internationalism, which highlighted cultural differences to counter Soviet communism, faced strong headwinds. As the axis of modernism was firmly tied to two competing centres— New York and Paris—postwar decolonization led to a global societal upheaval, and counternarratives emerged other than the Western and the Soviet. The 1970s and '80s foregrounded the idea of contested modernity to indicate not only transformations in social, economic, and political structures but also how to comprehend reality. One such site was the Vancouver Conference on Modernism (March 12–14, 1981), which brought to the forefront a rethinking of history and debates concerning modernism and modernity.[33]

The imperative to distinguish modernism in aesthetic terms from the institutionalizing process is critical to comprehending the shifting terrain of what constituted "modern." This places the burden on two registers: institutionalization of the image in the form of archives, and its epistemic focus. Critically, this means that the donation of the Black Star Collection was, in effect, a purchase by the Canadian state through its spending programs, in keeping with a larger set of cultural policies that have their origins in the Massey Report of 1951—itself a response to UNESCO and Cold War cultural internationalism.

31 Jody Berland, personal communication, May 14, 2018. For more, see "Nationalism and the Modernist Legacy," in *Capital Culture: A Reader on Modernist Legacies, State Institutions, and the Value(s) of Art,* ed. Shelley Hornstein and Jody Berland (Montreal: McGill-Queen's University Press, 2000), 14–38.

32 Quoted in Zainub Verjee, "The Great Canadian Amnesia," *Canadian Art,* June 20, 2018, https://canadianart.ca/essays/massey-report-the-great-canadian-amnesia/.

33 See Benjamin Buchloh, Serge Guilbaut, and David Solkin, eds., *Modernism and Modernity: The Vancouver Conference Papers* (Halifax: Nova Scotia College of Art and Design, 2004).

The Conundrum of "Outstanding Significance and National Importance"

When the CCPERB program works as intended, there is almost no disclosure of information to the public—often not even the fact that a specific item has been designated as cultural property on behalf of the Canadian state and in the interests of Canadian citizens. CCPERB decisions that relate to or affect taxpayer information are protected under the *Income Tax Act*, the *Access to Information Act*, and the *Privacy Act*. Regardless of the difficulty of illuminating key issues in the political economy of cultural property gifting, we posit that donors of large photographic archives are uniquely poised to receive significant benefits from the legacies of CPEIA and CCPERB, due as much to photography's relationship to definitions of nationhood (inherited from the Massey Report) as to the machinations of fair-market valuations of large archives.

When Ryerson University (as it was then known) acquired the Black Star Collection, it was acquiring a body of work with very specific conditions attached, including not only creation of The Image Centre itself but also the expectation that the collection would remain in The Image Centre's holdings in perpetuity.[34] The importance of the collection and the cash donation that came with it to ensure The Image Centre's creation were clearly sufficient incentives to accept such a restricted gift. Given the foundational relationship between The Image Centre and the BSC, it is possible to see aspects of The Image Centre's eventual mandate in the university's application for cultural property designation.

The Image Centre's founding collections curator (at the time of application known as curatorial manager of the Mira Godard Study Centre), Peter Higdon, was tasked with explaining how the loss of a proposed donation of a

34 This is a significant point, as under the current *Income Tax Act*, museums may not deaccession any works designated through CCPERB for ten years after acquisition, unless it is to an accredited institution, preferably with a comparable collections mandate; if a work is deaccessioned by sale, there is a financial penalty to the institution to recoup lost tax revenue. Museum best practice is to accept only unrestricted gifts whenever possible; the vitality of a living collection requires flexibility of interpretation, display, and, when necessary, final disposition of works in order to evolve the collection in careful and deliberate ways. See Zainub Verjee, "Why Deaccessioning Is Never a Straight Story," *Canadian Art*, July 30, 2018, https://canadianart.ca/essays/why-deaccessioning-is-never-a-straight-story/.

New York City–based photo agency's picture library would significantly diminish the national heritage of Canada. At that time, justifications of national importance were expected to "transcend organizations and their mandates"; if cultural property was determined to be "of outstanding significance and national importance (OS/NI), it will be so regardless of the organization in which it happens to reside."[35] Higdon's OS/NI report to CCPERB includes two interrelated rationales for the collection's importance to Canada: first, the presence of other large photojournalistic archives in southern Ontario, and second, the Black Star Collection's value for studying the arts. Significantly, Higdon describes Ryerson's proximity to the Sovfoto Archive at the MacLaren Art Centre in Barrie and the Klinsky Press Agency archive at the Art Gallery of Ontario. Noting that the collocation of three major global press photo collections within a hundred-kilometre radius would allow for unprecedented research into the history and practice of photojournalism, Higdon also specifically ties the Black Star Collection to the pedagogical functions of the university's School of Image Arts.

This is where Azoulay's theoretical premise—that photography as a materialist apparatus is used to produce subjects—offers a lens through which to read Higdon's rationale. Noting that the agency's picture library has outlived its "primary usefulness" in a business context, Higdon reflects that the black-and-white picture archive that would become the Black Star Collection has "achieved recognition as one of the great repositories of twentieth century photographic and world history, and has entered the fine art arena of collectibility."[36] However, as noted below in the case of the Annie Leibovitz collection, a large photographic archive's value might lie in its potential tax benefits for a collector rather than its intrinsic worth as photographs.

Ultimately Higdon's application to CCPERB was successful, as demonstrated by media releases identifying the Black Star Collection as cultural

35 Department of Canadian Heritage, "Outstanding Significance and National Importance (OS/NI): Writing an Effective OS/NI Justification for the Certification of Cultural Property by the Canadian Cultural Property Export Review Board" (Ottawa: Government of Canada, 2013), 3.

36 Peter Higdon, "Explanation of Outstanding Significance and National Importance." Application to the Canadian Cultural Property Export Review Board, item 6, November 10, 2004. Acquisition files, The Image Centre, Toronto.

property. As with the Massey Report, Higdon's justification of national importance to CCPERB reflected extensively and ambivalently on Canada's proximity to the United States, noting:

> Not being similarly at the centre of global influence and power, we as Canadians are less inclined to assume that our culture is monolithic and inevitable, and more inclined toward a desire to understand what is authentic and discrete in the nature of other countries and cultures. In this we have the advantage of the outsider's viewpoint, and an ability to engage in a particular quality of critical thought and reflection in relation to the US that is a natural outcome of our geopolitical positioning.[37]

The Massey Commission was distinctly uncomfortable about mass media, and in particular the growing cultural hegemony of the United States in the postwar period. It is noteworthy that in this technological age, when weekly periodicals have been subsumed by accelerated forms of digital media, the artifacts of mid-century American mass-media organizations come to a nation that has at times resented their undue influence. However, ambivalence about US cultural hegemony is an integral aspect of what it means to be a Canadian. Because of—not despite—this cultural hegemony, the histories of these media artifacts are presented as an advantage in terms of interpreting their meanings in an increasingly decentralized world, and thus they are worthy of a second life, even at the cost of significant financial resources at the federal level. In Higdon's justification, anxiety about cultural influence is transposed into a unique strength: as a result of our more marginal geopolitical position, only we as Canadians are able to fully understand this print archive from a late period of the American empire, and the way it manifested American power in the post–World War II and Cold War period.

Returning to the themes of the Massey Report—refinement, education, and taste—justifications of national significance did not necessarily require that the proposed object or objects have a strong relationship to Canadian life; national importance could include some form of "documentary

37 Higdon, "Explanation of Outstanding Significance and National Importance."

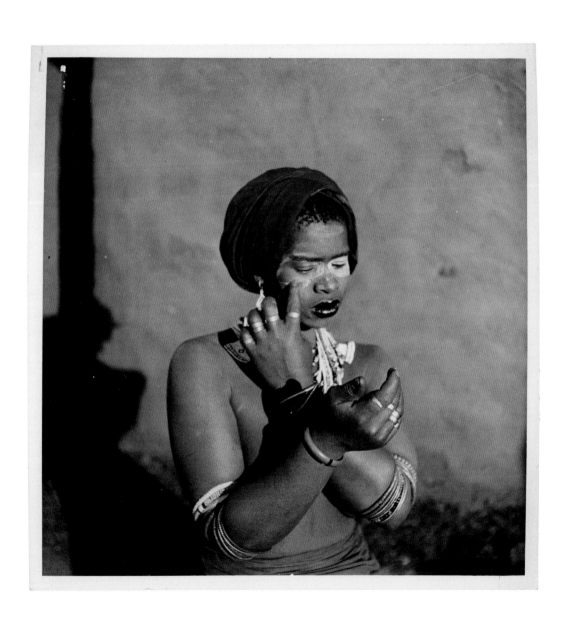

or research value" for the Canadian public.[38] That three photo agency archives/collections ended up in southern Ontario had less to do with the turn to digital making print libraries obsolete than it does with the vagaries of Canadian tax law, each successful application to CCPERB strengthening the justification for the next. It has indeed become impossible to imagine that a scholar of photojournalism could avoid doing research in this part of the country, particularly now that the three archives/collections have been joined by others, most notably the Rudolph P. Bratty Family Collection at The Image Centre, which comprises nearly 25,000 photographs of Canadian subject matter from the *New York Times* Photo Archive.

The presence of these archives/collections in Canada attests to the two regimes of value currently in place for such collections: as already discussed, the value of these collections to researchers, but also their value to investors. To understand the potential value these collections might hold, it is necessary to look once again at ruptures in the CCPERB process. The 2013–14 failure to donate a significant trove of Annie Leibovitz photographs to the Art Gallery of Nova Scotia through CCPERB revealed that the donors stood to receive double their financial commitment of $4.75 million in tax returns if the collection was designated as cultural property with a fair market value of $20 million.[39] The dissonance between the sale price of an entire collection and the value of each photograph within it—its fair-market value, which forms the basis of the tax benefit—represents a unique financial benefit to the donor, extending the value of the gift beyond the philanthropic.

We have seen in this chapter how the Black Star Collection, in its move from commercial entity to cultural institution, is perfectly interwoven with the state's project and its inherent modernist impulse. But beyond

38 Factors under this rubric include: Is the property of high real or potential interest to scholars? Does the property hold the potential for new scholarship in a field of study? Does the property have the potential to make a significant and lasting contribution to a field of study? Does the property have significant educational value? See Canadian Heritage, "Outstanding Significance and National Importance," 6.

39 Richard Cuthbertson, Susan Allen, and Jack Julian, "Cultural Gem or 'Tax Grab'? $20M in Annie Leibovitz Photos Caught in Canadian Quandary," CBC News, July 12, 2017, https://www.cbc.ca/news/canada/nova-scotia/cultural-gem-or-tax-grab-20m-in-annie-leibovitz-photos-caught-in-canadian-quandary-1.4181765.

those modernist underpinnings, it foregrounds the very imperative of the social contract of an image. In some recent scholarship, such as the works of John Tagg, Ariella Azoulay, and Sheldon Wolin,[40] the impetus to put an image, and thus its visuality, in the centre of the study of politics has become the primary organizing metaphor for theoretical imagining. Further, international registers such as UNESCO's Memory of the World allows these images, as in the case of *The Family of Man*, "to explain man to man through the universal language of photography."[41] The terms of discourse, institutionalization, and networks of photographic images create an affective regime: the culture and politics of the sensorial. Yet, premised on the modernist impulse of change—the relationship between image and change—one can argue that the aporia dictates that the condition of image-making for change is also the condition of the impossibility of image-making for change.

This is foregrounded as the paradox by which the Massey Report, which warned about the need to defend the Canadian state against the dominating influx of US mass media, is itself invoked to acquire mass-media artifacts manifested in collections such as Black Star's. Thus, as an inherent contradiction, Tagg's Griersonian/FSA frame remains firmly embedded. Does this imply that there is an urgent need for "reconstitution of a new archivism or of a new documentarism"?[42] Or do we embrace photography as a nonessential secular contract between citizens and the state, invoking Azoulay's notion of photography as a civil contract? This case study reveals that, beyond its rich archival resources, the Black Star Collection as a whole becomes a communicative act in defining the social contract of the image, rather than offering itself as a universal and transparent truth. Or does the Black Star Collection at Toronto Metropolitan University somehow define its limits of epistemic inquiry?

40 Wendy Brown, and Sheldon S. Wolin, *Politics and Vision: Continuity and Innovation in Western Political Thought, expanded edition* (Princeton: Princeton University Press, 2016).

41 UNESCO Memory of the World, "The Family of Man."

42 Tagg, *Disciplinary Frame*, 233.

BLACKS
ADULTS

Part 2
Generating Visibilities in the Black Star Collection

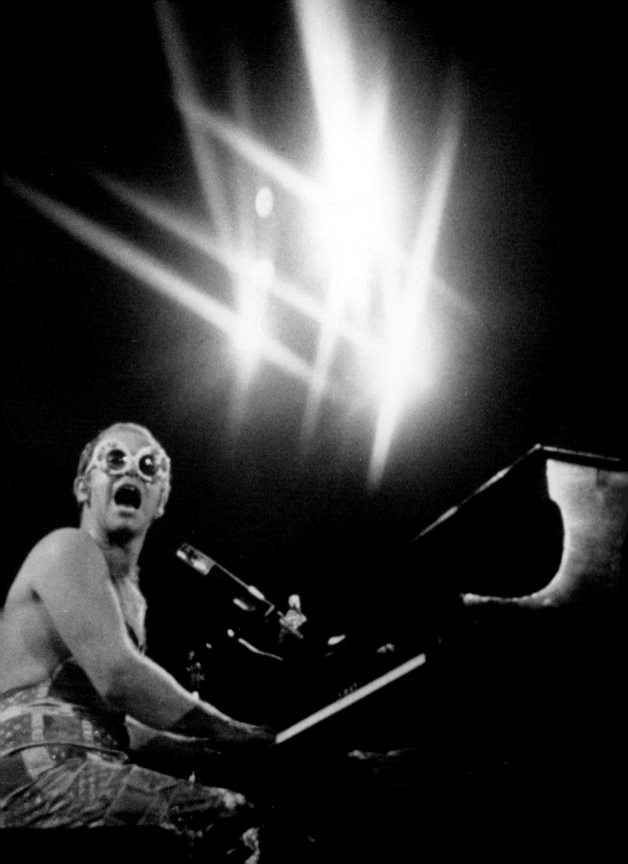

Black Star
Gay Rights, Gay Life

Sophie Hackett

In 2014 I curated the exhibition *What It Means to Be Seen: Photography and Queer Visibility* at The Image Centre, to coincide with WorldPride celebrations in Toronto that same year. The exhibition examined the role that photographs, as vehicles of visibility, played in creating both a movement for gay rights and a sense of community for 2SLGBTQ+ individuals from the 1960s to the 1990s in the North American context. It was one of a series of exhibitions during The Image Centre's first years based in the institution's core holding, the print archive of the Black Star press agency.

As part of my research, Image Centre staff provided me with a folder of 299 photographs they had identified as pertaining to gay subjects. It was an intriguing, if curious, mix of images of gay liberation gatherings and of protests both for and against gay rights—altercations with police; portraits of unnamed gay men and women and well-known figures alike; fight and flamboyance. Of these photographs, 273 can be found under Black Star subject headings that explicitly reference subjects related to gay communities, chiefly in the United States: in New York City and the Washington, DC, area, plus a concentration of works made in San Francisco between 1970 and 1991. The other 26 are subcategorized under PERSONALITIES by their individual names, as notable public figures. In a collection that numbers almost 300,000 photographs, the question remains: Could it contain more photographs with queer relevance? And by what parameters? This publication project has given me a chance to revisit the photographs and the Black Star Collection more broadly to explore these questions.

Three subject categories explicitly bring together photographs that are relevant to the questions at hand:

Figure 5.1
Dennis Brack, *Elton John Performing on Stage*, December 1973 (detail). Gelatin silver print, 25.4 x 20.6 cm. BS.2005.150494.

1. Demonstrations with the descriptive subcategory labels "AIDS" and "GAY":

DEMONSTRATIONS/A.I.D.S. (19 prints)

DEMONSTRATIONS/A.I.D.S. DEMONSTRATION IN FRONT OF THE WHITE HOUSE (4)

DEMONSTRATIONS/A.I.D.S. DEMONSTRATION IN WASHINGTON (7)

DEMONSTRATIONS/A.I.D.S. DEMONSTRATION OUTSIDE F.D.A. BUILDING IN ROCKVILLE, MD (2)

DEMONSTRATIONS/A.I.D.S. PROTEST, PUBLIC SCHOOL IN N.Y.C. (7)

DEMONSTRATIONS/GAY LIBERATION (103)

DEMONSTRATIONS/GAY MARCH WASHINGTON D.C. (AIDS QUILT) (6)

DEMONSTRATIONS/GAY RIGHTS BILL (3)

DEMONSTRATIONS/GAY's [*sic*] REVOLT SAN FRANCISCO (9)

2. Homosexuality

HOMOSEXUALITY/CHRISTOPHER STREET (18 prints)

HOMOSEXUALITY/CRISCO DISCO (1)

HOMOSEXUALITY/GAY AFTER HOUR CLUBS (9)

HOMOSEXUALITY/TRANSSEXUAL (11)

HOMOSEXUALITY/TRANSVESTITE (32)

3. Medical

MEDICAL/AID's [*sic*] (21 prints)

MEDICAL/AID's. PATIENT (1)

MEDICAL/AID's. PATIENTS (16)

MEDICAL/AID's. TEST (2)

DEMONSTRATIONS/GAY LIBERATION gathers the largest number of photographs, with a total of 103. This rubric unites a disparate array of public gatherings, with the majority depicting gay liberation marches and gay festivals in the early 1970s, precursors to present-day gay pride parades. Though these events were created with a political purpose—to raise the visibility of gay communities and signal the existence of a critical mass of gay individuals—they also acted as occasions where attendees could safely socialize in public.

Photographers approached these events chiefly in two ways: using a wide view to capture the crowd, often filling the frame with people and

Figure 5.2
Michael P. Smith, *Mardi Gras Celebrations, New Orleans, Louisiana,* 1984. Gelatin silver print, 25.3 x 20.2 cm. BS.2005.254105.

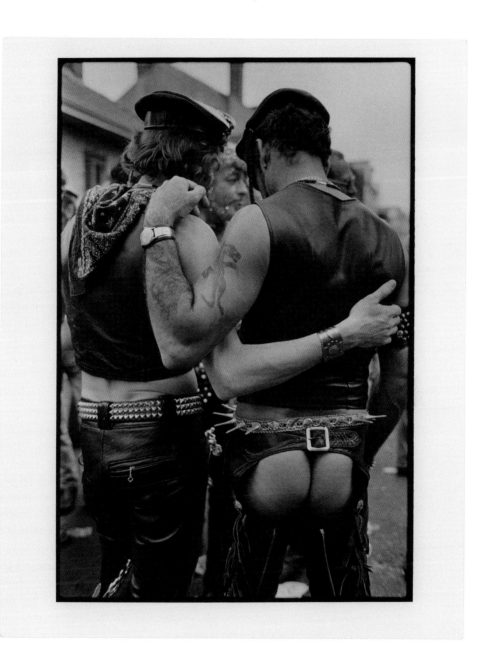

their placards or banners—to relay the collective political aims—or with a closer view that centres on public displays of same-sex affection and/or distinctive appearance or modes of dress, such as drag queens, leather daddies, or boyish women—to relay individual experience and self-expression (fig. 5.2). A sense of cheeky playfulness is evident in many of these images, conveyed through facial expressions, body language, and clothing, embodying the idea of liberation. For example, two individuals stand in the centre of the frame in a 1974 photograph, brandishing a sign for Street Transvestite Action Revolutionaries (STAR), declaring that transvestites have always been free (fig. 5.3)

Other photographs in this category include protests against government policies (or the lack thereof) and court rulings. These images often highlight acts of civil disobedience, be they peaceful or violent, and often involve altercations with police. For instance, there are several prints of a sit-in at New York's City Hall in 1983 after the defeat of a bill that proposed adding "sexual orientation" to the criteria in the city's human rights code. In one image, male police officers carry away a seated woman who doesn't resist as she looks calmly at the photographer (fig. 5.4).

In another photograph, from May 21, 1979, a group of men stand on a San Francisco street corner jeering at helmet-clad police officers, stolid sentinels in an animated crowd. The men were protesting the decision in the trial of Dan White, who murdered San Francisco mayor George Moscone and city supervisor and gay rights activist Harvey Milk, as too lenient. Events of that night, which came to be known as the "White Night" riots, appear in eight other photographs in this category, all taken by Eric Stein. Three of the prints are inscribed on their verso "GAY REVOLT – SAN FRANCISCO" and feature police cars engulfed in flames, the exposure for which makes them all the more incandescent, tipping the rest of the scene into deeper darkness. In two prints a television cameraman is silhouetted against the flames, the image a dramatic symbol of how a community's frustration and anger becomes news—so much so that nine more prints of five images have their own separate category, DEMONSTRATIONS/GAY'S [sic] REVOLT SAN FRANCISCO. These pictures seem to want to make literal the idea of fighting for rights, to make the clash of values visible and specific.

Photographs of the second National March on Washington for Lesbian and Gay Rights, in 1987—six prints classified as DEMONSTRATIONS/GAY

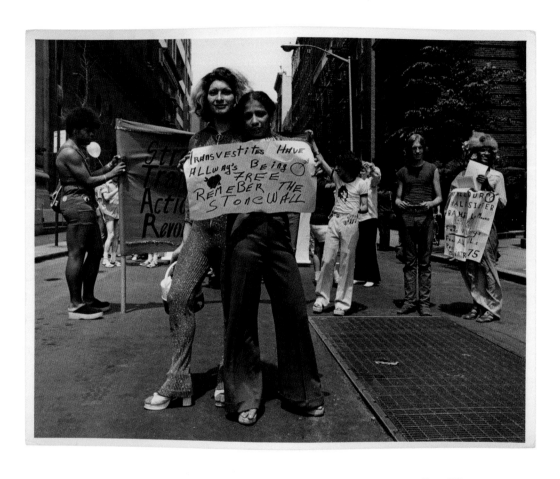

Figure 5.3
Michael Hanulak, *Gay Liberation Demonstration, New York, New York*, 1974. Gelatin silver print, 20.2 x 25.4 cm. BS.2005.246352.

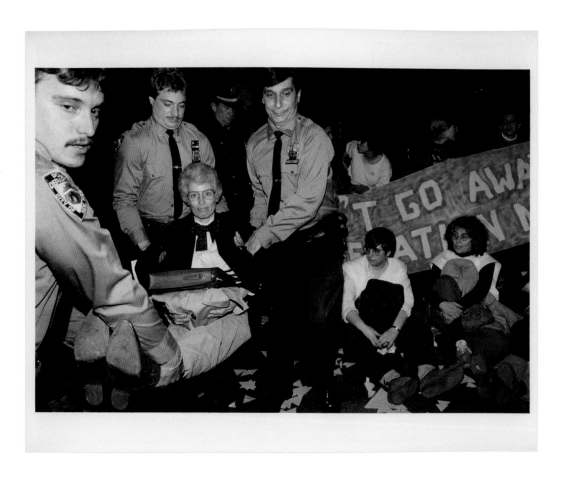

Figure 5.4
Andrew Savulich, *Gay Rights
Demonstrators Being Arrested
for City Hall Sit-in after Negative
Vote on Gay Rights Bill, New York*,
February 23, 1983. Gelatin
silver print, 20.3 x 25.3 cm.
BS.2005.246301.

MARCH WASHINGTON D.C. (AIDS QUILT)—also merit attention. The AIDS Memorial Quilt, which was first publicly displayed during that march, is formed of thousands of panels created in memory of individuals who died of AIDS. Photographs of the quilt emphasize its size in long and/or elevated views of the Mall, or they emphasize personal loss with intimate views of visitors communing before a section of the quilt.

The subcategories listed under DEMONSTRATIONS thus highlight gatherings of people for gay causes or memorials; civic disruptions in urban environments, often marked by a police presence; and slogans on placards or buildings, whether for or against gay rights. These elements also serve to highlight a visual vernacular of eventfulness in the context of representing civil rights movements.

Where DEMONSTRATIONS relies for the most part on events as the reason for the photographs, the category HOMOSEXUALITY is harder to define. The eighteen prints in the group CHRISTOPHER STREET are chiefly portraits. A photograph of two men wearing tight jeans, Western-style shirts, aviator sunglasses, and Stetson hats, and another of a man, unremarkably dressed, with a brown paper package tucked under his arm, are both inscribed "Homosexuality, Christopher St." To our contemporary eyes, some of the visual cues seem clear while others do not. What chiefly unites these works is that sixteen of the eighteen were made by a single photographer, Jamie Spracher, and all in 1980, perhaps even in a single season, as the summer attire attests.

Two other HOMOSEXUALITY groups deal with gay parties and clubs: CRISCO DISCO (one print) and GAY AFTER HOURS CLUBS (nine prints). The disco image centres on two shirtless revellers dancing with abandon at a party. The nine photographs of after-hours clubs in New York's meatpacking district were all made by a single photographer, Joseph Rodriguez. They chiefly feature the unassuming entrances of the clubs, some with patrons entering or leaving, in the early morning. Evidently taken from inside a car, the point of view creates a sense of distance from the subjects, even a sense of surveillance (fig. 5.5). The notable exception is a photograph of a sex worker, who strikes a glamorous pose in the middle of the street, defiantly, playfully confronting the photographer.

The TRANSVESTITE group is the least consistent category under HOMOSEXUALITY. Only twelve of the thirty-two prints depict individuals in drag or in costume, including an image of Divine, muse to filmmaker Waters. The

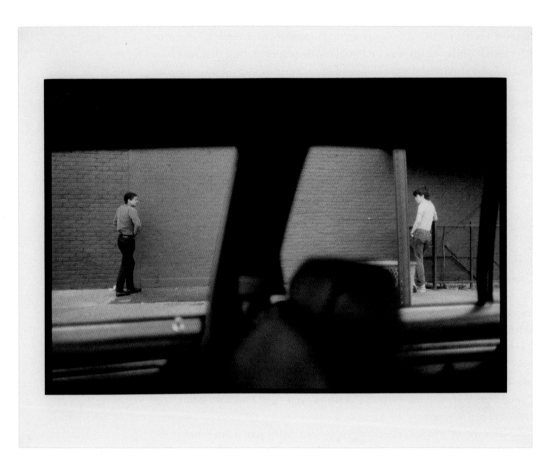

Figures 5.5 and 5.6
Joseph Rodriguez, *Two Men Outside the Back of the Anvil, New York, New York*, ca. 1980. Gelatin silver print, 22.2 x 25.4 cm. BS.2005.254068.

Jamie Spracher, *Badlands, Christopher Street, Manhattan Island, New York*, 1980. Gelatin silver print, 25.2 x 20.1 cm. BS.2005.254097.

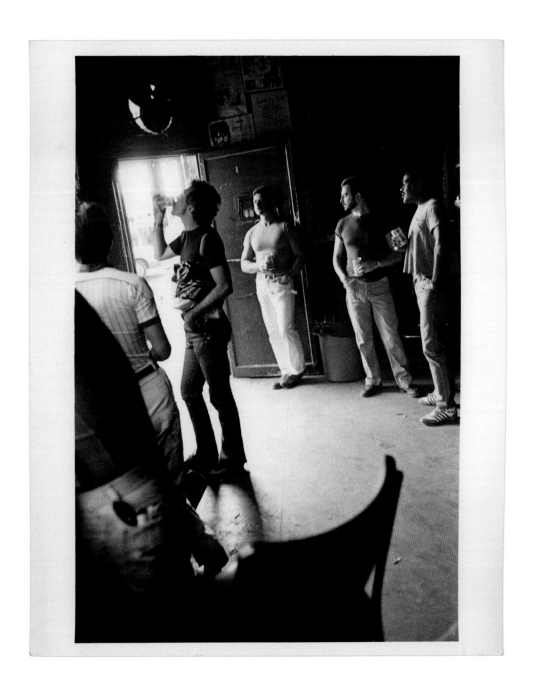

photographers aim to emphasize the extravagance of the subjects' poses and clothing. Much like the sex worker described above, the subjects seem to play to the camera, making eye contact with the photographer and striking poses. The rest of the photographs chiefly depict gay men almost as types: a sweater-clad older couple, young men holding hands, and other striking individuals. One image labelled "Homosexuality, Christopher St," depicting patrons inside the gay bar Badlands, appears to have been miscategorized. It offers a notable contrast to Rodriguez's work on after-hours clubs. The photographer, Jamie Spracher, took the photograph from inside the bar, looking towards the door as if also a patron (fig. 5.6).

Last, the eleven photographs in the HOMOSEXUALITY/TRANSSEXUAL category, all taken by Klaus Meyer, document the daily routines of a trans couple, Clemens and Gudrun. The series includes images of each before and after their respective transitions, emphasizing the transformation that has taken place. Though Meyer seems to be aiming to normalize their lives, the photographs bear publication stamps from the German magazine *Stern* (1991) and the American tabloid *National Enquirer* (1992), indicating that the material was presented in contexts known for sensationalizing stories of gender-nonconforming people.

The category HOMOSEXUALITY thus chiefly comprises portraits of individuals who are (or are assumed to be) homosexual, particularly if they present themselves as distinct from the North American heterosexual and/or cisgender norms of the time. Gestures of same-sex affection appear throughout DEMONSTRATIONS and HOMOSEXUALITY, indicating a new convention: a visual shorthand to communicate that the image pertains to queer communities.

It's no surprise that, as a collection of press photographs, the focus is on depicting events and eventfulness. As an agency with a retrieval system for hundreds of thousands of photographs, Black Star dealt well with factual material such as events. And, in many ways, these explicit categories represent what was visible to those outside the queer community. This is not to suggest that Black Star didn't have staff who identified as gay, or that the photographers from whom they acquired images weren't gay, but by the 1970s, when most of these images were made, the agency was an engine of the mainstream media, and issues relating to queer communities were perceived as marginal. The gay rights movement was still in its infancy. Many

Figure 5.7
Carol Bernson, *Divine*, 1987. Gelatin silver print, 25.3 x 20.2 cm.
BS.2005.147001.

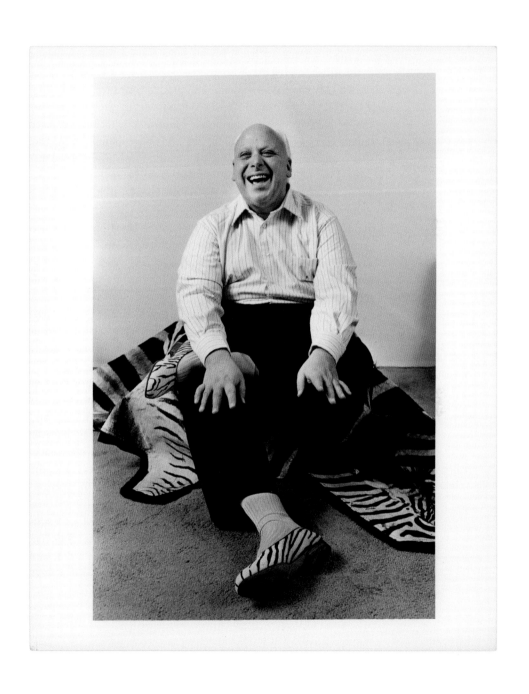

activists in the movement—Gerald Hannon, for example, who was part of the collective that founded the Toronto newspaper *The Body Politic*—have indicated that they learned how to take and process their own photographs precisely because the mainstream media weren't covering stories that were important to 2SLGBTQ+ communities.[1] Those photographs were used chiefly in publications created by and for 2SLGBTQ+ communities. In other words, they were created by and circulated among an existing audience that was beginning to mobilize politically and that knew, because of media outlets fed by agencies such as Black Star, they needed images if they were going to make any real political gains.[2]

Considering the number of photographs in the Black Star Collection that explicitly relate to gay rights, it's clear that the collection does not stand as a comprehensive record of the moment, particularly when compared to the holdings of the New York Public Library or the ArQuives (formerly the Canadian Lesbian and Gay Archives) in Toronto, which were sourced largely from individuals active in the movement, such as Kay Tobin and Diana Davies in the case of the former and members of the Body Politic collective in the case of the latter.[3] But the Black Star Collection can nonetheless remain a source for queer inquiry.

There is a second group of photographs to consider here. The collection includes hundreds of subcategories under the rubric PERSONALITIES: of and relating to notable public figures. These are typically listed as PERSONALITIES/ [PERSON'S NAME], but at times certain personalities are grouped by national origin—for example, PERSONALITIES/ARGENTINA/EVITA PERON (26 prints), and even PERSONALITIES/IRANIAN PERSONALITY GROUPS OUTDOORS (24 prints). The initial folder of 299 images to which I had access included four personalities: Anita Bryant (12 prints), Rock Hudson (26), Harvey Milk (5), and Dr. Robert Gallo (2). Bryant was a singer who actively opposed gay rights initiatives in the 1970s; heartthrob actor Hudson died of AIDS in 1985; San Francisco politician and gay activist Milk was murdered in 1978; and Dr. Gallo helped isolate HIV in the early 1980s as the agent causing AIDS.

1 Gerald Hannon, interview with the author, March 3, 2014.

2 Hannon, interview.

3 See Jason Baumann, ed., *Love and Resistance: Out of the Closet into the Stonewall Era; Photography by Kay Tobin Lahusen and Diana Davies* (New York: W. W. Norton, 2019).

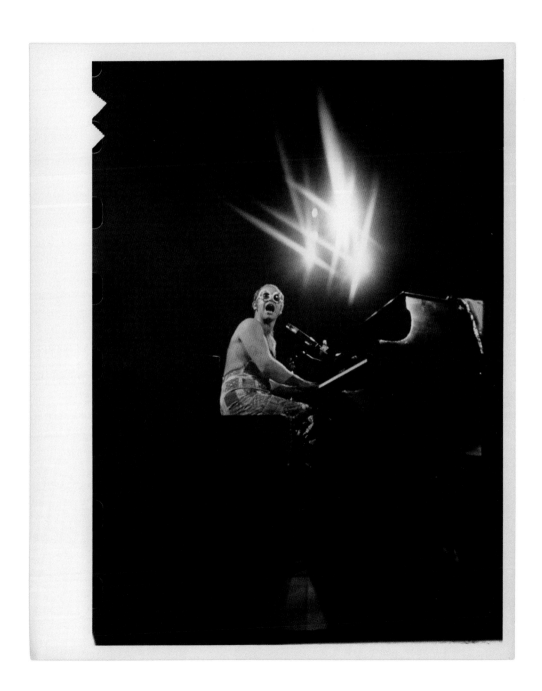

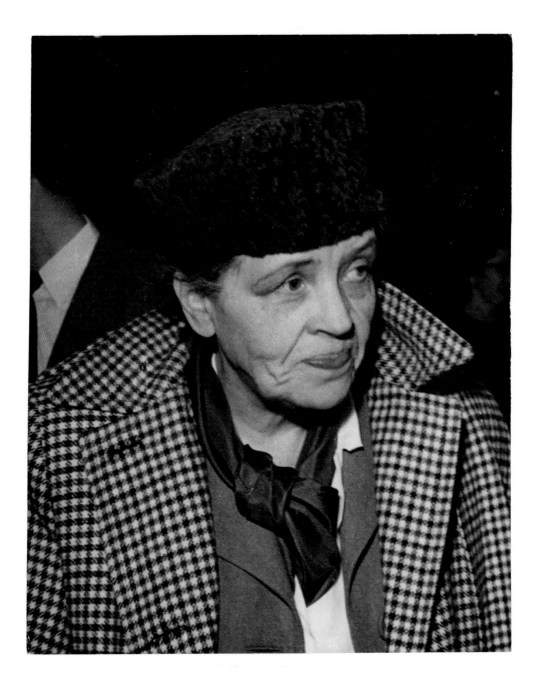

These figures don't have much in common save for the period in which they lived; that is to say, they would have been newsworthy around the same time.

In reviewing the category PERSONALITIES more closely, I identified an additional eighty figures arguably related to queer life. Some are significant because they are (or were) gay or trans, for instance, Christine Jorgensen, who underwent gender affirmation surgery in the early 1950s; dancer Rudolf Nureyev, who defected to the United States from Russia; drag queen Divine, muse to John Waters; tennis great Billie Jean King; filmmaker Pier Paolo Pasolini; and writer and activist James Baldwin. Others are related because they became gay icons in the North American context: singers Liza Minnelli, Barbra Streisand, and Dolly Parton, and actors Bette Davis, Dustin Hoffman, Hedy Lamarr, and Elizabeth Taylor, to name only a few.

I relied on my own knowledge of queer culture to identify these figures, because they are important parts of my personal queer pantheon, because I know their biographies, or because I'm aware of their cultural impact in primarily white North American queer communities—for instance, with a certain cadre of gay men. This impulse to identify, mark, or claim individuals as part of queer culture is very much tied to the moment when I came out, in the early 1990s. I was the beneficiary of more than twenty years of activism that prized visibility as an effective means of arguing for gay rights. Collectively there was strength in numbers: we were part of society. Individually, coming out as a political strategy meant that my family had to reckon with a gay daughter. Rejection was a risk, but so was acceptance. Making the fact of queer individuals visible thus had tremendous importance in proving our existence and advocating for our rights. I feel it still has relevance as a strategy for examining images in the Black Star Collection.

The photographs of those eighty figures add 1,254 more to the group of queer-related photographs, for a total of 1,553 works. It is no surprise that PERSONALITIES largely comprises portraits in some form: formal close-ups, paparazzi-type shots, environmental portraits at home, or casual views of a subject at work. A spotlit Elton John plays piano on stage (fig. 5.8); writer Anne Rice sits at her desk, the walls around her papered with images and ephemera (including portraits of Nureyev and Greta Garbo); fashion designer Christian Dior makes sure a model's look is just so; former First Lady Eleanor

Figure 5.9
Unknown photographer/ Post-Dispatch Pictures, *Djuna Barnes at a Literary Cocktail Party*, ca. 1960. Gelatin silver print, 25.5 x 20.4 cm. BS.2005.129652.

Roosevelt attends an event on a diplomatic tour of India; poet Walt Whitman is immortalized by a bronze sculpture in a New York state park.

In many respects these black-and-white portraits of queer personalities differ very little from the portraits of other subjects. In most cases the record for these individuals lists no connection to the gay community; neither does it typically list (for anyone in the category) what they are in fact known for. The Tagasauris keywords that have been added to the image records for works that have been digitized likewise do not note sexual or racial identities. The individual's fame, success, and/or newsworthiness is a matter of timely collective recognition. It is notable that some very well-known queer figures are *not* included in the Black Star Collection—Gertrude Stein and Alice Toklas, Francis Bacon, David Bowie, Billie Holiday, Larry Kramer, Robert Mapplethorpe, Nina Simone, Susan Sontag, and John Waters among them—surprising for the scale of their cultural achievements more broadly and highlighting how cultural importance is often out of synch with newsworthiness. Where the photographers covering events in the DEMONSTRATIONS category had to find ways to visually signal that a march was for a queer cause, the strategies for representing public figures, queer or not, remain much the same: focus on their distinctiveness, be it because of appearance, style, or professional role. Paradoxically, this similarity of approach is what allows queer clues to emerge in the PERSONALITIES category.

The single print of Djuna Barnes, trailblazing author of the novel *Nightwood* (1936)—described as a "recluse" in an inscription on the verso—presents a stylish woman at a New York cocktail party (fig. 5.9). Her astrakhan hat, minimal makeup, and checked coat with the collar jauntily popped immediately call to mind earlier portraits of her, including those by Berenice Abbott, as a gender-defying pioneer in Paris. Billie Jean King's balletic athleticism on the tennis court is enshrined in a number of views (fig. 5.10). The strength and grace she radiates in these photographs (and many more, not only in the Black Star Collection) would expand the idea of what was acceptable for women in sport. And in one of the queerest images I came across, Cecil Beaton stands with the actor Gary Cooper at Paramount Studios (fig. 5.11). The verso declares that Beaton, the "noted British photographer, selected Gary Cooper as one of the most interesting men in Hollywood." In their exchange of looks—Beaton's giddy, even wolfish delight and Cooper's charming bemusement—Beaton seems to be cruising Cooper.

Figure 5.10
Dennis Brack, *Billie Jean King,* 1974. Gelatin silver print, 25.3 x 19.3 cm. BS.2005.177137.

What, overall, do these photographs tell us about queer life, beyond the fact of these eighty lives? In their modest numbers and their captions (where they are present), the photographs I've identified reveal the homophobic attitudes of the time towards queer individuals, ranging from obliviousness to derision and at times leavened with a dose of starstruck celebrity fascination. An image of Christine Jorgensen, glamorously posing in a bathing suit by a hotel pool, is hand-labelled on the verso "Ex-GI turned nightclub singer/dancer," expressing astonishment at how well she embodies the feminine ideal of the time (fig. 5.14). Divine, the only figure to appear under both a general heading (HOMOSEXUALITY/TRANSVESTITES) and PERSONALITIES, appears in masculine dress (fig. 5.7). A series of photographs of Karl Lagerfeld from 1979 chronicling his daily life fixates on his preferences in ways that seem so obvious they can be read as either hilariously innocent or cunningly camp (figs. 5.12 and 5.13). The caption of an image of Lagerfeld on a plane, copies of the newspaper *Le Monde* and the magazine *Hommes* beside him, reads: "He dislikes flying but when he does, he upholsters his first-class seat and even puts a pillow on his stomach for the belt. 'Because I am so touchy there.'"

Together, the sets of photographs categorized according to explicitly queer subject headings and the public figures in PERSONALITIES reveal a culture aware of but made uneasy by the growing presence of queer individuals and the growing clamour to recognize their rights. As I describe in the essay that accompanied *What It Means to Be Seen*, individuals in queer communities have long honed a sense of visual literacy to navigate the world—a visual literacy that, when applied to photographs, has helped to build a queer visual culture, particularly since the 1970s.[4] In the absence of images, queers built their own visual codes and claimed existing images as their own. Though evidently at work since the late nineteenth and early twentieth centuries, North American versions of this visual literacy began to be described and codified in various ways in the 1960s and '70s, perhaps most famously in Susan Sontag's *Notes on "Camp"* (1964), but also by Hal Fischer and Thomas Waugh in 1977 and

Figure 5.11
Mondiale, *Cecil Beaton and Gary Cooper at Paramount Studios*, ca. 1931. Gelatin silver print, 25.8 x 20.4 cm. BS.2005.130559.

4 Sophie Hackett, "What It Means to Be Seen: Photography and Queer Visibility" (Toronto: Ryerson Image Centre, 2014).

Figures 5.12 and 5.13
Unknown photographer/
Stern, *Karl Lagerfeld
Traveling by Plane*, 1979
(recto and verso). Gelatin
silver print, 23.9 x 30.7 cm.
BS.2005.179716.

8) He dislikes flying but when he does, he upholsters his first-class
seat and even puts a pillow on his stomach for the belt.
"Because I am so touchy there."

47/78

JEB (Joan E. Biren) in 1983.[5] This visual literacy—the ability to "read" images—also remains an active force and a source of pleasure.[6]

Another researcher with different experience and reference points would no doubt pull out a different set of names or mine other categories altogether, for instance, sports or occupations. In other words, queerness in the category PERSONALITIES and in the Black Star Collection more generally emerges through both a knowledge of queer history and culture and lived experience. This underscores that queerness, in addition to being a fact, is also a mode of interpretation. As the sense of queer identity evolves beyond the fact of sexuality, and as the urgencies of visibility shift, so too will the set of images with queer relevance. It is a dance between queerness as fact and queerness in the eye of the beholder, between fact and interpretation—which is to say, it is unfixed and unbounded.

Figure 5.14
Attributed to Roland Rose, *Christine Jorgensen by the Swimming Pool of Princess Hotel in Bermuda*, 1953–54. Gelatin silver print, 24 x 19.7 cm. BS.2005.171892.

5 Susan Sontag, "Notes on 'Camp,'" *Partisan Review* 31 (Fall 1964): 515–30; Hal Fischer, *Gay Semiotics: A Photographic Study of Visual Coding among Homosexual Men* (San Francisco: NFS Press, 1977); Thomas Waugh, "A Fag-Spotter's Guide to Eisenstein," *Body Politic* 35 (July/August 1977), suppl., 15–17; JEB (Joan E. Biren), "Lesbian Photography: Seeing Through Our Own Eyes," *Studies in Visual Communication* 9, no. 2 (Spring 1983): 81–96.
6 Sophie Hackett, "Queer Looking: Joan E. Biren's Slide Shows," *Aperture* 218 (Spring 2015): 40–45.

"Smile / Social Issues / Swing"
Bias and Contradiction in Evolving Archival Descriptions
of Indigenous Subjects

Reilley Bishop-Stall

My first encounter with the Black Star Collection at The Image Centre (formerly the Ryerson Image Centre) was through remote access to the database. Some of my prior research surrounded the recirculation of archival photographs of Indigenous people, taken primarily by non-Indigenous photographers and often with insufficient contextualization. I have questioned the tendency of media, educational, and political organizations to rely on historical images to illustrate accounts of ongoing settler-colonial violence and Indigenous dispossession, and have investigated the impact of these images on public perception of Canadian colonialism.[1] I therefore saw the chance to engage with the Black Star Collection as an exciting opportunity to gain insight into the internal structures and archival practices of one of the most influential photojournalism agencies of the twentieth century. I was interested to see if the selection and mobilization of images representing Indigenous–settler relations has been reflected and reinforced in news media archives—in the actual makeup, indexing, and categorization of press photography. I was also looking forward to investigating how a collection of photojournalistic prints would factor into some of my larger questions about image description, archival ethics, colonial gatekeeping, and institutional bias.

Being located outside Toronto and avoiding travel because of the ongoing COVID-19 pandemic, I began my investigative process remotely, through a hidden link provided by The Image Centre that gave me access to

Figure 6.1
Buddy Mays, *Cochiti Indian Girls, Cochiti Pueblo, New Mexico*, ca. 1980 (detail).
Gelatin silver print,
20.3 x 25.3 cm.
BS.2005.049121.

1 A salient example of this is the extensive reliance on black-and-white images by the media and even by organizations such as the Truth and Reconciliation Commission of Canada (TRC) to represent the history of Canada's Indian Residential Schools (IRS), despite their continued operation well into the 1990s, arguably contributing to the belief that the era of forced assimilation is much more historically distant than it actually is. See Reilley Bishop-Stall, "The Art of the Apology: Apathy, Accountability and the Politics of Redress," *Art Journal Open*, December 2020, http://artjournal.collegeart.org/?p=14821.

the internal database. While I thought this virtual search engine would serve simply as my entry point to the collection, it ended up becoming the focus of my research. What I encountered in that virtual space was a perplexing convergence of subject headings, search terms, and descriptive approaches to individual images that I soon understood had been generated at different periods of time. As is the nature of archival description, each approach is both informative and inadequate—opaque and illusive, yet illustrative of the particular intentions and ideologies of its (usually unnamed) authors.

In The Image Centre's database, images that have been digitized appear alongside a series of details: category, photographer and date (when known), medium, dimensions, and accession number. These are followed by a series of Tagasauris keywords, The Image Centre's credit line, and the Black Star picture library's original subject heading. These represent a record of three different organizations entering information at three different times: Black Star's initial cataloguing of the photograph, which took place sometime between 1935 and the end of the century; evidence of The Image Centre's acquisition of the collection in 2005; and the addition of searchable keywords in more recent years.

While it was the Black Star agency's original organization that I had initially been interested in, the Tagasauris keywords captured my attention for reasons that are outlined below. These terms, generated by a combination of artificial and crowdsourced human intelligence, are largely disconnected from the Black Star picture library's indexing system and are much more indicative of contemporary research practices using online search engines such as Google or Flickr. The combination of these different descriptive systems from decades apart, however, illuminates changing needs in and approaches to the research, collection, and perception of photographic images. This is further enhanced by the Black Star Collection's migration from the corporate media sector to The Image Centre, a public institution that has research as one of its core mandates. Indeed, the acquisition of the collection is a testament to the photographic print's shifting value at specific moments in history. Furthermore, the various attempts to index or describe the images within the collection represent a response to changing research practices and expectations. This chapter examines some of those changing values, functions, and approaches by analyzing the tagging of specific images within the Black Star Collection and investigating how the selection of keywords betrays structural or societal assumptions about photographic subjects and expected audiences and image use.

From Event to Archetype: Press Photography's Evolving Identity

In her catalogue essay for The Image Centre's 2012 exhibition *Archival Dialogues*, Jennifer Allen describes how drastically the indexing incentives for a twentieth-century corporate media agency contrast with the priorities of historians, archivists, and researchers today. A fast-paced and deadline-oriented environment in which photographs were essentially tools, the photo agency gave priority to the most saleable images, first as illustrations for news reports and later as generic or stock photos. Allen writes: "Once its expiry date had passed for topical news, the photograph had a chance to gain a second life as a general picture with a far less specific claim to a time The photograph was an event and then became a thematic illustration: timely and then somehow timeless."[2] The evolution of the image from event to type, and the capacity of photographs to lose their specificity and become invested with new meanings, is of specific interest to me. Of course, all photographs are marked by a series of choices, framing devices, and potential biases, but it is precisely this process of displacement and decontextualization that allows a single image to become a stand-in for entire structures, histories, or cultures. Whether still or moving imagery, visual media are prioritized online, and with media consumption and interaction increasingly occurring in digital spaces, there is a rising demand for images that can be immediately illustrative of broad or complex concepts and realities. Arguably, the process of a photograph's progression from event to archetype has been condensed and exacerbated online.

Furthermore, Allen describes the contracted temporality of the news cycle as having a direct impact on the cataloguing tendencies of the agency. Explaining the lack of dates attributed to photographs in the Black Star Collection, she argues, "Since the photo agency worked in terms of minutes, hours and days, the year seemed light years away and somehow superfluous information in its classification system."[3] Details desired by historians and researchers were deemed largely irrelevant for the agency. As a result, Black Star's organization of its ever-growing picture

2 Jennifer Allen, "Crate 17," in *Archival Dialogues: Reading the Black Star* Collection (Toronto: Ryerson Image Centre, 2012): 112.
3 Allen, "Crate 17," 111.

library is fundamentally confounding when taken out of the context of the newspaper and magazine industry. Repeatedly moving to larger and larger spaces, the agency stored its photographs in massive filing cabinets, the order of images constantly changing as new photographs were added.[4] Arranged in some cases by location and in others by subject or personality, the drawers were alphabetized and occasionally organized in chronological order. Yukiko Launois, who worked in the Black Star libraries during the 1960s and '70s, confirmed that when she started there was no official indexing system, and that information was instead stored in the librarians' and president's brains.[5] Furthermore, multiple prints of the same image exist throughout the collection, often distributed among different drawers.

I was warned of these various obstacles when approaching the collection and was grateful for the labour already performed by so many staff and researchers to make some sense of the holdings. For instance, photographs depicting Indigenous subjects represent a relatively small segment of the collection as a whole, but a previous researcher had compiled a list of 429 photographs of "Native American" subjects, noting that additional images were included in Black Star's Canadian content.[6] Of these, a fair amount have been digitized; using the remote search engine, it was with those that I began. I was well aware that, in order to locate what I was interested in seeing, my search terms would need to align with the language in use at the time of the photographs' production; I was therefore unsurprised to see Black Star categories such as

4 Allen, "Crate 17." Allen notes: "Ironically, the agency's filing cabinet reached its final order when the collection was sold and dissolved."

5 Yukiko Launois, interview by Nadya Bair, October 31, 2016, p.2 : "For instance, I get a letter and there are a few items: colour, ice fishing. So I have no idea. I have to go to Howard Chapnick, who is president, sit down with him. And he had elephant memory— he knew everything. He would say, Ivan Massar did a story on ice fishing for *Life* magazine in nineteen-sixty-something and so I would climb up to the cabinet and go through the take and find *Life* magazine and then ice fishing."

6 It is important to note that this list does not necessarily include all the images of Indigenous subjects, as many photographs were mislabelled and/or misfiled under erroneous subject headings, and the process of cataloguing photographs in the Black Star Collection, both historically and more recently, is subject to human error and missing or inaccurate information.

INDIANS/CHILDREN and CANADA/INDIANS. What I was struck by, however, were the more recent Tagasauris keywords linked to images under those headings.

The first thing I noted was an inconsistency of terminology. At times the term INDIAN is still employed, at others NATIVE AMERICAN. Sometimes both terms appear. Without reason, INUIT is often included alongside NATIVE AMERICAN, and sometimes qualified with the phrase "formerly known as Eskimo" in parentheses. Admittedly the presence of that phrase made me bristle, not only for its unnecessary use of the racist slur but also because it betrays an assumption about the identity of future researchers, a common problem within archival practice. Here, it would appear, the assumed audience is not Inuit, who certainly would not need such clarification.

The second thing I was struck by was the inclusion of terms encompassing judgments or subjective responses alongside more benign descriptive words, and often arbitrarily applied. This issue was highlighted in a number of cases by a jarring combination of seemingly conflicting terms. An image attributed to the celebrated commercial photographer Peter Simon (1947–2018) pictures two children hanging upside down from a shared swing, enormous smiles on their faces, captured perhaps mid-laugh (fig. 6.2). It seems to have been taken in a residential setting—a yard, perhaps—with part of a house and a trio of mailboxes visible in the background. While one child holds their arms tight to their sides, hands against the pockets of their jeans and their hair confined under a cap, the other hangs with abandon, their arms and loose hair nearly touching the ground and casting a shadow as lively as the children themselves. Handwritten along the bottom of the print, presumably by the photographer, is "Julie Wanderhoop + cousin swinging in Gay Head." A stamp on the back of the print dates the image to 1978.

While no other contextual information is provided, one is here given the location: Wampanoag territory (Aquinnah, Massachusetts), a site with a complex history of inconsistent tribal recognition and a lengthy land-claim dispute encompassing the popular summer vacation spot Martha's Vineyard. If the photograph was taken in 1978, this was two years after the Gay Head Wampanoag filed a lawsuit against the US government for previously denied tribal recognition and return of their territory. The legal

Julie Wanderhoop + cousin swinging in Gay Head

battle would not be settled for thirteen years. The photograph is classified under the Black Star Subject INDIANS/CHILDREN. The Tagasauris keywords are as follows:

2 PEOPLE / CHILD / DAY / FEMALE / FUN / HANGING UPSIDE-DOWN / LIFESTYLE AND LEISURE / MALE / NATIVE AMERICANS IN THE UNITED STATES / OUTDOORS / SMILE / SOCIAL ISSUES / SWING / THREE QUARTER LENGTH

This is a compilation of terms that would make the image easily searchable if one were looking for a photograph of Native American children playing on a swing. Equally, it could be found if someone were looking for an image of "social issues."

I was taken aback by the inclusion of the term SOCIAL ISSUES alongside the words FUN, LEISURE, and SMILE, and no matter how long I stared at the image, I could not determine what "social issues" were being referred to. As far as I understood, the keywords were intended to describe only what is visible or implied in the image, and therefore application of the term would have nothing to do with territorial disputes in the region or other contextual information. "Social issues" is vague, to be sure, but it is also subjective and biased and implies dysfunction, deviance, or disadvantage—characteristics that I cannot reconcile with the vibrant smiles of the children playing in the picture. It was this photograph and its Tagasauris description that initially grabbed my attention, confirming that I would be spending a great many hours in the database, obsessively measuring keywords against the images to which they were linked.

Confronting "Social Issues"

I started seeking out patterns and, to some degree, I found them. Mainly, however, I found a pattern of inconsistency. The term SOCIAL ISSUES appears in 6,500 Tagasauris lists within the Black Star Collection. It was impossible for me to examine every image described in this way, but I found it applied commonly to images of people drinking or taking drugs, participating in protests or demonstrations, or pictured partially or entirely nude. SOCIAL ISSUES is employed often for images collected under the Black Star subjects

Figure 6.2
Peter Simon, *Julie Wanderhoop and Cousin Swinging in Gay Head*, ca. 1978. Gelatin silver print, 24.8 x 18.9 cm. BS.2005.255397.

BOWERY TYPES, BUMS, HOMELESS, HOMOSEXUALITY, POVERTY, PROSTITUTION, TRANSVESTITES, and VIOLENCE. And finally, SOCIAL ISSUES is frequently applied to photographs of Black and Indigenous people. While it is difficult to ascertain definitive numbers because of the inconsistent and unconventional cataloguing of the Black Star Collection, my own research found the term applied to between 80 and 90 percent of digitized images under the Black Star subject heading PEOPLE/BLACK(S).[7] Additionally, of the 428 photographs collated under the heading NATIVE AMERICAN, nearly half are tagged with the term SOCIAL ISSUES. This number increases to 70 percent for images under the Black Star subject heading INDIANS/CHILDREN.[8] Many are as baffling as Simon's photograph of the two young cousins on a swing. Those that do not bear the SOCIAL ISSUES tag for the most part do not picture people, but rather architecture or objects. In those that do picture people but don't include SOCIAL ISSUES, other questionable and unsupported terms often appear, including SADNESS, POVERTY, and CREEPY (fig. 6.3).

The Black Star Collection includes a number of prints by New Mexico-based photographer Buddy Mays. Figure 6.4 is a close-up portrait of two smiling girls probably around four or five years old. Leaning towards the camera, their faces take up most of the frame, with little in the background visible but a doll in a crib. The Black Star subject heading for the image is NEW MEXICO/INDIAN CHILDREN 1977–1980, and the Tagasauris keywords are as follows:

2 PEOPLE / BLACK-AND-WHITE / BLANKET / BROWN HAIR / CHILD / DAY / DOLL / FEMALE / GIRL / HEAD AND SHOULDERS / INDIAN CHILDREN / INDOORS / LOOKING AT CAMERA / NATIVE AMERICANS IN THE UNITED STATES / NEW MEXICO / PIGTAILS / SOCIAL ISSUES

7 To come up with these percentages, I conducted a series of small representational searches of all the digitized and tagged images under Black Star subject headings that included BLACKS and PEOPLE/BLACK. These included BLACKS/RELIGION and PEOPLE/BLACKS/POVERTY, among others. The numbers of digitized and tagged images in some cases are extremely small but still enlightening. For instance, under the subject heading PEOPLE/BLACK MEN, only fifteen images have been described by Tagasauris, and under PEOPLE/BLACK WOMEN, only ten. In each of these cases, all but one include the tag SOCIAL ISSUES.

8 Forty of the photographs under this subject have been digitized and tagged by Tagasauris, and twenty-eight include SOCIAL ISSUES.

Detail

Category: The Black Star Collection
Object Type: photograph
Photographer: MAYS, Buddy
Title: San Juan Indian
Event Date: ca. 1980
Medium: gelatin silver print
Dimensions: overall: 25.4 cm x 20.32 cm
Accession Number: BS.2005.049148
Tagasauris Keywords: 1 person; Braid; Day; Hair; Head and shoulders;
Male; Native Americans in the United States; New Mexico; Outdoors;
Sadness; Senior adult; Wood; frown line.noun.01; frown line.noun.01
Credit Line: Image from the Black Star Collection at Ryerson University.
Courtesy of the Ryerson Image Centre.
Black Star Subject: NEW MEXICO / PEOPLE LATE 70S - EARLY 80'S
Retouching: N

Figure 6.3
Example of questionable
Tagasauris keyword:
"sadness," screenshot,
detail view of individual item
entry, The Image Centre
internal database, accessed
April 7, 2022. While no
longer representative of the
IMC's cataloguing practices,
the historical "Tagasauris
Keywords" field remains
searchable to staff and
researchers upon request,
but not available to the public.

The picture appears to have been taken on the Tesuque Pueblo Indian Reservation near Santa Fe, New Mexico, and at least one of the children appears in other photographs by May.[9] It is again unclear what part of the image would imply "social issues" to a viewer, unless one considers the uncomfortably obvious (settler) assumption that images of Indigenous children easily connote social disorder or dysfunction. Of course, this assumption implies both an anti-Indigenous bias and a like-minded, non-Indigenous audience. I resolved to get more information about that tag in particular.

Another of May's photographs (fig. 6.5) under the same Black Star subject heading, which may or may not have been taken in the same location, is a tightly cropped portrait of a toddler. In this case the child is not smiling. However, neither are they displaying any evidence of distress such as that implied in the Tagasauris list:

1 PERSON / CHEEK / CHILD / DAY / EYE / HEAD AND SHOULDERS / HOMELESSNESS / INDOORS OR OUTDOORS UNKNOWN / LIFESTYLE AND LEISURE / LOOKING AT CAMERA / MALE / NATIVE AMERICANS IN THE UNITED STATES / NEW MEXICO / NOSE / SOCIAL ISSUES / STARVING

SOCIAL ISSUES appears again, as if it is as indisputably present in the image as the child's eye and nose. Additionally, and without any context to support the suggestion, this child is also described as "starving" and "homeless." Examples such as these abound throughout the collection; at least one undated photograph under the Black Star subject heading INDIANS/CHILDREN, attributed to Harry Tabor, is tagged with the phrase SAVE THE CHILDREN (fig. 6.6). There can be no question that this terminology betrays racial prejudice on the part of its authors. Biased and offensive terminology is, in fact, one of the most controversial aspects of archival knowledge as it exists today; the field's commitment to preserving history and provenance often ensures the retention of outdated titles and subject headings assigned earlier to images. Black Star's subject

9 The girl on the left in fig. 6.4 is pictured in another photograph that must have been taken during the same shoot, as she wears the same clothing and barrettes. The image is available for purchase on the photographer's website in a variety of formats, including different-sized prints, pillows, face masks, and even a jigsaw puzzle—further testament to the degree to which photographs can be decontextualized over time. See Pixels, https://pixels.com/featured/three-little-indian-girls-buddy-mays.html.

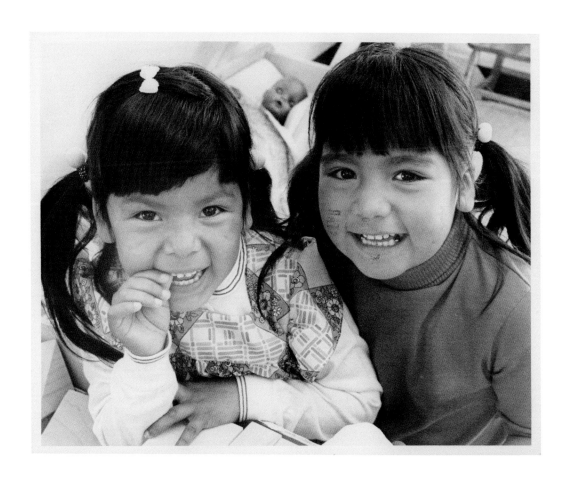

Figure 6.4
Buddy Mays, *Cochiti Indian Girls, Cochiti Pueblo, New Mexico*, ca. 1980. Gelatin silver print, 20.3 x 25.3 cm. BS.2005.049121.

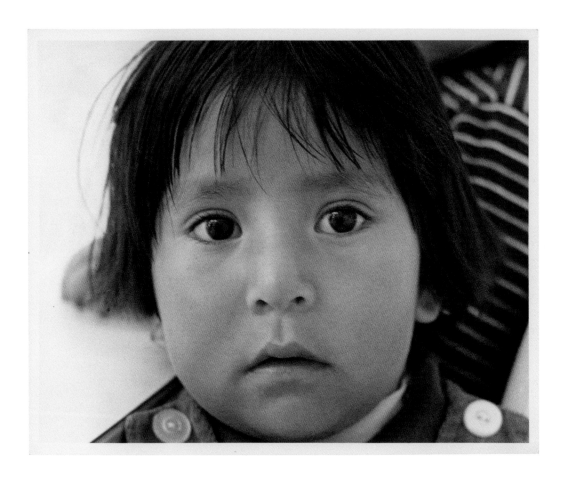

Figure 6.5
Buddy Mays, *Cochiti Pueblo Indian Child, New Mexico,* ca. 1980. Gelatin silver print, 20.5 x 25.4 cm. BS.2005.049117.

headings are, of course, a perfect example. The Tagasauris keywords, on the other hand, are not historical holdovers but contemporary additions reflecting current perceptions. However, in this case it is not a traditional archivist who is accountable, and the issue of authorship could not be more complex.

Tech Innovation in Archives

Tagasauris was founded in 2009 as a metadata company whose aim is to make online visual media navigable, computational, and interrelated. As the company's CEO, Todd Carter, explains, the goal is to "make images smart"—to create content that is aware of both itself and how it relates to the rest of the world.[10] A core component of this work is the replacement of reductive or static text streams with semantic entity graphs, achieved by mining data repositories on the Web to encompass limitless amounts of background knowledge in a single tag.[11] When working with institutions such as libraries and archives, Carter argues, Tagasauris was created in order to relieve overqualified staff from basic or menial labour, outsourcing simple tasks to crowdsourced workers while allowing the experts to focus on more specialized projects.[12]

One of the company's earliest contracts of this kind was with the Magnum photo agency—a contemporary and competitor of Black Star—

10 Todd Carter and Silver Oliver, "Multimedia Semantics," presentation at the New York Semantic Web Meetup, December 4, 2014, YouTube video, 26:09 min., https://www.youtube.com/watch?v=ox1PH9WPAsA. For further information, see "About," Tagasauris.com, https://www.tagasauris.com. See also Fred Benenson, "Hidden Treasure: Lost Photos from the Set of *American Graffiti*," *Wired*, June 28, 2011, https://www.wired.com/2011/06/pl-americangraffiti/, and James Grundvig, "Graphing the Spillway of Big Data: Interview with Tagasauris CEO Todd Carter," *Huffington Post*, December 6, 2017, https://www.huffpost.com/entry/big-data-tagasauris-ceo_b_1973567.

11 Todd Carter gives the example of the wealth of information and other terms contained in the tag BARACK OBAMA, such as MAN, AFRICAN AMERICAN, and FORMER PRESIDENT OF THE UNITED STATES. With an entity graph, all these individual tags would not be necessary, as they would be collated under the single tag BARACK OBAMA; conversation with the author, March 8, 2022. See also Todd Carter, "A 'Visual First' Web Is Emerging," presentation at Digital Asset Management NY, May 5, 2014, YouTube video, 21:15 min., https://www.youtube.com/watch?v=SeYIuL4_QpY.

12 Carter, conversation with the author. Tagasauris relies on online crowdsourcing marketplaces such as Amazon Mechanical Turk (MTurk) to locate and hire its annotators.

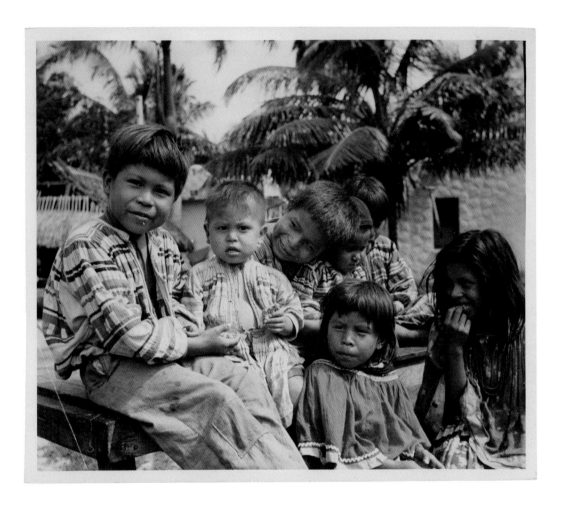

Figure 6.6
Harry Tabor, *Indian
Village, Miami, Florida*,
ca. 1950–64. Gelatin silver
print, 20.2 x 23.3 cm.
BS.2005.255402.

and shortly after that, Tagasauris was contracted by The Image Centre to apply its services to the Black Star Collection. The novel design of systems such as Tagasauris is a reasonable response to criticisms that have, over the past few decades, been levied against traditional archival practices concerning issues of authority, transparency, and accessibility. The power relations governing archival knowledge, reinforced in cataloguing and description, have been well explored. I myself have written about the colonial legacy of archives and the gatekeeping practices that perpetuate power structures, affording European and settler archivists and image-makers the power to know, name, and describe histories, peoples, and events with a presumed—yet impossible—neutrality.[13] Attempts at reform have included initiatives to increase diversity and place more power and authority in users' hands. This latter action is also intended to better reflect contemporary research practices and social media.[14]

With many publications tackling these issues around the turn of the twenty-first century, a fair amount of techno-optimism is evident in some of the key critical texts on the topic. In their 2002 article "Colophons and Annotations: New Directions for the Finding Aid," Michelle Light and Tom Hyry argue that there is a fundamental contradiction in archival practice, whereby the mediating role and subjective perspectives of archivists are often obscured by claims of impartiality or objectivity.[15] They argue, "Archives and archivists are not disinterested bystanders documenting human experience, but active agents in creating very specific views of historical reality."[16] Similarly, Heather MacNeil has asserted that, far from being neutral tools to facilitate research, archival descriptions and finding aids are themselves "socio-historical texts," compromised by the authors' intentions and

13 Reilley Bishop-Stall and Heather Campbell, "An Inuit Approach to Archival Work Based on Respect and Adaptability," in *The Routledge Companion to Indigenous Art Histories in the United States and Canada*, ed. Heather Igloliorte and Carla Taunton (New York: Routledge, forthcoming).

14 A good example is "Project Naming," initiated in 2002 by Nunavut Sivuniksavut in collaboration with the Government of Nunavut and the National Archives of Canada—now Library and Archives Canada (LAC)—enabling Indigenous people to identify unnamed individuals in the LAC photography collections.

15 Michelle Light and Tom Hyry, "Colophons and Annotations: New Directions for the Finding Aid," *American Archivist* 65, no. 2 (Winter 2002): 217–18.

16 Light and Hyry, "Colophons and Annotations," 219.

determined by individual and deliberate decisions.[17] These authors, among others, have called for increased transparency in the field. Light and Hyry propose the inclusion of a colophon with all archival finding aids, to disclose the archivist's identity and individual decisions in order to foster greater accountability. They further suggest that user annotation be encouraged to allow an archive to exist as more of a living, evolving entity.

Underscoring these ideas as they were first put forth in the early 2000s was a perception of the Internet as a liberatory technology that could fundamentally change archival structures, making information more equitable and accessible. Drawing on Light and Hyry's proposals, MacNeil describes the Internet in her 2005 article as "an ideal vehicle for transcending the artificial limits imposed by current descriptive practices," opening the door for multiple voices and diverse perspectives to enter the archival record.[18] Of course, looking back after twenty years of increased social media growth and user participation online makes the optimism of these authors already feel somewhat dated. There is little evidence to suggest that the multiplicity of voices online has led to increased transparency or accountability in archives, or in any other sector. It has, however, most certainly contributed to expectations of increased online availability of information—including images—and this is a reality with which libraries, archives, and research centres must increasingly contend.

The model put forth by companies such as Tagasauris arguably confronts both concerns about archival rigidity and exclusivity and public expectations for increased access. My experience remotely searching the Black Star Collection, however, suggests that this type of image description—generated by machine/human collaboration—can in fact lead to even greater opacity when the participants remain anonymous. Additionally, in the attempt to redistribute descriptive power to multiple entities and incorporate machine learning to offset individual bias, the terms generated in the cases cited above in fact confirm and repeat pre-existing divisions and settler-colonial power structures. What is more, the singular focus on visual analysis for the purpose of making images more search-and-findable leaves ample opportunity for error—both repeating and

17 Heather MacNeil, "Picking Our Text: Archival Description, Authenticity, and the Archivist as Editor," *American Archivist* 68, no. 2 (Fall/Winter 2005): 274.

18 MacNeil, "Picking Our Text," 276.

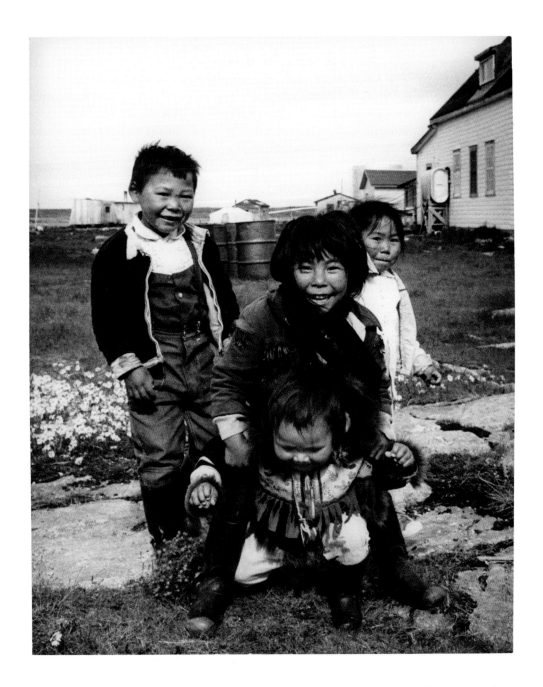

confirming misidentifications in the collection's original categorizations and adding even further misinformation.

A final image located during my process of tracking the SOCIAL ISSUES tag in the Black Star Collection provides a salient example. The photographs by German-Canadian photographer Peter Thomas, taken in Baker Lake (Qamani'tuaq), Nunavut, in the 1960s, have already been the focus of some study. Visual artist Marie-Hélène Cousineau took them as her object of focus for the 2012 exhibition *Archival Dialogues*. A French-Canadian settler who lived and worked in Nunavut for many years, Cousineau was able to identify some of the individuals pictured in Thomas's photographs and reunite them with their portraits in Nunavut. Over the course of my Tagasauris research I located a photograph, undated but taken by Peter Thomas, filed under the Black Star Subject heading CANADA/PEOPLE/CHINESE & JAPANESE (fig. 6.7). I looked at the image for a long time and came to the conclusion that it had most certainly been misidentified; it pictures the same northern terrain, architecture, and even children that appear in other photographs taken by Thomas in Nunavut in 1967.[19]

The Black Star subject heading was part of the limited contextual in-formation provided to Tagasauris employees who were analyzing the image. The keywords selected for the photograph do not correct the earlier error and also, in this case, do not include NATIVE AMERICAN, INDIAN, or INUIT. Still, tagging an image of racialized children, regardless of (equally problematic) cultural confusion, the term SOCIAL ISSUES once again appears—this time following the terms OUTDOORS, RECREATION, and SMILE:

4 PEOPLE / BARREL / CANADA / CHILD / CHILD / DAY / FEMALE / FEMALE FULL LENGTH / GRASS / LIFESTYLE AND LEISURE / LOOKING AT CAMERA / MALE / MALE OUTDOORS / RECREATION / SMILE / SOCIAL ISSUES / THREE QUARTER LENGTH

If some of the most significant shortcomings of archival knowledge and authority surround issues of bias and lack of transparency and accessibility,

19 The child in the centre of the image holding the arms of the baby appears in at least one other of Thomas's photographs, wearing the same jacket. That photograph (BS.2005.095211) is filed under the Black Star subject heading CANADA/PEOPLE (CHILDREN) and includes an inscription locating the site of the photograph as Coral Harbour, NU.

my original search of The Image Centre's database implied that none of these problems has been overcome by the technological solutions offered so far. Rather, from what I could see, bias has been retained, anonymity has increased opacity, and the images found using common search terms can easily exacerbate errors of interpretation.

I had the opportunity to discuss some of these issues with Todd Carter, the CEO and founder of Tagasauris, and from our conversation I gained both a greater understanding of the ideology and intentions behind the company and further insight into the challenges of updating existing archival systems. Similar to the proposals made by authors such as MacNeil and Light and Hyry, Carter asserts that Tagasauris was always intended to be a living, dynamic system, constantly changing and evolving in tune with societal shifts and the "wisdom of crowds."[20] Indeed, he maintains that the value of Tagasauris lies largely in its plurality, combining the knowledge of experts and laypeople with computational efficiency.[21] However, Carter adds the qualification that the system can function as it was intended only if it is ever-evolving and perennially updated. Furthermore, he is adamant that all archival or annotation systems should provide provenance in order to account for and illuminate bias.[22] These points echo my primary criticism of both traditional archival practices and contemporary image annotation. The fact remains that the Tagasauris terms in The Image Centre's internal database, available to on-site and remote researchers, are neither attributed to individual authors nor augmentable in any obvious way.[23]

20 Carter, conversation with the author. See also Carter and Oliver, "Multimedia Semantics."

21 Carter refers to the concepts "quantum truth" or "CrowdTruth," which were developed by computer scientists Lora Aroyo and Chris Welty to account for and harness disagreement and diversity in human behaviour. See CrowdTruth: The Framework for Crowdsourcing Ground Truth, http://crowdtruth.org, and "To Be AND Not to Be: Quantum Intelligence?" TEDx talk, April 28, 2015, YouTube video, 13:08 min., https://www.youtube.com/watch?v=CyAI_IVUdzM&t=11s.

22 Carter, conversation with the author.

23 Carter notes that using online programs such as Amazon MTurk to hire annotators means that provenance is recorded and preserved in all cases, but a fundamental problem with the structure is that the information is rarely accessible to end-users. Indeed, while Tagasauris may have this information, The Image Centre and other clients do not; conversation with the author.

More Work to Be Done

During my research I learned that The Image Centre abandoned using Tagasauris because of its obvious shortcomings. So, when I was searching the digitized portion of the Black Star Collection, I was not actually tapping into the Tagasauris system. The company's search terms were themselves defunct but still visible to researchers and staff in The Image Centre's database. They are, therefore, easily one of the first things encountered by researchers (such as myself) who approach the collection virtually. What is more, their combined visibility and inactivity amount to a perplexing reversal: instead of the knowledge graph being invisibly overlaid or annotating a "smart image," the tags are exposed as awkward attempts at image description. That said, I would not argue that the Tagasauris terms have lost their use or relevance, as they certainly captured this researcher's interest. While mostly uninformative in terms of understanding the collection and its components, they are illustrative of the structural biases and assumptions linked to online image analysis, which, I argue, still need to be better understood and adapted or challenged.

I asked Todd Carter about the tag SOCIAL ISSUES, which seems to be applied in ways that are both prejudicial and arbitrary. He confirmed that it is likely part of Tagasauris's controlled vocabulary, acting as a sort of net to catch any number of more precise (or equally vague) descriptors. He suggested that if an annotator wrote "economic anxiety" or "disenfranchisement," for example, it would be subsumed under the larger term "social issues."[24] This answer confirmed my assumption that there must be a control list of terms for annotators to use, as SOCIAL ISSUES seems too odd a tag to be selected so often. Considering some cases where I came across the SOCIAL ISSUES tag, I can assume that terms such as "activism," "protest," "drug use," or "fighting" might have been caught in its net.[25] However, I am ultimately left with more questions than answers when I look back at an image such as *Julie Wanderhoop and Cousin Swinging in Gay Head* (fig. 6.2) and imagine

24 It should be noted that Carter was making an educated guess about the terms that might be caught by the "social issues" net, not reading from a list or official document.

25 See the examples of types of images often tagged with SOCIAL ISSUES on pages 173–74 of this chapter.

the countless possible descriptors that could have led to the bizarre application of the SOCIAL ISSUES tag. Very few options come to mind that dispel my concern over the biases and assumptions held by anonymous annotators approaching images of Indigenous children.

In our conversation about these concerns, Carter questioned the tendency to perceive bias as essentially negative, arguing that there is value in disagreement and messiness, and that biases can be enlightening.[26] I have to agree with that final point, as my research for this project has certainly illuminated—if not explained—the persistence of certain assumptions and stereotypes in image analysis. Contrary to my original expectations, these revelations do not concern the internal power structures of corporate media or traditional archives but are illustrative, rather, of broader structural or societal biases that persist in online image collection, annotation, and mobilization. I continue to question, however, the benefit of exposed bias without its adequate attribution or explanation. There may certainly be potential to incorporating "evergreen" annotation systems into archival practice to counter the often unjustified preservation of outdated, ambiguous, or uninformative image descriptions.[27] That said, my experience of remotely researching images from the Black Star Collection at The Image Centre suggests that, at this point, attempts to adjust existing structures to address public expectations surrounding archival accessibility have done little to limit opacity and anonymity in the industry.

26 Carter, conversation with the author.
27 "Evergreen" is a term Carter commonly employs to describe dynamic and adaptive annotation systems.

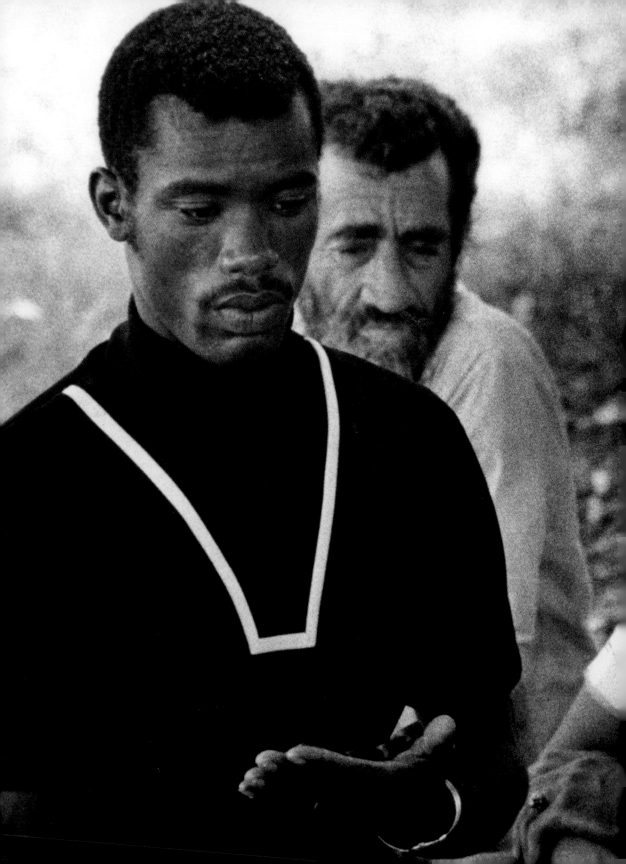

"Caribbean Misc."
Finding the Caribbean in the Black Star Collection

Alexandra Gooding

My first research interaction with the Black Star Collection at The Image Centre was in 2018,[1] as an eager graduate student in the Film and Photography Preservation and Collections Management (F+PPCM) master's program at Toronto Metropolitan (formerly Ryerson) University.[2] Born and raised in Barbados, I had migrated to Toronto seven years before and was increasingly looking for ways to connect with my home region and contribute to the field through my work, despite not living there. By the time I was faced with my first graduate research assignment, I had been working part-time at The Image Centre for six years, first as a gallery attendant and then as a curatorial and research assistant. I was aware of the gems that might be hiding in the Black Star Collection. Its breadth of coverage, spanning the 1930s through the early 1990s,[3] had been repeatedly hailed by photography historians and curators as a "repositor[y] of collective global memory [that] tells the cultural, social and political history of the 20th century"[4] and "one of the great repositories of twentieth century photographic and world history."[5]

Figure 7.1
Gary A. Conner, *Domino Game During Siesta Time, San Juan, Puerto Rico*, October 1969 (detail). Gelatin silver print, 23.1 x 19.8 cm. BS.2005.002371.

1 I am grateful to Thierry Gervais, Peter Higdon, Valérie Matteau, Gaëlle Morel, Anna Jedrjedowski, and Chantal Wilson for their willingness and enthusiasm over the years to discuss the nuances of and challenges presented by the Black Star Collection. Their personal experiences with the collection and their observations of others' interactions with it have profoundly impacted my work. I am especially grateful to Charlene Heath for her unwavering support and numerous soundboarding sessions. Finally, thanks to Anthony Martinez-Cuervo for his exceptional dexterity with Excel, saving me hundreds of hours of otherwise tedious labour.
2 I was later awarded the Howard Tanenbaum Fellowship in 2020, enabling me to continue this research.
3 Though most literature dates the collection's materials up to the 1980s, my own research unearthed at least a few prints made in the early 1990s.
4 Doina Popescu, "Introducing Archival Dialogues," in *Archival Dialogues: Reading the Black Star Collection*, ed. Peggy Gale (Toronto: Ryerson Image Centre, 2012), 8.
5 Peter Higdon, "Explanation of Outstanding Significance and National Importance,"

Based on its renowned scope and given the plethora of notable moments that occurred in the Caribbean during the twentieth century, it did not seem unreasonable to me that the collection would contain images of that region. The challenge, however, lay in finding them. Beyond knowing that I was seeking images of or about my home region, I did not know exactly what I was looking for or what I would find. The most logical approach was thus to focus on what I did know: I was seeking images related to a specific geographic area. Searching the collection using Caribbean place names therefore became my primary methodology.

Rudimentary searches for a handful of Caribbean place names in The Image Centre's collection database returned ample results. On the one hand, I was excited to recognize familiar scenes, landmarks, and activities. On the other, I was frustrated by the results: the images I sought were not necessarily filed together. I wanted to look at them all to determine which images of my home region had been deemed worthy to be extracted by Black Star to serve its primarily North American audience. By default, such an examination would also reveal what was considered irrelevant, and thus illustrate the gaps in this collection.

Around this time, Charlene Heath, The Image Centre's archivist and research coordinator, shared with me a copy of the subject headings that were used by the Black Star agency to organize the collection. I hoped that this list might clarify how Caribbean images had been filed, but it did not. Instead it emphasized the inconsistency with which the images I sought had been arranged: some were filed by a Caribbean regional place name, some by a Caribbean state name, some by both regional and state names, and others by only a town or city name. Others were filed only by subject, the name of the person in the image as a subheading under PERSONALITIES, and without any geographic reference to the Caribbean. My broadening confusion about the collection's apparent disorganization led me to ask: Who designed this filing system? Why is it so inconsistent? How was it envisioned to serve the collection's users?

Conversations with several former and current Image Centre staff members and multiple unpublished internal resources have since greatly

<hr />

Application to the Canadian Cultural Property Export Review Board, item 6, November 10, 2004, 9; Acquisition files, The Image Centre, Toronto Metropolitan University, Toronto.

informed my understanding of the different lives of this filing system.[6] Its original purpose was to help make the Black Star agency's picture library saleable, but since its subsequent migration to accompany the donation of the Black Star Collection, it has guided staff, students, researchers, curators, artists, and historians looking for their own needles in the collection's haystack. The filing system reflects Black Star's operations as a photo agency during the twentieth century.[7] The agency's fast-paced environment necessitated a means by which its numerous picture librarians could quickly organize prints in a way that also enabled their rapid retrieval through a subject search, some days, weeks, months, or even years later.

The collection's primary appraiser, Penelope Dixon, explained in her appraisal report that "[m]aintaining the integrity of the collection as a picture Archive [*sic*] was an important consideration and it was determined that the order in which the prints were found and how they were originally identified was indicative of the inner workings of an active photographic agency."[8] Dixon meticulously outlined the inventory and rehousing processes undertaken by her team to preserve the picture library's original order.[9] Their database accompanied the collection's transfer to The Image Centre, where the data were migrated into that institution's existing database. The agency's subject file and folder headings were transcribed into a password-protected "Black Star Subject Headings" spreadsheet,[10] which lists 23,025 subject headings and continues to be a critical tool for staff and external collection users.[11]

6 See Penelope Dixon & Associates, "An Appraisal of the Black Star Archive," August 26, 2003; Higdon, "Explanation of Outstanding Significance"; Yukiko Launois, interviews by Nadya Bair, October 31 and November 4, 2016, transcripts, The Image Centre, Toronto Metropolitan University, Toronto.

7 Dixon, "Appraisal," 41.

8 Dixon, "Appraisal."

9 See "The Inventory Process" in Dixon, "Appraisal," 35–41.

10 Valérie Matteau, telephone interview with the author, January 17, 2022.

11 My own research has shown that this is not an accurate count of the subject headings, as it includes misspelled headings without any prints that are often erroneous duplicates of a correct heading. They were probably misspelled from their inception at the agency, introduced into the Dixon team's database during their inventory and appraisal process, or added by human error during The Image Centre's transcription of headings from the Dixon team's database into Excel. A close

Throughout my graduate education, the concept of "original order"—sometimes called *respect des fonds*[12]—was repeatedly endorsed by instructors as one of the field's "best practices," likely because of its status as the backbone of highly regarded and widely used anglophone archival description manuals around the world.[13] *Respect des fonds* requires that "records created, accumulated, and/or maintained and used by an individual or corporate body must be kept together in their original order, if it exists or has been maintained, and not be mixed or combined with the records of another individual or corporate body."[14] My formal training enables me to understand and appreciate Dixon's reasoning for preserving the collection's original order, especially since it offers insight into the operational aspects of each print within the contexts of the agency and the illustrated press. However, for a Caribbean scholar interested in finding images that can augment the region's recorded histories, this original order presents significant navigational challenges. To some extent the commercial context that drove creation of this filing system perpetuated a Euro-American geographic relativism that was still pervasive in the early and even mid-twentieth century. The remainder of this chapter discusses how I amalgamated the collection's holdings of verifiable Caribbean-related imagery and offers some of my key findings and observations.

comparative audit of the list and The Image Centre's database is needed to determine the true total subject-heading count.

12 It must be stated that while some individuals use "original order" and *respect des fonds* interchangeably, others treat original order as one of two elements comprising *respect des fonds*, the other being the principle of provenance.

13 See, for example, "Statement of Principles," in Association of Canadian Archivists [ACA], *Rules for Archival Description*, rev. ed. (Ottawa: Bureau of Canadian Archivists, 2008), xxiii; and International Council on Archives Committee on Descriptive Standards, "Introduction" in *ISAD(G): General International Standard Archival Description*, 2nd ed. (Ottawa: International Council on Archives, 2000), 8.

14 ACA, *Rules for Archival Description*, xxiii.

Circumventing Original Order

Delimiting the Caribbean remains challenging even among Caribbean scholars, for various reasons. First, there is uncertainty and disagreement about the ontological origins of Caribbean place names that are in use today, particularly in distinguishing which names derive from the region's original inhabitants and are therefore perhaps more self-representational, versus those that were thrust upon the region by European and North American outsiders.[15] Additionally, regional and subregional names (such as Caribbean, West Indies, Lesser Antilles, Leeward Islands, and Windward Islands) were used inconsistently by different European colonizers, in part because the names being used were translated across multiple European languages, sometimes with slight variations in meaning.[16] My past research has demonstrated how these ambiguities have hindered the cataloguing and archival description of Caribbean collection materials, consequently obfuscating intellectual accessibility to those materials.[17]

Furthermore, the history of the Caribbean is a history of both forced and voluntary migration. As a result, it is not uncommon for the region to be considered in discourses of space and place. Scholars have suggested that Caribbean spaces are ever expanding and boundless and that "the Caribbean"

15 For discussions about the ontological origins of place names such as Caribbean and West Indies, see Antonio Gaztambide-Géigel, "The Invention of the Caribbean in the 20th Century (The Definitions of the Caribbean as a Historical and Methodological Problem)," *Social and Economic Studies* 53, no. 3 (2004): 127–57; and Michelle Stephens, "What Is an Island? Caribbean Studies and the Contemporary Visual Artist," *Small Axe* 17 (July 2013): 8–26. For the impact of naming and renaming on national and regional identities, see Valérie Loichot, "Renaming the Name: Glissant and Walcott's Reconstruction of the Caribbean Self," *Journal of Caribbean Literatures* 3, no. 2 (Spring 2002): 1–12. For work focused on preserving Indigenous languages within the Caribbean, see Julian Granberry and Gary S. Vescelius, *Languages of the Pre-Columbian Antilles* (Tuscaloosa: University of Alabama Press, 2004) and Gerd Carling and Rob Verhoeen, *Diachronic Atlas of Comparative Linguistics* (DiACL), https://diacl.ht.lu.se/.

16 Gaztambide-Géigel, "Invention of the Caribbean," 133–34.

17 Alexandra Gooding, "Trouble in Paradise: Expanding Applications of the Getty Thesaurus of Geographic Names® to Enhance Intellectual Discoverability of Circum-Caribbean Materials". *KULA: Knowledge Creation, Dissemination, and Preservation Studies* 6, no. 3 (2022): 1–17. https://doi.org/10.18357/kula.227.

may even transcend geographical place altogether.[18] This is exemplified by the plethora of Caribbean diasporas around the world[19] and the notion of a "Circum-Caribbean" or "Wider Caribbean" region, a recent conceptualization to include states that have shared histories with and surround the "Insular Caribbean." The Circum-Caribbean has been defined as "a space which includes the insular Caribbean, together with the northern coastal states of South America, Central America, and the Caribbean coast of Mexico,"[20] a definition that demonstrates the difficulty of separating the Caribbean from other, historically linked areas such as South, Central, and Latin America. While Circum-Caribbean theory has greatly influenced my understanding of blurry regional boundaries, the term is potentially problematic when it comes to collections organization, as it can encourage institutions to group Caribbean materials with those of South, Central, and Latin America, ultimately burying Caribbean content within the (typically) larger volumes of South, Central, and/or Latin American items.

My Caribbean upbringing and education taught me to consider the Caribbean from both geophysical and historical perspectives, as well as from the sociopolitical and socioeconomic. When I embarked on this project, I initially considered allowing the Black Star subject headings to guide my definition of the region, including only those images filed under subject headings that began with the regional names CARIBBEAN or WEST INDIES. This approach excluded numerous island and mainland territories. A broadened scope, which included images filed under subregional names such as BRITISH WEST INDIES and DUTCH WEST INDIES, still proved incomplete, and it became necessary to define the region independently from the agency's headings. Instead I combined

Figure 7.2
Number of verified Caribbean-related prints in the Black Star Collection per Caribbean state. Courtesy of the author.

18 Carole Boyce Davies, *Caribbean Spaces: Escapes from Twilight Zones; Reflective Essays* (Champaign: University of Illinois Press, 2013), 1; Stephens, "What Is an Island?," 8.

19 The largest Caribbean diasporas are in the United States, Canada, the United Kingdom, Spain, France, and the Netherlands. Diasporic neighbourhoods even borrow Caribbean place names: Little Jamaica (Toronto); Jamaica (New York City); Little Haiti (Miami); Little Jamaica (London). See Keith Nurse, "Diaspora, Migration and Development in the Caribbean," *FOCAL Policy Paper*, September 2004. https://www.focal.ca/en/publications/policy-papers-briefs/204-policy-papers-a-briefs-2004.

20 Ileana Sanz, "Early Groundings for a Circum-Caribbean Integrationist Thought," *Caribbean Quarterly* 55, no. 1 (March 2009): 1.

Anguilla	19
Antigua and Barbuda	20
Aruba	4
Barbados	27
Belize	9
Bermuda	117
Bonaire	0
British Virgin Islands	3
Caribbean (unspecified)	8
Cayman Islands	0
Cuba	1029
Curaçao	70
Dominica	2
Dominican Republic	188
French Guiana	41
Grenada	48
Guadeloupe	57
Guyana	13
Haiti	393
Jamaica	126
Martinique	38
Montserrat	4
Puerto Rico	342
Saba	4
St. Barts	9
St. Kitts and Nevis	24
St. Lucia	6
St. Martin / St. Maarten	20
St. Vincent and the Grenadines	0
Suriname	78
The Bahamas	171
Trinidad and Tobago	101
Turks and Caicos	0
United States Virgin Islands	57
Virgin Islands (unspecified)	18

a geophysical approach with a socioeconomic approach; my resulting definition included all the islands comprising the Caribbean archipelago, as well as all the member states and associate members of the Caribbean Community (CARICOM).[21] This allowed me to include sixteen Caribbean states that would have otherwise been excluded by a headings-driven approach.[22] In the research discussed here, the "Caribbean" encompasses Anguilla, Antigua and Barbuda, Aruba, The Bahamas, Barbados, Belize, Bermuda, Bonaire, the British Virgin Islands, the Cayman Islands, Cuba, Curaçao, Dominica, Dominican Republic, French Guiana, Grenada, Guadeloupe, Guyana, Haiti, Jamaica, Martinique, Montserrat, Puerto Rico, Saba, Saint Barthélemy (St. Barts), Saint Kitts and Nevis, Saint Lucia, Saint-Martin and Sint Maarten, Saint Vincent and the Grenadines, Suriname, Trinidad and Tobago, the Turks and Caicos Islands, and the US Virgin Islands.[23]

Within these parameters I began surveying the 23,025 subject headings to identify which ones indicated Caribbean connections. Initial attempts to survey the list using keyword searches of place names repeatedly proved problematic, as they did not accommodate the inconsistencies and redundancies that exist in the subject-heading system. A manual review was deemed to be the most thorough and responsible approach. In addition to providing the flexibility to address redundancies, typos, and inconsistent heading formations, a manual approach enabled me to apply my personal knowledge of the Caribbean to identify subject headings that would have been overlooked by keyword searches for present-day place names. These included "locations" headings, sometimes identified by their former colonial names (e.g., Guyana as BRITISH GUIANA; Suriname as DUTCH GUIANA; Belize as HONDURAS/BELIZE), "subjects" headings with

Figure 7.3
Fred Ward, *Military Parade at Plaza de la Revolución, Havana, Cuba*, 1977. Gelatin silver print, 25.3 x 28.4 cm. BS.2005.000499.

21 Formed in 1973, CARICOM superseded the Caribbean Free Trade Association (established in 1965), which itself succeeded the earliest formal attempt at regional integration, the West Indies Federation (1958–62).

22 The missing states that were added are the Bahamas, Belize, Bonaire, Cayman Islands, Cuba, Dominican Republic, French Guiana, Guyana, Puerto Rico, St. Barts, Saint-Martin (the agency included only Sint Maarten), St. Vincent and the Grenadines, Suriname, the British and US Virgin Islands, and Turks and Caicos.

23 This list includes only the present-day place names for these states. Past and current place names appear in the Black Star Collection, and both were included and synthesized during my research.

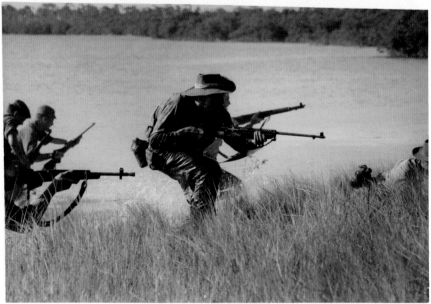

"Caribbean Misc."

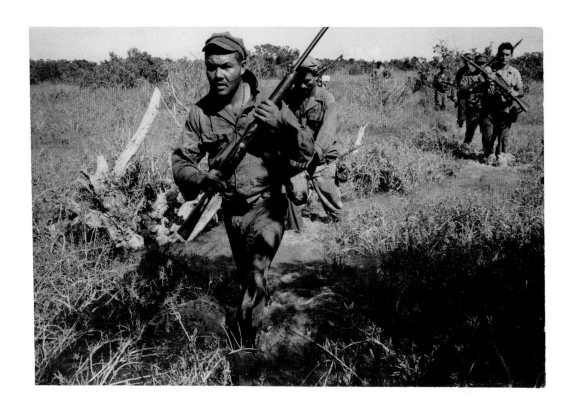

Figures 7.4–6
Fred Ward, *Anti-Castro Rebel
Volunteers Learn the "Art of
Warfare" from American Military
Volunteers in the Florida Keys*,
1960–61. Gelatin silver prints,
BS.2005.048094,
16.9 x 24.5 cm.
BS.2005.048090,
16.8 x 24.6 cm.
BS.2005.048091,
16.7 x 24.6 cm.

terms commonly associated with the region (e.g., BEACHES; HURRICANE; SUGAR), and "personalities" headings whose Caribbean connections were not explicitly indicated (e.g., PERSONALITIES/JEAN-CLAUDE DUVALIER).[24]

Altogether, 299 subject headings with explicit Caribbean connections and 15 additional subject headings deemed potentially viable were identified. The 3,398 prints represented by these 314 subject headings were consulted (virtually if digitized, in person if not) and the prints' corresponding database records were exported from the database into a spreadsheet organized by subject heading. The vast majority of headings that proved fruitful in my search were "locations"; otherwise, just sixteen "subjects" headings, four under "personalities" and two under "presidents" proved relevant.

The spreadsheets of database records corresponding to Caribbean-related material were synthesized into a single Excel workbook (henceforth the "Caribbean Inventory"), with one spreadsheet for each Caribbean state represented in the Black Star Collection. Finally, digital images of all the prints included in the Caribbean Inventory were compiled. My colleague Anthony Martinez-Cuervo auto-imported the digital recto of each print into the inventory by writing a script that cross-referenced each image's file name with specific data in the inventory, to ensure that every image was correctly matched with its data. Only 11 of the 358 prints filed under the 15 additional subject headings were verifiably related to the Caribbean and incorporated into the Caribbean Inventory.[25] In total, 3,046 prints spanning 302 subject headings were identified as relevant to the Caribbean, representing 31 of the 35 Caribbean states included in my search (see fig. 7.2).

24 Dixon stated that the agency's original filing system was organized into five sections: Subjects, World War II, personalities, Presidents, and Locations. Dixon, "Appraisal," 21.

25 The recto and verso of each print (or digital copies) were inspected; a print was included in the inventory if its image or textual annotations explicitly connected it to a Caribbean state included in my regional definition. Even if visually similar to other explicitly Caribbean prints in the Black Star Collection, only those prints with explicit annotations or unmistakeable landmarks were included in the inventory. Nine prints were identified from the subject heading INDUSTRY/SUGAR – FOREIGN and one print each from INDUSTRY/SUGAR and BEACHES/BEACHES.

Observations and Interpretations

Having amassed my dataset, I could now look *at* the images rather than simply *for* them. Just three of the 31 Caribbean states represented in the Black Star Collection account for 57.9 percent of verified Caribbean-related content: 1,029 prints across 68 subject headings related to Cuba, 394 prints across 42 subject headings related to Haiti, and 342 prints across 30 subject headings related to Puerto Rico.

Looking at Cuba, the terms CUBAN REVOLUTION, ANTI-CASTRO, ARMY, GUERRILLAS, and CRISIS appear frequently in subject headings. These terms and their associated images—Soviet-issued military weaponry being paraded through Havana's streets (fig. 7.3), anti-Castro rebel communities hiding in the Cuban countryside, and "embittered refugees" turned anti-Castro guerrillas undergoing military training in Florida (figs. 7.4–6)—make Cuba's twentieth-century sociopolitical challenges hyper-visible, even without directly portraying conflict.

For Haiti, one finds DUVALIER, REFUGEES, UNREST, and other phrases indicating upheaval, such as OVERTHROW GOV[ernment]. Crowds swarm around the former National Palace in Port-au-Prince as young men sit atop moving vehicles, celebrating Jean-Claude Duvalier's exile from the country.[26] More than two dozen prints represent the 1980s and '90s Haitian refugee crisis in Florida, most of which show the bloated, often naked dead bodies of unsuccessful migrants washed up on Florida shores; several of the prints are duplicates. I am repeatedly drawn to one print filed under PEOPLE/HAITIANS REFUGEES – 33 DIE. Two Black, presumably Haitian men are standing in what appears to be the doorway of an airplane, one of them appearing to restrain the other with the help of a white man in a uniform. Another presumably Haitian man sits at their feet. His distressed expression and raised arms seem to ask the viewer *What are we supposed to do now?* (fig. 7.7). On the print's verso a label reads simply: "Haitian refugees in Miami / Credit © 1982 / Miami Herald from Black Star." Whether these men have just arrived in Florida, are being deported back to Haiti, or are being taken into or released

26 The palace, completed in 1920, was severely damaged in the devastating 2010 earthquake and subsequently torn down.

"Caribbean Misc."

from a Florida detention camp remains a mystery, but the seated man's anguish is clear.

The images relating to Puerto Rico are less explicitly political than those for Cuba and Haiti, in both their content and their subject headings, except for the sparse coverage of pro–Puerto Rican independence demonstrations. The sparseness of that coverage is itself arguably political; it is unlikely that Black Star's American clients would want to emphasize such events, given the United States' desire to maintain control over the island territory.

The volume of prints related to each of the three Caribbean states, the types of images present (or absent), and how they were filed emphasize the United States' historical interest in those territories. Considered together, these elements logically demonstrate that Black Star, an American corporation, heavily skewed its coverage of the Caribbean to supply its largely American audience with images of Caribbean territories in which the United States had vested interests.

The remaining 42.1 percent of my dataset depicts twenty-eight other Caribbean states. Patterns emerge in the way these mainly "location" headings are subcategorized. The most common subheadings are PEOPLE, INDUSTRY, SUGAR, ARCHITECTURE or BUILDINGS or HOMES, TRANSPORTATION, RELIGION, and EDUCATION. A plethora of too-familiar visual tropes repeatedly appear across hundreds of prints: local boys and teenagers diving from rowboats into the ocean to retrieve coins thrown by tourists from cruise ships; men in rowboats waiting to sell their catches to the same tourists when they disembark; donkeys (later horses) being ridden or walked or pulling a wooden cart as they carry goods bought or for sale; women and girls balancing produce-filled baskets atop their heads, often at or heading to or from the market; agricultural labourers working in the fields; landscapes of countryside and scenic images emphasizing lush foliage and bodies of water; market vendors with their offerings and bustling market scenes (figs. 7.8–11). These are the most prevalent examples of historical visual tropes of the Caribbean found in the collection.

These tropes were carefully crafted by European and North American governments and corporations in the late nineteenth century to transform the Caribbean into a place of touristic desire for their citizens,

Figures 7.7
Unknown photographer/ *Miami Herald, Haitian Refugees in Miami, Florida,* ca. 1982. Gelatin silver print, 25.4 x 20.3 cm. BS.2005.268375.

in order to benefit the economies of those outsider metropoles.[27] The motifs were so widely reproduced and circulated that they soon became the commonly held perception of Caribbean places and people. The more familiar they became to viewers, the more they continued to be reproduced and circulated, creating an endless loop of "place-images."[28] By the time I began my research into the collection, I was well acquainted with such views; my master's thesis used a collection of late-nineteenth- and early-twentieth-century Caribbean picture postcards as a case study. I had also recently assisted Dr. Julie Crooks on a landmark exhibition and catalogue that focused on historical, modern, and contemporary Caribbean visual culture, for which I had to research more than two hundred photographs from the Montgomery Collection of Caribbean Photographs, dating from circa 1840 to 1940.[29]

It was not entirely surprising to find residues of such tropes in the Black Star Collection. The agency's clients continued to reproduce such views of the Caribbean because they were familiar to their audiences; Black Star simply obliged in order to satisfy clients' needs and make profits. Perhaps one of the most interesting aspects made visible by the collection's iterations of these tropes is the modernization of industry, in particular the mechanization of sugar production; quite literally we see the transition from hand-harvesting and ox-drawn carts to "tractor hoists," "machine cutters," and trucks, from dying windmills to factories with their chimneys billowing smoke and steam.

Based on the decades covered by the collection and the reputation it has garnered as "a visual history of the world,"[30] what *was* surprising was the almost complete absence of images of the galvanizing independence and regional integration movements that swept the Caribbean in the

Figure 7.8
Charlotte Kahler, *White River Junction, Jamaica*, ca. 1950. Gelatin silver print, 23.8 x 18.8 cm. BS.2005.002182.

27 For an in-depth discussion and reading of colonial and touristic visual tropes of the Caribbean, see Krista A. Thompson, *An Eye for the Tropics: Tourism, Photography, and Framing the Caribbean Picturesque* (Durham, NC: Duke University Press, 2006).
28 Rob Shields defines "place-images" as "various discrete images associated with real places or regions regardless of their character in reality"; see *Places on the Margin: Alternative Geographies of Modernity* (London: Routledge, 1991), 60.
29 See Julie Crooks, ed., *Fragments of Epic Memory* (Toronto/New York: Art Gallery of Ontario/DelMonico Books, 2022).
30 Dixon, "Appraisal," 28.

Figures 7.9–11
Lorena Bach, *Haitian Peasants near the Artibonite Dam*, ca. 1960. Gelatin silver print, 20.4 x 25.4 cm. BS.2005.001978.

Andrew Holbrooke, *Children Riding a Donkey with Jugs for Water, Haiti*, ca. 1981. Gelatin silver print, 20.6 x 25.5 cm. BS.2005.001818.

Herbert Lanks, *Bamboo Grove Road, Jamaica*, ca. 1950. Gelatin silver print, 24.2 x 16.5 cm. BS.2005.002095.

twentieth century.[31] In the decades spanned by the collection, thirteen Caribbean states became independent,[32] and several formal attempts were made to integrate regionally, namely the West Indies Federation (1958–62) and the Caribbean Free Trade Association (1965), which in 1973 became the Caribbean Community (CARICOM). I could not find any of these momentous events in the collection, leading me to question if its coverage is as globally comprehensive as has been claimed.

The absence of these milestones in the Black Star Collection is underscored and amplified by the hyper-visibility of touristic tropes of the region. But beyond these and the typical elements of daily life outlined in the agency's headings, there are a few gems to be found—if you know what to look for—that indicate a truer sense of Caribbeanness: men playing a game of dominoes (fig. 7.12); Carnival revelry in the streets, albeit strange to see in monochrome; people playing cricket on a beach; young men known as "tuners" converting empty oil barrels into steelpans (fig. 7.13) and musicians ("pannists") playing pan. These images invoke meaningful moments of Caribbeanness and help to counter the hyper-visible "place-images" of the Caribbean that pervade the collection and that still torment the region today. On the one hand, Caribbean territories replicate these place-images in order to sustain their tourism-driven economies; on the other, many are seeking to fully sever their colonial ties and to forge stronger national and regional identities.

My time thus far with the Black Star Collection has taken me across the Caribbean and to parts of the global Caribbean diaspora. Black Star's corporate and American contexts certainly had an impact on how Caribbean places and communities were represented (or not) by and to outsider audiences. By intellectually rearranging the agency's

Figure 7.12
Gary A. Conner, *Domino Game During Siesta Time, San Juan, Puerto Rico,* October 1969. Gelatin silver print, 23.1 x 19.8 cm. BS.2005.002371.

31 Throughout this research I have found only one image of independence celebrations—from Cuba.
32 In chronological order, they are Jamaica and Trinidad and Tobago (1962); Barbados and Guyana (1966); The Bahamas (1973); Grenada (1974); Suriname (1975); Dominica (1978); St. Lucia and St. Vincent and the Grenadines (1979); Belize (1981); Antigua and Barbuda (1981); and St. Kitts and Nevis (1983). Haiti, the Dominican Republic, and Cuba have been independent since 1804, 1844, and 1902 respectively.

"Caribbean Misc."

Caribbean content from an insider Caribbean perspective, I was able to disrupt the original order imposed by the agency and undo the invisibilization that it enforced. Through this process I found and made visible a few previously buried images that portray the region's culture more aptly than the copious views of political turmoil and historical touristic tropes that permeate the collection. For me, each of these hidden gems is a small site of resistance against the visual tropes assigned to the Caribbean by outsiders, and each is emblematic of the resilience of this region and its people.

Figure 7.13
Anne Bolt, *The "Tuner" Grooving Out the Chalk Marks That Delineate Notes on the Steel Pan,* ca. 1960. Gelatin silver print, 23 x 19.6 cm. BS.2005.002638.

Telling on Archival Erasure

The Stories Behind Griffith Davis's Liberia Photographs

Drew Thompson

Introduction

Griffith Davis is a name not frequently associated with Black Star.[1] He worked for the organization for only three years (1949–52) before folding his work as a professional photographer into a thirty-year career as a US Foreign Service officer. Davis was quite possibly the only African-American photographer to work for Black Star, even as the picturing of Black subjects was fundamental to the photo agency's founding and operation.[2] Davis's photographs of African political affairs form a critical backbone for how Black and African histories are represented within and presented by Black Star and its black-and-white print collection that now resides at The Image Centre. Thus the absence of Davis's life and work from Black Star's historical narrative is striking, and it requires further consideration.

Figure 8.1
Griffith J. Davis, *Griff and Muriel Davis (right) Screen Davis' Production of Liberia's First Promotional Film "Pepperbird Land" Commissioned by President and Mrs. William V. S. Tubman of Liberia in Executive Mansion*, ca. 1952 (detail). Gelatin silver print, 25.5 x 20.7 cm. BS.2005.215340. © Griff Davis/Griffith J. Davis Photographs and Archives.

1 This article benefited from the help of several people, who I wish to thank. In preparation of writing, I spoke to Dorothy M. Davis, Griffith Davis's daughter, who offered extraordinary insight into her father's life story and professional trajectory. I also benefited from conversations with Paul Roth and Thierry Gervais, and feedback from Pamila Gupta and Sean Jacobs.

2 The Black-owned illustrated news and lifestyle magazine *Ebony* maintained an over 50-year relationship with Black Star. When looking more closely at the subject matter featured in the Black Star Collection, which includes events associated with the US civil rights movement along with independence and decolonization efforts in Africa, the point established here is not evident at first glance. The Image Centre's database for Black Star centres on *Life* magazine and not on a publication like *Ebony*, which had an entirely different readership and focus. Also, there is evidence that *Life* magazine misappropriated photographs by Davis. For example, Davis took a widely used photograph of the poet Langston Hughes, available in the Black Star Collection. *Life* magazine used Davis's photograph in an article and labelled Hughes as a Communist sympathizer, in contrast to the images initial purpose as a headshot and portraiture. See, *Life*, April 4, 1949, 42.

You don't learn much about Davis and his work by simply searching for his name in the Black Star Collection. The photo archive's current organization undercuts the import, complexity, nuance, and diversity of his professional practice and images. Davis's prints are grouped according to the locations photographed, which include Italy, Ethiopia, and Liberia. Text appears on each print's verso in two forms, handwritten and/or typed; the origin of these texts remains unknown. The typed text resembles a photo caption, but it does not give any indication of the assignment Davis may have been completing. The handwritten text, however, does illuminate how Black Star handled his photographs. Based on the text written on versos, there appear efforts to categorize the prints into categories such as "village life," "statue," "foreigner," and "building," and the prints also feature photo credits with Davis's name. Searching press databases for Davis's Black Star photographs does not always yield the intended results. Some photographs in the collection were published but attributed directly to Davis and not to the photo agency. Other Black Star photographs never surfaced in the press. Organizing Davis's prints based on authorship alone ultimately fashions them into one long reportage. As a result, a range of methodological hurdles surface when interpreting the Black Star photographs attributed to him.

An entry point into Davis's expansive and highly decontextualized Black Star photographs is an image of Davis, his wife, the President of Liberia, and the President's wife (fig. 8.2). Standing in a wood-panelled room under an ornate chandelier, the four figures gather around a film projector. Davis, identified by the handwritten caption, has a slight smile as he positions the film spool. The others peer directly at the projector with glances bordering on boredom. Regardless of its scripted and seemingly mundane nature, the scene warranted photographing. A smaller version of this image appeared as a halftone in *Ebony* magazine with the headline "Global Honeymoon: A Photographer Takes Own Pictures of Travels on Three Continents."[3] The photo caption reads: "Liberian President and Mrs. V. S. Tubman are interested spectators as Muriel and I [Griff] prepare to show movies we took of Liberia to guests after delightful luncheon given by the Tubmans in our

3 *Ebony*, September 1952, 95.

honor."[4] Before his wedding Davis had been in Liberia to photograph the President's inauguration and to complete unspecified assignments for Coca-Cola and Republic Steel.[5]

The print and corresponding halftone invite consideration of the elements and layers in the making and viewing of Davis's Black Star photographs, specifically those taken in Liberia, on which this chapter focuses. This print is one of a handful of Davis's photographs in the collection that surfaced in the press. However, there are limitations to interpreting the print and the halftone strictly through the frame of press photography and the photo agency Black Star. Davis's photographing of his personal life overlapped with the picturing of Tubman. Images such as figure 8.2 display Tubman's own interest in Davis's pictures. Then there is the picturing of Davis in the company of Tubman, which presents him as both maker and spectator of his own images.[6] Before travelling to Liberia, Davis worked as *Ebony* magazine's first roving editor, photographing Black life in the segregated South and across the United States.[7] His work with Black Star added an international dimension to his portfolio. More specifically, his photographs of Liberia position him squarely within an African diaspora and display what photo theorist Leigh Raiford calls a "photographic practice of diaspora."[8]

With some ingenuity, Davis broke down the fourth wall between press photography, foreign diplomacy, and public relations.[9] He positioned himself as an active agent in fashioning Liberia as a type of lodestar—a model of independence and an ideal world where Blacks lived safely and prospered. Also, his blurring of the press photographer's role and extending it to the realm of diplomacy and public relations exposes the various networks he accessed and through which his images circulated. By 1950, as the above

4 *Ebony*, September 1952, 96.

5 *Ebony*, September 1952, 95.

6 Leigh Raiford, "Notes Toward a Photographic Practice of Diaspora," *English Notes* 44, no. 2 (Winter 2006): 212.

7 Photographs from this time also appear in the Black Star Collection; however, they are not readily associated with Davis and specifically his entry into professional press and news agency photography.

8 Raiford, "Notes," 212. For more on this idea of the "photographic practice of diaspora," see Emilie Boone, "Reproducing the New Negro: James Van Der Zee's Photographic Vision in Newsprint," *American Art* 34, no. 2 (June 2020): 4-5.

9 I am grateful to Sean Jacobs, who helped me articulate this point.

print and its associated halftone suggest, Davis had travelled to Liberia on three separate occasions for news organizations such as *Ebony* and *Life*, in addition to work commissioned by American corporations. Over time he developed a close relationship with Liberia's president.

Even after leaving professional photography in 1952, Davis, at Tubman's request, photographed state visits and films on Liberia. On one occasion in 1953, Tubman asked him to cover the visit of Ghanaian independence leader and Pan-Africanist Kwame Nkrumah. *Ebony* billed the visit as "Meeting May Change Face of West Africa" and recapped: "The meeting of these two most important Negro leaders of democratic Africa was a symbol of an Africa that is rising swiftly to maturity at a time when the Dark Continent is being torn by racial conflict and nationalist upheavals from one end of its huge expanse to the other."[10] The coverage featured photographs by Davis of Tubman feting Nkrumah with an honorary military guard and a banquet, along with a visit to an iron mine.[11] In a statement directed to Liberians, Nkrumah said, "The map of Africa is a multi-colored nightmare, each color except Liberia, Egypt and Ethiopia, representing the humiliations under which we, Africa's sons and daughters have labored for centuries."[12]

The idea of "changing the face of West Africa" positions Davis's photographs and the events pictured as an alternative view of Africa that contradicts the dominant and more widely viewed images of warfare and struggle. Nkrumah's statement alludes to the significance of visual and rhetorical images of Liberia, at the time one of only a few independent African nations. As presented in *Ebony* and elsewhere in Davis's Black Star photographs, Liberia is an ideal, something to aspire to. His photographs offer a roadmap for independence in Africa.

Davis is on the margins of Black Star's history as a photo agency. Furthermore, his photographs are under-recognized and under-studied because of the methodological challenges they pose. His Black Star photographs of Liberia at the time of Tubman's election and the start of his second term are part of a constellation of image-making practices that

10 *Ebony*, March 1953, 16.
11 Photographs taken at the same time as these published series are available in the Black Star Collection.
12 *Ebony*, March 1953, 16.

Davis himself participated in and facilitated, whether it be working simultaneously for other news organizations or working personally for Tubman. Davis was very intentional and deliberate in his photographic practice, especially as it related to work completed on the African continent. Therefore I approach an analysis of his Black Star photographs of Liberia and his relationship with the photo agency through an authorial lens. I situate his professional career and images within the context of the African-American struggle for civil rights and the independence efforts of Africa. Such an approach circumvents the methodological complications posed by the Black Star Collection, and it serves to give nuance and specificity to the historical and political context in which Davis worked and produced work for Black Star.

This chapter illuminates the role of African-Americans in the history of photography in Africa while illustrating the ways in which African affairs played out within the African diaspora. The first section unpacks how Tubman, a recurring figure in Davis's photographs, used Davis's presence as photographer to visualize his power and to expand Liberia's sphere of influence. The resulting images exhibit elements of Tubman's mode of self-display and the relationships he cultivated with journalists—details that highlight the historical and sociopolitical contexts Davis navigated and that mark another chapter in the history of photography in Liberia and the diaspora. Davis photographed prominent Americans who attended Tubman's second inauguration; many of those guests had dedicated themselves to the fight for equality and racial justice in the United States. The second section parses the representational politics of African Americans being seen in Liberia and in the presence of Liberia's leaders.

"Affairs of the State"

Davis travelled to Liberia for the first time in 1949. Details of his trip emerge not from within the Black Star Collection but in Davis's hometown newspaper. According to the *Atlanta Daily World*, his task in Liberia was "to cover West African assignments for various American magazines and industrial concerns through Black Star."[13] The trip to Liberia reflected American news and corporate interests in the nation that dated back to its

13 "Photo Standalone," *Atlanta Daily World*, October 30, 1949, 1.

founding in 1847. Furthermore, at the time of Davis's visit, Tubman was aggressively courting the US government and American corporations for investment in Liberia, all while campaigning for re-election. Black Star was not removed from those efforts; in fact, through its circulation and distribution of images, the agency inserted itself into foreign diplomacy and created exhibition possibilities that leaders such as Tubman readily accessed.[14]

Despite his affiliation with American news organizations, Davis was party to "affairs of the state." This phrase features in the captions of several of his Black Star photographs. Organizing the photographs with those captions brings into view Tubman's efforts to articulate his standing as a head of state and to convey his power through photography. In one photograph (fig. 8.3), Davis photographs from off to the side as Tubman participates in a receiving line. He pictures the President dressed in a traditional Liberian cloth that mirrors those worn by the men he greets. The men, who presumably can't see Davis photographing the exchange, are older than Tubman, yet one bows to presumably convey his respect. According to the caption, Tubman's cloth is made of fabric from different parts of Liberia; it resembles a patchwork quilt representing the nation's diverse ethnic composition. Leaders from those ethnic groups have come to meet the President. Similarly, the photograph attests to Tubman's recognition of the ethnic groups and courtship of their support. Davis's photographs of Tubman thus elevated and supported the leader's political ambitions.

Countless photographs do not include the phrase "affairs of the state," but the settings exhibit their own symbols of power and statecraft. Davis's photographs are captivating for their subject matter. They are also beautiful for how Davis exquisitely captures through black-and-white film unique

14 For example, *Life* in 1953 attributed photographs to "Griff Davis from Black Star and the Joint Liberian-U.S. Commission"; at the time, Davis was no longer affiliated with Black Star. In 1953 Black Star, with the support of apartheid South Africa's embassy information office, coordinated an exhibition of South African photographer Constance Stuart Larrabee's photographs at the American Natural History Museum in New York City. For more on this collaboration between Black Star and governments in Africa, see "Africa's Only Republic: Founded by Former Slaves from U.S., Liberia Is a Little Bit of America," *Life*, May 4, 1953, 51–54, and Christraud M. Geary, "Life Histories of Photographs: Constance Stuart Larrabee's Images of South Africa (1936–1949)" (paper prepared for the conference "Encounters with Photography: Photographing People in Southern Africa, 1860–1999," Cape Town, July 14, 1999).

moments and the environments in which they occur, each with its own specific activity and lighting. As such, the realm of aesthetics, more so than what is happening within the picture frames, sometimes relays greater details and meaning.[15] Each setting has its own decorative elements, including table linens, curtains, and other forms of ornamentation. The documented environments also require specific forms of dress, ranging from suits with ties to tuxedos and top hats for the men and dresses for the women.

Davis photographed Tubman dressed in a double-breasted suit with shirt and tie and smoking a cigar as he conducted a morning meeting with advisors. The caption mentions Tubman's love of Balmoral cigars, which he apparently dipped in French perfume. The image offers an intimate and candid view. It does the exact opposite of humanizing Tubman by relaying his fine tastes. The print and its caption offer one explanation for why Tubman frequently holds a cigar in Davis's photographs. Furthermore, several print versos feature the handwritten phrase "The Eternal Cigar" or "The Tubman Story," as if Black Star was using Tubman's habit of smoking cigars while conducting state business to craft a story for sale to news organizations. Another element of the images of Tubman holding a cigar is the elite class politics practised by the leader, which Davis himself fitted into because of his work as a photographer and his own educational pedigree.[16]

Davis's photographing of Tubman and Tubman's own interest in photography intersected with a longer history of photography in Liberia. At play as well was the legacy of African Americans' engagement with the country. When Davis visited Liberia, African Americans were vigorously debating the role of the nation, and of Africa more broadly, within the struggle for civil rights and social justice in the United States. Photography was

Figure 8.3
Griffith J. Davis, *President of Liberia William V. S. Tubman Greets Indigenous Tribal Chiefs Who Come to Call on Him*, ca.1952. Gelatin silver print, 19.9 x 19.6 cm. BS.2005.215275. © Griff Davis/Griffith J. Davis Photographs and Archives.

15 I am grateful to Pamila Gupta for drawing my attention to this element of Davis's work.

16 Davis studied at Morehouse College, a Historically Black College and University, where the author and cultural activist Langston Hughes mentored him. He developed his skills as a photographer while taking photographs of campus life in the early to mid-1940s, and in the process he developed close relationships with seminal African-American political and cultural leaders, including Benjamin Mays, Hughes, and Hale Woodruff. After graduating in 1947, he worked for a year at *Ebony*. In 1949, he graduated from Columbia University's School of Journalism. During his studies he enrolled in a photojournalism course at New School for Social Research with Kurt Safranski, one of Black Star's co-founders.

fundamental to Liberia's founding. In 1847, formerly enslaved Black populations in the United States travelled to Liberia in order to establish a new nation. The photographer Augustus Washington was part of the exodus of freed Blacks. Upon arriving in Monrovia, Liberia's capital, Washington opened a studio and made daguerreotypes of the newly settled people who served as the nation's first political leaders. Not too dissimilar from the way Davis pictured Tubman, leaders posed for Washington seated at a table with a stack of papers; the daguerreotypes were intended to show them actively governing. To convey social status, others, many of them women, dressed up for portraits by Washington. Photo historian and theorist Shawn Michelle Smith argues that Washington's daguerreotypes fashion a self-governing and self-sufficient Liberia under the leadership of formerly enslaved populations.[17] Smith also contends that there is a two-sidedness to the daguerreotypes.[18] On the one hand, the sitters and the users of the images intended them for audiences in the United States, to advertise their success and to challenge those who questioned their abilities and Liberia's autonomy. On the other hand, they were meant for display in Liberia to convey the sitters' sociopolitical influence.

There are many parallels between Davis, Tubman, Washington, and Washington's sitters that help to frame Davis's photographs of Liberia, as well as to explain the politics of representation that unfolded through them. Tubman, like Washington and his sitters, was a descendant of people who had been enslaved in America, and in Tubman's case he was also a direct descendant of Liberia's founders. Like Tubman, Washington went on to work in Liberia's court system and legislature. Davis's rise as a photographer and then his pursuits in US diplomacy were unparalleled, considering the conditions of African Americans, and his career resonated in many respects with the lives of Tubman and Washington.

Tubman engaged with a photographer such as Davis in a way similar to Washington's sitters. At the time he was actively appealing to American business and foreign interests, which partly involved socializing with prominent

17 Shawn Michelle Smith, "Augustus Washington Looks to Liberia," *Nka Journal of Contemporary African Art* 41 (November 2017): 10. Also see, Dalila Scruggs, "'The Love of Liberty Has Brought Us Here': The American Colonization Society and the Imaging of African-American Settlers in Liberia," PhD diss., Harvard University, 2010.

18 Smith, "Augustus Washington Looks to Liberia," 11.

Black journalists and cultural figures. Davis photographed those exchanges and the prominent African Americans who visited Liberia. In the process, his photographs positioned Tubman within an important diasporic context that was instrumental to Liberia's independence and from which Tubman sought legitimacy. To that point *Life* magazine published, in conjunction with Davis and the Liberian–US Joint Commission, a photo essay featuring pictures of men working at a mine, students pledging allegiance to the Liberian flag, and Tubman conducting state affairs.[19] The magazine also published an article identifying Tubman as one of its readers.[20] Simultaneously, Tubman capitalized on Davis's standing in the global media by commissioning him to show his photographs as part of a Liberian-funded exhibition at American Museum of Natural History in New York City, titled *Liberia 1952*.[21] Thereafter, from 1953 to 1957 and at Tubman's request, Davis made numerous films about Liberia, including *Pepperbird Land* (1952), featuring a voiceover by the famed African-American actor Sidney Poitier, and other films about Tubman's inauguration and state visits by African leaders. Tubman also appears as a collector of Davis photographs; his personal and official image archive is available online through the Indiana University Bloomington.[22]

Davis's photographs of Tubman reflect the political control that Tubman exerted with Davis's support as photographer. Elements of political manoeuvring and repositioning are on display. The 1953 *Life* article described above reported that the population native to Liberia since its founding totalled 1.5 million people. There was a small political and social elite of 25,000 people, commonly referred to as "Americo-Liberians," who descended directly from Liberia's founders. Tubman was all too aware of the disproportionality between the Americo-Liberians and populations native to Liberia, which placed pressure on his legitimacy and chances for re-election. Supposedly, according to Davis's unpublished Black Star photographs, up until Tubman's election almost all the government leaders were descended

19 "Africa's Only Republic: Founded by Former Slaves from U.S., Liberia Is a Little Bit of America," *Life*, May 4, 1953, 51–54.

20 "Speaking of Life," *Life*, August 1, 1949, 87.

21 "Photo Exhibit of Liberia to Tour U.S.A.," *The Crusader,* September 12, 1952, 1.

22 William V. S. Tubman Photograph Collection, Liberian Collections, Indiana University Bloomington, https://webapp1.dlib.indiana.edu/images/splash.htm?scope=lcp/tubman.

from people who had been freed from slavery and who had founded the nation. To return to figure 8.3, Tubman is recognizing representatives of local populations who have no formal political representation, and similarly, those greeting Tubman identify him (at least as portrayed by the photograph) as the leader of Liberia. In another set of images of Tubman visiting rural areas, he toasts several chiefs who have come to greet and congratulate him. He even travels in the company of these figures. In figure 8.4, Davis photographs from alongside the car transporting Tubman as onlookers gather around the vehicle and try to get a glimpse of the President or shake his hand. Seated in front of Tubman, who has a cigar in his mouth, is a chief, symbolizing how Tubman generates an element of his power from such public events, in addition to being in the presence of rural leadership.

Figure 8.5 places into relief the reworking and enhancing of Tubman's political power that Davis orchestrated by disrupting the boundaries between press and official photography. In the image, a tall figure wearing a pinstriped gold cloth puts his hand on a Bible that Tubman is holding. The President wears a tailcoat. In the background stand men dressed similarly to Tubman who are looking in different directions. The caption on the verso of the print editorializes the moment:

> President swears in new members of House of Representatives in Liberian Congress patterned after the legislative body of USA. Before Tubman came to office in 1944 the aborigine population of Liberia (more than 1,500,000) had no direct representation in Congress. Only Americo-Liberians were congressmen (about 20,000 descendants of freed American slaves). So far Tubman has put 13 native representatives in Congress. Fellow in native gown is one of [the] men he put in Congress in effort to break down ageold [sic] barriers between so-called "civilized" and "uncivilized" elements of population.

Here it is worth distinguishing between the photographed event, the photograph, and its accompanying caption. There is a lack of clarity in the image with regard to who is swearing in whom. The caption alludes to the revolutionary and unconventional nature of the photographed moment, and it attributes that moment to Tubman. The photograph, along with the caption, fashions both Americo-Liberians and populations native to Liberia, despite the disparity in representation, as recognized governing

Figure 8.4
Griffith J. Davis, *President of Liberia William V. S. Tubman Shakes Hands with Liberians Who Come Up to the Window to Greet Him,* ca. 1951–52. Gelatin silver print, 22.4 x 19.4 cm. BS.2005.215272. © Griff Davis/Griffith J. Davis Photographs and Archives.

officials. The establishment and extension of Tubman's power as president involve being seen with populations that are under-represented in government and being seen as the one who elevates their literal representation within government. The photograph is one object that, like the pictured event, is intended to reshape public perception of the government and its leader(s). Within "affairs of the state," new power structures, economic and diplomatic interests, and modes of representation surface that can easily go unnoticed when using the current headings and organization of the Black Star Collection.

The Inauguration

In 1952 Davis was on hand for the inauguration of Tubman as president of Liberia for a second term. He was initially in Liberia to photograph the opening of the US embassy in Monrovia and the arrival of the first Black ambassador in the entire US diplomatic corps. In addition he photographed the building of roads and railways by the Liberia Mining Corporation, an effort by the entrepreneur Lansdell K. Christie to export iron ore to US markets.[23] Images of these developments are featured in the Black Star Collection, but a subset includes Tubman's swearing in as president. Pictures also show Tubman swearing in members of government, cultural performances, and ceremonies attended by foreign dignitaries.

The images easily blend in with the "affairs of the state" photographs. However, within this subset of images appear prominent Black cultural and political figures such as Etta Moten, Mary McLeod Bethune, Dan Burley, and Pearl Primus. Davis's presence at the inauguration represented international interest in the moment. Within that space, he documented not only the festivities but also other African-American dignitaries from a range of sectors, both public and private, who attended—an aspect of his reportage

23 For more on Lansdell K. Christie's activities in Liberia, see Davis's Black Star photograph. See also Paul Richard, "The Nation's Peale of Fortune," *Washington Post*, November 8, 1979, https://www.washingtonpost.com/archive/lifestyle/1979/11/08/the-nations-peale-of-fortune/5297fc00-317b-4f4f-9867-d952457a9755/; C.H., "Exploit in Liberia," *Popular Economics* 2, no. 3 (November 1951): 18–20; and "Bomi Bonanza," *Time*, March 28, 1949, https://content.time.com/time/subscriber/article/0,33009,799961,00.html.

that the Black Star Collection renders insignificant and of little interest. However, the presence of these Black American luminaries and Davis's photographs of them contrast with their position and representation in a racially segregated America. Within Liberia and the context of Tubman's inauguration, a space for being seen anew—or at least differently—emerged for Davis and the African Americans he photographed. Such space for representation and documentation harked back to Liberia's founding; it was the same visual sphere that was fundamental to the nation's sovereignty. How African Americans appeared and what it meant to be seen in such a context requires further explanation.

The author and cultural critic bell hooks writes about the importance of photographs for Black families. In her essay titled "In Our Glory: Photography and Black Life," she argues that organized efforts by Blacks for civil rights were overly concerned with "good" or "bad" images that worked in the service of the struggle for desegregation.[24] She says that in the moment, many of those fighting for freedom overlooked the "politics of representation," specifically the confining ways of seeing Black figures that would persist long after desegregation.[25] Hooks postulates, I would argue somewhat incorrectly, that "black people have made few, if any revolutionary interventions in the arena of representation."[26] Her analysis focuses on snapshots as "sites of resistance" in order to "talk about the significance of black image production in daily life prior to racial integration."[27]

One of many counterpoints to hooks's assertations would be the images of African Americans that Davis photographed in Liberia, which can be viewed as "interventions in the arena of representation" that pre-dates integration.[28] Many people whom Davis photographed never viewed his specific images, but they did see him take their picture. The photos did not appear in the press even though the press context provided a reason for their taking. Davis's photographs of African Americans in Liberia function as counterimages to the ones of lynching and civil rights abuses that the Black Star Collection

24 bell hooks, "In Our Glory: Photography and Black Life," in *Art on My Mind: Visual Politics* (New York: New Press, 1995), 58.
25 hooks, "In Our Glory."
26 hooks, "In Our Glory."
27 hooks, "In Our Glory," 59.
28 hooks, "In Our Glory," 58.

includes and that are prominently featured in the US media landscape. But Davis's photographs are more complicated: they illuminate certain modes of seeing and being seen that were possible only in a diasporic context such as Liberia.

Here I would like to introduce an image that Davis took in Atlanta, Georgia, before he travelled to Monrovia and worked officially for Black Star. A couple ascends a long staircase at nighttime. The woman wears on her shoulders the coat of her gentleman companion. The man wears a white shirt and suspenders hold up his slacks. Light emanating from either the setting or Davis's camera hits the backs of the figures so that their shadows extend up the steps. Davis has positioned himself at the foot of the stairs to take the image. As viewers we are left to speculate about the identity of the figures. I have encountered this image in two forms, one as a print in the Black Star Collection and the other as a halftone published in *Ebony* magazine. The print includes the caption "Going through colored entrance at movie" and the assigned labels "Negro" (a term used to refer to African Americans and populations from Africa) and "segregation." The image appeared in *Ebony* with an article titled "Atlanta: Its Negroes Have Most Culture But Some of the Worst Ghettoes in World" and it features the caption "'Buzzard's roost' where Negro moviegoers must go at big downtown Fox Theater is up five flights of stairs. Four downtown white theaters admit Negroes to 'colored balconies.' Six Negro theaters show third-run films."[29]

In one respect, figure 8.6 as a print and a halftone displays an attempt by Davis to photograph segregation in its crudest, perhaps most invisible form while humanizing and honouring his subjects. In another respect, such images offered context and one framework for interpreting the modes of seeing and being seen that unfolded in and around Davis's images of Blacks in Liberia. The "Buzzard's roost" was an area in movie theatres designated for Blacks only. The photographed subjects in figure 8.6 must ascend several long flights of stairs to get to their designated seats. Even though the couple can afford tickets, segregation prevents them from sitting next to White patrons and viewing the film from the same level.

29 Langston Hughes and John C. Alston, "Atlanta: Its Negroes Have Most Culture But Some of the Worst Ghettos in World," *Ebony*, January 1948, 23.

This is one instance where Blacks and Whites viewed the same film separately. But Blacks and Whites were not always in a position, financially or politically, to see the same films. In an article about Black experiences in segregated Southern movie theatres, Charlene Regester cites a White patron who expressed his surprise at seeing Blacks while watching a film at the Fox Theater, the site of figure 8.6. The patron, Leo Shairo, states:

> [T]ucked away in nigger heaven . . . I remember the first time I ever went to a movie in the South. It was during the war. I went to a big palace—the Fox in Atlanta, maybe, and it was hot. Well, I was watching the picture when I suddenly realized I heard this rustling sound above my head. I jerked around and to my shock and surprise, I saw another balcony, and it was full of people! It was the blacks, of course, waving programs and fans to keep cool. I had heard of this "nigger heaven," but never seen one.[30]

There were many layers to seeing and being seen in the American South at the time of segregation, and Davis was fully aware of that. As Shairo's experience suggests, Whites were sometimes encountering Blacks in movie theatres for the first time. Identifying the figures in the photograph or seeing them from the front is irrelevant to understanding how segregation occurs at the level of sight. By electing to position himself at the base of the stairs and photograph the couple from the back, Davis alludes not only to the separate entrance but also to the distance and angle (i.e., looking down from the balcony) from which Black moviegoers had to view films.

Figure 8.6 contrasts starkly with figure 8.2, which fashions Davis as a filmmaker and photographer who produces materials for Black audiences, including the president of Liberia. Davis appears in figure 8.2, whereas in figure 8.6 he positions himself behind the couple and is not visible in the print. From the image it is unclear whether the couple was aware Davis was taking their picture. Together, figures 8.2 and 8.6 illustrate the multidimensionality and range of Davis's practice, which started in Atlanta and then extended to Liberia. In fact, in the Liberia photographs Davis either

Figure 8.6
Griffith J. Davis, *Going Through Colored Entrance at Movie, Fox Theater, Atlanta*, ca. 1948. Gelatin silver print, 25.2 x 19.7 cm. BS.2005.280822.
© Griff Davis/Griffith J. Davis Photographs and Archives.

30 Charlene Regester, "From the Buzzard's Roost: Black Movie-going in Durham and Other North Carolina Cities During the Early Period of American Cinema," *Film History* 17, no. 1 (2005): 114.

photographs himself or appears in the pictures. In terms of dating, he produced figure 8.2 long after figure 8.6. The latter includes the inscribed labels "Negro" and "segregation," again illustrating how the Black Star Collection's organization erases historical context and biography in favour of converting images to stand-ins for a universal Black experience. Such labels don't apply to the photographs of Liberia, especially the ones by Davis of African Americans.

So what are we to make of these photographs of African Americans in Liberia? Let's take the image of Mary McLeod Bethune (fig. 8.7), a civil rights activist who started schools for Blacks in the segregated South. Davis photographed Bethune at different ceremonies and performances associated with the presidential inauguration. She was in Liberia because President Harry Truman had appointed her a member of the US delegation assigned to attend the inauguration. On the same occasion Tubman awarded Bethune Liberia's highest honour, Commander of the Order of the Star of Africa. A photograph of the occasion is not among Davis's Black Star photographs, but his image of the dancer Pearl Primus receiving a similar medal is. Davis was not the only individual photographing Bethune; inauguration guests also had cameras and photographed in unofficial capacities. For example, an image of Bethune like the one by Davis is in Tubman's photographic collection; it was taken by Leon M. Jordan, who was in Liberia to train the police force.[31] Jordan's and Davis's decision to photograph Bethune attests to her reputation, and it alludes to the importance of seeing such a figure within the inaugural context. Tubman bestowed recognition on her and other African Americans, and several people in attendance felt the need to photograph the moment. Such recognition did not always carry over to the United States.

Bethune and Tubman had met before the inauguration, in 1947 in the United States. According to an *Ebony* magazine article, Bethune expressed her support of Blacks going to live in Liberia,[32] but Tubman was not of the same opinion. Mention of the meeting was in the context of an article

Figure 8.7
Griffith J. Davis, *Mrs. Tubman and Mrs. Bethune (Member of the American Special Mission) Speaking to a Visitor*, ca. 1952. Gelatin silver print, 21.4 x 20.7 cm. BS.2005.132354.

31 Leon M. Jordan, *Mary Jane McLeod Bethune, American Educator and Civil Rights Leader, Converses with Guests During a 1952 Event Honoring President Tubman's Inauguration*, 1952, Monrovia, Liberia, William V. S. Tubman Photograph Collection, Liberian Collections, Indiana University Bloomington, https://webapp1.dlib.indiana.edu/images/item.htm?id=http://purl.dlib.indiana.edu/iudl/lcp/tubman/VAA7927-5108.

32 "A Future in America, Not Africa," *Ebony*, July 1947, 40–41.

advocating for Blacks to stay and fight for civil rights rather than go to Liberia, a nation founded by formerly enslaved populations and where Blacks enjoyed certain recognition.[33] Almost five years after meeting Tubman, Bethune herself visited Liberia, but Davis's photograph of her did not hold the same value for the US press. Photographs of formative events and figures of Black American and African cultural and political history (such as those authored by Davis) influenced Black Star's creation, viability, and longevity.[34] Nevertheless, the Black Star Collection presents the images of Bethune and other prominent African Americans as stock photographs intended for general editorial use. The print represents the two-sided nature of how African Americans viewed Liberia and how they saw themselves within the context of that country.

Conclusion

The Black Star Collection features labels that attempt to control the narrative around photographs, and yet in the process these categories obscure the range of networks that Davis accessed and travelled within as a photographer. Additionally, the collection's existing organization completely eclipses how Davis used photography to establish and mediate his different roles, ranging from news photographer to public relations expert to diplomat. Davis's career was unprecedented. He was fluent in a range of photographic genres, many of which are on display in his work from Liberia. His role as a photographer was not confined strictly to press, photo agency, or war photography. Furthermore, Black Star's day-to-day operations overlapped with US foreign diplomacy

33 "A Future in America, Not Africa," *Ebony*.

34 Look no farther than in the Black Star photographs attributed to Davis. Davis's Black Star photographs are not limited to the time of his formal three-sided affiliation. Photographs surface from Davis's early years practising photography while studying in Atlanta, Georgia, and include portraits of African-American trailblazers, like the writer Langston Hughes, the university president and educator Benjamin Mays, and the painter Hale Woodruff, and from assignments completed for *Ebony* magazine. A prominent element of Davis's Black Star Collection photographs are images of Liberia and Ethiopia, principally of each nation's leaders, which Davis produced for other news organizations. Black Star appears interested in aspects of a photographer's archive independently of whether an image was produced in a particular news context.

and unfolded against the backdrops of African independence, the post–World War II question of decolonization, and the US civil rights movement. As evidenced by this analysis, viewing Davis exclusively within the purview of the Black Star Collection is limiting and can be misleading. The way he photographed African affairs is deeply connected to his own biography, as are the contents of his Black Star photographs and the visual syntax through which to interpret them. Davis's photographs are markers in both the history of photography in Africa and the African-American history of photography. Because of the politics of representation at stake, a biographical approach is essential when analyzing Davis's Black Star photographs.

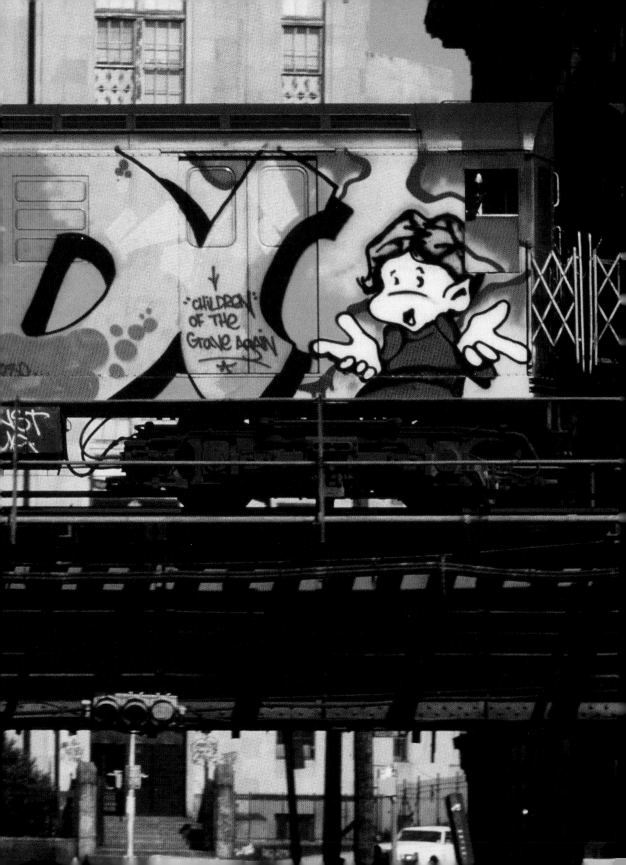

Picturing Wild Style
Martha Cooper, Black Star, and New York's Underground

Vanessa Fleet Lakewood

One of Martha Cooper's first and most significant graffiti images is the portrait she took of a teenager named Edwin Serrano, who posed for her in front of a wall painted with the big block letters of the name he assumed as an aerosol writer, HE3 (fig. 9.2). In the picture, Serrano coolly stares back at the photographer, crouching low on the sidewalk and displaying a sketchbook open to his stylized signature. Cooper met Edwin in 1979, two years after she moved to New York City to become a photojournalist. With aspirations to shoot for *Life* or the *New York Times*, Cooper had taken a job as the only woman staff photographer at the *New York Post*. She would walk the boroughs of the city searching out pictures for daily assignments. Moving through the poorer neighbourhoods of the Lower East Side and Alphabet City, Cooper would use up her leftover roll film by snapping pictures of children and young people playing among abandoned buildings and rubble-filled lots. Noticing Cooper with her camera in hand, Edwin had asked, "Why don't you take pictures of graffiti?"[1]

Cooper remembers this photographic encounter as a turning point in her understanding of the hyper-visible and esoteric forms of writing that proliferated on New York's public surfaces. In conversation with Edwin, Cooper learned that graffiti writers were signing their names in public, and she was fascinated by the planning and complex design processes that found expression in their work. "It was thought to be random vandalism," she recalled, "but in fact, it was highly organized."[2] This early portrait reveals the connection between self-naming and public writing while also narrating the creative process behind graffiti.

Figure 9.1
Martha Cooper, *Children of the Grave Again, Part 3, by Dondi*, 1980 (detail), in Martha Cooper and Henry Chalfant, *Subway Art* (New York: Holt, Rinehart & Winston, 1984), 34–35. © Martha Cooper.

1 Martha Cooper, *Hip Hop Files: Photographs, 1979–1984* (Cologne: From Here to Fame, 2004), 14.
2 Martha Cooper, interview with the author, New York City, February 6, 2017.

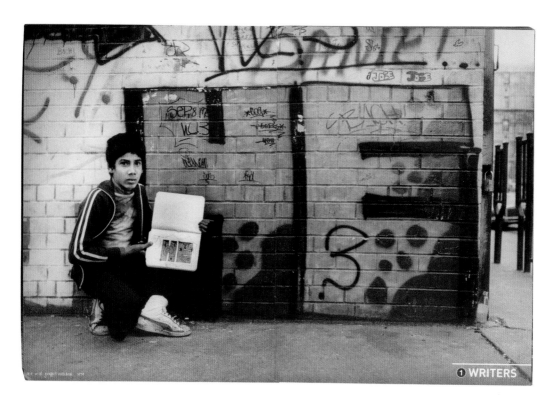

WRITERS

Figure 9.2
Martha Cooper, *HE3 with
Graffiti Notebook*, 1979, in
Martha Cooper, *Hip Hop
Files: Photographs, 1979–1984*
(Cologne: From Here to
Fame, 2004), 12–13.
© Martha Cooper.

Edwin offered to introduce Cooper to a graffiti "king," initiating her into the society of aerosol artists who would break into subway yards to bomb the trains with paint. Cooper met the legendary writer Donald White, known as Dondi, who permitted Cooper to document his process of painting a whole-car subway masterpiece through the night, finishing at sunrise (fig. 9.3). Before long, Cooper's interest in the cultural movement verged on obsession; by 1980 she had quit her unionized position at the *Post* so she would have more time to photograph the trains.[3]

Describing her attempts to publish her now-celebrated graffiti pictures, however, Cooper had three words: "Rejected, rejected, rejected." Apart from a short profile that appeared in an art magazine, mainstream news outlets shied away from the material, and Cooper "never got the story [she] wanted."[4] Reconceiving her graffiti story as a photobook, co-authored with artist and documentarian Henry Chalfant, she finally found a publisher in Germany, resulting in the ground-breaking publication *Subway Art* (1984).[5]

My research on Cooper sought to contextualize the legacy of this under-studied photographer and her contributions to photographic representations of graffiti. I drew upon various sources, including Cooper's extensive personal archives, as well as the Black Star Collection. I wanted to understand her unique vision and the work she was creating as she turned away from photojournalism to pursue personally motivated documentary projects: shooting children's play, street life, and the emergent forms of graffiti and hip hop.

While Cooper's impact and legacy are recognized in hip-hop and street art scholarship, her work has not received enough attention from scholars of photography and visual culture. To better contextualize her images from the late 1970s and early 1980s, I turned to the Black Star Collection to explore the work of her predecessors and peers, New York–based photojournalists who encountered and pictured the city at a time of economic, social, and political upheaval—and enormous creative potential. Concentrating my search on the post-1960s era, I used place-based search terms to navigate Black Star's subject categories—New York, the Bronx, and the Lower East

3 Cooper, interview.
4 Cooper, interview.
5 Martha Cooper and Henry Chalfant, *Subway Art* (New York: Holt, Rinehart & Winston, 1984).

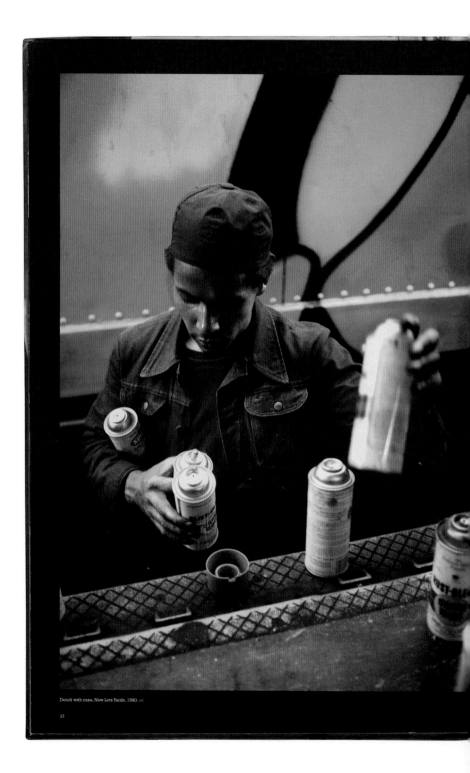

Dondi with cans, New Lots Yards, 1980. MC

32

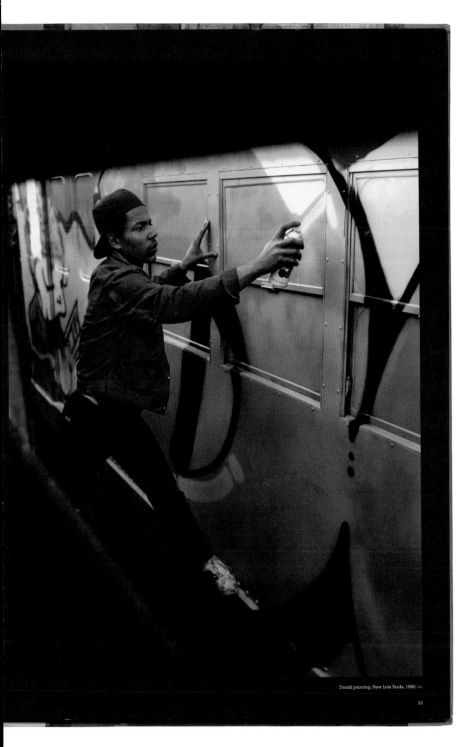

Dondi painting, New Lots Yards, 1980. MC

33

Figure 9.3
Martha Cooper, *Dondi with Cans, New Lots Yards, 1980 and Dondi Painting, New Lots Yards*, 1980 in Martha Cooper and Henry Chalfant, *Subway Art* (New York: Holt, Rinehart & Winston, 1984), 32–33. © Martha Cooper.

Side among others—analyzing approximately 850 photographs. Organizing these by the makers' names inscribed or labelled on the prints' versos, I identified 130 creators, of whom 16 were women.

Being aware of the failure of news publishers to recognize the graffiti movement as worthy of documentation, I did not expect to find such imagery represented in the collection. To my surprise, graffiti was incorporated into press pictures not only as peripheral detail but also as a central focus, and sometimes named in the prints' inscriptions. Among these we can identify various types, including political wall writing, surfaces covered with signatures, train murals, subway car interiors, imagery associating writing with youth gangs, and in one instance, the surfacing of graffiti on canvas in the gallery world. Analyzing these images helped reveal what made Cooper's vision so distinctive, underscoring the level of trust and access she built up with her subjects and her refusal to pathologize the writing movement.

Examining this collection caused me to re-evaluate Cooper's visual contribution to the history of the graffiti movement. At the same time, the collection raised new questions for me about the conditions that framed how the ephemeral form was made visible and permanent in the historical record. This chapter begins by examining graffiti's emergence as a cultural movement in New York, exploring how writing was documented, preserved, suppressed, and disseminated. I then turn to my research in the Black Star Collection, its pictures of post-1960s New York, and my unexpected findings of graffiti images by numerous photojournalists. I reflect on how the collection complicated my earlier reading of Cooper's work, as well as what it clarified about her vision of writing culture. Considering the press and the archive as sites where underground acts might be either remembered or made invisible, I conclude by exploring the liminal nature of graffiti in the photographic record, oscillating between obscurity and infamy.

"Photography Was the Proof"

When I began to turn towards Cooper as a research subject, it was not because I was drawn to her images of aerosol writing and subway murals. Rather, it was Cooper's contribution to the early visual cultures of hip-hop dance that drew me to her work. Cooper played an instrumental role by

publishing her images in the first newspaper article on breakdancing, titled "Physical Graffiti" and written with performance scholar Sally Banes.[6] This occurred when hip hop was transitioning from its original underground form and becoming more visible to a wider public, coming into view through performances, articles, how-to manuals, photographs, and films. In these early presentations to outsider audiences, graffiti was positioned as one of the foundational elements of the culture: the visual expression of hip hop's innovative aesthetics.

At that early stage in my research process, I was hesitant to approach Cooper's early pictures of subway writing, as well as her later images of aerosol pieces by muralists who had started to paint legally, moving their art practices above ground. I initially found the aesthetics of aerosol murals to be impenetrable; I stared at the images of writing and wondered if I would ever comprehend it. But, my interest in the subject grew as I considered how writing was being publicly defined to outsider audiences and what that meant for the creators of its forms.

The contagious nature of writing culture took hold in New York City during the late 1960s and early 1970s, when an explosion of names associated with numbers appeared and spread across walls, over subway cars, and along the routes of city buses. Writing first took the form of small-scale "tags" or signatures that often incorporated the number of the tagger's street address. Writing culture spread widely, inviting participation by its aesthetic openness: all that was needed was a marker, a can of spray paint, and a name. By the mid-1970s graffiti had evolved as writers sought to execute increasingly elaborate, colourful, and labour-intensive pieces.[7] Writers even modified the nozzles of aerosol cans to achieve a wider distribution of paint, setting their work apart from the skinny letters of the earlier generation of taggers.

While the movement was flourishing, with writers innovating in styles and techniques, city and transit authorities were actively working to curb their activities, which were characterized as signs of social dysfunction and criminality. Graffiti was first considered a public nuisance, but when the practice became defined as an urban problem associated with gang activity

6 Sally Banes, "Physical Graffiti: Breaking Is Hard to Do," *Village Voice*, April 22, 1981, 31–33.
7 Tricia Rose, *Black Noise: Rap Music and Black Culture in Contemporary America* (Middletown, CT: Wesleyan University Press, 1994), 42.

and violence, anti-graffiti sentiment intensified.[8] This introduced an era of "moral panics that fueled the surveillance and criminalization of graffiti writers."[9] The year 1972 marked a change in the political conception of the illicit form; the city council declared a "war on graffiti" and the first anti-writing laws were passed when Mayor John Lindsay made it illegal to carry a can of spray paint in any public space.[10] Various other tactics were employed to suppress the actions of writers: razor wire and police dogs were added to train yards, and the Metropolitan Transportation Authority (MTA) began to use costly measures to clean the trains, taking painted subway cars out of service for treatment with a chemical solvent known to artists as "the Buff."

Even as writing was being criminalized, discouraged, and erased, it emerged as a source and a subject of photographic and documentary material. As graffiti writers recognized the ephemeral nature of their creations, it became crucial to get good pictures of their pieces before they disappeared from view. Documentation gained currency as writing took on more aesthetic complexity and photographing walls and subway masterpieces became an integral part of the culture. As Tracy Fitzpatrick observes, "Documentation of subway writing was critically important to its development, particularly because the transit authority would erase what it could."[11] In addition to photographing their own work, writers also looked for their tags in pictures that circulated in the news media. This was how Dondi first became aware of Cooper as a documenter of writing; he spotted his tag in the background of a news picture under her byline. "Photography was the proof," Cooper stated, and she captured scenes of writers gathered in small living spaces, looking through albums of their snapshots of painted trains.[12]

In their efforts to suppress graffiti, law enforcement and vandal squads also photographed tags, walls, and trains, amassing collections of pictures used to identify repeat writers and to serve as evidence in criminal prosecutions. In a

8 Ronald Kramer, *The Rise of Legal Graffiti in New York and Beyond* (London: Palgrave Macmillan, 2017), 14.

9 Stefano Bloch, *Going All City: Struggle and Survival in LA's Graffiti Subculture* (Chicago: University of Chicago Press, 2019), 190.

10 Kramer, *Rise of Legal Graffiti*, 14.

11 Tracy Fitzpatrick, *Art and the Subway: New York Underground* (New Brunswick, NJ: Rutgers University Press, 2009), 181.

12 Cooper, interview.

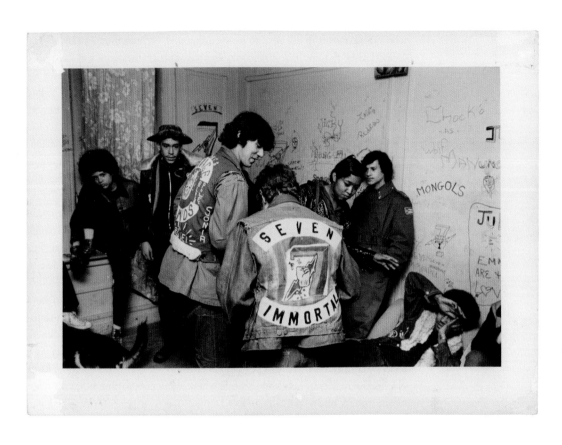

Figure 9.4
Michael L. Abramson, *Members of Seven Immortals, the Bronx, New York*, ca. 1972. Gelatin silver print, 18.5 x 25.2 cm. BS.2005.253193.

telling anecdote from his memoir as a young writer, Stefano Bloch recalls feeling lucky that he did not have a personal archive of his graffiti work the day police came and raided his home. Once he was in custody, a detective asked Bloch for his autograph and showed him binders full of signatures of "other writers he had captured, and pictures of his favourite graffiti."[13] The police could be as obsessive and knowledgeable about writing as writers were among themselves.[14]

Examining early published works on graffiti reveals how documentarians first grappled with the form and how they sought to make it understandable to a broader public. One of the first news media profiles on the subject was published by an anonymous author in the *New York Times* in 1971: "'Taki 183' Spawns Pen Pals."[15] The text spotlighted a writer whose moniker could be seen across the city, and it conveyed the excitement writing held for young people, suggesting that TAKI 183 was a possible originator of the form. But after 1971, newspaper editorials and letters in news publications tended to portray graffiti as an urban crisis.[16]

In 1972 Herbert Kohl published his photo-essay on graffiti and self-naming, *Golden Boy as Anthony Cool*, featuring black-and-white photographs by James Hinton.[17] Kohl, an educator who reflects on his experiences teaching in low-income communities in New York, explores writing as a form of communication and personal expression for young people. His essay orients the reader in neighbourhoods where there are "gaping holes on most of the streets where buildings have burned down or been condemned and torn down."[18] But the photographs illustrating this work do not focus on poverty, instead dealing explicitly with walls and writing. Another early publication, *The Faith of Graffiti*, with text by Norman Mailer and colour photographs by Jon Naar, sought to position aerosol writing as a valid form of art, asserting that the form is "the expression of the ghetto."[19]

13 Bloch, *Going All City*, 193–94.
14 Bloch, *Going All City*.
15 "'Taki 183' Spawns Pen Pals," *New York Times*, July 21, 1971, 37.
16 See Joe Austin, *Taking the Train: How Graffiti Art Came to Be an Urban Crisis in New York City* (New York: Columbia University Press, 2002).
17 Herbert Kohl, *Golden Boy as Anthony Cool* (New York: Dial Press, 1972).
18 Kohl, *Golden Boy as Anthony Cool*, 3.
19 Mervyn Kurlansky, Jon Naar, and Norman Mailer, *Faith of Graffiti* (Westport, CT: Praeger, 1974).

When Cooper began photographing public writing seriously in 1979, the movement had evolved to become a remarkable aesthetic form. She was determined to make her subjects and their works visible as something more than an urban problem. Cooper and Chalfant's *Subway Art* presented more than two hundred colour photographs documenting aerosol paintings on trains, while also revealing the process of the work and the sociality of writing culture. Cooper's images are impressive and dynamic, featuring murals blazing against the backdrop of the city. Her use of colour film was a significant creative choice in her documentation of the art form, exalting the chromatic expressions of Wild Style writing and the full vibrancy of train murals pictured in the city context.[20] The trust and access she gained among writers allowed her to create photographs for which there was no aesthetic precedent. Shot from inside an adjacent subway car, Cooper's image of Dondi at work on a whole-car mural depicts the artist balancing between the two trains, holding a can of spray paint, his face illuminated by a blue pre-dawn light (fig. 9.3).

But despite the aesthetic innovation of these images, the early reception of *Subway Art* was mixed, evidencing the skepticism of critics and publishers who struggled to understand the "painters (or vandals)" at the centre of her lens.[21] One reviewer called Cooper and Chalfant's pictures "bold and subtly threatening," while denouncing subway graffiti as "gang warfare by spray-can."[22] Even after Cooper and Chalfant's 1984 publication, writing and aerosol art remained contested territory in contemporary discourse.

Black Star Underground

The first place I spotted graffiti in the Black Star Collection was in a group of photographs by Michael Abramson, who shot an in-depth assignment on youth gangs in the Bronx in 1973. Abramson's black-and-white

20 "Wild style" is a lettering style that is deliberately illegible to outsider audiences.

21 Unknown author, "Subway Art by Martha Cooper and Henry Chalfant," *Amateur Photographer*, 29 September 1984. [Press clipping]. Martha Cooper Personal Archives, New York, NY, United States.

22 Clancy Sigal, "Spray Can Gang," *New Society*, ca. 1984. [Press clipping review of Subway Art]. Martha Cooper Personal Archives.

photographs of the allegedly fearsome gangs—the Black Spades, Savage Skulls, and Seven Immortals—depict teenagers wearing embellished vests and denim jackets, roughhousing and embracing on the street and in their clubhouses. I recognized some of the images from books chronicling hip hop's early cultural formation. Steven Hager's 1984 book *Hip Hop: The Illustrated History of Break Dancing, Rap Music, and Graffiti* uses some of Abramson's images in its first section, titled "Fire in the Bronx," with text that suggests hip hop evolved from (and as an alternative to) gang activity and violence in the devastated neighbourhood. This is important to note because of the parallel with graffiti, which was also portrayed in print as gang-related, a sign and symptom of crime in the city.

Without publication stamps, it is not clear where else Abramson's images may have been circulated in mainstream publications, but his pictures do provide insight into less visible forms of wall writing. For example, a group photograph of members of the Seven Immortals depicts a central figure with his back to the camera, displaying his adorned jacket to the photographer (fig. 9.4). The walls in the interior space have been written and drawn on with black marker, using simple lettering. The Seven Immortals insignia is drawn on the back wall in a style consistent with the jacket's design. It is possible that Abramson was deliberately incorporating this writing into his composition to emphasize the linkage and reveal the importance of aesthetics and style to expressions of identity and belonging for his young subjects.

Some Black Star photographers, such as Barbara Pfeffer, seemed to shoot graffiti in a way that intentionally emphasized its associations with social marginalization. In one example, Pfeffer created a stark photograph presenting a poorly lit image of a narrow entry leading down a flight of stairs, where numerous tags have been painted across the walls. The print is inscribed "Graffiti – Slums" on its verso. Another image by Pfeffer was taken as she held up her camera to peer through a wire fence at a Black teenager playing handball (fig. 9.5). Pictured with his back to the photographer, the teen is poised mid-step, aiming his ball towards a concrete wall painted with tags. Like Pfeffer's image of the stairwell, the photographer's disciplinary perception of her subject is evident in the framing and starkness of the composition. The wire fence in the image's foreground reinforces the divide between the photographer and her subject. Such imagery associating wall writing with poverty and city slums reflects a vision that is both

Figure 9.5
Barbara Pfeffer, *Playing
Handball in New York City,*
ca. 1965. Gelatin silver
print, 17.4 x 23.4 cm.
BS.2005.265888.

Figure 9.6
Hiroyuki Matsumoto,
Graffiti on a Subway Train,
New York, 1973. Gelatin
silver print, 17.2 x 25.2 cm.
BS.2005.276113.

pathologizing and paradoxical. Appearing to relate a story of urban abandonment and neglect, the presence of this writing also evidences the presence of the everyday young people who dwelled in these environments.

In other visions of graffiti in the Black Star Collection, there are surprising examples of photographers who, like Cooper, seem to have had a visual interest in the subject and worked creatively to capture its elusive forms. Hiroyuki Matsumoto has several images of train murals, suggesting that he may also have been interested in writing and appreciative of the colourful paintings that would come into view on the crowded subway platform. One of his photographs of a train mural is shot from a mid-low angle as the subway doors open, revealing the passengers inside (fig. 9.6). I can imagine the photographer spending time on underground subway platforms waiting for a painted train to pull into the station, picturing graffiti in the quotidian space of daily travel.

Likewise, Kathleen Foster sought out aerosol writing as a photographic subject. She photographed a subway platform wall covered in tags by foundational writers of the movement (fig. 9.7). Moreover, Foster was the only photographer in my sample who followed graffiti above ground into legal spaces, when it became a gallery trend in New York's art scene. In 1981 Foster photographed a canvas by Bama, then a member of the United Graffiti Artists (UGA) collective, whose code of conduct forbade them to paint illegally (fig. 9.8).

Throughout my samples from the Black Star Collection were examples of graffiti pictured as peripheral details or in the background of a scene, sometimes occupying a large or small area of the print but not mentioned in the inscriptions and subject headings found on the versos. It is often unclear whether Black Star photographers were consciously incorporating the form into their work or the writing was simply making itself known through its proliferation on city surfaces. Shelly Rusten's photograph of a Black couple embracing on a sidewalk is a striking example of this (fig. 9.9). The photographer captured the pair holding one another closely, seemingly unaware of the presence of her camera or the two white passersby staring openly at them. The presence of a tag, "Bobby XX Revolt," on the wall at the right of the frame adds a coded element to Rusten's complex and evocative image. Inscribed on the verso of the print is BLACKS – ADULTS, a subject heading that does not offer clues as to how the image was interpreted or used (fig. 9.10).

Figure 9.7
Kathleen Foster, *Hunts Point Avenue Subway Station, New York City*, ca. 1981. Gelatin silver print, 20.1 x 25.3 cm. BS.2005.253534.

Figure 9.8
Kathleen Foster, *Bama,*
ca. 1981. Gelatin silver
print, 20.4 x 25.2 cm.
BS.2005.253532.

With the exception of some of Abramson's work, the photographs in my sample did not come with information that would help trace where they might have been circulated and seen. Nevertheless, these works were collected through a network of visual agents: photographers filing their pictures and editors marking and sorting them along the lines of publishable categories. Recognizing the ephemeral nature of writing's markings on the city and the active pursuit of its eradication, those agents may have considered the photographs as evidence, as potentially holding historical significance. Others may have seen writing only through its fragmentary symbolic associations with other picture categories, such as NEW YORK/GANGS, NEW YORK/SLUMS, or NEW YORK/SUBWAYS.

Graffiti in the Archive

In the historical record, aerosol writing emerges as a movement shaped alternately by possibilities of visibility and processes of invisibilization. Even as photography and print documentation have been critically important to how the ephemeral form is seen, celebrated, and remembered, other sources hold charged symbolic associations, distortions, and silences. Examining how graffiti was envisioned by Black Star photographers exposes multiple ways in which the form was contended with and visually managed. These works' inscriptions and subject headings offer additional clues to how writing was coming into view as it moved above ground through a network of photographers and editors. At the same time, those inscriptions, labels, and subject headings can also serve to obscure the presence of graffiti in the collection, distributing its form among other publishable fields.

The sample of New York pictures in the Black Star Collection confirms in some ways the pathologized vision of early graffiti that seems to have fixed itself in the public imagination. In images of poor neighbourhoods there are visual associations between urban abandonment and public writing, appearing like a target within targeted communities. But there also emerge other publishable horizons for writing, found in the works of photojournalists who evinced curiosity and visual interest in the form and who worked skilfully to incorporate it into their press images. Within these we can observe various gazes upon graffiti, including the diverse perspectives of women creators

Figures 9.9 and 9.10
Shelly Rusten, *Couple Embracing in the Street, New York City*, 1970 (recto and verso). Gelatin silver print, 28.3 x 19.3 cm. BS.2005.266374.

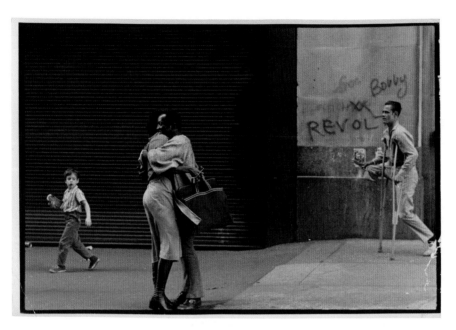

Figure 9.11
Martha Cooper, *Children of the
Grave Again, Part 3, by Dondi*,
1980, in Martha Cooper and
Henry Chalfant, *Subway Art*
(New York: Holt, Rinehart &
Winston, 1984), 34–35.
© Martha Cooper.

such as Foster, Pfeffer, and Rusten, as well as notable creators of colour such as Matsumoto, who, like Cooper, followed train murals with his camera. Their works and others reveal multiple points of view on writing at a significant historical moment, when public walls both above and underground were covered in the signatures of the movement's foundational creators.[23] It was also a time when writing's aesthetics were evolving in train murals, the creators of this culture were being criminalized by city and transit authorities, and some writers began moving their work onto graffiti canvases in gallery spaces. The Black Star Collection speaks to the specific conditions that framed how writing was becoming visible.

Positioning Cooper against these makers, it is possible to observe how she was building on this visual repertoire and what set her apart as a documentarian: shooting subway art on Kodachrome film in good light, in places where the train tracks moved above ground (fig. 9.11). Cooper formed important relationships with the writers, with whom she worked collaboratively to achieve her powerful documentation of their train murals. She recalls how writers would call her after they had completed a piece, with directions to the subway line and whether to look for the mural on the "morning" or the "afternoon" side of the car. The writers valued good documentation of their work, and Cooper provided them with copies of her photographs. The level of trust and access she gained enabled her to create images of train murals in full colour against the backdrop of the city, moments before they disappeared from view. The relationships she developed with her subjects also allowed Cooper to document previously unseen aspects of writing culture: writers in subway cars and train yards, gathered in their living spaces, and posing in front of collections of spray cans, as well as in action executing their murals. Cooper's work made visible people who were barely recognized in the public life of middle-class America, making permanent the ephemeral traces of an aesthetic movement and the individuals who contributed to its development.

23 These include BARBARA 62, EVA 62, EDDIE 181, LIONEL 168, TABU, and CHARMIN 65, among other recognizable names.

The graveyard is the center
gather here to pray, sing, g

Part 3
Curating with the
Black Star Collection

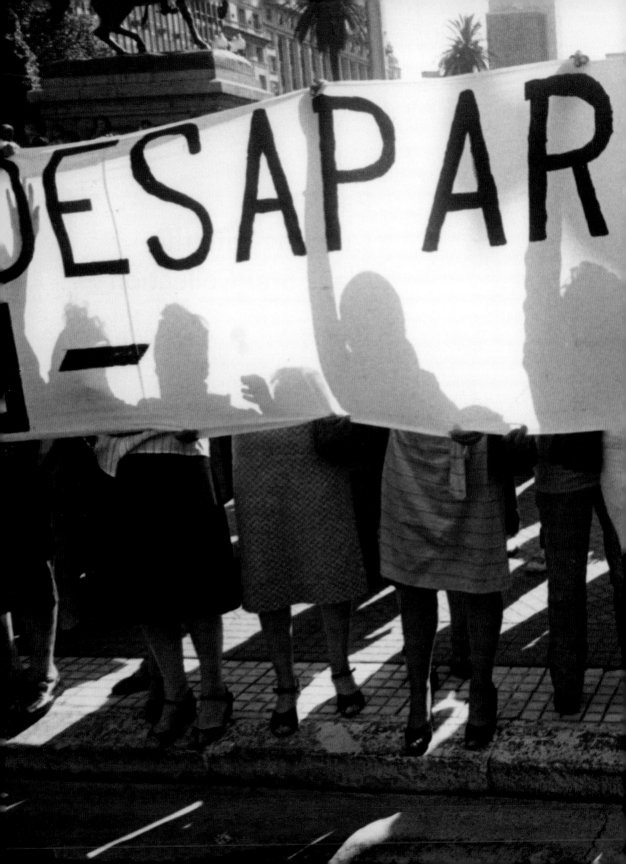

Getting to Know the Unknowable
Black Star and the Rudolph P. Bratty Family Collection

Denise Birkhofer

When I took up my post at The Image Centre in September 2016, I was mindful of stepping into the proverbially big shoes left by Peter Higdon, the institution's founding (and only previous) collections curator. It was during Higdon's tenure of more than thirty-five years that the Black Star Collection came to Toronto Metropolitan (formerly Ryerson) University—a result of the cumulative labour of numerous individuals and years of planning and execution—becoming the cornerstone of the vast photography collection that now falls under my purview. Comprising upwards of 291,000 prints, Black Star is by far the largest single collection in The Image Centre's holdings, but it is not, of course, alone. It forms part of a steadily growing collection of more than 400,000 photographic objects spanning the history of the medium, including works by major historical and contemporary practitioners, examples of vernacular or commercial photography, and in-depth artist archives. But despite the extensive and varied materials represented in The Image Centre's holdings, the institution is often regarded as synonymous with the Black Star Collection. It is not an uncommon experience for me to encounter surprise when individuals first learn that The Image Centre has "more than just Black Star," even from those with some knowledge of the fields of photographic history or institutional collecting.

Given its iconic status and sheer scale, I wondered how I would ever begin to understand the monumental Black Star Collection. In time I discovered that one method of getting to know this "unknowable" collection, paradoxically, was to start by familiarizing myself with a smaller analogous collection. This process began just two months after my arrival, when The Image Centre took possession of the second-largest acquisition in its history, the Rudolph P. Bratty Family Collection. Encompassing more than 21,000 press prints depicting Canadian content, culled from the still-operational

Figure 10.1
Daniel Ricardo Merle, *Disappeared Demonstration (Mothers of the Plaza de Mayo), Buenos Aires, Argentina,* October 28, 1982 (detail). Gelatin silver print, 18.0 x 23.9 cm. BS.2005.103433.

New York Times Photo Archive, the Bratty Collection joined Black Star to further "confirm our institution's growing reputation as one of the key international repositories for significant archives of press photography."[1]

A promised gift from Toronto entrepreneur Chris Bratty, made in conjunction with the 150th anniversary of the confederation of Canada, the collection was to be featured in a major exhibition and a corresponding publication in less than a year's time. The result of this immense task was *The Faraway Nearby: Photographs of Canada from the New York Times Photo Archive*, co-curated with Gerald McMaster, Canada Research Chair and a renowned specialist in Indigenous visual history.[2] Together we meticulously combed through more than 150 file boxes of photographs to select a symbolic 150 images to represent the Bratty Collection in the book; this selection was expanded into a checklist of more than 220 objects for the corresponding exhibition, which was thematically organized according to traditional newspaper sections, such as National News, Travel, and Sports.

By museum standards for a project of that scale, *The Faraway Nearby* came together at lightning-fast speed. While extremely challenging, execution of the project was achievable because of the diligent coordination and efforts of a team of individuals. The months of November and December 2016 were devoted to object selection. McMaster and I conducted a painstaking first pass through the entire collection over the course of two weeks, culling an initial group of hundreds of photographs that was then refined into the final selection of objects. Meanwhile, The Image Centre's collections staff worked continuously to record and process the selections at the various stages. Beginning in January 2017, the bulk of planning was completed in less than eight months, in anticipation of the exhibition opening and book release in September.

In contrast, applying an analogous approach to the Black Star Collection would have been much less successful. Conducting such a methodical

1 Paul Roth, "Foreword," in *The Faraway Nearby: Photographs of Canada from the* New York Times *Photo Archive*, eds. Denise Birkhofer and Gerald McMaster (Toronto/London: Ryerson Image Centre/Black Dog Publishing, 2017), 7.

2 The exhibition was on view in The Image Centre's main gallery from September 13 through December 10, 2017.

and exhaustive review of the collection, as my co-curator and I did for *The Faraway Nearby*, would be prohibitive. Its scale and diversity of subjects would result in the project's taking so long that the curatorial objectives would become lost in the process, or it would necessitate a much larger team working together to craft a composite narrative. The latter is akin to the strategy employed by Gaëlle Morel and Paul Roth, respectively The Image Centre's exhibitions curator and director, who acted as lead curators for The Image Centre's 2023 exhibition *Stories from the Picture Press: Black Star Publishing Co. and the Canadian Press*. As with *The Faraway Nearby*, this exhibition was conceived in conjunction with a milestone: the tenth anniversary of the opening of The Image Centre. Grappling with the question of how to represent the institution's most significant and extensive collection in a single cohesive exhibition, Morel and Roth opted to focus on key stories of twentieth-century history as told through the photographs, rather than attempt the impossible feat of providing a comprehensive overview of the entirety of Black Star. They invited a team of contributors, including myself, to organize discrete thematic sections for the exhibition, resulting in a team-curated show highlighting specific episodes or photo stories that ranged from the everyday to the most newsworthy events of the past century.[3] The contributors approached the task from their areas of personal research interest, which produced an appropriately diverse array of subjects.

The strategy of starting with specific subject matter is the most common point of entry into the Black Star Collection. This is the methodology most often applied by visiting researchers, of whom The Image Centre welcomes many each year. These subject-based inquiries likewise inform how the collection is processed from a collections care standpoint, as high-resolution digitization is an ongoing process and is prioritized based on demand. Moving forward, the Bratty Collection will likely be accessed and processed in a similar way.

The two collections have a great deal in common. Both are parts of larger corporate press collections based in New York City and represent the golden age of black-and-white photojournalism, with gelatin silver

3 Contributors included Alexandra Gooding, Valérie Matteau, Grace van Vliet, Rachel Verbin, D'Arcy White, and Chantal Wilson.

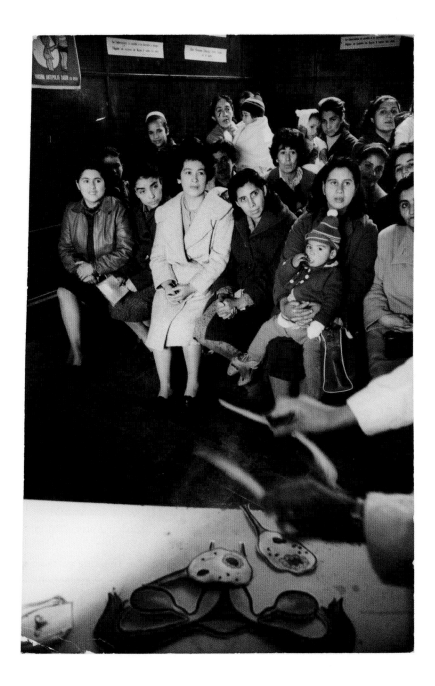

prints ranging from World War I through the 1980s.[4] Both collections were originally organized by subject headings to best suit the pictorial needs of the corresponding institution, stored in vertical folders in filing cabinets in the newspaper's photo morgue or the press agency's picture library. As both collections span the same historical period, it is not surprising that they cover a similar range of topics: military conflicts, sports, political figures and other public personalities, and scenes of everyday life. The primary difference is sheer scale: the Bratty Collection features just 870 individual subject headings as compared to Black Star's staggering 23,025. Likewise, the geographical scope of the Bratty Collection is limited to Canada (but extending to the country's international relationships and the activities of Canadians living abroad), while Black Star is truly global in its coverage.

For these reasons I have come to think of the Bratty Collection as a more digestible version of the mammoth Black Star Collection. The magnitude and breadth of the latter have prevented me (and countless other researchers) from diving into Black Star over the subsequent years the way that McMaster and I did with the *New York Times* material in just a matter of months. Instead I have had to dip in my toe gradually, advancing slowly as project-driven opportunities arise. For my contribution to *Stories from the Picture Press*, for example, I drew on my expertise in Latin America and organized two stories: a photo reportage by Doris Heydn on Mexican Day of the Dead celebrations from the 1940s, and a 1971 photo essay by Ted Spiegel on government family-planning policies in Chile (fig. 10.2). These topics were two of five that were presented to the lead curators for inclusion. Topics not selected included a 1940s photo story about sidewalk secretaries servicing Mexico City's illiterate populations, by American photojournalist Victor De Palma; photographs of the 1968 government-sanctioned massacre of hundreds of unarmed civilians in the Tlatelolco neighbourhood of Mexico City; and images of public protests against the dictatorial practice of "disappearing" dissenting citizens in Chile and Argentina in the 1970s

Figure 10.2
Ted Spiegel, *A Birth Control Clinic in Santiago, Chile,* 1971. Gelatin silver print, 25.3 x 16.2 cm. BS.2005.105132.

4 While primarily comprised of gelatin silver prints, the Bratty Collection features a more diverse representation of photographic technology than Black Star, including techniques introduced in the second half of the twentieth century such as facsimile (fax) prints, stabilization prints, and wire photos.

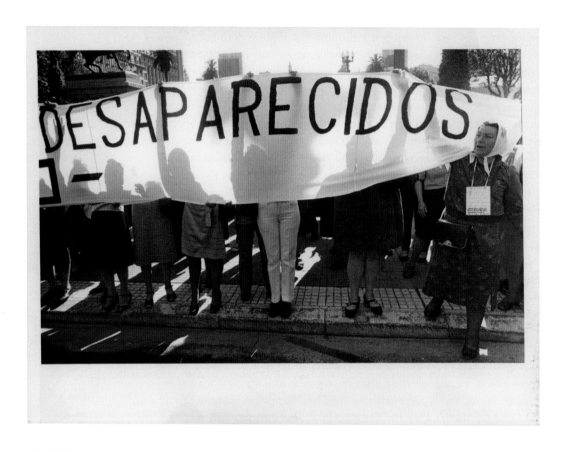

Figure 10.3
Daniel Ricardo Merle,
Disappeared Demonstration
(Mothers of the Plaza de Mayo),
Buenos Aires, Argentina,
October 28, 1982. Gelatin
silver print, 18.0 x 23.9 cm.
BS.2005.103433.

Figure 10.4
Installation view of *The Faraway Nearby: Photographs of Canada from the* New York Times *Photo Archive*, 2017. Digital image. Photograph by Riley Snelling. © Riley Snelling, The Image Centre, Toronto.

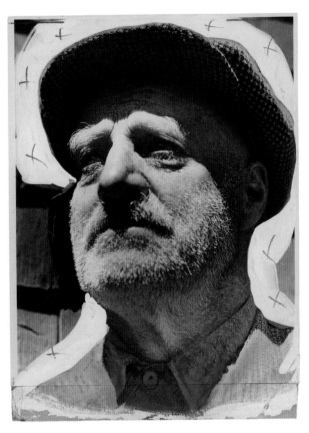

Figures 10.5–7
Maxwell Frederic Coplan
for Canadian National
Railway Company, *French
Canadian Face*, January 1938
(recto and verso). Gelatin
silver print with attachment,
retouching, and editing
marks, 28.1 x 20.9 cm.
Rudolph P. Bratty Family
Collection, The Image
Centre, Toronto Metropolitan
University, NYT-37-592.

John MacCormac, "An 'Anti-
Communist' Quebec Stirs
All Canada," *New York Times
Magazine*, January 9, 1938, 10.
The Image Centre, Toronto.

and '80s (figs. 10.1 and 10.3). These themes were identified through targeted searching for known watershed moments in Latin American history (the Tlatelolco massacre, *los desaparecidos*), as well as a more methodical and exhaustive box-by-box search of all photographs from the region in the collection. This search resulted in the discovery of many compelling portraits of everyday life such as the Día de Muertos and street secretary images.

To illustrate my different experiences with researching photo stories from the two press collections, the remainder of this chapter focuses on Heydn's Day of the Dead photographs in comparison with a series of portraits of Quebecers from 1938 by Michael Frederic Coplan, featured in *The Faraway Nearby* (fig. 10.4). While both sets of images reflect a mid-century American interest in portrayals of the people and customs of foreign cultures, an analysis of the information physically present on the prints themselves offers further insight into the intentions of both the image-makers (American photographers working abroad) and the content generators (administrative and editorial personnel at the Black Star agency and the *New York Times*).

Coplan's gelatin silver prints are headshots of five individuals seen in three-quarter profile, taken from a heroizing low camera angle. Nimbus-like white markings and red-orange X's encircle each head. On one example a retoucher has affixed a paper attachment to extend the photograph's lower edge and has painted in parts of the collared shirt and jacket (fig. 10.5). "French Canadian Face" is inscribed in pencil on each print's verso, along with "$10" and Coplan's last name only. In the upper right-hand corner a date stamp reads "JAN-9 1938"; a second date appears in the centre: "POSTED/JAN 15 1938/EDITORIAL AUDITING DEPT" (fig. 10.6). From these inscriptions the researcher can gather valuable, if incomplete, information about the subject, date, and creator of the photographs. An additional clue is found in the form of the pencil notation "MAG" above the date in the upper corner; further investigation revealed that this indicates the image's reproduction in the *New York Times Magazine* published on that date. Coplan's photographs were used to illustrate an article titled "An 'Anti-Communist' Quebec Stirs All Canada," appearing alongside the caption "Typical French Canadian faces against the backdrop of a typical French Canadian town" and accompanied by the credit line "Canadian National Railways, Coplan" (fig. 10.7). Additional research into photographers

for the Canadian National Railway Company was required to reveal Coplan's full name and identity.[5]

The published layout illustrates how editing marks serve to isolate parts of a photographic image for printing; in the magazine the five portraits are composed into a seamless montage. The format of the *New York Times Magazine* allowed for a more dynamic pictorial narrative than the single photograph traditionally used to illustrate articles in the newspaper's daily issues. While Coplan's original assignment or the purpose behind the creation of these portraits remains unknown, the context of the article and the editing of the photographs reduce the subjects to a visual stereotype, intended by the *New York Times* to illustrate the idea that "the [French Canadian] peasant is being transformed into a proletarian."[6] That limited viewpoint of course failed to capture the complexities of the social, political, and cultural changes occurring in Quebec during the late 1930s.

Doris Heydn's photographs of Mexican Day of the Dead festivities from the Black Star Collection offer a more nuanced representation of their subjects, which is not surprising, given her lifelong commitment to studying Mexican art and culture. Trained as an art historian, Heydn relocated from the United States to Mexico around 1940. There she earned acclaim as a pre-eminent scholar of the ancient Americas, working as a curator at the National Museum of Anthropology in Mexico City and publishing many essays on pre-Columbian art and archaeology. She employed photography as a tool to support her scholarly research, focusing on Mexico's folkloric traditions and archaeological ruins.

The photographs featured in *Stories from the Picture Press* are intimate portraits of celebrants of Día de Muertos, which is observed annually from October 31 through November 2 in remembrance of deceased loved ones (figs. 10.8 and 10.9). Heydn pays careful attention to the accoutrements of the holiday, such as the personal altars erected at homes or gravesites, laden with offerings to entice the departed soul to visit: candles, orange marigolds, *papel picado* (colourful perforated tissue-paper decorations), and possessions

5 Cross-referencing the Black Star Collection reveals just one photograph credited to Coplan, an aerial view of a marching band from an unknown date and location.
6 John MacCormac, "An 'Anti-Communist' Quebec Stirs All Canada," *New York Times Magazine*, January 9, 1938, 10.

Day of the dead

Mexico
religion
2

PHOTO CREDIT ⭐
doris heydn

from BLACK STAR

20 picas × 3 15/16"

Flush t & b

941
16

feast for dead souls, set on
altar style table includes
tamales, fruit, pumpkin,
pulque, "Bread of the dead".

#8³⁰

58-529

Figures 10.8 and 10.9
(previous pages)
Doris Heydn, *Day of the
Dead Altar, Mexico*, ca. 1942
(recto and verso). Gelatin
silver print, 23.8 x 19.5 cm.
BS.2005.096819.

or photographs of the deceased. Other images focus on vendors of *calaveras* (sugar skulls) and *pan de muerto* (a sweet egg bread featuring a decorative bone motif). The central role played by women in these celebrations is highlighted throughout the series.

While the cultural significance of the holiday is well-known, what additional information can be learned from the notes and markings on the prints themselves? The versos of the gelatin silver prints reveal various inscriptions; some feature an ink stamp crediting the photographer by her full name, while her name is written in pencil on others. All display Black Star's credit stamp and the pencil notations "Day of the dead" in the upper left corner and "Mexico/religion" in the upper right. A few have no discursive caption information, while others feature descriptions of the image content in pencil, for example, "feast for dead souls, set on altar style table includes tamales, fruit, pumpkin, pulque, 'Bread of the Dead'" (fig. 10.9). These notes may have been written by the photographer herself in her position as cultural expert, but they also may have been added by another party or by a Black Star staff member after the prints' arrival at the agency. Other versos from the series feature similar descriptive captions, but as typewritten attachments.

One such example (fig. 10.11) includes a typewritten credit to famed Mexican photographer Manuel Álvarez Bravo, to whom Heydn was married from 1942 to 1962, below Hedyn's own credit written in pencil. This epitomizes the not-uncommon problem of attribution prevalent not only in the Black Star Collection but also in the broader histories of photojournalism and documentary photography, in which the sharing of assignments or equipment between partners (romantic or otherwise) often leads to confusion of authorship. While difficult to confirm, it is likely that the attribution to Álvarez Bravo is false, given that the five other photographs in the series are credited to Heydn alone. Moreover, Heydn was a frequent contributor to Black Star and is represented by 148 prints in The Image Centre's collection, while Álvarez Bravo is not known to have had a professional relationship with the agency.[7]

7 Only one other known photograph in the Black Star Collection features a credit to Álvarez Bravo. It depicts Monte Albán, a much more likely subject for Heydn, given her scholarship on Mexico's pre-Columbian ruins. Fourteen other prints under the subject heading MEXICO/RUINS are attributed to Heydn.

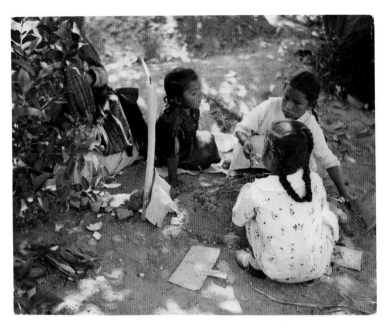

The graveyard is the center of the festival. Young and old gather here to pray, sing, gossip, eat, and even to sleep.

Photo Manuel Alvarez Bravo

Figures 10.10 and 10.11
Doris Heydn, *Gathering in Graveyard, Day of the Dead, Mexico*, ca. 1942 (recto and verso). Gelatin silver print, 19.5 x 24.1 cm. BS.2005.096820.

Unlike Coplan's portraits, Heydn's versos do not provide any clues as to where and when they might have been published. Without such indications, the researcher must consult other resources, such as likely periodicals for publication. However, searches to date in the magazines of major Black Star clients *Life*, *Look*, and *Time* have not produced fruitful results. Similarly, Heydn's images are mostly free of the editing and retouching marks that are such prominent characteristics of the Quebec faces (with the exception of figure 10.8, which features small crop marks at the upper left and centre). Without a published context, Heydn's series lacks the added layer of historical information that can be gleaned from that of Coplan. This is, in my experience, one of the critical differences that informs research in the Black Star and Bratty collections, a result of the intended functions of the two original press photo libraries. The *New York Times* photo morgue was located on site in the newspaper's offices, offering easy access for photo editors to pull images; in fact the same images were used repeatedly and reproduced in widely varying contexts, each instance being diligently recorded on the print's verso. The picture library of the Black Star agency, on the other hand, was disseminated to a wide variety of external clients as needed; a vast majority of the holdings may never have been circulated or published, and of those that were, not all may have been returned. Thus, much of the context for the images' use has been lost or remains unknown.

Although divergent in scale, both press collections are products of a particular era of American photojournalism, feature similar organizational structures, and span parallel time periods and subject matter. However, the result of the above institutional differences in image use is that the average print from the Bratty Collection is more likely than one from Black Star to offer the researcher material clues about its context, in the form of editing and retouching marks and inscriptions. Ultimately, in answer to my question of how one gets to know an unknowable collection, I learned that a possible solution is to start with a knowable one. For me, the more approachable Bratty Collection was like a Black Star starter collection; it offered valuable lessons in how to implement a subject-matter-based approach to a press photo archive of this scale on an individual project basis. After directing my attention first to the Bratty Collection, I was later able to apply the experience to Black Star, with the understanding that familiarizing

myself with the collection would be a slow, incomplete, and piecemeal process that will be sure to evolve over the course of my tenure at The Image Centre.

To sum up my comparative findings, while subject matter is demonstrably the most effective point of entry into both collections, serendipitous discoveries remain possible, provided that the researcher is able to dedicate adequate time and strategic application of search parameters—both more challenging with Black Star. The researcher should likewise expect to encounter more contextual and material clues when working with the Bratty Collection, and therefore a greater number of potentially unanswered questions in the Black Star Collection. To close with the words of my predecessor, Peter Higdon, each collection can equally be described as a "visual laboratory" for scholars focusing on iconic moments of the twentieth century: "The very organization of the archive is a map to its purpose—history and documentation available to those who would immerse themselves in the quest for meaning."[8]

8 Peter Higdon, "Introduction," in *Black Star: The Ryerson University Historical Print Collection of the Black Star Publishing Company*, ed. Michael Torosian (Toronto: Lumiere Press, 2013), 13.

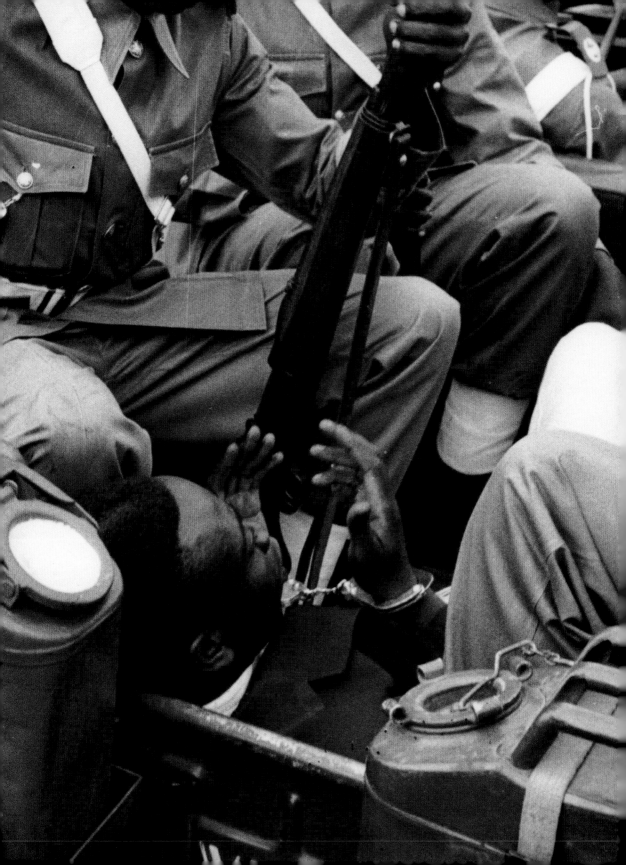

Reflections on *Human Rights Human Wrongs*

Mark Sealy in Conversation with Taous Dahmani

Taous Dahmani: When The Image Centre invited you to look at, respond to, and produce a project around the Black Star Collection, it was still in the early stages of its creation. Thus, before your first trip to Toronto to see for the first time the agency's former black-and-white picture library—approximately 292,000 prints, then housed in a warehouse in the north of the city—how did you envision your work?

Mark Sealy: From about 1988 to 1991 I worked with Network Photographers in London, so I had a sense of what an agency's picture library might be like.[1] I could easily conceive the set-up and storage. For example, I could imagine the photographs' very simple categorizations or how they would be kept in filing cabinets. As a matter of fact, it was exactly what I expected: a lot of prints and a lot of boxes, in a lot of filing cabinets. From there, with Valérie Matteau and Stefani Petrilli from The Image Centre, we were able to think about the levels of inquiry that I wanted to make. That was a very useful and supportive process, just discussing the collection, its order, its contents, and just searching.

Figure 11.1
Robert Lebeck, *Young man steals the sword of King Baudouin I, during procession with newly appointed President Kasavubu, Leopoldville, Republic of the Congo (now Democratic Republic of the Congo)*, June 30, 1960 (detail). Gelatin silver print, 20.7 x 30.0 cm. RIC.2012.0108. Gift of Robert Lebeck, 2012. The Image Centre, Toronto.

Dahmani: Could you tell us about the genesis of the project and how your interests met with the collection?

Sealy: I don't think Doina Popescu wanted to be a director-curator. She wanted to give curators the opportunity to work in the collection. I had an initial research proposal that was more bookended, but I was invited to do

1 Network Photographers was an independent cooperatively owned picture agency founded in London in January 1981 and closed in 2005.

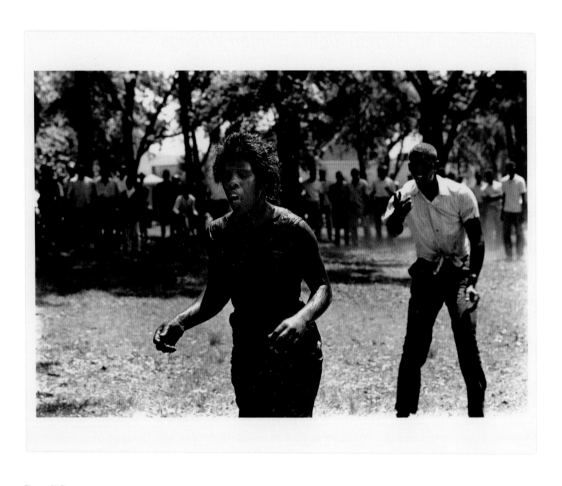

Figure 11.2
Charles Moore, *An African-American woman regaining her balance after being hit in the knees by a jet of water from a firehose, Birmingham, Alabama,* May 1963. Gelatin silver print, 20.2 cm x 25.35 cm. BS.2005.280896. © Getty Images/Charles Moore.

an exhibition and a catalogue. The project was centred around the Universal Declaration of Human Rights and very important world events that happened around 1948, leading to the 1994 Rwandan genocide. I was looking at the context of the emergence of the Cold War, the creation of Israel, and the formation of the apartheid regime in South Africa, and asking myself what lessons had we maybe learnt or had to try to learn. I guess the exercise was to try to find a kind of critical dialogue, using Judith Butler's *Precarious Life*, on how the Black body was seen in these archives.[2] Working towards the exhibition, I was very interested in how the world was trying to reset itself as a new humanitarian space and yet how violent that Cold War period was— thinking that, in a sense, that period had never ended. Working with the Black Star Collection was an opportunity to look at these moments through the lens of a very typical and powerful North American photo agency. I had already been working on a project with the Royal Festival Hall that looked at "disposable people," and I wanted to build on that idea, asking "What does liberation look like?"[3]

Dahmani: Were there any disappointments or, on the contrary, pleasant surprises?

Sealy: I really enjoyed the research; it was brilliant to be just looking at photographs and have the time to do it. It was an incredible privilege. It was a lot of "Wow, look at this" and "Wow, look at that." Finding—I don't like the term *discovering*—or coming across the young German photographer Robert Lebeck's images of pre–Independence Day Congo was the crowning glory of this research (figs. 11.3-7).[4] How had I never seen that moment before? Maybe the images had been familiar in Germany, but they certainly had not, in my view, been circulating. That one image says so much: an African ex-serviceman stealing a king's sword from a cascade, going down, holding it up, and then Black African soldiers under the authority of white Belgian soldiers arresting this guy on the day, when you know that within just a

2 Judith Butler, *Precarious Life: The Powers of Mourning and Violence* (London: Verso, 2004).

3 Mark Sealy, Malbert Roger, and Bales Kevin, *Documenting Disposable People: Contemporary Global Slavery* (London: Hayward, 2008).

4 Congo gained independence from Belgium on June 30, 1960.

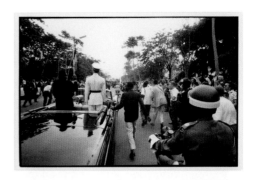

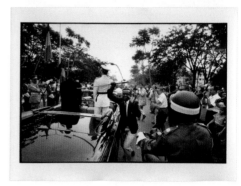

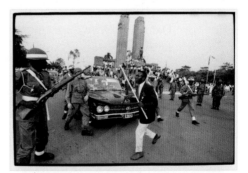

Figures 11.3–7
Robert Lebeck, *Young man steals the sword of King Baudouin I, during procession with newly appointed President Kasavubu, Leopoldville, Republic of the Congo (now Democratic Republic of the Congo)*, June 30, 1960.
Gelatin silver prints.
RIC.2012.0104 , 20.7 x 30.6 cm.
RIC.2012.0111, 30.4 x 40.6 cm.
RIC.2012.0108, 20.7 x 30.0 cm.
RIC.2012.0106, 20.7 x 30.4 cm.
RIC.2012.0110, 30.6 x 20.7 cm.
Gift of Robert Lebeck, 2012.
The Image Centre, Toronto.

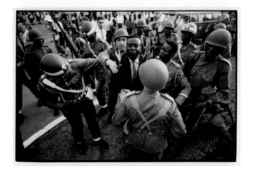

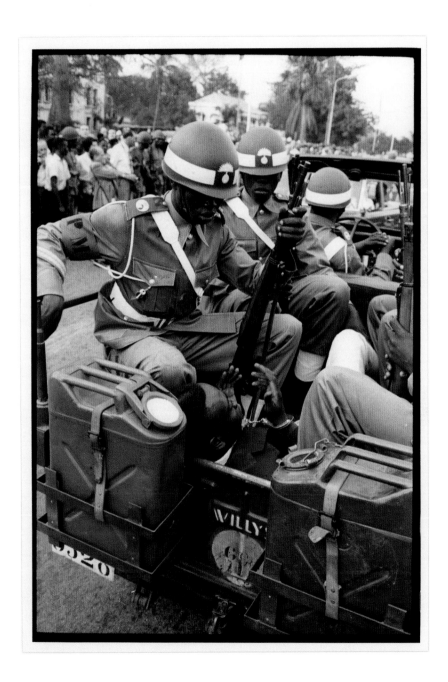

few months the Belgians were back in control and Lumumba was dead (figs. 11.3–7). Some things were important to show because I was learning about them, and I wanted to share that knowledge.

Another striking image was Martin Luther King surrounded by people's heads as if by a multiplicity of voices (fig. 11.8). I had never seen that photograph before either, and the stress on his face made me want to share the idea that the man must have been under so much pressure all the time to be in that moment, to be in that space. That is why it is also one of the covers for the catalogue.

Dahmani: Once fully immersed in the collection, you had to work with the original indexing and the terminology for the collection by subject, location, and author. What methodology did you adopt to make your transversal final selection of 316 prints—just 0.1 percent of the entire collection?

Sealy: I was looking for unusual things or maybe places that people had forgotten about. I would pull, for example, ALGERIA, and I would look at how Algeria had been represented. Some pictures never came to the fore because of the French. Magnum, as an agency, couldn't bring itself to produce or put into circulation an empathetic set of images that showed Algerian soldiers as not being brutal. It was quiet censorship and a man-ufacturing of representation. In a way I realized I was doing evidential research. Another example could be ANGOLA. Under that name you could find a lot of close-up photographs of dead Black people; in the collection you could only see broken African bodies. Let's not forget that in 1960 something like seventeen or eighteen African countries had been liberated: a huge moment in terms of asking how we visualize a continent on the march of change.

A last example could be VIETNAM (fig. 11.9). I would find very few images of American soldiers compromised by death, but lots of images of Vietnamese soldiers being compromised in pretty brutal conditions. American soldiers would be seen wounded, and the idea conveyed was one of heroism and patriotism, whereas the Vietnamese would quite lit-erally be seen being waterboarded. How could that dichotomy be okay? The idea was to feel my way through the work: it was a kind of a curatorial praxis. Often the intuition was correct. This was not really an intellectual

journey but an emotional journey. The images that made me feel something were the ones that stayed on the selection table. Those feelings were not just about pleasure; I wanted to investigate the images that also caused discomfort. I reject the idea that we have seen too much violence, and I think we have to look harder at difficult things.

Dahmani: In the exhibition catalogue *Human Rights Human Wrongs*, you state that the core question that preoccupied you during construction of the project was "How has so much human devastation taken place and how has so much wrong been enacted on the human body within the climate of human rights?"[5] How did the concept (and the title) of the *Human Rights Human Wrongs* exhibition come into being?

Sealy: I had been reading a lot around human rights because I was looking for a kind of position within the politics of how we understand race, and so I had been spending time with the work of people such as W. E. B. Du Bois. From my own experience, when we talk about the politics of race, it becomes a polarizing space straight away, but if we talk about rights—human rights—it becomes a wider conversation. It was a strategy for inclusion framed around rights. Human rights as a concept has its fault lines, but sometimes I think, "If not that, then what?" So maybe the title should have been a question: "Human Rights, Human Wrongs?" Article 6 of the Universal Declaration of Human Rights was really important because it conveys the idea about the right to representation; taking that legal idea as a visual idea was a key driver for the exhibition (fig. 11.13).

Thinking about all those people in those frames who had no rights over their representation, and how that representation gets amplified through news media and agencies and then becomes capitalized and ultimately turned into currency. If you see racialized people only as debased or less than human, consider them slaves, broken bodies, and always compromised, the results are devasting, and the exhibition pointed to that fact. And the collection was full of compromised photographs of the Black subject. Take the prison images from São Paulo (fig. 11.10): it's a violent manhunt for prisoners

5 Mark Sealy, *Human Rights Human Wrongs* (Toronto: Ryerson Image Centre, 2013), 107.

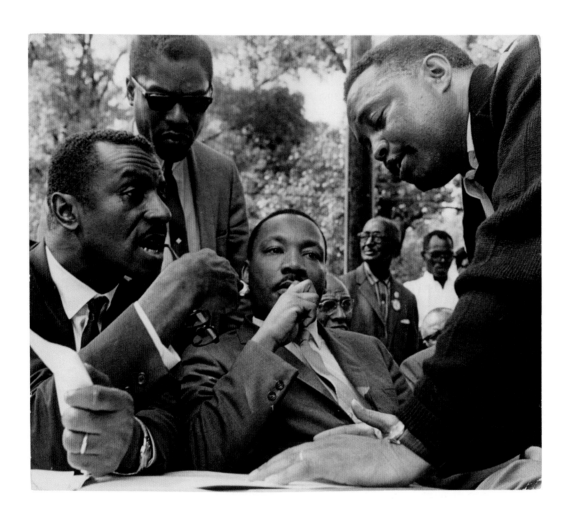

who tried to escape brutal conditions, and when they were captured, killed, or wounded, the powers that be held the bodies up to the camera for display—and mostly they are brown bodies being treated as hunters' trophies for the camera.

The idea was to ask "Is this form of representation just, in terms of a human's rights? Should we continue allowing the Global South to be articulated by so few Northern voices and so few formulaic images?" That's really what the premise of the exhibition was; it was about producing evidence.

Dahmani: The images you mention make me think of the infamous lynching photographs that were made into postcards.[6]

Sealy: This is precisely what I was trying to say, Taous. It's very hard to look at these images; people could easily say the exhibition was a bit of a "gorefest"— there were loads of broken bodies—but actually, as with the lynching photographs, I was trying to get people to think about what was going on *outside the frame*. The overriding element that comes out of those lynching photographs is not the actual hanging bodies; it is the white audience having so much fun. I was trying to open the space of Eurocentric thought and critique it by saying "This is what you like to look at. Why?" So much of the work was about trying to say that the situation in focus tells us nothing about the political environment in which so much chaos and death resulted. Often the captions were just too binary.

Dahmani: You have written that "a key function of decolonising the camera is not to allow photography's colonial past and its cultural legacies in the present to lie unchallenged and un-agitated, or simply to be left as an unquestioned chapter within the history of the medium."[7] How did you proceed to this critical examination in the specific case of the Black Star Collection and the *Human Rights Human Wrongs* exhibition?

Figure 11.8
Bob Fitch, *Reverend Martin Luther King Jr., Surrounded by (left to right) Reverend Fred Shuttlesworth, Reverend Bernard Lee, and Hosea Williams, at Kelly Ingram Park, Birmingham, December 1965.* Gelatin silver print, 18.7 cm x 21.5 cm. Black Star Collection, The Image Centre, Toronto Metropolitan University. BS.2005.177499.

6 See James Allen, Hilton Als, Leon F. Litwack, John Lewis, and Arlyn Nathan, *Without Sanctuary: Lynching Photography in America* (Santa Fe, New Mexico: Twin Palms Publishers, 2020).

7 Mark Sealy, "Decolonising the Camera: Photography in Racial Time" (PhD diss., Durham University, 2016), 2.

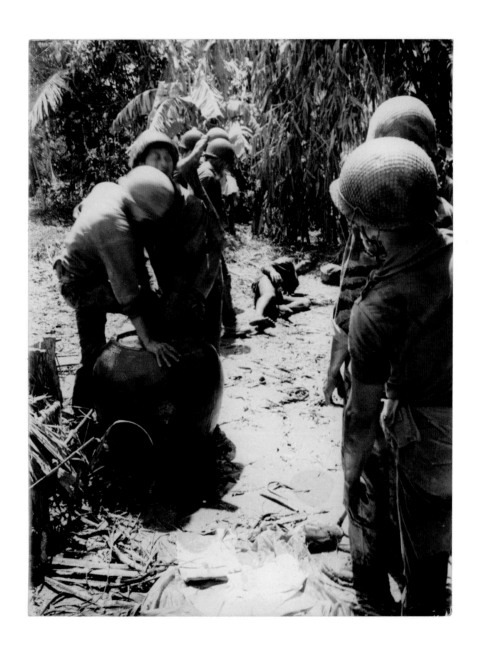

Sealy: There seems to have been a time in photography when everyone was saying "This is very truthful," and what I am really trying to say is "This is just a punctuation mark in a much wider conversation." History is a nuanced, entangled narrative. When you look at images, you can't simply frame people, because there are all these multiple other histories and moments and timings that are happening all around us. If we come back to the Congo, for example, and Robert Lebeck's photographs, when you look at them and then know what happened afterwards, the issues of denial and colonial complicity shine through. If we put this mosaic of elements together, we might just understand the wider story and that it is still an ongoing story. The impact of Lumumba's killing is still being felt. Archives and collections are there to be unpacked so that these other stories can be added, missing chapters written—actually, maybe that's the wrong word. *Silenced* chapters, upon reflection, might be a better way to understand the work these images tried to do.

Dahmani: The scholar Susie Linfield asked in *The Cruel Radiance: Photography and Political Violence*, "What, then, is photography's role in revealing injustice, fighting exploitation, and furthering human rights?"[8] I'd like to ask you that exact same question.

Sealy: I like the idea of a "photographic crime scene." I see photographs as either damning evidence or as part of a case. Photographs become part of a case or part of our understanding of that case. So when we find atrocities like the concentration camp images—which were used in the exhibition through the pages of *Life* magazine—it is really interesting how even that was originally rendered in *Life* as a narrative. The subjects were not given a racial identity at that point, not named as Jewish but as "war prisoners." Maybe some people would not have been as empathetic when the images were originally published if they had been captioned otherwise. They are incredibly uncomfortable, but it's really important that we look. We must not stop looking and examining the work images do; in culture, meaning is not fixed.

Photography is a space of inquiry, a very important rear-view mirror towards the road of justice, not the conclusive stamp. That's why I'm so interested

Figure 11.9
James H. Pickerell, *Torture in Vietnam*, 1966. Gelatin silver print, 18.1 x 23.9 cm. BS.2005.081497.
© Jim Pickerell.

8 Susie Linfield, *The Cruel Radiance: Photography and Political Violence* (Chicago: University of Chicago Press, 2010), 33.

in Eyal Weizman's work through the research group Forensic Architecture; there's a forensic position, and it's not always what you think you can see. It's what could be triggered behind the image, what also might be missed or made absent when seen from a different perspective of time, culture, or politics.

Dahmani: In the exhibition catalogue you state: "Dead Africans arrive on the page without history."[9] This statement prompts a question about the representation of violence. The exhibition and the catalogue are visually horrifying. We see photographs of corpses, bloody scenes, restrained human beings, body parts, starving bodies, immolation, murders and executions, tortures, humiliations, and mass graves. Could you describe the ethical questionings at play while organizing the exhibition?

Sealy: Each time you show colonial images, you reproduce the violence of that coloniality. But we can't not look at this violence; otherwise it gets reinvented, it gets denied—think of Holocaust denial or slavery denial. It's difficult and it's uncomfortable, but I think, within the context of trying to articulate it through the lens of human rights and human wrongs, you get to ask what is wrong and what is right. It's a kind of unresolved place, but I would rather it wasn't buried; I would rather we looked at it. I would rather we said, "That is the way we were in the West, and that is the way we treated these people." Let's take Kenya, for example, where the concentration camp was reinvented because of the Mau Mau fighting for liberation (fig. 11.11). All these kinds of hypocrisies need to be worked through.

Figure 11.10
Henri Ballot, *World's Biggest Jail Break*, June 1952. Gelatin silver print with masking tape, 18.2 cm x 16.7 cm. BS.2005.104253.

Looking properly at our past is difficult. I don't think I could even do that show now, because it's wearing, it takes its toll. But I do think it's important that we have projects such as *Without Sanctuary*[10]; those photographs have to be there in the world. And I do think it's important that we bring them out and we look at them and have them in the public realm. Then we know who and what we are. Otherwise they will be haunting the present also, because they are denied.

9 Sealy, *Human Rights*, 107.
10 Allen, *Without Sanctuary: Lynching Photography in America*.

Dahmani: I think it's also a question of maybe creating a space for complexity—which is kind of crucial right now, especially in our polarizing worlds.

Sealy: On the one hand we may have the *New York Times* in the 1950s and '60s as a "gorefest," but then in the 1990s someone turned the dial somewhere else. You got Malick Sidibé and Seydou Keïta, who created vibrant images of everyday life in Africa. We could see people partying, people having fun, people being proud of themselves, in studios, constructing their own identities. Prior to that, realistically, there was not that much out there. *DRUM* magazine was probably the only place doing more nuanced and complex African stories. *DRUM* magazine in a sense is a very different world in terms of what Africa looks like.

The majority world has been represented through archives such as those of the Black Star agency. That was the "image truth." Now we are saying that there are many other voices out there and it's exciting and necessary that we provide platforms for the work. If we can have a conversation, the left and the right, the straight and the queer, the violent and the passive, then there is a space for these conversations to happen and for new knowledge to surface. The more we do the listening work, the better it is. Photographs, as Tina Campt has been saying, do speak to us.[11] I'm more into the idea of the jazz of it all: I don't think they just say speak; each time I look at a photograph, a different tune happens. They are not saying the same things. Why? Because I have moved in time—what I refer to as racial time. I have experienced children or a disaster or death or loss or happiness. And when I look at a photograph again, I might bring all that cultural baggage or my life experience to the picture, which enables me to go off on journeys not known.

Dahmani: These Black Star photographs were taken to be sold to press organs; their materiality in the collection reminds us that they were and still are objects partaking in capitalism. How do you address the commodifying of emotions, and especially the commodifying of violence against Black bodies?

11 Tina M. Campt, *Listening to Images* (Durham, NC: Duke University Press, 2017).

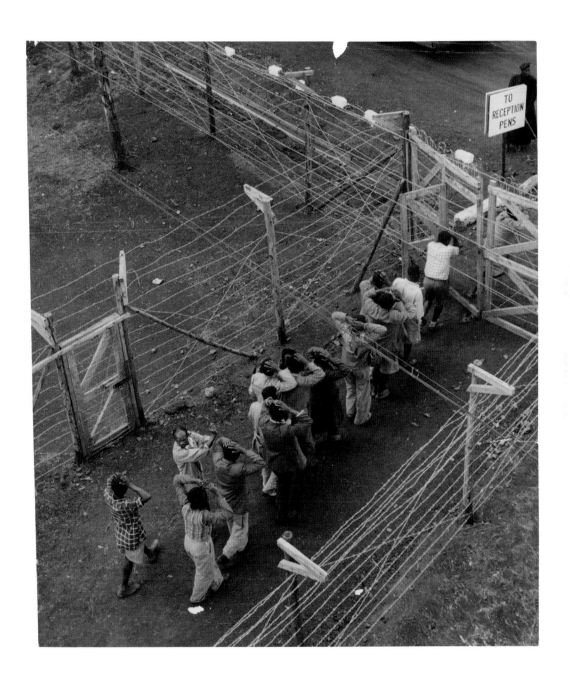

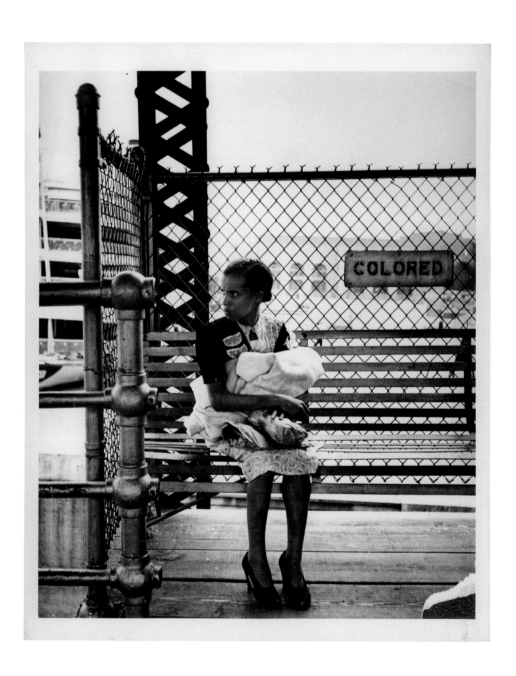

Sealy: The key thing there is that it's the Black Star picture *agency*. So it's a commercial entity, full stop. In the exhibition there was a big tower made of the entire print run of *Life* magazine so that people could see what this pillar, what this archive looked like, where these images were supposed to be destined. I wanted the audience to understand where some of the images lived or worked and then what they looked like once on the page of the magazine. I wanted to make visible the correlation between the photographs, their destination, and their archive as a public memory rather than a private one—i.e., the agency. I was trying to unpack the commodification of photographs through that link by bringing the monument of *Life* magazine into reality as an object.

Dahmani: One of the challenges of the Black Star Collection is that there are no contact sheets, negatives, research cards, or catalogue cards, but there is some important information on the backs of some prints. Yet *Human Rights Human Wrongs* is very context/history driven, with chronologies, theory, essays. Could you share your reflections on this point?

Sealy: Volumes and volumes of images, research, and work never made it into the exhibition, but I lived with them for a very long time. I pulled hundreds and hundreds of images and I cut them all out and worked my way through them: blowing it up, seeing what it all looked like.

Within the exhibition there were all these little cards that we made to provide historical information. Each time there was what I would call a critical historical conjuncture, a moment of meeting or difference or a photograph as a pause; I wanted to give people a wider historical context of what else was going on at the time this photograph was taken. The idea was that none of this was happening in isolation. And I am hoping that the show came across as a place that said, "My God, what are we doing? What have we done? Where is this going? Where does it begin and where does it end?"

I also used video clips to try to amplify some of the historical speeches—for example, Marlon Brando's speech about Hollywood being effectively racist in the 1970s—reminding people that these conversations have been happening through key figures for a very long time. Through interviews, through seeing the collection, through presenting the versos, you could get a sense of what the index was doing. It was just an opening. I like to curate

Figure 11.12
Walter Sanders, *A Black Woman Sits on a Bench Designated for "Colored" People*, ca. 1935. Gelatin silver print, 25.2 cm x 20.5 cm. BS.2005.280814.

as a kind of opening. So much of Western intellectual work is about finding the answer; I like the question.

Dahmani: Following on from the last question about contextual information, one of the solutions you found was through oral history. You recorded an interview with Bob Fitch and Matt Herron, two white photographers who covered the civil rights movement. Could you explain the value and limitations of this approach for your research and curatorial experience at The Image Centre?

Sealy: Some very important research happened there. I spent some time with Matt Herron and Bob Fitch, who were Black Star photographers. I started off quite hostile with them: What are two white guys doing photographing the civil rights movement? But in the end I fell in love with them. I was not down there with some fat white sheriff pointing a gun at my head. The key thing is that Black photographers would have been killed there photographing the civil rights protests. I thanked Bob and Matt for their photographs in the Black Star Collection because they were trying to do something deliberately empathetic, deliberately advocating the rights that the marchers were fighting for, deliberately working in that space. They were switched on to a kind of new America, a new form of Black consciousness. I learned from that conversation a great deal about acting and taking responsibility for each other. At least they did the bloody work, right? At least they got on the bus; at least they gave us something.

Dahmani: Recently, in his book *Black Paper*, Teju Cole wrote: "Perhaps too much is made of individual photographs. What if we had, for each incident, not one photograph, but a hundred? . . . Would we be able to hold on to our innocence?"[12] This statement made me think of your curatorial choice of creating a mosaic of images (fig. 11.14). The mass of photographs allowed visitors to become judges of history and, perhaps, also to trigger a sense of morality or even empathy. How did your choice of hyper-multiplicity serve your curatorial discourse?

12 Teju Cole, *Black Paper: Writing in a Dark Time* (Chicago: University of Chicago Press, 2021), 196.

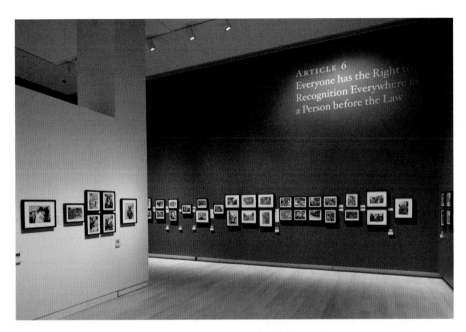

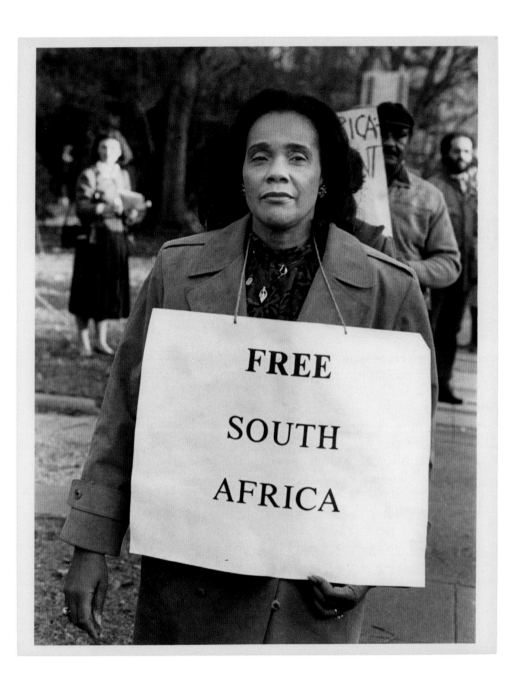

Sealy: It's about not subscribing to the idea of the decisive moment, that myth of photography, getting that one great picture that says the whole moment. It's ridiculous that we have to advocate multiplicity even after all the considerations on the essential Black subject, and also feminist theories on the importance of multiple perspectives on femininity, queerness, etc. I was also really influenced by the work of Emmanuel Levinas: this idea that if I look at you, then I take responsibility for you and I have to care for you. I have to see you. It's my ethical duty.

It's not about positive and negative images; the Western world treating the rest of the world as a tourist place is odd. Just this idea of travelling through, meandering, floundering, not caring, is troublesome. It's hard to take responsibility or to think about taking responsibility for places, but we must.

Dahmani: In the specific case of *Human Rights Human Wrongs,* do you differentiate your curatorial work from the creation of the catalogue, and if so, how?

Sealy: They are not the same. The catalogue is a place where you can contemplate, disagree or agree with the work. Shows come and go. The book stays, it has an ISBN number; they get deposited in libraries, they get left behind if they do not sell—it's legacy work. As for the ideas, some of them become redundant, some of them don't work. When you look back, you might do something very differently from how you might have ten years earlier. Exhibitions have to be enquiries, open dialogues, rather than dictates.

Conversations change, intentions and ideas do not always work, but at least an exhibition contributes to the conversation of the times we are in. And maybe in thirty years' time that conversation might be relevant again. Things live differently in different times. So it was a conversation with the collection through the lens of a curator who was trying to say something about the way the Black body sits in the Black Star agency's black-and-white print archive, and, if fortunate, offered some pause for reflection to help reset a possible new future.

Figure 11.15
Rick Reinhard, *Coretta Scott King on Picket Line near South African Embassy, Washington, DC,* November 29, 1984. Gelatin silver print, 25.3 x 20.4 cm. BS.2005.288520.

Speculating on the Visual Archive of Climate Change

Bénédicte Ramade
Translated by Bernard Schütze

Over recent decades the notion of climate change has become ubiquitous in the Western mediascape. How does it manifest itself? In order to represent the visuality of climate change, one must take an interest in either the causes—and they are multiple—or the consequences—and they are countless. It is therefore impossible to imagine encompassing it in a single image. In 1995 the threats to Earth's climate were spelled out by the Intergovernmental Panel on Climate Change (IPCC): concentration of greenhouse gases, rising surface temperature, disruptions in water cycles, climate warming/cooling, pollution, and extreme weather events.[1] There are so many topics to research, including natural catastrophes (fires, droughts, floods) and environmental accidents such as pollution or spills, but also the resulting damage, populations in crisis, and large numbers of injured or dead. The media use shocking images to report these intense meteorological accidents, and they can also draw on comparative tools derived from science to demonstrate loss and attrition, whether in terms of glacier surfaces, plant coverage, or erosion.

But above all, this visuality of climate change is presented as mainly statistical, consisting of data represented by curves, pie charts, and numbers converted into colour codes. Today this tool prevails in informational discourse, but this has not always been the case. In the 1970s, US illustrated magazines such as *Life* and *Newsweek* elected to use photographic coverage over the art of statistics. What exactly did their treatment of environmental news look like during this seminal period of public awareness–raising about the subject? Given the current state of the planet, it was very probable that an exploration of the Black Star Collection would testify to aporia and to

Figure 12.1
Hiroshi Takagi, *Juvenile Japanese Macaque Deformed by Mercury Poisoning, Minamata, Japan*, ca. 1978 (detail). Gelatin silver print, 30.6 x 23.8 cm. BS.2005.248406.

1 The Intergovernmental Panel on Climate Change is an independent body that brings together 195 United Nations member states. It was founded in 1988.

an iconography that was altogether insufficient. Otherwise, how is one to explain how climate change became so critical and the environmental situation so desperate? We must not have seen it. If not, does this mean that the photographic image failed to serve the environmental cause?

The structure of the exhibition *The Edge of the Earth: Climate Change in Photography and Video* (fig. 12.2) already existed in its thematic outline when my study of the Black Star database began. In terms of the subject headings used to index the images, the database would not logically include a "climate change" category, because the term was not in common usage before the 2000s and still remains somewhat abstract.[2] It was therefore through the signs associated with climate change—its causes and its consequences—that the visuality would take shape, both in the exhibition structure and in the research feedback from the Black Star Collection. These images would form a composite representation of climate change, a representation that was both retrospective in terms of the Black Star Collection and prospective in terms of contemporary art.

Among the terms found in the subject headings, NATURAL DISASTER provided only an image of an uprooted tree; the LANDSCAPE category did not really have an environmental dimension; ANIMALS was subdivided by species; WEATHER included FOG, SNOW, and STORMS; and ENVIRONMENT consisted of five subsections: ANIMALS, DISASTERS, PLANTS, POLLUTION, and WEATHER, a grouping that remains cautious. The images found there were not necessarily synonymous with proof of climate change, the events could have occurred in different parts of the world, and it was not possible to discern a visual coherence. ATOMIC EXPLOSION was also consulted, but the images of mushroom clouds were linked more to historical and sociocultural events than to environmental ones. Furthermore, their effect was too predictable, too linked in significance with World War II and the Cold War. Where, then, could be found the unexpected?

2 I am here thinking of the "hyperobject," a concept devised by Timothy Morton that he defines as follows: "A hyperobject could be a black hole. A hyperobject could be the Lago Agrio oil field in Ecuador, or the Florida Everglades. A hyperobject could be the biosphere, or the Solar System. A hyperobject could be the sum total of all nuclear materials on Earth; or just the plutonium, or the uranium. A hyperobject could be the very long-lasting product of direct human manufacture, such as Styrofoam or plastic bags, or the sum of all the whirring machinery of capitalism. Hyperobjects, then, are 'hyper' in relation to some other entity, whether they are directly manufactured by humans or not"; Timothy Morton, *Hyperobjects: Philosophy and Ecology after the End of the World* (Minneapolis: Minnesota University Press, 2013), 1.

Figure 12.2
Installation view of *The Edge of the Earth: Climate Change in Photography and Video*, 2016. Digital image. Photography by Riley Snelling. © Riley Snelling, The Image Centre, Toronto.

Under the ECOLOGY heading, the profusion of subcategories came as a complete surprise to me. I had not considered the term *ecology* because it is not so widely used nowadays, when the focus in the media is on climate change. In addition, the word does not appear frequently in the American context, where the predominant terms in the 1970s were *environment* and *Earth*. However, it is ECOLOGY that comes out on top in Black Star's subject headings; this main category contains eighty-nine different subcategories that most frequently use the words *pollution*, *drought*, *contamination*, and *demonstration*.

The unexpected quantity of easily accessible images in the collection— where I had envisaged a long, complex inquiry with multiple intersecting factors—should therefore mean that the media had covered environmental problems widely. This is exactly what the art historian Finis Dunaway concludes in his studies; he focuses precisely on the constitution and evolution of photographic representations of American environmentalism when he considers "how popular environmentalism has been entwined with mass-media spectacle of crisis. The fusion of politics and spectacle has encouraged Americans to see themselves as part of a larger ecological fabric, and to support personal and political change to protect the environment."[3] The Black Star Collection thus reflects this growing environmental awareness in American society, notably since media coverage of the January 28, 1969, Santa Barbara oil spill, which held the attention of journalists and reporters for months.[4]

The exhibition therefore had to give a prominent place to the images found in the Black Star Collection among the 1,300 or so listed, in order to demonstrate and to question the persistence of visual tropes in contemporary media. It was also necessary to consider their mode of exhibition: alongside magazines that had dedicated their pages to such subjects. In educational terms, juxtaposing these images with illustrated magazines could lead to a comparison between the images that were published and the ones that were not retained for eventual publication, which would have left those pictures

3 Finis Dunaway, *Seeing Green: The Use and Abuse of American Environmental Images* (Chicago: University of Chicago Press, 2015), 2.

4 The other marker is the June 1969 conflagration of the Cuyahoga River in Cleveland, a fire for which there appears to be no photographic record because of its nocturnal and relatively brief nature. The catastrophe was caused by the release of high concentrations of hydrocarbons into the waterway.

in a passive archival role. The images had to be looked at for what they had become after being stripped of their informational purpose: visual tropes of climate change that would function in the exhibition like a collective Western unconscious.

Since *The Edge of the Earth* opted to create a dialogue between photographers and artists who are clearly engaged in a testimonial, informative, and political initiative of an environmental nature and producers of other works and images that are more ambiguous and less bound by such a mission, the Black Star Collection images were also to play an active role, not simply to bear witness to bygone history. In this triggering of a dialogue between two modes of approaching the environmental realities that are at the core of climate change, the exhibition aimed to lead its viewers towards interpreting the effectiveness of the various visual strategies, their complementarity, and the influence of context, and to question their own place, responsibility, and agency. The images from the Black Star Collection not only supplied a historical context—their significant presence in the collection indicated an already well-established environmental consciousness—but also questioned the impact of press photographs.

If those images were published and seen repeatedly, why is the environmental situation in such a deteriorated state? Do the images testify to an inability to act? And why, despite the length of time since the events they report, do they still prove pertinent today? Though the exhibition was not dedicated exclusively to environmental photography per se, it did invite some of the field's principal protagonists, such as Edward Burtynsky, Peter Goin, Richard Misrach, Joel Sternfeld, and Sharon Stewart. These photographers, all of whom began their careers in the late 1970s or early 1980s, inherited a visual environmental culture that had been shaped by the illustrated press since 1962, the year of publication of *The Silent Spring* by the scientist Rachel Carson. The book popularized the results of Carson's research on the harmful effects of pesticides (primarily DDT) that were used abundantly in domestic and industrial contexts at the time. In this ecological bestseller, first published as a three-part serial in the *New Yorker* in June 1962,[5] Carson correlated the

5 Published in *The New Yorker* 16, 23, and 30 (June 1962). Rachel Carson was described as "reporter at large."

increase in cancer and the disappearance of animal species with the massive use of domestic, agricultural, and industrial insecticides.

In 1963 about half a million copies of *Silent Spring* were sold, an exceptional figure for a book on science.[6] Thanks to a bitter media debate—a counterproductive smear strategy by the chemical tanker industry served to boost the book's success—Carson was invited to explain herself on television before her denigrators on the April 3, 1963, edition of the very popular *CBS Report*, and in the same year, on the Senate floor. The television show, in which the scientist confronted a learned assembly of male specialists with science degrees (mandated by the Department of Agriculture and a pesticide manufacturer), interspersed the discourses of both sides with short reports illustrating their respective positions. The program showed the toxic effects of massive fumigations with pesticide products on birds, fish, and insects, as well as the subsequent results in terms of yields and productivity, notably in the agricultural domain. The use of filmed images is very significant, because it announced modern Western society's entry into the era of environmental communication and its expansion.[7]

Life, *Newsweek*, and *National Geographic* thus opened their pages to this subject in 1966.[8] On August 23, 1968, *Life* dedicated five double-page spreads to a visual investigative report on the Great Lakes by Alfred Eisenstaedt, supported by copious aerial views of the industrial sites laying waste to the lakeshores, "foambergs" on Ohio's Cuyahoga River—which became "famous" on June 22, 1969, when it burst into flames—and pollution slicks of ominous colours and iridescence. On February 7, 1969, the same magazine revisited the topic with a platform offered to photographer Martin Schneider, this time documenting air pollution throughout the country. "Pollution: Is This the Air You Want to Breathe?" was the title of this shock

6 In October 1962 it was part of the Book of the Month Club selections, a rare honour for a book of such scope.

7 The *National Geographic* archives make it possible to search the usage frequency of some terms in their publications over selected periods. Between 1962 and 1975, the occurrences of *ecology* and *pollution* increased considerably, beginning with none in 1962 and up to twenty times in 1972, thus testifying to the importance of the subject.

8 Gisela Parak, "Depicting Disaster. Environmental Photography under the Nixon Presidency," *Photographs of Environmental Phenomena: Scientific Images in the Wake of Environmental Awareness, USA 1860s–1970s* (Bielefeld, Germany: Transcript, 2015), 137-215.

tactic, buttressed by aerial views of Washington, DC, covered in purple or yellow smog and hellish landscapes in Montana or Indiana showing dense billows of factory smokestack emissions. New York City was shown almost disappearing under a thick blanket of pollution.

As part of the "Pollution" article, a report tracing incidents and other impacts of air pollution, written by Richard Hall, was illustrated by a parade of citizens wearing surgical masks protesting against pollution in an industrial landscape in New Jersey, the small group led by a woman and her young child, both wearing masks. This photograph, taken by Robert Phillips, was the cover of a special August 3, 1970, issue of *Life* devoted to the environment, subtitled "Our Polluted Earth: The Crisis of the 1970s" (fig. 12.3). The editorial, by René Dubos, an American agronomist, biologist, and ecologist of French origin, used the headline "Mere Survival Is Not Enough for Man," and three-quarters of the issue covers related subjects in an equally gloomy tone (fig. 12.4). "Battles Won," illustrated with photographs by George Silk, is the only respite in this highly charged issue (fig. 12.5).

In the same year, *Newsweek* also made ecology the subject with its January 26, 1970, thick special issue about environmental degradation (figs. 12.6 and 12.7). On the cover, an Earth seen from space is encircled by a collage of threatening arrows filled with photographs of crowds, an auto scrapyard, mountains of garbage, billowing factory smokestacks set against an apocalyptic sky, and oil spills in the sea. These illustrations confirm the presence of certain visual tropes that were soon to recur in several other features, among which were those in *National Geographic*. And they can all be found in the Black Star Collection, indicating that the agency was in tune with the era's editorial approach to the subject.

The exhibition selections were not only to bear witness to the collection's exemplary nature, by drawing on comparable items published in the illustrated press but were also influenced by the current aesthetics of climate change. The most often reproduced motifs in the magazines—factory chimneys emitting thick clouds of smoke (Carl Hartup [fig. 12.8], Belluschi, Michael Crummett), piles of wrecked cars (Gunnar Braten [fig. 12.9]), used tire dumps (Don Routledge), mining drills and geological pollution (Gerald Brimacombe, Barbara Pfeffer)—would be displayed alongside more unconventional images such as the one by Tom Ebenhoh showing rows of used

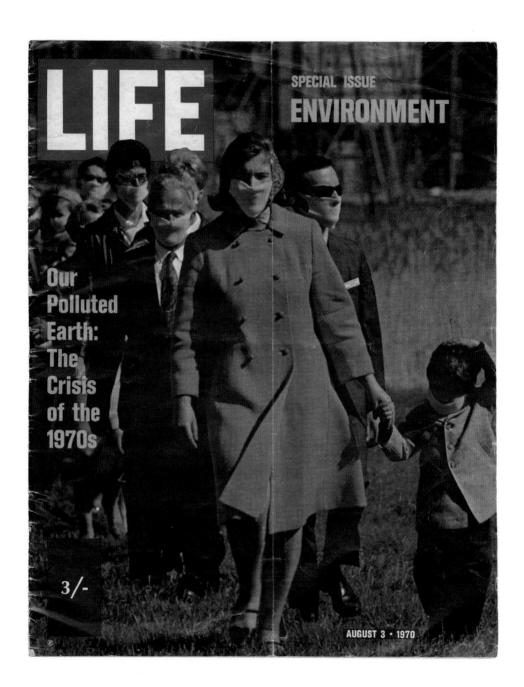

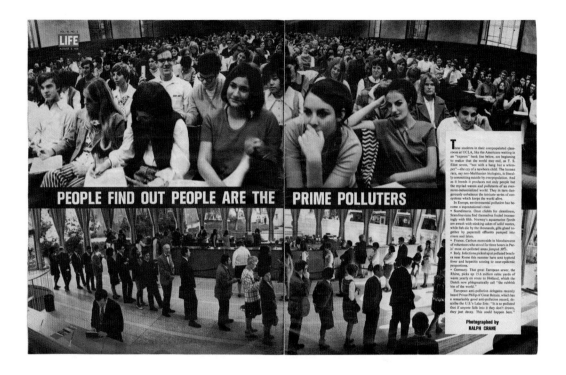

Figures 12.3 and 12.4
Robert Phillips, *Citizens Protesting Pollution in an Industrial Landscape, New Jersey*, ca. 1970. *Life*, August 3, 1970: cover. Private collection, Montreal, Quebec.

"People Find Out People Are the Prime Polluters," *Life*, August 3, 1970: 6–7. Photographs by Ralph Crane. Private collection, Montreal, Quebec.

Sometimes the fight to save our natural beauties seems doomed by its very magnitude. Yet taken case by case conservation is a cause for hope. All across the land dedication and determination are beginning to pay off

BATTLES WON

Wood family flanks conservationist Ted Steele (fourth from left)

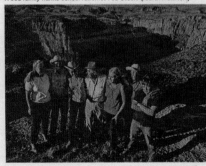

Aravaipa Canyon is a place where saguaro cactus and prickly pe[ar] march across the rims, hawks float in the updrafts, cougars and bc[b] cats and ringtail cats patrol the dusty ledges. So it has alwa[ys] been. And now, for as long as the conservationists' money flo[ws] and the creeks don't rise, so it will always be, preserved as a livi[ng] museum of the canyon-and-rimrock country of the Southwest. It i[s a] conservation battle won, one of a number of such victories acr[oss] the country. The canyon walls rise on 4,400 acres ranched for yea[rs] by the Wood brothers, Fred and Cliff, in southern Arizona. The ran[ch] was purchased by conservationist Ted Steele ("The environment[is] like a religion to me") on behalf of the Nature Conservancy, an [or]ganization whose function is to hold the land in trust until a buy[er] who will preserve it can be located. Steele hopes to raise $1.5 milli[on] to finance the purchase—a new battle. Choosing what to save a[nd] what to spend among our still-plentiful natural beauties is nev[er] easy, and making a preservation decision stick is more try[ing] still. Each threat means a fresh fight. To lose is to lose for goo[d]

Photographed by GEORGE SILK

46

A turkey vulture glides between the walls of Aravaipa Canyon

Rocks and desert plants line the canyon rim

Figure 12.5
(previous pages)
"Battles Won," *Life*,
August 3, 1970, 46–47.
Photographs by George Silk.
Private collection,
Montreal, Quebec.

cars serving to counteract soil erosion. It was about simultaneously showing a certain triteness or normalizing of subjects and how these often caption-less images represent the current dysfunction of the planet—because the photographs are still current, after all. Only two images referred to minor catastrophes or identified climate accidents: a fuel storage tank that caught fire after being hit by lighting (Carole Sill, fig. 12.20) and a landslide in Orlando (Ric Feld). The others displayed critical situations that were not linked to a particular event.

Finally, a series documented the first Earth Day rallies in 1970 (Dennis Brack, John Collier, Fred Ward, Gene Daniels) and thus echoed a recur-ring representation in the press during the era of citizen mobilization in the United States. I believed it was important to show that the public, following the example of the photographers, had also been galvanized into action. This first sets of works showed that the Black Star agency responded to the environmental worries of the period and put together a visual reserve corre-sponding to the prominent sources of concern at the time. But two sets of works broke away from that logic.

Three images probably taken by Hiroshi Takagi in 1978 show juvenile Japanese snow monkeys (macaques) suffering from Minamata disease, which is caused by mercury poisoning and leads to brain damage and severe develop-mental and physical disabilities (figs. 12.10–12). This type of industrial pollution (caused by the Chisso Corporation in the specific case of Minamata) had been brought before the eyes of the Western world by the investigative photo report-ing begun by W. Eugene Smith and his wife, Aileen Mioko Smith, in 1971 and published in *Life* in 1972. Those images notably included the severely ill Tomoko Kamimura, whose body, crippled and disfigured by the disease, was photographed by the Smiths as her mother bathed her. Since the poisoning of the local population had been caused mainly by consumption of fish and other seafood, it was logical that the species involved were also affected by the disease, but those were never photographed.

Figures 12.6 and 12.7
Newsweek, January 26, 1970,
cover and 38–39. Private
collection, Montreal, Quebec.

The three images of macaques documented an aspect that had been ignored in global media coverage of the Minamata scandal, and thus ex-posed the troubling relationship between the physical disfigurements seen in the people photographed by the Smiths and those of the snow monkeys. The choice of these images from the Black Star Collection implicitly referred to the well-known investigation by the Smiths, paragons of the humanitarian

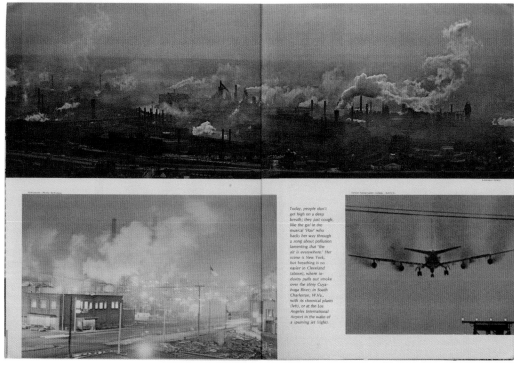

Today, people don't
get high on a deep
breath; they just cough,
like the girl in the
musical 'Hair' who
hacks her way through
a song about pollution
lamenting that 'the
air is everywhere.' Her
scene is New York,
but breathing is no
easier in Cleveland
(above), where in-
dustry puffs out smoke
over the slimy Cuya-
hoga River; in South
Charleston, W.Va.,
with its chemical plant
(left), or at the Los
Angeles International
Airport in the wake of
a spuming jet (right).

Speculating on the Visual Archive of Climate Change

Figures 12.8 and 12.9
Carl R. Hartup, *Air Pollution
from a West Side Factory in
Fort Wayne, Indiana,*
ca. 1975. Gelatin silver
print, 20.5 x 25.3 cm.
BS.2005.248073.

Gunnar Braten, *Junked Cars
at Jetstar's Graveyard, Denver,
Colorado,* 1975. Gelatin
silver print, 20.3 x 25.5 cm.
BS.2005.248571.

Speculating on the Visual Archive of Climate Change

and political engagement of a certain type of photographic reportage,[9] and thus offered an original complement to the subject. Takagi's first image (fig. 12.10) reveals, emerging from its mother's fur, the atrophied hand of a juvenile primate, which resembles the contracted hands of little Tomoko. The second image (fig. 12.11) shows a young macaque exhibiting the physical signs of the disease posing on a table surrounded by a Japanese family, and the third image (fig. 12.12) displays an adult monkey with a juvenile that is also deformed. Up until then, the animal victims of the catastrophic poisoning of the Minamata community were not known or represented in media coverage of the cause, which had been dominated by the human tragedy. An interest in the wildlife aspects of the pollution would certainly have seemed inappropriate at the time, but nowadays hindsight makes it possible to unearth these images without solely prioritizing humans in order to understand the symbiotic dimensions of the environmental crisis.

Takagi's images were one of the most important discoveries from this research, along with an ensemble of ten photographs by Gene Daniels covering air pollution in Los Angeles. Though most of the time we found only single images documenting smog and air pollution—except for Carl Hartup and his factory smokestacks (fig. 12.8)—the reportage initiated in November 1971 was different. The group is made up of three panoramas showing the congested, smoke-filled freeways of the California city and seven "portraits" shot from the backseat of a car stuck in a traffic jam. This latter series captures with a certain playfulness the exhaust fumes that sometimes block the windshield and the driver's reflection in the rear-view mirror (figs. 12.13–18). I decided to grant artistic status to six of these systematically created images[10] and to bring them together in a single context, in the manner of the photographic series Ed Ruscha carried out in Los Angeles at the end of the 1960s. It was about amplifying the aesthetic character of such photojournalistic reportage (in Daniels's case, its conceptual systematization), all the while underlining the signature rigorous approach of this photographer, who was assigned in 1972 to cover the Pacific zone for the *Documerica* series. For five years the US Environmental Protection Agency financed that mission to "pictorially

Figure 12.10
Hiroshi Takagi, *Juvenile Japanese Macaque Deformed by Mercury Poisoning, Minamata, Japan*, ca. 1978. Gelatin silver print, 30.5 x 23.7 cm. BS.2005.248402.

9 See Brett Abbott, *Engaged Observers: Documentary Photography Since the Sixties* (Los Angeles: J. Paul Getty Museum, 2010).
10 The seventh, which had traces of retouching, was not used.

Figures 12.11 and 12.12
Hiroshi Takagi, *Juvenile
Japanese Macaque Deformed
by Mercury Poisoning,
Minamata, Japan*, ca. 1978.
Gelatin silver prints,
23.8 x 30.5 cm.
BS.2005.248407.
30.6 x 23.8 cm.
BS.2005.248406.

document the environmental movement in America," as it was defined by former *National Geographic* photo-editor Gifford Hampshire, who was then in charge of *Documerica*. The series' ambition was to match the importance of the documentation of the Dust Bowl and its social consequences by the FSA (Farm Security Administration) in the 1930s.

From the particularization of Daniels's photographs—from their "artification," so to speak—my reflections on the exhibition methods for the images from the Black Star Collection grew clearer. The documentary groups gathered through a play of analogous motifs were to be distinguished from the rest of the works by being shown systematically with continuous framing, thus underlining the coloured vinyl panels containing the explanatory texts for each room. Rather than opting for showcases, which would have confined the archival prints to a relative visual inertia as simple witnesses to the past, we chose to foreground their precursor and prognostic characteristics, to turn the images into visual chronological guides by linking them with the texts that introduced new themes (fig. 12.19). The only thing missing was the captions, for their strong indexical character added nothing to the images. Freed of their information-conveying function, the photographs could more readily reveal their great aesthetic qualities.

This valorization made it possible to engage the Black Star images in a dialogue with the other works and to partake in the exhibition's reflection on contextual effects. In fact, by articulating "message-based" works with others less bound to an environmental agenda, the curatorial logic sought to show the great porosity of the images—at times "greenwashed" and at other times restored to their aesthetic dimension. The Black Star photographs played a very important role in creating this experience of images, since they made it possible for us to realize that we have inherited our present from those past situations. This visible confrontation did not serve solely as a type of visual archaeology; it also inscribed these press photographs in contemporaneity. The images of the sick little snow monkeys thus accompanied the text of the "Breaking Nature" section, a chapter of the exhibition that focused primarily on the pollution caused by plastics and petrochemicals in general. Since Minamata disease in Japan was caused by the negligence of the petrochemical industry, which had poured its highly toxic discharges into river and ocean waters, it constituted the

entry point for a visual actualization using works presenting the causes (oil and gas extraction in Canada and the United States) and the consequences (pollution and impoverishment of Indigenous communities).

In the "Anthropocene" section, a set of photographs from the Black Star Collection documented our long dependence on hydrocarbons and fossil fuels by using visual tropes to focus on the hyper-consumerism of cars in the 1970s (heaps of old tires, piled-up scrap cars). They were chosen because they evoked images from Edward Burtynsky's famous *Oil* series (1999), made at garbage dumps and gigantic storage sites, images that have become archetypical of environmental bankruptcy. A second Black Star group literally illustrated the geological aspects of the Anthropocene era. It showed the exposed strata of a lignite mine (lignite is a soft coal used for heating and electricity generation) and the fractured rocks of a coal mine in Farmington, New Mexico—two particularly polluting mining sites. The image of a 1981 landslide in Florida that engulfed a car and a trailer, shown in cross-section, clearly paid tribute to a well-known photograph by Joel Sternfeld, *After a Flash Flood, Rancho Mirage, California, July 1979*. Finally, Tom Ebenhoh's image of an ingenious method for recycling wrecked cars—lined up in a ditch to counter the erosion of Oklahoma farm fields in 1975—was chosen to reference the Dust Bowl of the 1930s. The photographs from the Black Star Collection demonstrated the visual culture of reference, both photojournalistic and artistic, to the works exhibited all around them.

The following section, "Climate Control," was introduced by the exhibition room text and the two Black Star image ensembles (see fig. 12.2). Four photographs taken by Carl Hartup, a photographer with the *Fort Wayne News-Sentinel* in Indiana, repeated the story of factory chimneys spewing plumes of smoke, which were intuitively understood to be causing pollution (see fig. 12.8). Extensive captions had been inscribed on the versos, documenting the emissions in more detail, but in the various *Life*, *Newsweek*, and *National Geographic* issues dedicated to air pollution,[11] images of this type are

11 Martin Schneider, "Air Pollution," *Life*, February 7, 1969, 38–50; *Newsweek*, "The Ravaged Environment," January 26, 1970, 30–40; Gordon Young and James B. Blaire (photog.), "Pollution: Threat to Man's Only Home," *National Geographic* 138, no. 6 (December 1970): 738–78; Walter Orr Roberts, "We're Doing Something about the Weather," *National Geographic* 141, no. 4 (April 1972): 518–55.

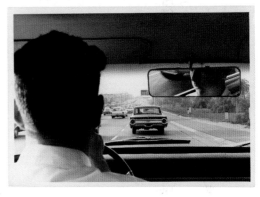

Figures 12.13 and 12.14
(opposite)
Gene Daniels, *Automobile Exhaust, Los Angeles, California*, ca. 1971. Gelatin silver prints, BS.2005.248177, 18 x 25.4 cm. BS.2005.248176, 16.8 x 24.5 cm.

Figures 12.15–18
Gene Daniels, *Automobile Exhaust, Los Angeles, California*, ca. 1971. Gelatin silver prints, BS.2005.248179, 17 x 24.9 cm. BS.2005.248180, 17 x 24.8 cm. BS.2005.248181, 17.9 x 25.4 cm. BS.2005.248182, 17.9 x 25.4 cm.

not usually linked to any pertinent information. Since the photographs sufficed on their own to symbolize environmental damage and pollution, the captions were not exhibited.[12] This made it possible to appreciate the aesthetic value of these information-based images and, since they were neither dated nor readily locatable, their interchangeable and generic character. Hartup's images were therefore sufficiently paradigmatic to illustrate the *Clean Air Act*—passed in 1970 to control air pollution in the United States—as much as air pollution itself.

It is this characteristic, common to many photographs of environmental subjects at the time, that was highlighted by the mounting of *The Edge of the Earth*, echoing what Finis Dunaway says about environmental photojournalism of the 1970s:

> From Santa Barbara [oil spill] to Earth Day and beyond, audiences encountered an array of images that signified ecological interconnection and the all-encompassing reality of the environmental crisis. While some images focused on particular places or spectacular disasters, the coverage of the environmental crisis transcended specific locales to imagine Americans living through a critical moment, a temporal horizon in which the future looked increasingly uncertain and threatening.[13]

It is exactly in this manner that two other images from the Black Star Collection function—by relaying very precise but completely generic situations. The first, taken by Michael Crummett in 1975, is of a typical western American landscape polluted by toxic emissions from the Four Corners power plant, which is on Navajo territory. A sign in the foreground states: "LAKE CLOSED UNTIL FURTHER NOTICE," while thick plumes of smoke tower over the field and road beyond, choking up three-quarters of the image. The caption on the verso of the second image, by Carole Sill, states: "Smoke from a burning, lightning struck oil tank. Taken from a distance of approximately twenty-five miles. Located near Augusta, Kansas, in a district of many oil wells, refinerys [*sic*], etc." In other words, it was an ordinary accident, but

12 Another common visual trope was images of smog swallowing up panoramas of New York and Los Angeles.

13 Dunaway, *Seeing Green*, 39.

Figure 12.19
Installation view of *The Edge
of the Earth: Climate Change in
Photography and Video*, 2016.
Digital image. Photography
by Riley Snelling. © Riley
Snelling, The Image Centre.

one of monstrous dimensions if we rely on the size of the noxious smoke plume that fills the frame. Here again the contemporary viewer does not need to know the origin of the smoke, since the image serves as a speculative screen, echoing another work presented in the room.

On a TV screen in the gallery, Hicham Berrada's video *Celeste* (2014) displayed thick blue smoke being emitted in an undetermined green space, framed by a window (fig. 12.21). With no explanation, no sound, and no context, the artwork was open to all sorts of speculation and theories: a demonstration? serious pollution of nature? a tribute to Yves Klein? This dizzying freedom of interpretation seemed completely out of place next to Sharon Stewart's activist photographic investigation of sites polluted by the petrochemical industry in Texas. However, that was precisely what the exhibition aimed to do: to engage the viewers in an analysis of their point of view and its context. The press image was endowed with enough legitimacy to be understood within the exhibition's global mechanics, which sought to palpably convey the effects of a cross-pollination between engaged works and others that weren't; between upfront works and other, more elliptical ones or images that had been stripped of their informative purpose, such as those from the Black Star Collection. Left "free," the press photographs were not labelled in the exhibition because, as they had been released from their (now obsolete) information-bearing mission, they could be affirmed as visual matrices of climate change and once again become topical.

The numerous images from the Black Star Collection thus perfectly represented the fervour for environmental topics documented from the late 1960s to the mid-1970s in US illustrated magazines such as *Life*, *Newsweek*, and *National Geographic*. The selection of archival images sought to represent the main visual tropes of a North American environmentalism that is still in effect today. This body of work also served to demonstrate the visual culture of the representatives of environmental photography exhibited in *The Edge of the Earth*, to point out the similarities between their images and those of the press, and to underline those filiations and the resulting continuity. Finally, the archival images questioned the outdated nature of their environmental information, all the while paradoxically asserting the critical continuance of ecological problems that are still with us today, represented here in an analogue

Figure 12.20
Carole Sill, *Smoke from a
Burning Lightning-Struck Oil
Tank near Augusta, Kansas,*
ca. 1959. Gelatin silver
print, 20.4 x 25.4 cm.
BS.2005.248094.

Figure 12.21
Hicham Berrada, *Celeste*,
2014. Digital photograph.
© Hicham Berrada. Courtesy
of the artist and Galerie Kamel
Mennour, Paris.

manner. In order to testify to the inertia of the situation, it was important to highlight the invariable and generic character of some images and some subjects. Moreover, ridding them of their informative value also allowed these images to be recognized for their aesthetic value, thus responding to the expanded visuality of environmentalism broadly represented by the contemporary works in the exhibition. Using the surprisingly numerous images found hidden in the Black Star Collection, it was not only about putting together a visual archive of media attention to the causes and effects of climate change, but also about activating those old images in the current context, to restore their aesthetic—not just their testimonial—dimension. Some of the images are accusatory and others more silent, while a few have become clichés. Confronted by the evident visibility of environmental degradation, they were nourished and, in some cases, transformed by those contexts, while current practices gained a photographic genealogy.

Afterword

Paul Roth

While the Black Star photo agency's black-and-white print archive ended up at a university in Toronto, its nearly 300,000 photographs might just as easily have been destroyed—hauled to a landfill or abandoned in a storage facility. Though many do not realize it, such a fate has befallen (and will continue to endanger) many picture files once held by community newspaper companies, magazine and book publishers, distribution agencies, and stock photo services. Entire visual histories have been lost in this way, all around the world. Of course, many physical print libraries live on in one form or another, whether boxed and preserved in university special collections or museums, where they await the researchers who might unearth, investigate, and contextualize the stories they contain. Some libraries are monetized by commercial rights and reproduction firms—the successors to agencies such as Black Star—that charge fees for use of the images in media, and still others are held as assets for future sale by corporations or collectors. Most such archives remain physically inaccessible, with only a fraction of their images available digitally.

That Black Star's distribution prints survived in the approximate form and organization of the agency's filing system during the heyday of the picture press is something of a minor miracle. Beyond mere survival, moreover, the collection's acquisition by Ryerson University (now Toronto Metropolitan University) inspired the school's leaders. They invested heavily in the scholarly lure and research possibilities of this visual resource of twentieth-century history and culture. Far from burying the print archive in boxes, rarely to be accessed, the university chose to build, staff, and fund a new research centre and museum to house the collection and make it as accessible as possible. To the institution's visionary president, provost, and board of governors, the Black Star Collection suggested a rich opportunity for public outreach, a lure to future students and visiting scholars from near and far.

When I arrived at the university in late 2013 to become the second director of the Ryerson Image Centre (RIC, now The Image Centre), I myself was drawn by the Black Star Collection, not only the prints and their possibilities but also the strong sense of potentiality and responsibility generated by stewardship of the photographs. Founding director Doina Popescu, along with her advisory board and a growing staff, were committed to shaping a robust and dynamic institution around the collection at a time of constriction and retreat for many photography museums in North America. As the RIC was being developed and new staff were hired, with its offices and galleries integrated into a renovated brewery warehouse shared with the university's School of Image Arts, other photography museums were facing declining audiences and revenue, sclerotic bureaucracies, and progressively reduced staffing. Here in Toronto was a new and growing photography institution, one that seemed energetic and light on its feet, dedicated to exploring photo history through its collection and in its exhibitions and publications.

In her foreword, Doina describes the early history of our young institution. I'd like to conclude this book with an explanation of how we have been shaped by this extraordinary collection and the challenges it presents. During my first days at the RIC, Doina emphasized the central role of the Black Star prints in our formation and conceptualization. The collection, she said, should never be left boxed up like ashes in a mausoleum, as are so many collections of this type in larger and more established institutions. I thus took it as axiomatic that we treat the Black Star Collection, as well as other parts of our collection (and future acquisitions), as a living entity and an open resource. That we invite people in to generate new scholarship. That we base our own exhibitions around original research in the collection and build on and around the strengths of our holdings—chief among them, the Black Star photographs. That, in effect, we let the collection teach us.

In a crucial way, our ongoing consideration of the Black Star Collection has influenced our very understanding of the medium we study and, by extension, the ways we operate as an institution. The photographs themselves, many of which feature remnants of the airbrushing and other retouching that accompanied their reproduction in print, and which retain captions, labels, and other annotations from their distribution and publication, insist

that we reframe our perspective. We no longer have the luxury of thinking of photography merely as an "art form," as so many museums do. Images are made and understood in many ways, for many purposes, and by many audiences. Looking at this collection, we cannot misunderstand the photographers as being the sole authors of the photographs, operating independently; rather, we must contextualize their function within a complex ecology that begins with commissions and assignments and ends with the picture in print, to be viewed by others. Knowing this, we cannot continue perpetuating the common romantic notion that a photograph operates somehow mystically, as an image without ground, free of the paper it is printed on, free of the time in which it was made, free of the culture that produced it—a mere portal through which the contemporary viewer may access the event, thing, person, or idea that is depicted. Black Star's press prints and the publications that reproduced them force us to confront the actual object that carries the image—an object inscribed with the history of its manufacture and reproduction—so that we understand, and can explain to our public, the context of the photograph's production and public reception.

Photography's complex ontologies are endlessly and variably suggestive, and so it was only natural that this new photo museum would ground its work in research, if only to seek out and do justice to the many stories the medium has to tell. Our exhibitions, for example, are anchored by scholarly and artistic enquiry. Exploration in the Black Star Collection in particular has been central to a number of the exhibitions we've organized, including *Black Star Subject – Canada* (2014); *What It Means to Be Seen: Photography and Queer Visibility* (2014); *Dispatch: War Photographs in Print, 1854–2008* (2014); *Burn with Desire: Photography and Glamour* (2015); and *The Edge of the Earth: Climate Change in Photography and Video* (2016). We have also organized shows devoted to single historic events where Black Star's coverage was extensive, for example, the turning point of the American civil rights movement—*Birmingham, Alabama, 1963: Dawoud Bey / Black Star*—in 2017; and a legendarily destructive earthquake—*TERREMOTO: Mexico, 1985*—in 2018. In these and other exhibitions, our staff and guest curators have combined photographs distributed to the press through Black Star with the work of other photographers covering the same subject from different perspectives, including artists who have more recently revisited public memories of past events.

Recovering histories from the corpus of Black Star is not easy. The collection imposes serious demands on curators and scholars and effectively calls us towards more complex storytelling. For one thing, it is extremely difficult to search for specific subjects, events, photographers, or images, given that the prints came to us with an inconsistent and somewhat rudimentary filing system. Beyond that, the searching itself reminds us, day by day, of how many layered stories there are to tell within, behind, and between the pictures. We are ever cognizant that the histories preserved in the Black Star Collection are backgrounded by the processes of production and selection hinted at in the markings on the print versos; the prevailing social, political, and personal contexts prevalent at the time the images were made; and the circumstances and outcomes of their publication and public reception. Knowing this, we cannot help but be drawn to and galvanized by the overlapping narratives revealed through research.

In this way, Black Star's presence at the heart of our institution exerts a formidable gravity, inspiring us to interrogate the relationship between medium and subject in all our exhibitions and public programs, and in similarly complex and open-ended ways. Shows we've mounted that do not include Black Star prints often reflect this same curatorial sensibility of inquiry and reflexivity, for example, *Attica USA 1971: Images and Sounds of a Rebellion* (2017); *The Faraway Nearby: Photographs of Canada from the New York Times Photo Archive* (2017); *Jim Goldberg: Rich and Poor* (2018); *Gordon Parks: The Flávio Story* (2018); *The Way She Looks: A History of Female Gazes in African Portraiture* (2019); and *Mary Ellen Mark: Ward 81* (2023). These exhibitions bring research right to the surface, inviting our audience to explore the subject in multivalent ways as party to the inquiries of our curators.

Beyond our exhibitions, Black Star influences our institution in other ways. Our collection is utterly defined by its presence. In Toronto (and in some corners of the photo world) we are best known as the repository of this famous press print collection, to such an extent that we sometimes worry that it overshadows our other holdings, defining us to the exclusion of the other resources we shepherd. When the collection arrived, it joined a small teaching collection assembled over time by the university's photography teachers. In one moment we went from having approximately 3,000 photographs to nearly 300,000. Such a transfiguration

cannot help but exert an influence on the future, and so it did. Since its acquisition we collect to fill in the gaps of the Black Star Collection and to build on its strengths.

To demonstrate Black Star photographs in print, we acquired a complete run of *Life* magazine, the publication that had the most integral professional association with the agency. That in turn led to our acquisition of two out of three original magazine dummies that precipitated the launch of *Life*, created by Black Star's co-founder Kurt Safranski circa 1935 to convince Henry Luce of the need to publish a picture magazine. To represent photojournalism in Canada (a geography largely absent from Black Star's coverage), we acquired the Rudolph P. Bratty Family Collection of twentieth-century Canadian history: 21,000 press prints repatriated from the *New York Times* Photo Archive. To expand our representation of documentary photography beyond assignment photojournalism, we've added career-spanning research collections of Magnum photographers Bruce Davidson and Jim Goldberg, both of whom maintained a purposeful independence from the picture press.

Beyond Black Star's magnitude and positive inspiration, the collection challenges us in ways we still struggle to resolve. Its vast size and scope, exhilarating to so many curators and scholars who have worked within it, can be daunting as well. The trees seem impossible to make out in the vastness of the forest. That apparent impenetrability gives the Black Star Collection an intimidating effect: Can we ever know the collection in its entirety? Can we even identify and make available its many photographs? We are forever learning of picture stories we haven't seen, agency photographers we didn't know about, background information that reframes our understanding of how Black Star did its work. Given the collection's scale, we've digitized only a fraction of the photographs, and we've catalogued even fewer. Going forward, we have a responsibility to digitize the collection at greater speed. We are collaborating with others to experiment with artificial intelligence, in hopes that machine learning and digital research can allow us to more quickly and reliably aggregate cataloguing information and metadata for the photographs. If we succeed in those areas of improvement, we can make the collection more accessible to those who want to explore it.

Ten years after we opened our doors, our commitment to the Black Star Collection continues: to making its photographs available for research, to exploring the collection through research and publications, and to building our

other holdings around its horizons. We are forever asking ourselves, "What will we do next to illuminate Black Star?" As I write this afterword, we are finishing a new exhibition called *Stories from the Picture Press: Black Star Publishing Co. and the Canadian Press*. This show, presently scheduled for fall 2023, will feature individual story assignments along with personalities and subjects preserved in the agency's picture files. Our curators hope to illuminate how photographers worked in the context of Black Star—and, as a point of comparison, at Canada's premier national news agency—to tell different stories. The exhibition's thirty-five "chapters" will illuminate how Black Star worked in the context of North American press agencies, how its distribution to magazines and newspapers contributed to public understanding of news events and personalities, and finally, how this singular distribution outlet for photographs came to preserve a visual historical record of the twentieth century.

The book you are holding in your hands is also an important part of our efforts to continue activating, illuminating, and understanding the Black Star Collection. With this sixth volume in the IMC Books series (formerly RIC Books), we pause, look at the work done to date in the collection, and try to explain what we've learned—both what our researchers have discovered from working with the prints and what we can understand from their experiences and discoveries. And then we'll put the book on the shelf and keep going.

Notes on Contributors

Nadya Bair is assistant professor in the Department of Art History at Hamilton College in Clinton, New York. Bair received her PhD in art history in 2016 from the University of Southern California with the support of a Mellon/ACLS Dissertation Completion Fellowship and was the recipient of a Getty/ACLS Postdoctoral Fellowship in the History of Art. She has also held postdoctoral fellowships at The Image Centre and Yale University's Digital Humanities Lab. She has published articles on photography and the press in the journals *American Art* and *History of Photography* and also in several edited volumes. Bair is the principal investigator for Inside the Decisive Network, a digital project that accompanies her book *The Decisive Network: Magnum Photos and the Postwar Image Market* (University of California Press, 2020), which won the 2021 PROSE Award for Media and Cultural Studies.

Denise Birkhofer, PhD, Institute of Fine Arts, New York University, is collections curator and research centre manager at The Image Centre, Toronto. She has held curatorial positions at the Allen Memorial Art Museum (AMAM), Oberlin College, and the Grey Art Gallery, New York University, among other institutions. A specialist in modern and contemporary art and photography, her numerous exhibitions include *Fred Wilson: Black to the Powers of Ten* (AMAM, 2016–17); *The Faraway Nearby: Photographs of Canada from the* New York Times *Photo Archive* (The Image Centre, 2017); *TERREMOTO: Mexico City, 1985* (The Image Centre, 2018); and *CANADA NOW: New Photography Acquisitions* (The Image Centre, 2022). Birkhofer has published and presented widely on such topics as photography archives, institutional collecting, street photography, female artists, and art of the Americas.

Reilley Bishop-Stall, PhD, is a settler-Canadian art historian whose research centres on Indigenous and settler representational histories, with a specific focus on historical and contemporary photography and anti-colonial and activist art. She received the 2018 Arts Insights Dissertation Award for McGill University's best dissertation in the humanities, and her work has been published in peer-reviewed journals such as *Photography & Culture*, *Art Journal Open*, and *Journal of Art Theory and Practice*. Having recently completed a Horizon Postdoctoral Fellowship with Inuit Futures in Arts Leadership: The Pilimmaksarniq/Pijariuqsarniq Project, Dr. Bishop-Stall is currently Assistant Professor in the Department of Art History at Concordia University, Montreal.

Taous Dahmani is a French, British, and Algerian art historian, writer, and curator specializing in photography. Her academic research focuses on the photographic representation of struggles and the struggle for photographic representation. Her projects mainly involve the links between photography and politics, such as the visual culture of protests, migratory narratives, and intersectional feminist discourses. She has published in various scientific journals and regularly presents papers at academic conferences. She also writes for art magazines and is frequently invited to hold public "in conversations with" photographers. She works in Paris, Marseilles, and London. Dahmani is editor and content advisor for *The Eyes*, a trustee of the Photo Oxford Festival, and on the editorial board of *MAI: Feminism and Visual Culture*. She is also the 2022 Louis Roederer Discovery Award curator at Rencontres d'Arles.

Thierry Gervais is an associate professor at Toronto Metropolitan University and head of research at The Image Centre, Toronto. He was the editor-in-chief of *Études photographiques* from 2007 to 2013 and is the author of numerous articles on photojournalism in peer-reviewed journals and scholarly publications. He was the curator of the exhibition *Dispatch: War Photographs in Print, 1854–2008* (The Image Centre, 2014) and co-curator of the exhibitions *Views from Above* (Centre Pompidou-Metz, 2013), *Léon Gimpel (1873–1948): The Audacious Work of a Photographer* (Musée d'Orsay, Paris, 2008), and *L'événement: Les images comme acteurs de l'histoire* (Jeu de Paume, Paris, 2007). At The Image Centre he organized the symposia "The

'Public' Life of Photographs" (2013), "Collecting and Curating Photographs: Between Private and Public Collections" (2014), "Photography Historians: A New Generation?" (2015), and "Photography: The Black Box of History" (2018). He edited *The "Public" Life of Photographs* (2016), the first volume of the academic RIC Books series, published in partnership with MIT Press. His most recent book (with Gaëlle Morel), *The Making of Visual News. A History of Photography in the Press*, was released by Bloomsbury in 2017. His current research focuses on retouched press photographs.

Alexandra Gooding emigrated from Barbados to Toronto in 2011. She holds a BFA (Hons) in Photography Studies and an MA in Film and Photography Preservation and Collections management, both from Toronto Metropolitan University. She has received several awards and grants, including a Government of Barbados exhibition award, an Ontario Graduate Scholarship, a SSHRC Canada Graduate Scholarship – Master's, and the 2020 Howard Tanenbaum Fellowship at The Image Centre. She has held curatorial, collections, and administrative positions at The Image Centre, the Stephen Bulger Gallery, and the Art Gallery of Ontario. Her research focuses on photographic representations of the Caribbean and how augmented applications of metadata and indexing schema can make Caribbean material culture more intellectually accessible in collection catalogues. Her research has been published in *KULA: Knowledge Creation, Dissemination, and Preservation Studies* and she is currently the newsletter editor for the Museums Association of the Caribbean.

Sophie Hackett is Curator, Photography, at the Art Gallery of Ontario (AGO) and adjunct faculty in Toronto Metropolitan University's master's program in Film and Photography Preservation and Collections Management. Hackett's areas of specialty include vernacular photographs, photography in relation to queerness, and photography in Canada from the 1960s to 1990s. Her curatorial projects include *Barbara Kruger: Untitled (It)* (2010), *Max Dean: Album; A Public Project* (2012), *What It Means to Be Seen: Photography and Queer Visibility* (2014), *Fan the Flames: Queer Positions in Photography* (2014), *Introducing Suzy Lake* (2014), *Outsiders: American Photography and Film, 1950s–1980s* (2016), *Anthropocene* (2018), *Diane Arbus:*

Photographs, 1956–1971 (2020), and *What Matters Most: Photographs of Black Life* (2022). Hackett was a 2017 fellow with the Center for Curatorial Leadership in New York City.

Christian Joschke is a professor at the École des Beaux-Arts de Paris and a co-founder and co-editor of the journal *Transbordeur: Photographie, histoire, société*. He is the author of *Les yeux de la nation: Photographie amateur et société dans l'Allemagne de Guillaume II, 1888–1914* (The eyes of the nation: Amateur photography and society in the Germany of Wilhelm II, 1888–1914; 2013) and co-editor, with Damarice Amao and Florian Ebner, of *Photographie, arme de classe: La photographie sociale et documentaire en France, 1928–1936* (Photography as a weapon for the working class: Social and documentary photography in France, 1928–1936; 2018). He is currently working on a book about the worker-photography movement in Germany during the 1920s.

Vanessa Fleet Lakewood is a writer, educator, and cultural worker. Her writing on contemporary art, photography, and performance appears in *C Magazine*, *Prefix Photo*, and *The Oxford Handbook of Hip Hop Dance Studies*. Her doctoral research project on the American documentary photographer Martha Cooper was awarded a Vanier Canada Graduate Scholarship and The Image Centre's 2018 RIC Research Fellowship. She is an adjunct professor in the Film and Photography Preservation and Collections Management graduate program at Toronto Metropolitan University. She lives and works between Toronto and Fort Erie, Ontario, in the traditional unceded territories of the Haudenosaunee and Anishinaabe people and the Mississaugas of the Credit First Nation.

Vincent Lavoie is a professor in the Department of Art History, Université du Québec à Montréal (UQAM), and a member of the university's Figura research centre. He is the author of *Photojournalismes: Revoir les canons de l'image de presse* (Paris: Hazan, 2010) and *L'affaire Capa: Le procès d'une icône* (Paris: Textuel, 2017; translated into Italian by Johan & Levi, published by Monza, 2019) and the editor of *La preuve par l'image* (Québec: Presses de l'Université du Québec, 2017). His recent essay *Trop mignon! Mythologies du cute* (Paris: PUF, 2020; Paris: Humensis, 2022) questions the paradigm of cuteness in contemporary animal representations. He is the principal investigator of a SSHRC-funded research team dedicated

to studying the visualities of animal welfare. He is also a member of the SSHRC-funded international and interdisciplinary research group Archiver le present, dedicated to the analysis and valorization of contemporary artistic and literary practices that problematize the hoarding, classification, and recording of information flows.

Valérie Matteau is Senior Exhibitions Officer at The Image Centre in Toronto, where she is responsible for the management of exhibitions and exhibition-related publications. In this role she has collaborated with numerous curators on exhibitions and catalogues, including *Birmingham, Alabama, 1963: Dawoud Bey / Black Star* with Gaëlle Morel (2017; 2019, Museum of Contemporary Photography, Chicago, IL), *The Edge of the Earth: Climate Change in Photography and Video* with Bénédicte Ramade (2016), *Human Rights Human Wrongs* with Mark Sealy (2013; 2015, The Photographers' Gallery, London, UK), and *Archival Dialogues: Reading the Black Star Collection* with Doina Popescu and Peggy Gale (2012). From 2006 to 2012, Matteau worked primarily with the Black Star Collection, facilitating access to the collection for staff, researchers, guest curators, and writers. Matteau holds an MA in Photographic Preservation and Collections Management from Toronto Metropolitan University.

Emily McKibbon is an independent writer and curator of settler descent currently based in Tkaronto. She has worked in curatorial, collections, and research capacities at the MacLaren Art Centre, Barrie, Ontario; the George Eastman Museum, Rochester, New York; the Getty Research Institute, Los Angeles; The Image Centre, Toronto; Seneca College, Toronto; and the University of Guelph, Ontario. Her writing has been published in *Canadian Art*, *C Magazine*, *PRISM international*, *Room*, *The New Quarterly*, and other literary and arts periodicals. She has received numerous awards and recognitions, including an honourable mention for Best New Magazine Writer at the Canadian National Magazine Awards.

Doina Popescu is Founding Director of The Image Centre at Toronto Metropolitan University. In a career spanning three and a half decades she has curated and spearheaded innumerable exhibitions, critical arts publications, and public programs with a focus on local, national, and international

dialogue, visitor engagement, and the essential role of the artist in society. Prior to joining TMU, Popescu was Deputy Director and Program Curator at the Goethe-Institut Toronto. She has extensive expertise in institutional leadership and international partnerships and is a board member of numerous multidisciplinary organizations that further cultural exchange and understanding through the arts.

Bénédicte Ramade is an art historian, critic, and independent curator specializing in environmental issues. Since 2016 she has focused on the growing entanglement of knowledge and artworks with/in the Anthropocene and has developed research on animal points of view and botanical agency. In collaboration with The Image Centre, Ramade curated the 2016 exhibition *The Edge of the Earth: Climate Change in Photography and Video* and edited the accompanying catalogue. *Vers un art anthropocène: L'art écologique américain pour prototype*, her monograph published in 2022 by Les Presses du réel, updates her doctoral dissertation about ecological art from an Anthropocene perspective. With ten years' experience teaching at the Université de Paris 1 (Panthéon Sorbonne), Ramade now works as a sessional lecturer at both the Université du Québec à Montréal (UQAM) and the Université de Montréal.

Paul Roth is Director of The Image Centre at Toronto Metropolitan University. He previously served as Senior Curator of Photography and Media Arts at the Corcoran Gallery of Art and as Executive Director of the Richard Avedon Foundation. Since 1990 he has organized (or helped organize) more than a hundred museum exhibitions and film programs. Roth is co-author and co-editor of four books about the American photographer Gordon Parks, including *Gordon Parks: The Flávio Story* (Göttingen: Steidl, 2018) and *Gordon Parks: Collected Works* (Steidl, 2012). He is also the author and editor of *Richard Avedon: Portraits of Power* (Steidl/Corcoran Gallery of Art, 2008).

Mark Sealy, PhD, OBE, is interested in the relationships between art and photography and social change, identity politics, race, and human rights. He has written for many of the world's leading photographic journals, produced numerous artists' publications, curated exhibitions, and commissioned

photographers and filmmakers worldwide. In addition, he is an advisor to several leading cultural institutions, including the Tate, the Paul Mellon Centre for the Studies in British Art, and the Baltic Centre for Contemporary Art. Sealy's published critical writings on photography include *Photography: Race, Rights and Representation* (2022) and *Decolonising the Camera: Photography in Racial Time* (2019). He has been the executive director of Autograph (formerly the Association of Black Photographers) since 1991. He is a professor of photography, rights, and representation at University Arts London, London College of Communication.

Drew Thompson is an educator, writer, and independent curator who specializes in African and Black diaspora visual and material culture. He is the author of *Filtering Histories: The Photographic Bureaucracy in Mozambique, 1960 to Recent Times* (University of Michigan Press, 2021) and is working on another book titled *Coloring Black Surveillance: The Story of the Polaroid in Africa, the Anti-apartheid Struggle, and the Contemporary Art World*. Currently he is affiliated with the Bard Graduate Center in New York and previously taught at both Bard College and Toronto Metropolitan University's School of Image Arts.

Zainub Verjee is a critic, writer, artist, and art administrator. For more than four decades her work has been closely associated with the discourses and practices of art at the intersection of digital technologies, cultural policies, institutions, law, labour, anthropology, politics, philosophy, and international relations. She has contributed to academic journals and books and her commentaries have appeared in *Canadian Art*, *Parallelogram*, *Galleries West*, and the *Georgia Straight*. She has held senior positions at Western Front (Vancouver), the Canada Council for the Arts, the Department of Canadian Heritage, and the City of Mississauga. She is a Senior Fellow at Massey College, University of Toronto, and a McLaughlin College Fellow at York University, Toronto. She has received numerous awards, including a Governor General's Award in Visual and Media Arts for outstanding contributions to the arts, and honorary doctorates from OCAD University, Toronto, and NSCAD University, Halifax. Currently she is executive director of Galeries Ontario/Ontario Galleries in Toronto.

Index

Series Editor
Dr. Thierry Gervais

Editors
Dr. Thierry Gervais and Dr. Vincent Lavoie

Copy Editing and Index
Gillian Watts/Word Watch Editorial Services

Proofreading
Laura Edlund

Project Management and Rights and Reproductions
Alexandra Gooding

Imaging
Laura Margaret Ramsey and Hilary Wilson

Book Design and Type Setting
Anne Cibola and Marco Cibola/Studio Ours Inc.